Digital Storytelling

Digital Storytelling

The Narrative Power of Visual Effects in Film

Shilo T. McClean

The MIT Press Cambridge, Massachusetts London, England

MIT Press books may be purchased at special quantity discounts for business or sales
promotional use. For information, please email special_sales@mitpress.mit.edu or write
to Special Sales Department, The MIT Press, 55 Hayward Street, Cambridge, MA 02142.

This book was set in Garamond and Bell Gothic and was printed and bound in the
United States of America.

Library of Congress Cataloging-in-Publication Data

McClean, Shilo T.
Digital storytelling : the narrative power of visual effects in film / Shilo T. McClean.
 p. cm.
Includes bibliographical references and index.
ISBN 978-0-262-13465-1 (hc.: alk. paper)—978-0-262-63369-7 (pb.: alk. paper)
1. Cinematography—Special effects. 2. Digital video 3. Digital cinematography.
4. Motion picture authorship. I. Title.

TR858.M348 2000
791.4302'4—dc22

 2006049020

10 9 8 7 6 5 4 3 2

Contents

Contents

Preface

[W]ith all [the] magical technological advances that have brought movies to where they are today, everything we do on film is based on the most human of arts, and it's the art of storytelling. In every culture all around the world, storytelling is how people connect with one another. State-of-the-art technology will change, but state-of-the-heart storytelling will always be the same.

—SID GANIS, PRESIDENT OF THE ACADEMY OF MOTION PICTURE ARTS AND SCIENCES, MARCH 5, 2006, 78TH ACADEMY AWARDS

I often overhear people comment that they did not like a film because it was "all effects and no story." I can sympathize with wishing for a *better* plot, but no major feature film has been released without at least *some* pretence of a story, no matter how many digital visual effects (DVFx) were used. Many of these stories do have substantial script problems, and sometimes films with quite terrible scripts are remarkable only for their superlative DVFx. Unfortunately, people seem to assume that the effects took over, as if they had been invited onto the set and promptly did away with all copies of the script, mesmerized the director, and bludgeoned the crew into making "an effects film."

Some directors do appear to go quite mad in the glow of the production's greenlight. This can be a case of overindulging in tricky camera moves, hyperspeed editing, relentless music, and, of course, DVFx. As a reaction to this, other filmmakers seek a "purer" kind of filmmaking that eschews stylized camera moves, editing, music, or DVFx. Yet, between these extremes, there are many films and filmmakers who use these effects quite powerfully.

The intention of this book is to travel that ground between the extremes and discover how DVFx impact narrative. The subject is of interest to writers, filmmakers, digital-visual-effects artists, film theorists, and film aficionados (especially those who love DVFx, of course)—and each of these groups approaches the issue from a unique perspective.

For screenwriters, the focus largely is on how DVFx can open up their storytelling. Many writers avoid creating scenes requiring effects out of fear that they would price their script out of the market. Others shun DVFx as "the enemy": an innovation that is undermining storytelling. The truth, however, is that the best use of DVFx and other great advances in technology very often result from writers' own imaginations and derive from good storytelling.

Directors, cinematographers, and production designers are sometimes reluctant to use DVFx because they, like writers, fear the costs, but also because they fear that the technical requirements will curtail their creative style. Of course, technical requirements are the very stuff of filmmaking and are often the inspiration for fabulously creative solutions. Yet with DVFx, the fear of the technical is most likely linked to the fear of handing over control to digital-visual-effects artists, who are only just beginning to be accepted as a part of the "real" film crew. The reluctance of filmmakers to welcome these artists as part of the collaborative process is unfortunate because invariably the best results in DVFx come about when the artists work as an integral part of the production.

For the effects artists, knowledge of traditional film production often is something gained outside of their professional experience. Familiarity with the principles of camera movement, editing, and screen grammar can come second to expertise in particular software packages and how to survive "life on the box." This is changing as more digital-visual-effects artists gain on-set experience and as filmmakers with experience in cinematography, production design, and editing become digital-visual-effects artists. However, it is important that these artists do more than simply follow a director's brief. When filmmakers and effects artists create DVFx using the common ground of narrative function instead of focusing on technical details only, it enhances the likelihood that the effects will work thematically as well as visually.

When effects are used with the kind of considered knowledge that has shaped filmmaking practice, such as camera movement, they are best poised to create work that has lasting value. When something is used not only because it is a technical solution but also a narrative tool, the contribution it makes to the story overall can add to the expression of the film's themes. Yet most texts on

DVFx focus either on the technical aspects or, in academic writing, on the relationship it has to specific genres, most commonly science fiction. For the most part, film theorists have looked long and hard at how DVFx have worked within certain genres but have ignored how they are used across the medium of narrative film as a whole.

Accordingly, this book is primarily about storytelling. It addresses the various interests of writers, filmmakers, and film theorists within the larger idea that DVFx are an important way to enhance storycraft. Drawing on examples from across the spectrum of filmmaking, the book demonstrates expressive use of DVFx and discusses the implications of these creative uses.

For many, the pleasure of watching a film comes from being able to watch it on a number of levels, and this book shows how DVFx "work" within filmmaking as another level that can be considered when analyzing filmcraft. For the connoisseur, true appreciation is not simply knowing how the effects were produced and other technical facets of the images on the screen, but also in understanding how effects are used narratively and symbolically within films.

Having written previously on the practical implications of DVFx on the production process, I found it important to address the other impacts of DVFx. When filmmakers seek fresh ways to visualize their story elements through these effects sequences, they are influencing not only how the film will be produced and the practical development of DVFx, they are also making a contribution to the film storytelling canon. I hope this book will be a resource for writers, filmmakers, and theorists who want to rethink the use of DVFx in film.

Acknowledgments

This book has its origins in the Kenneth Myer Fellowship that I received upon graduating from the Australian Film, Television, and Radio School. So first I would like to thank Andrew Myer and his family for the generous endowment of that award. This book is derived largely from my PhD thesis for the University of Technology Sydney, and for the support I received in completing that degree I would like to thank my supervisor Stephen Mueke and cosupervisor Margot Nash. I would also like to thank Sean Cubitt, Noel King, and Andrew Murphie for their invaluable comments upon that thesis and its transformation into this book.

Thanks also must go to the great stalwarts from industry for their aid and support throughout this project: Greg Smith, Zareh Nalbandian, and Anna Hildebrandt of Animal Logic, one of the world's leading digital-visual-effects studios. My appreciation also goes out to faithful friends and advisors Mike Chambers, Mark Pesce, Peter Giles, Ian Brown, and Ron Roberts. I also must thank the filmmakers who have encouraged and supported this endeavor: Robert Connolly and John Maynard from Arena Films, John Weiley from Heliograph, Michael Gracey, and especially Dr. George Miller for agreeing to be my mentor on this journey.

I would like to extend my thanks to Doug Sery and Mel Goldsipe of The MIT Press for welcoming this book and then whipping it into shape. Their expertise and advice has been invaluable.

Throughout this whole process I have enjoyed the support of friends who did not flinch at attending movies with a companion who scribbled notes

throughout, by torchlight. My partner James Murty has my eternal gratitude for having endured not only multiple screenings of entirely terrible movies but the task of listening to my many drafts, verbalized mental debates, and a writing schedule that lasted into the wee hours of the morning for the last few years. I also have to thank my son Connor, born in the middle of this undertaking, who has been very tolerant of being read screeds of film theory instead of the fairy tales recommended by Bruno Bettelheim.

A version of chapter 4 was previously published as "Trick or Treat: A Framework for the Narrative Uses of Digital Visual Effects" as part of the proceedings of the 2004 Hawaii International Conference on Arts and Humanities.

Digital Storytelling

1

The Bastard Spawn: Hollywood Computer-Generated-Effects Movies—Some Introductory Comments

Bram Stoker's sixtyish Dutch doctor is re-cast as a thirtyish hunk (Jackman) . . . (who) goes to Transylvania to save the last of a family of vampire slayers (Beckinsale) from Count Dracula (Roxburgh). . . . *Van Helsing* is the bastard spawn of a sub-genre, a Gothic fantasy movie inspired by the graphic novel and the computer game. . . . It is beautifully shot, monumental in conception, full of amazing effects, and dull as someone else's tax returns. It's an example of everything that is wrong with Hollywood computer-generated-effects movies: technology swamps storytelling, action is rendered meaningless by exaggeration, and drama is reduced to monotonous physical bouts between "good" and "evil."[1]
— PAUL BYRNES, *SYDNEY MORNING HERALD*

For digital-visual-effects artists, the last twenty years have been, to borrow a phrase, the best of times and the worst of times. DVFx are considered a fundamental element for "blockbuster" films, which affords the effects artists not only regular employment but also a certain status among fans that was rarely achieved by previous generations of special-effects artisans. On the other hand, as Paul Byrnes's review of *Van Helsing* (2004, Sommers) indicates, DVFx routinely are cited as the means by which Hollywood is ruining storytelling.

The attention being accorded to the use of DVFx is not unique in the history of filmmaking. When sound and color first were introduced, the arguments mounted against them were much the same. One complaint in particular, that the spectacle of these technologies undermines storytelling, is a focus of this book.

In considering this issue, some interesting distinctions need to be taken into account. Film critics often imply that the use of DVFx is a substitute for "good"

storytelling. Such comments suggest that storytelling used to be better before the advent of DVFx and that the use of these effects is symptomatic of a "Hollywood gone bad." Some scriptwriters have suggested to me that a story is no longer necessary as long as a film has sufficiently impressive digital visual effects. This, however, is not said as a compliment to the standard of effects usage. It is more like speaking ill of the dead—an R.I.P. for storytelling while the digital effects dance on its grave.

Film theorists take a different approach, focusing largely upon issues of spectacularity and its relationship to narrative. Theorists interested in a genre such as science fiction look upon the use of effects with something of a proprietary interest, claiming the use of such effects has particular validity for science-fiction films. Some go so far as to say that effects are a defining trait of the science-fiction film.

The fact that DVFx are one of the most significant and expensive aspects of the digital revolution in film makes them particularly interesting to theorists with broader interests in the areas of technology and globalization. These theorists often see other factors than straightforward technological advancement at play in the adoption of DVFx by corporately financed film producers. While some of these arguments approach X Fileian proportions in their attribution of sinister and far-reaching political and economic influences, there are undeniable relationships between the development of DVFx and their use in military applications. Digital visual effects also are closely associated with the range of entertainment products that are the commercial interests of the fastest growing, most powerful industry: global entertainment.

Serious as these concerns are, however, economic/political arguments are not the focus of this book. Discussion of the economic, industrial, and political machinations that are of influence in the industry is best led by experts in the fields of economics and politics, and it is a subject that does not lack for attention. Similarly, the case studies in this book do not take up many of the wider issues of narrative theory, reception theory, psycho-sociological theory, philosophy, and others that might be pursued valuably by theorists considering the impacts of DVFx.

In fact the task of writing this book, even limiting it to the parameters chosen, has meant curtailing discussion in many areas. There are aspects of narration, camera movement, art history, developments in new media, and the film industry that could pursued further with great benefit. I have restrained myself from taking too many detours yet hope that I have signposted, for readers who

wish to continue on at the end of this path, some of these fascinating alternate journeys and recommended the best of many resources I have drawn upon.

This book is grounded in filmmaking, specifically the scriptwriting process. It looks at the issues that arise out of the impact of DVFx on the storytelling process and the closely related issues of spectacularity and narrative functioning, including associations with particular genres. I hope it also offers a starting point for rethinking DVFx usage overall.

So the questions that inspired this undertaking include:

- Does using DVFx undermine classical storytelling structure?
- Are DVFx being used as a substitute for story?
- Do DVFx always draw attention to themselves?
- Should DVFx be limited to certain genres?
- Have DVFx fundamentally changed the filmmaking process? And if so, how?

Paul Byrnes's critical response to *Van Helsing* is a good place to begin considering these questions. The review reveals certain flaws in logic that are central to the criticisms aimed at DVFx in filmmaking.

For example, to describe a film as a Hollywood computer-generated-effects movie is almost as helpful as describing it as a Dolby-surround-sound film or a 35mm film movie. Further, to make the accusation that "technology swamps storytelling"—perhaps meaning that the effects are more interesting than the story—is more a comment on the story than it is upon the technology. As the reviewer goes on to observe, other aspects of the technology of filmmaking—in particular, its cinematography—also are showcased in *Van Helsing*. So why is cinematography not blamed for the swamping of story?

In all likelihood, neither the cinematography nor the DVFx are to blame for the story's failings. The reviewer himself has identified a significant number of factors that influence a story's quality: poor structure, massive changes to fundamental plot details in the adaptation from an original source, poor premises, and reliance upon spectacle as a substitute for action, character development, and thematic resonance. In other words, it seems fair to say that it should come as no surprise that the film is a disappointment, to put it politely, when a filmmaker takes an idea but does little to give it substance in the way of real characters then goes on to give these character sketches very little to do except engage in relentless fight sequences and for precious little thematic reason. Further, as Byrnes has noted, although he *blames* the effects, he does seem to understand

that reducing a film's theme to monotonous physical bouts between "good" and "evil" or that by halving the age of the lead character, the filmmakers have made substantial alterations to the original story of Dracula—with consequent box office results.

Yet, while *Van Helsing* is what would most often be described as a "Hollywood computer-generated-effects movie," an equally curious reading of effects is presented by Chris Norris in his review of *The Eternal Sunshine of the Spotless Mind* (2004, Gondry):

The conventional mode for rendering . . . [the effects in the film] would be some kind of multiple screen, CGI morphing, and other techniques that a toddler would now read as Special Effect. Following some sublime atavistic impulse, Gondry instead opts for low-tech, painstakingly wrought effect—labors of love rather than Industrial Light and Magic—and the results are somehow more dramatic.[2]

Charlie Kaufman's script has earned accolades and awards for its achievement in scriptwriting. For this cleverly crafted story, the issue is not about a weak script being dressed up with layers of digital effects. Quite the contrary, the argument is that the effects make the story *more dramatic* because they were *not* crafted by computers. In other words, Norris seems to be suggesting that it is the use of computers in creating effects that can suck the soul out of a story.

However, this neglects two important points about the use of effects in *The Eternal Sunshine of the Spotless Mind:* most people are unlikely to know how the effects were achieved, and because visual effects are now predominantly produced digitally most audiences are likely to assume that the images were digitally crafted. More to the point, some of the effects in that movie were in fact DVFx—not, as Norris's warmly praises, ". . . analog instead of digital—seeking a small, quiet place to tell the sweet lovely story with global resonance."[3]

The Eternal Sunshine of the Spotless Mind relies upon digital composites and computer-generated (CG) effects to create and destroy the beach house and to add debris and snow elements.[4] Further, in a use that was necessary for practical reasons but also thematically resonant, Catherine Feeny reports:

Gondry's idea was that, as Clem walks down the street, the viewer realizes she has only one leg. "We had to remove both legs and create a CGI leg says [Louis] Morin [Visual Effects Supervisor, Buzz Image Group] . . . [and] removed the head from the first take and used it to replace the head in the second take. The only thing that wasn't touched was the middle part of her body."[5]

This digital erasure and reconstruction, when considered within the context of a story about someone having her memories erased and reconstructed takes on a deeper meaning. As a technical achievement, the effects work is unexceptional (although well executed). As a narrative achievement however, it is notable.

Thus, in this instance the reviewer is reading effects based on an assessment of story quality, and here the wonderfully dramatic script is giving the digital and analog effects a perceived warm analog glow. Essentially, the story is good and the effects, both digital and analog, are performing the rightful job of effects: to support the kind of story being told.

Of course neither Byrnes nor Norris deserves to be taken to task for their comments on the use of effects in these films because they are expressing views that are often held by film commentators. What I find most valuable from these examples is that they show the ease with which DVFx are scapegoated for common storycraft failings and, in the case of *The Eternal Sunshine of the Spotless Mind,* that there is a perception that analog is "real" but digital is not.

It is also important to note that these films tell quite different kinds of stories yet both rely upon visual-effects imagery. In this they give a good indication as to why the questions raised above have become so important to our consideration of how effects are being used in film storycraft.

While researching how DVFx impact traditional film-production practices,[6] virtually every effects artist I interviewed stated that effects always derive from story. It was this discrepancy between what the commentators say and what the digital-effects practitioners assert that demanded further investigation. This book looks at how the growing use of DVFx influences, and is influenced by, story.

Within film theory there is a long-held belief that narrative integrity always is sacrificed for the benefits of spectacle when effects are used. Often even those who are enthusiastic about current developments in the use of special effects discuss them in a manner that reflects admiration but also the view that effects overwhelm story. Yet, as digital effects are incorporated in more films and more kinds of films, and because the range of practice is such that it becomes virtually impossible to detect the presence of effects, there is an increasing need to reconsider the place of these affects in contemporary filmmaking and how they have come to hold this place.

Theories on the impact of spectacle on narrative predate the use of DVFx and usually are couched in terms of "special effects." The term "special effects" generally is used in a broad fashion to cover an array of film techniques. So it is

important to make a distinction between digital visual effects and special effects because the critics of DVFx often suggest that their use is a contemporary phenomenon that detracts from a glorious past of much better storytelling, in spite of the well-established arguments about special effects clashing with narrative engagement.

Almost any history of film will cite the very early use of special effects. In 1897 Méliès's films used in-camera effects, and the value that effects offered to filmmakers were prized to such an extent that, as Andrea Gronemeyer has said, beginning in the 1920s, "[Hollywood] directors controlled the largest production budgets in the world and could invest staggering sums in stars, costumes, sets, and special effects."[7] Hollywood filmmakers were not alone in using effects. Gronemeyer, discussing French Impressionism, states, "By using optical tricks, they [the Impressionist directors] attempted to illustrate the impressions of the film characters: Dreams, memories, visions and thoughts."[8] This practice later was taken up by Hollywood and has become developed even more expressively since DVFx were introduced.

These observations on film history point to an early use of special effects, the diversity of uses to which effects have been applied, and that effects were of interest for a range of film practitioners. This establishes the foundation upon which DVFx builds. However, in order to distinguish digital effects' impacts from this historical practice, it is important to clarify what comprises effects usage. Gronemeyer's reference to optical tricks is but one kind of "special effect." Pyrotechnic effects, mechanical effects, matte paintings, glass mattes, rear projection, miniatures, models, prosthetics, make-up, specialized props, and such also were well within the scope of early filmmakers, who used them to great result. These techniques, in addition to the optical "trickery" of special lenses and optical printing, enjoyed broad application from the earliest days of filmmaking and are still integral to "special effects" practice. Many films that use DVFx do so in conjunction with other special effects, so Norris's high opinion of the analog nature of the effects in *The Eternal Sunshine of the Spotless Mind,* should, to be fair, apply to a great many other contemporary films that also mix traditional-special-effects crafts and digital visual effects.

Therefore, the history of special-effects practice is valuable for two reasons. First, it allows consideration of how DVFx have impacted narrative structure by providing an opportunity to compare digital-visual-effects usage with traditional-special-effects practice. Second, it offers an opportunity to show how the theoretical placement of traditional special effects, in particular the arguments about

spectacle and genre, informs our current understanding of the impact of digital-visual-effects usage.

There is a vast discourse on spectacle and its relationship to narrative and genre, and these views are taken up in more detail throughout the book. However, for the sake of establishing the relevant tensions that are of issue, the following authors have made particularly useful observations that outline the range of arguments that have developed.

Vivian Sobchack, in her article "The Fantastic," makes reference to "foregrounding a range of cinematic practices identified as 'special effects.'"[9] She does this in the context of discussing films that "defy or extend verisimilitude by portraying events which fall outside natural confines."[10] Her discussion of the development of special effects usage from Méliès (1902) through fantasy adventures from the 1930s to the 1950s and the biblical epics of the late 1940s and 1950s highlights the "special" tag attached to the use of "special effects" and the association of these effects with certain kinds of narrative. This marking out of spectacular effects and their association with genres such as science fiction has become a cornerstone for much of the academic analysis of the field.

Building on Albert J. La Valley's statement that "Special effects thus dramatize not just the thematic materials of science fiction and fantasy plots, but also illustrate the 'state of the art,'"[11] Martin Barker argues that this "arbitrarily limits special effects to the realm of the celebration of technology."[12] Barker's argument is that special effects serve to indicate "moments where modality shifts take place"[13] in a narrative and that "to become 'special' in any film, some moments have to be signalled apart."[14] This reflects the idea that special effects have a narrative impact but contains it within the perspective that they stand out and serve to change the flow of the narrative. He goes on to observe:

Special effects have to be both narratively integrated and convincing representations of a realistic fictional world here for the audience to believe in them sufficiently, and so to engage with the resulting dilemmas posed for the film's characters. On the other hand, the simultaneous self-reflexivity of effects solicits attention in a more direct fashion, inviting the audience to see them as effects, and to react with awe and wonder at the capacity of the cinematic apparatus.[15]

Here is the issue that really needs to be addressed, as the questions earlier have outlined. As Barker and many others have argued, classical narrative is supposed to be so engrossing as to keep the "apparatus" of the filmmaker invisible, but spectacle, as created by effects, also is supposed to make the audience

aware of the technology of filmmaking. So the question arises: is it ever possible for spectacle—and effects—to fit into classical narrative filmmaking?

Joel Black also considers these issues in *The Reality Effect: Film Culture and the Graphic Imperative.* He comments that "A growing number of science-fiction and action-adventure films . . . don't just use special effects; they are special effects."[16] This comment is easy to accept for films that rely almost entirely upon computer-generated environments as backdrops for live-action performances in a greenscreen studio or films that make extensive use of computer generated performances either interpolated with an actor's real performance (such as in *Spider-Man* [2002, Raimi]) or major role performances by a CG character. He also observes that "Whereas special effects were formerly reserved for isolated scenes except in the case of full-length animated features, such effects are now routinely used throughout the entire picture."[17] This is true, not only for the spectacular special effects he is highlighting but also for a myriad of "invisible" effects that work to underpin narratives across a range of genres. In raising the issue of impacts Black comments that "while special effects once allowed film-makers to present glimpses of the unreal world of dreams (*Un chien andalou* [1929, Buñuel], *The Wizard of Oz* [1939, Fleming], *Spellbound* [1945, Hitch-cock], today's sophisticated effects are increasingly used to produce a heightened illusion of reality itself (crashes, disasters, wars, space travel, etc.)—of truth as visible spectacle, of reality as anything that is filmable."[18]

These comments on "unreal" worlds and "heightened illusions of reality" raise important questions about how we are to assess the relationship of effects to narrative especially as DVFx are quite capable of imperceptible use.

Black also goes on to speak about using digital effects "in place of shooting the image"[19] as if this were in some way an extraordinary practice. This is indicative of what I call *pre-tech paradigms,* where the idea that digital image creation is somehow exceptional, distinct from "real" filmmaking, a mind-set shown in Norris's review of *The Eternal Sunshine of the Spotless Mind.* As the diverse case studies in this book show, this is a misconception because the use of digital effects is increasingly integral to the filmmaking process, whether its use can be perceived or not.

In real terms, filmmakers now have three options for image capture: sound stage, location, or digital studio. Each of these options brings a particular quality of experience, level of control, and perceived set of aesthetics. Each has its own advantages, and experienced filmmakers can manipulate these options to an extent that makes it difficult for anyone not on the crew to assess which

method created the images. Increasingly, the images in feature films originate in all three sources and sometimes it is difficult, if not impossible, to distinguish where and how elements were sourced.

Black's discussion also gives example of another common practice—the conflation of digital effects with other digital practices and technologies. In his discussion he places digital effects within postproduction and slides from discussion of effects to digital technologies such as editing and storage.[20] This lumping together of all things digital is a common misunderstanding, as can be the enshrining of "digital" as necessarily a symbolic representative of "the digital" as a concept. As digital technologies pervade more and more levels of experience, the use of the term and discussion of its meaning and application requires more precision if it is to be informative. In the case of DVFx, the use of digital images in film is quite advanced and, while production pathways are eased by growing use of digital-camera image capture through to the very-well-established use of digital sound and picture editing, image creation using DVFx remains an area of particular interest and should be understood as a specific aspect of the overall production path.

Another crucial distinction within this discussion is that the use of digital effects is considered to be a goal-specific use of technology that is a fundamental part of the *production,* not the *post*production process. This distinction is a more accurate positioning of the tasks and role digital effects hold within the industrial practices of film production. Digital visual effects are image capture and creation and, increasingly, they are becoming part of the story-development process working in what once was described as the preproduction stage of filmmaking. Looking at digital visual effects in this way also allows examination of the relationship DVFx have to narrative alongside other image-creation practices that operate within the industrial structures of the production of film images. This comparative assessment is necessary because much of the traditional view about effects tends to hold the physical practices as separate and "special." It also, as mentioned, tends to confuse a variety of technical inventions under the heading "digital" and, in so doing, does not offer a full opportunity to properly consider the true impacts of DVFx in creating narrative.

For example, Barker remarks that "Special effects . . . are pointless if they don't evoke at least a component of the reaction that fireworks can catch from us: 'Wow!'"[21] Clearly interest is in those effects that are meant to be spectacular, but this becomes something of a circular argument. Effects are defined as those that can be discerned as effects and, if they can be discerned as effects, they

must be spectacular or they are, in his view, pointless. He then goes on to state, "there cannot be a general theory of special effects since the 'special' can only be defined by its difference from the ordinary modality of viewing proposed by the particular film in which FX occur."[22] Again his argument, by focusing on spectacular DVFx, does not take into account those instances where effects serve to ensure "the ordinary modality of viewing" by working invisibly to support the narrative.

These various commentators demonstrate some of the misconceptions that prevail even though they, at the same time, make valid and crucial points about the use of effects in film. The observation that special effects are used to great value in certain types of narrative is quite correct, as is the view that the use of effects must be integrated with narrative. Further, the argument that special effects can be used to mark certain moments in the narrative as "special" also is valid—but it does not necessarily lead to instances of narrative interruption.

To limit effects to certain kinds of narrative, to moments of self-reflexive spectacle, to say that they must have a "Wow!" factor, is to underestimate the scope and power of digital-effects practice and their contribution to contemporary film. While this book does not propose a general theory of special effects per se, it certainly points to opportunities for a wider understanding of effects within the general theory of film and provides a framework for analyzing their narrative functions.

How effects might be perceived to impact narrative is highlighted by Laura Kipnis's comment that, "New computer software such as the infamous 'morphing' technique of *Terminator 2: Judgment Day* (1991, Cameron), become the stars of the big new blockbusters, which now tend increasingly to be written around new special effects rather than special effects being used organically to help tell a compelling story."[23] This view of the perceived impact of digital effects on storycraft reflects a set of fears held by scriptwriters. Implicit in these criticisms is the view that blockbusters, especially the ones incorporating digital effects, are not aimed at telling a compelling story—which, it is implied, *should* be the goal if the creation is to fulfill its function as a film.

In the first instance, this view presupposes that the aim of film is to serve the classic Hollywood narrative goal of telling an easily understood, linear story with cause-and-effect structure, a goal-oriented protagonist, and a clearly resolved ending. This classic structure is a standard against which it is easy to examine the achievement of the filmmakers in instances of particular films as well as an assessment of the validity of criticisms such as the ones cited above. Fur-

thermore, the vast majority of early digital effects–laden films were developed and produced by the Hollywood system. Nonetheless, there is no consensus that film narratives need to conform to this standard, nor that commercial films are limited to strictly linear narrative structures.

David Bordwell, Janet Staiger, and Kristin Thompson define the classical Hollywood narrative as "telling stories clearly, vividly, and entertainingly"[24] and maintain that "Hollywood continues to succeed through its skill in telling strong stories based on fast-paced action and characters with clear psychological traits."[25] According to these authors, classical stories should establish the film's story world (or "diegetic" world) and its disruption, the character's traits and goals, and move forward through a series of actions that causally and linearly lead to a resolution of the character's goal and reestablishment of a balanced world.

Most criticisms of the use of digital effects pertain to the alleged failure to contribute to this narrative structure and are used to support assertions that films that do not meet the classical standard exist solely for the purposes of spectacle. In *Narration in the Fiction Film,* Bordwell asks the question, "Is there anything in a narrative film that is not narrational?" and raises Roland Barthes's concept of "fellow travelers" and Thompson's "excess" materials.[26] In analyzing the use of digital effects and their contribution or lack of contribution to narrative, there exists the opportunity through case-study analysis to take up at least some aspect of the question of excess and the established views about the inherent spectacularity of DVFx.

One way to assess this is raised by Bordwell in his examination of contributors to narrative, where he observes that "narration can in fact draw upon any film technique as long as the technique can transmit story information."[27] The efficient transmission of story information is integral to the scriptwriting process and so the analysis of the extent to which the adoption of DVFx are used to transmit story information is considered indicative of its impact, or at least its utility, in achieving the established norms of Hollywood storycraft.

On this point of spectacularity, Bordwell states that "Hollywood (from its earliest days) has eagerly employed spectacle and technical virtuosity as a means of artistic motivation" for the purpose of narration, and while he goes on to state that "exploitation of special effects all testify to a pursuit of virtuosity for its own sake," he adds that "digressions and flashes of virtuosity remain for the most part motivated by narrative causality or genre. . . . If spectacle is not so motivated, its function as artistic motivation will be isolated and intermittent."[28]

By looking at the extent to which the use of DVFx is motivated by narrative causality or genre, this book explores whether there is growing nonnarrative use of digital visual effects. It also looks at how and why they are used—i.e., spectacle for spectacle's sake or as an expansion of the stylistic devices available for plot or, for instance, expansion of a genre's canon.

Discussing this relationship with genre, Thompson comments in *Storytelling in the New Hollywood* that "Dazzling developments in special effects have made flashy style much more prominent, especially in science-fiction and action films. Yet these techniques have not broken down the principle that style's most fundamental function is to promote narrative clarity."[29] As Sobchack, Black, and Barker have argued in support of spectacularity, Bordwell and Thompson argue for the power of narrative engagement. It would seem that digital-visual-effects practice is caught in something of a theoretical rope-pulling contest, but these writers' positions are not mutually exclusive.

Digital visual effects are not the first technology to require accommodation for it to suit the needs of the classical Hollywood cinema. In his analysis of this school of filmmaking, Bordwell observed that there were camera angles that once were considered unsuitable for classical Hollywood cinema.[30] Then, he observes, where it suited their requirements to be innovative, classical Hollywood cinema filmmakers rapidly adopted and adapted experimental, art cinema, and avant-garde techniques.[31]

In *Cinema and Technology: Image, Sound, Colour,* Steve Neale documents how sound technologies led to soundstage-based filming[32] and that the general opinion of critics was that sound detracted from film style. Bordwell also describes at length the difficulty that film commentators had with the impact of sound on filmmaking.[33] In particular, the locking-off of the camera in a static position, the introduction of dialogue, and the impact of locked-off camera on performance have been raised to argue that the introduction of sound in films was a step backward in its stylistic development.

The introduction of color also attracted criticism. Steve Neale comments, "Colour was still overwhelmingly associated, aesthetically, with spectacle and fantasy (in the 1940s and 1950s)."[34] Citing Edward Buscombe's article "Sound and Color," Neale says,

Colour would, or could, "serve only to distract the audience from those elements in the film which carried forward the narrative: acting, facial expression, 'the action.' The unity

of the diegesis and the primacy of the narrative are fundamental to realist cinema. If colour was seen to threaten either one it could not be accommodated."[35]

Summarizing the arguments raised against the use of color, Neale says, "These comments highlight both the extent to which colour as spectacle was itself, however motivated, composed and controlled, to some extent incompatible with narrative and drama, and the extent to which, in any case, such motivation, composition and control was essential."[36] He also documents how the use of color was controlled strictly by special color consultants who assessed the aesthetic needs and emotional requirements of the drama to ensure color was used appropriately by filmmakers.[37] Even though color is still used to mark stories for both spectacular and narrative reasons (for example, *Pleasantville* [1998, Ross]; *Schindler's List* [1993, Spielberg]; and *Hero* [2002, Yimou]), it seems odd to think that color could be argued as being incompatible with narrative these days. Yet, as we see again with the introduction of DVFx, these traditional concerns simply have become attached to a newer technological change.

Bordwell has identified three factors that influence the adoption of technology—production efficiency (economy), product differentiation (novelty), and adherence to standards of quality and aesthetic norms.[38] Examination of the adoption of technical innovations for digital-image creation such as virtual camera moves or the narrative use of flash-forwards shows that there has been integration and exploitation of these techniques for storytelling purposes over the last twenty years and that this is quite in keeping with Bordwell's three criteria. As a proportion of one hundred years of cinema, the last twenty years represents a significant period of influence, one that has allowed the use of digital effects—emerging in feature filmmaking in the early 1980s—to establish its own norms and cues for filmmakers.

As Thompson observes "the science-fiction film often features special effects over stars as its major draw, as *2001* and *Star Wars* demonstrated."[39] One could argue that this also holds true for disaster films, such as *The Day after Tomorrow* (2004, Emmerich), or fantasy films such as *Stuart Little* (1999, Minkoff). In considering the impact then that these practices have had, Thompson's observation points to even more reason to accord DVFx a scrutiny comparable to that directed at stars or any other variable represented as a "major draw."

To do this, we must note of the *type* of film being assessed because criticism about "Hollywood computer-generated-effects movies" frequently is addressed

as an issue of digital effects rather than of the type of film, as the examples that opened this chapter show. The focus of this kind of criticism overlooks the fact that digital effects have vast potential and are used in a wide variety of films and storycraft practices. The kind of films employing digital effects that often are critiqued reflects but one storytelling option, yet critics repeatedly considered them to represent the singular digital effects option, and they frequently blame the narrative deficiencies of the type of film—as the review of *Van Helsing* indicates—on the use of these effects. It is entirely possible, and worth examining, that the extent to which the effects dominate a movie reflects the poor use of film technique by the scriptwriter and director. However, this is not to deny that digital effects can make a bad story worse and, where this is the case, how digital effects are used to poor result is noted. However, good digital effects work also can be wasted in an otherwise poorly structured story.

One of the fundamental arguments in this book is that knowledge of technical tools and mastery of the narrative uses of CGI (computer generated images) can offer new techniques to support storytelling. In some instances the discussion only can raise the broader issues that are the basis of film theory, and I hope that much of what I present here will offer theorists from different philosophical positions an opportunity to reconsider digital-effects practice within film as it pertains to their own areas of interest. As mentioned, while this book does not proffer a general theory of special effects, it does address fundamental questions about the purpose, quality, evolution, and narrative functions of DVFx. That this offers insight to the extent that digital effects are by nature self-reflexive or have aesthetic or ideological consequences will be—I hope— of value to filmmakers, film scholars, and theorists.

In *The Classical Hollywood Cinema,* Bordwell quotes cinematographer John Seitz's observation that, "Motion picture photography of the silent era was an optical and chemical business. The addition of sound changed it to more of an electrical business."[40] The adoption of digital visual effects—and other digital technologies—has moved filmmaking into a data business. The full impact and meaning of this will, in all likelihood, provide much creative scope for filmmakers and theorists alike, and how we go on to use this "data" is open for broad, but overdue, consideration. While the so-called Hollywood computer-generated-effects movies may be the child of a technology that is changing the business, it is virtually certain that, like the flicks and the talkies of previous generations, they will become legitimate inheritors of film storycraft.

2

Once upon a Time: Story and Storycraft

"Story" is used so readily and easily that moving on to the issue of examining the impacts of digital effects on how stories are told by filmmakers might seem to be a fairly straightforward task. However, volumes have been written on the subject of story, and a great many more on the qualities needed to create a good story.

In "Ancient Philosophy," Stephen R. L. Clark begins his account with a consideration of storytelling and its role in the development of philosophy. He states that the first storytellers "became . . . philosophers and the mythologies we find recorded by later, literate thinkers are the distorted record—Aristotle was later to say—of past philosophy."[1] In *On Stories* Richard Kearney, playing on Socrates's famous statement, goes so far as to say that "the unnarrated life is not worth living."[2] As these comments would suggest, it is certain that storytelling is fundamentally important to our cultures, our sense of identity—both as individuals and societies—and to our deepest thoughts and emotions.

It is for this reason that storytelling takes many forms. We have traditions of oral storycraft, written storycraft, and, in this last century, film storycraft. There is also a long tradition in the fine arts of telling stories through pictorial representation, a narrative practice that E. H. Gombrich suggested might have ended in the eighteenth century with the advent of landscape painting.[3] However, it is a narrative practice that he hypothesizes influenced revolutions in art. Speaking of the Greek revolution in lifelike representation, he posits, "When classical sculptors and painters discovered the character of Greek narration, they set up a chain reaction which transformed the methods of representing the human body—and indeed more than that."[4] This relationship between narrative

need and artistic progress is one that characterizes the use of DVFx in film-making, although I will leave the judgment of the magnitude of computer graphics' contribution to art to those better qualified to make such assessments. What I will argue is that in narrative filmmaking, the development of DVFx arises out of narrative demands.

In a discussion of the nature of art, James Monaco defines the spectrum of the arts as comprising the performance arts, the representational arts, and the record-ing arts—this latter category encompassing filmmaking. In confronting the changes being wrought in film production by digital technology, he asserts that the technology "is about to revolutionize our attitude toward the recording arts."[5]

In the case of digital visual effects, which is only one of the many digital technologies impacting upon filmmaking, I agree with Monaco's observation. Digital visual effects bring to the recording arts the power and the expressive-ness of the visual representational arts. As a result, their use draws upon the ex-tensive fields of art history, narrative and literary theories, and cultural studies, to name but a few, all of which can be considered to have bearing upon the use of DVFx in filmmaking. This chapter focuses on the foundation of narrative storycraft, and issues of visual representation are addressed in the chapter 3.

This discussion of narrative storycraft raises two main questions: what is story and what is a good story? At the most simplified level there are definitions such as the one by Kearney: "every story shares the common function of someone telling something to someone about something."[6] This is a very broad de-scription of story and would certainly capture a wide range of narratives. Mov-ing closer to the idea of story more common to Hollywood movies, Academy Award–winning scriptwriter and novelist William Goldman says that a "good story is something with an interesting premise that builds logically to a satis-fying and surprising conclusion."[7]

The most enduring treatise on storycraft is Aristotle's *Poetics*. In this work, (circa 360–355 BCE), he states:

We have established, then, that tragedy is an imitation of an action which is complete and whole and has some magnitude (for there is also such a thing as a whole that has no magnitude). "Whole" is that which has beginning, middle, and end.[8]

This "beginning, middle, and end" has inspired a great many theoretical dis-cussions and "frameworks" for storycraft manuals. It was Aristotle's view that "the poetic art" originated because "the habit of imitating is congenital to hu-

man beings from childhood . . . and so is the pleasure that all men take in works of imitation."[9]

He defined "six constituent elements" of tragedy: "plot, characters, verbal expression, thought, visual adornment, and song-composition."[10] In relation to those elements, he stated that "The greatest of these elements is the structuring of the incidents."[11] It was his premise that "plot is the basic principle, the heart and soul, as it were, of tragedy, and the characters come second."[12] The primacy of plot over character, and vice versa, is still a matter of passionate debate among storytellers. Aristotle argued that plots should be 'easy to remember'[13] and that a shift in fortunes should occur. He admired structures where the events took place "contrary to one's expectation yet logically, one following from the other" and asserted that "developments must grow out of the very structure of the plot itself."[14] He advised that "one should be artistic both in inventing stories and in managing the ones that have been handed down."[15] Here he is commenting not only on what constitutes a story, but also on those qualities that make a story "good" in the sense that it is well-constructed.

In discussing character Aristotle held that "one should always strive for either the necessary or the probable . . . [and] that the denouements of plots also should come out of character itself, and not from the 'machine.'"[16] He wrote the much quoted, but often unattributed, advice that "One should . . . choose events that are impossible but plausible in preference to ones that are possible but implausible" adding that "one's plots should not be made up of irrational incidents."[17]

Scriptwriting manuals often have rewritten Aristotle, but he is rarely, if ever, improved upon. The best, at most, elaborate upon his succinctly defined principles. However, there is more to story than the craft manuals address and, writing in the 1930s, Walter Benjamin observed that "the art of storytelling is coming to an end. Less and less frequently do we encounter people with the ability to tell a tale properly."[18] Writing of the great legacy bestowed by the oral tradition he observed that "the nature of every real story . . . contains . . . something useful."[19] This requirement that a story contain something useful moves beyond considerations of how to devise a story and on to the crucial issue of why to devise a story.

On this point, Benjamin observes that "In every case the storyteller is a man who has counsel for his readers" and went on to note that from his observation of modern times, "we have no counsel either for ourselves or for others."[20] In this he is echoed by one of the most influential storycraft writers in Hollywood, Robert McKee, who observes that the problem with Hollywood storytelling is

the "great blurring of values."[21] McKee has said that "What we go to the story-teller for is some insight into life and human nature. Whether it be comic or dramatic, it doesn't matter because every story has a meaning."[22] Both Benjamin and McKee argue that stories are more than straightforward accounts of events. McKee's statement suggests that an account of events inherently will reveal an expression of values.

In his essay *The Storyteller,* Benjamin states that, "The art of storytelling is reaching its end because the epic side of truth, wisdom, is dying out."[23] He argues that this is a result of the prevalence of the novel and that it has no con-nection with the oral tradition but instead relates to the dissemination of in-formation.[24] He makes the distinction that information is valuable only in its own time but that story transcends time offering value beyond the moment of its creation.[25] Writing on new media and its influences, Lev Manovich has said, "in the information age, narration and description have changed roles. If tradi-tional cultures provided people with well-defined narratives (myths, religion) and little 'stand-alone' information, today we have too much information and too few narratives that can tie it all together."[26] We certainly have plenty of narratives. However, narratives that tie together Aristotle's qualities for plot construction with wisdom of timeless value in the so-called information age definitely are scarce.

It is Benjamin's view that "The first true storyteller is, and will continue to be, the teller of fairytales."[27] His statement suggests that perhaps storytelling will continue after all, if only in the form of fairytale telling. It is to this form that Bruno Bettelheim brought his profound insights. Bettelheim, like his fel-low Holocaust survivor Viktor Frankl, believed that the search for meaning was "our greatest need and most difficult achievement."[28] This is the wisdom that lies within the fairytale. As Bettelhiem said, "only hope for the future can sus-tain us in the adversities we unavoidably encounter."[29]

In keeping with Aristotle's view, Bettelheim states that "the fairy tale has a consistent structure with a definite beginning and a plot that moves toward a satisfying solution which is reached at the end."[30] This broad definition is not sufficient to explain how events achieve that elusive satisfying solution that ties everything together. Quoting J. R. R. Tolkien, Bettelheim lists "the facets which are necessary in a good fairy tale as fantasy, recovery, escape, and consola-tion—recovery from deep despair, escape from some great danger, but, most of all, consolation" and adds that Tolkien said of the happy ending, "that all com-plete fairy stories must have it."[31] In Bettelheim's view, a child has a "deep need

for justice to prevail"[32] in a story's account and added an element to Tolkien's list, "a threat to the hero's physical existence or to his moral existence."[33]

This element of threat is crucial as "only by struggling courageously against what seem like overwhelming odds can man succeed in wringing meaning out of his existence."[34] In Bettelheim's view, it is the role of the story to provide a child with the opportunity to examine the battle between good and evil forces in order to "make choices about who one wants to be."[35] The stake in these choices must be suitably high—with survival being the ultimate reward. For, as Benjamin has noted, "Death is the sanction of everything that the storyteller can tell. He has borrowed his authority from death."[36] Fear of death, in Bettelheim's opinion, could be countered only by "forming a truly satisfying bond to another."[37] Essentially, only by overcoming the odds and winning the love of a female can the hero hope to live happily ever after.[38]

He compares this basic story structure with that of myths and makes a number of important distinctions. Acknowledging that they have many similarities and, indeed, that fairytales in some instances grew out of earlier myths, he argues that myths describe the events of superhuman heroes whereas fairytales "are always presented as ordinary, something that could happen to you or me or the person next door when out on a walk in the woods."[39] He adds that the myth is more likely to end tragically whereas it is crucial that the fairytale end happily.[40] As he puts it, "While the mythical hero experiences a transfiguration into eternal life in heaven, the central figure in the fairy tale lives happily ever after on earth, right among the rest of us."[41]

This distinction is essential for the fairytale to be effective. To convey the message that if we persist we will succeed, the fairytale must position itself in the arena of life "among the rest of us." It is only by convincing the child that the tale has wisdom, that it can be "useful"—as Benjamin asserts it must—that it will be able to help the child choose what kind of person to be, thus fulfilling the purpose of story.

The struggle is between the omnipresent evil and good that is found in every society and in every person, and the story serves to guide the child in making the personal choice between good and evil, providing a foundation for meaningful behavior in life. However, Bettelheim distinguished between myths and religious legends that sought to convey "the social ideals a child could pattern himself after"[42] and those stories that "embodied the cumulative experience of a society as men wished to recall past wisdom for themselves and transmit to future generations."[43]

The difference between myth and fairytale is the scale, the relationship to life in the cosmos versus life on earth. As Bettelheim notes, "Whatever strange events the fairy tale hero experiences, they do not make him superhuman, as is true for the mythical hero."[44] He argues that "In fairy tales, unlike myths, victory is not over others but only over oneself and over villainy."[45]

In the field of filmmaking, myths gained a new level of interest when Christopher Vogler's interpretation of Joseph Campbell's *Hero with a Thousand Faces* gained popularity in the 1990s. Campbell's original text, published in 1949, is a reputable study of heroic mythology, analyzing hero stories of many cultures and identifying a significant number of common elements. It was this discussion of common elements that formed the basis of Vogler's distillation, *The Writer's Journey: Mythic Structure for Storytellers and Scriptwriters.*[46]

However, Campbell's work covers a much broader, more meaningful range of concepts than Vogler's text. In Campbell's view, "The happy ending of the fairy tale, the myth and the divine comedy of the soul, is to be read, not as a contradiction, but as a transcendence of the universal tragedy of man."[47] This tragedy, the aforementioned date with death, makes an ironic statement of every happy ending. The triumph of the moment, indeed filmmaking's ability to capture and thus manipulate time by being able to replay these moments, is perhaps a truer measure of its craft than the many invented "mythological" tales that have gained so much attention. However, without getting distracted by this aside, it is important to observe that where Vogler's work takes a fairly superficial approach to the hero tales of mythology, Campbell's work is an attempt to capture the deeper purposes such tales serve.

The study and interpretation of mythology has been a staple in the intellectual diet for quite some time. In summarizing this body of work, Campbell states:

Mythology has been interpreted by the modern intellect as a primitive, fumbling effort to explain the world of nature (Frazer); as a production of poetical fantasy from prehistoric times, misunderstood by succeeding ages (Müller); as a repository of allegorical instruction, to shape the individual to his group (Durkheim); as a group dream, symptomatic of archetypal urges within the depths of the human psyche (Jung); as the traditional vehicle of man's profoundest metaphysical insights (Coomaraswamy); and as God's Revelation to his children (the Church). Mythology is all of these.[48]

In spite of these various perspectives on mythology, myths themselves present certain consistent qualities. Campbell argues that, "The standard path of

the mythological adventure of the hero is a magnification of the formula represented in the rites of passage: separation—initiation—return."[49] Campbell's accounts describe not only the various steps in the journey but the significance that these stages have for the developing personality and the individual's society. As he observes, the value of these stories is that they capture not only the conscious but the unconscious knowledge of humanity.[50]

He also notes the changes that have taken place in the focus of human attentions and how mythology has captured this move from wonder at "the animal world, . . . [to] the plant world, . . . [to] the miracle of the spheres, . . . [and finally to] man himself who is now the crucial mystery."[51] Man who, according to Benjamin and McKee, has reached a stage where the wisdom of the ages appears to have no relevance, and the experience of one generation is little valued and understood by the next. As Bettelheim defines it, "Wisdom is the consequence of inner depth, of meaningful experiences which have enriched one's life: a reflection of a rich and well-integrated personality."[52] Benjamin argues that this lack of counsel, of wisdom, was because the "communicability of experience is decreasing."[53]

This may have been a reason Campbell's theories have been given such credence and developed a following in the filmmaking community; the sheer weight of authority attached to tales from every culture since the beginning of time must offer a seductive power in an environment where the values of the day are hard to determine. It hardly needs to be said that it is difficult to tell a story that calls for a struggle between "good" and "evil" without a grasp on the difference between the two. To draw upon mythological standards and co-opt them to solve the problem of "the great blurring of values" certainly must seem an easy answer. However, the appropriation of the mythic structure does not solve the problem of having nothing of use, or nothing wise, to offer.

In *The Hero with a Thousand Faces,* Campbell has captured the structure of enduring story elements. Like Aristotle, Benjamin, and Bettelheim, he is of the view that stories have something important to convey, that they create patterns and structures out of life events and that they reflect the unconscious needs of humanity as much as they do the craft skills of the individual storyteller.

However, where storycraft manuals happily apply themselves to reworking the Aristotelian three-act plot structure and have readily adopted the Hero and the arc of its character development, academic consideration of film stories—narratives—has been considerably more complex. To venture off into the history of narrative theory would take this discussion quite far from where it needs

to go, but it is worth noting a few factors that might illuminate the differences between the approaches taken by scriptwriters and storytellers and that of narrative theorists.

The significance of narration theories for film studies is captured by Steve Neale:

What mainstream cinema produces as its commodity is narrative cinema, cinema as narrative. Hence, at a general social level, the system of narration adopted by mainstream cinema serves as the very currency of cinema itself, defining the horizon of its aesthetic and ideological possibilities, providing the measure of cinematic "literacy" and intelligibility. Hence, too, narrative is the primary instance and instrument of the regulatory processes that mark and define the ideological function of the cinematic institution as a whole.[54]

In *Point of View in the Cinema,* Edward Branigan summarizes the analysis of narration as "a simple unrolling, a logical progression, a violation, a set of oppositions, a set of alternatives, a control on connotation, a logic of reading, a reconstruction of unconscious mechanisms, and as a literal telling."[55] He goes on to relate these approaches to the work of theorists including Vladimir Propp, Noël Burch, Roland Barthes, Stephen Heath, Claude Levi-Strauss, A. J. Greimas, Claude Bremond, Christian Metz, André Bazin, Jean Mitry, and many others. In summarizing the field, Branigan has identified five types of narrative theory: plot theories, style theories, discourse theories, reception theories, and drive theories.[56] From a filmmaker's perspective the way a story's structure works, or the style of storytelling, its thematic intents, the audience's response, and the psychology behind an audience's reception are all factors of interest, even though to look at these theories in this simplified way would be a superficial approach to the theoretical work that underpins them. What is of importance is that, as Branigan notes, "a given theory is responding to some of our deepest beliefs about human beings and the nature of society, and reveals not only a narrative artifact, but also how we are thinking about the working of the human mind."[57] In a way, then, the goals of the theorists are not so different from that of the storytellers although the approach taken differs quite significantly.

In introducing his theories on narrative comprehension, Branigan identifies a narrative schema that he states is agreed upon by nearly all researchers. This schema is comprised of: "(1) introduction of setting and characters; (2) explanation of a state of affairs; (3) initiating event; (4) emotional response or statement of a goal by the protagonist; (5) complicating actions; (6) outcome; and

(7) reactions to the outcome."[58] This schema would be readily understood and valued by scriptwriters, who would recognize the structure that it describes. So, while there is commonality to the interests of the filmmakers and the theorists it would seem that one aspect of the difference between their approaches is "that narration is concerned with *how* an event is presented, how it happens rather than *what* is presented or what happens."[59]

In discussing science fiction, Vivian Sobchack has said that the writer's "primary goal is not to inform, nor to philosophize, but to create a narrative which dramatically—through its style and structure, its characterizations, its events and objects and places—provokes the reader to think, to observe, to draw his own abstract conclusions."[60]

Steve Neale also touches on this subject of the wisdom conveyed in stories. Describing the workings of narrative and genre, specifically horror films, he says, "the narrative process in the horror films tends to be marked by a search for that discourse, that specialised form of knowledge which will enable the human characters to comprehend and control that which simultaneously embodies and causes its 'trouble.'"[61]

Further, on this issue of wisdom, Branigan, discussing narrative says, "the actual process of moving from ignorance to knowledge will be of central importance to our experience of narrative."[62] This is both in understanding the story and responding to its themes. He adds, "One of the purposes of a narrative is to demonstrate how certain effects that are desired may be achieved, how desire is linked to possibilities for being, how events may proceed. In this way, narrative operates to draw the future into the present." These statements by Sobchack, Neale, and Branigan show that there is agreement by theorists that a requirement of story is to address the issues of wisdom, and there is recognition of Bettelheim's vision of the future that is needed to sustain us in our adversities.

How these two approaches converge also is addressed by David Bordwell in *Narration in the Fiction Film,* which documents three ways to study storytelling: as a representation, as a structure, or as a process.[63] He describes representation as addressing portrayal and broader meanings, structure as addressing "a particular way of combining parts to make a whole," and process as the way story materials are used to provoke a response from the viewer.[64]

As the foregoing would suggest, theories of narration are less concerned with how to create a story (either to originate or to re-present a story) and are more concerned with how stories work, that is how they are understood by their audiences. The mechanics of craft, for example the placement of the camera, are of

interest to theorists in terms of how this provokes a response, how that response resolves, and what patterns or significance such placements of camera, such responses, and such outcomes of response might indicate. In contrast, for a filmmaker, who would not be unaware of these issues, the placement of camera is a much more practical matter, one that is driven by the particular needs of the specific story being told.

The objective approach to story by narrative theorists is quite different from the approach used by the writers of story manual. Where the manual writers seek to instruct prospective creators of stories for practical application of say, Aristotle's theories, the theorists seek to understand why, for example, imitative behavior is congenital to humans. They seek to define imitative behaviors and the way they are understood. Questions such as how we understand stories and why we understand them are quite properly the province of the narrative theorists. Quite naturally, though, their studies however are after the event. They rely upon the output of creators to provide them with the materials to study, and so it is an interesting exercise to consider just where the point of power resides, in terms of storycraft.

As regards narration theory, it would seem that Aristotle is again a source of inspiration and authority. Bordwell, addressing Aristotle's distinctions between "the means of imitation . . . the object of imitation . . . and the mode of imitation,"[65] summarizes by stating that "The basic difference is between telling and showing. The secondary difference lies within the category of telling: does the poet speak in his own voice or through a character's?"[66] He notes that these questions remain open to consideration but goes on to clarify the difference between theories of telling (diegetic) and theories of showing (mimetic).[67]

Another distinction, as expressed by Tom Gunning, lies in "the double nature [of storytelling] involving both a story to be told and the telling of that story."[68] Bordwell addresses this when describing the principles of narration, referring to the work of the Russian formalists. This school of theory defined story as "a chronological, cause-and-effect chain of events occurring within a given duration and a spatial field,"[69] referred to as *fabula.* Bordwell defines the plot, or the *syuzhet,* as "the actual arrangement and presentation of the fabula in the film."[70]

From a theoretical perspective these issues of who is the narrator and how events are structured are important for a range of philosophical reasons. Where storytellers happily will exploit any technique of narration to tell their tales, the theorists ask: Who is telling the story? How is the story revealed by the camera? What is the camera's role in narration? And so on.

For instance, Gunning goes on to describe the work of Gérard Genette who defined "three different meanings for the term *narrative*."[71] These meanings include: "the language of the text,"[72] the content, and "the act of narrating itself."[73] This analysis by theoreticians is more akin to a scientific dissection than it is to the writers' guides for assembly. Yet, when taken together, these two approaches offer an intriguingly more complete view than they do apart. One facet of this view is that of the basic story structure. Gunning refers to Todorov's revision of Aristotle's story structure quoting Todorov's statement that "The minimal complete plot consists in the passage from one equilibrium to another"[74] and cites Bordwell's canonical story.

Bordwell himself describes this as a "common template structure,"[75] which can be summarized as: "introduction of setting and characters—explanation of a state of affairs—complicating action—ensuing events—outcome—ending."[76] It is his view that the canonical story is "learned from one's experience of stories"[77] and his study of its modes and norms provided the foundation for his narrative categories: classical narration, art-cinema narration, historical-materialist narration, and parametric narration.

Of these categories, classical narration most closely adheres to the Hollywood model of storycraft. This model, defined in Bordwell, Staiger, and Thompson's *The Classical Hollywood Cinema: Film Style and Mode of Production to 1960*, developed from film's earliest days and predominated in the American film industry—although it was not exclusive to that nation, nor was classical narrative the only narrative form used by American filmmakers.

Many early films, described by Gunning as "the cinema of attractions," did not draw upon storycraft but relied upon the attractiveness of the spectacle of projected images, displayed without much narrative structure. Gunning has said that "While storytelling was not totally foreign to cinema before the nickelodeon boom (1905–1909), . . . aspects of early cinema are best understood if a purpose other than storytelling is factored in. Cinema as an attraction is that other purpose."[78] He discusses the relationship between attractions and narrative, a discussion that is fundamental to many views about special effects in filmmaking, and makes the important observation that "Attractions are not abolished by the classical paradigm, they simply find their place within it."[79]

As Roberta Pearson notes, "There was a crisis in transitional cinema around 1907 signalled by the complaints in the trade press about lack of narrative clarity."[80] There was a long history of performance arts and representational arts that encouraged this expectation of narrative structure by audiences. Michele Pierson

has documented that special effects were regularly used in scientific lectures in the nineteenth century and that it was common for narrative structures to be used in order to display these scientific presentations of effects.[81] Brian Winston also has observed that there were many popular forms of entertainment that foreshadowed the development of cinema and that these forms served to prepare audiences for receptivity to cinema by "addicting" them to spectacle and narrative.[82] The early success of the spectacle of moving imagery quickly gave way to the need to satisfy audiences' expectations that the images convey something more. It was from that point in the history of cinema that narrative structures were developed by filmmakers, leading to what Bordwell, Staiger, and Thompson have defined as the classical Hollywood cinema.

Characterized by a cause-and-effect chain of events with a psychologically motivated main character whose development is revealed through goal-driven action in a double plotline of heterosexual romance and action, the Hollywood film (and variations on it) has become the dominant story structure of film. Supported by production techniques such as continuity editing, classical narratives sought to ensure the domination of the narrative and the subordination of the "apparatus." This theory of narration is not without its challengers in the field of film theory; nonetheless, Bordwell, Staiger, and Thompson have documented what is sometimes referred to the "Golden Age of Hollywood." It is upon this model that the vast majority of storycraft manuals seek to advise.

Formal scriptwriting can be dated from as early as 1897.[83] Although it took another ten years before scriptwriting became an established practice. After 1897 it took only a few more years before "spec" material being submitted to the studios numbered in the thousands.[84] Tom Stempel, in his history of screenwriting, identifies one of the earliest scriptwriting manuals, 1912's *How To Write Motion Picture Plays.*[85] He goes on to credit Thomas Ince as the force behind the narrative structure documented by Bordwell, Staiger, and Thompson,[86] and argues that Ince's use of screenplays gave him the level of control needed to ensure the best results—from a storycraft as well as a production-efficiency perspective.[87] In *The Genius of the System,* Thomas Schatz describes the "classical Hollywood" as, "a period when various social, industrial, technological, economic, and aesthetic forces struck a delicate balance . . . to provide a consistent system of production and consumption, a set of formalized creative practices . . . a way of telling stories, from camera work and cutting to plot structure and thematics."[88] He credits Irving Thalberg's role in making the "continuity script" the blueprint of the studio production line and describes

how the studios built up story departments, hiring writers from fields such as theater, journalism, and literature.

During this time, the screenplay quickly became the document forming the foundation of the Hollywood film, and standard approaches to storytelling were influential. Schatz quotes a memo by David O. Selznick, dated February 1934, describing "the outmoded [movie] formulas that the public knows even better than the producers."[89]

This issue of formula writing is one that arises throughout the history of filmmaking but became a standard complaint by the 1980s when it was argued that the influence of writing manuals was beginning to have a debilitating effect on the quality of films being made. According to Stempel, "You can tell by the narrative rhythm of an American film that it was written under the influence of Syd Field."[90] Syd Field's *Screenplay: The Foundations of Screenwriting,* published in 1979, did not present anything of remarkable innovation in terms of describing storycraft techniques. What it did achieve was to make basic Aristotelian principles accessible using the feature-length fiction film as a template.

Outlining the three-act structure with recommended durations for each act (helpfully illustrated with diagrams and suggested approximate page numbers), Field's manual provided guidance at a simplified level. It required of its readers little knowledge or experience in filmmaking as it was aimed to help anyone with the inclination to write a screenplay. The manual's success also encouraged quite a few others in the film industry to write their own "how-to" manuals.

In *How Not to Write a Screenplay: 101 Common Mistakes Most Screenwriters Make,* Hollywood reader Denny Martin Flinn deftly summarizes the influential texts of the 1980s and 1990s. He cites "Field's three act paradigm . . . McKee's five part narrative . . . John Truby's seven major steps . . . (and) Linda Seger's eight sections within three acts."[91] To his credit Flinn also acknowledges Joseph Campbell's monomyth from *The Hero with a Thousand Faces* and Aristotle's original, *Poetics.*[92]

A few of the manual writers also address story structures that do not seek to conform to the classical narrative structure. McKee in particular compares what he calls "classical design" with "minimalism" and "anti-structure,"[93] and Ken Dancyger and Jeff Rush wrote *Alternative Scriptwriting: Writing Beyond the Rules*[94] to help writers address the idea of nontraditional narrative structures. Like Dancyger and Rush, Linda Aronson, whose scriptwriting manual specifically addresses the nonlinear narrative, spends a great amount of her book advising on how to craft a classically structured script. She identifies four major

categories of parallel narrative: flashback, tandem, sequential, and multiple protagonist/antagonist stories.[95] Yet, in analyzing these stories she admits that she was "surprised to find how much they used the nuts and bolts of traditional three-act narrative to create unity and rising jeopardy in individual plots and across the film as a whole."[96] Similarly, Dancyger and Rush argue that in order to work against the rules, it is important to master them first. This acknowledgement of the relationship of Hollywood movies to linear narrative is not in any way a disavowal of other nonnarrative and nonlinear works.

On the subject of nonlinear narratives, Lev Manovich has raised the relationship between databases and narrative and cites the work of Peter Greenaway, who deliberately attempts to reconcile these in his films in order to challenge the classical narrative structure.[97] Manovich goes on to discuss the idea of interactive cinema saying that, "Beginning in the 1980s, we see the emergence of new cinematic forms that are not linear narratives, that are exhibited on a television or computer screen rather than in a movie theater—and that simultaneously give up cinematic realism."[98] He identifies these new forms as the music video and the CD-ROM–based game,[99] neither of which has replaced or even attempts to replace long-form feature film stories. This is not to say that cinema does not have nonlinear works. However, in the context of this discussion, nonlinear cinema, to the extent that it uses DVFx is doing so in a way that would have to be assessed from the context of the effects use within the specific text. A nonnarrative text's use of DVFx is simply unrelated to storycraft.

So it would seem that in spite of these new forms that fit alongside of traditional cinema and the experimentation of filmmakers outside of and marginally within the mainstream, the three-act structure prevails and remains the most financially successful form of commercial film narrative. It is for this reason that the main focus of most scriptwriting manuals is on how to write a screenplay that will be attractive to producers of Hollywood films. In fact, Linda Seger, in her manual *Making a Good Script Great,* writes that a script needs "(1) marketability; (2) creativity; and (3) script structure."[100] It is reasonable to consider that these elements are listed in order of perceived priority as well as value, although Seger argues forcefully about the importance of structure.

Furthermore, while many of the manuals make reference to scriptwriting as the fulfilling experience of creating art, they also declare the importance of their insights to crafting a product of commercial value. The back cover of Syd Field's *Screenplay* states that the book is intended to help writers "turn ideas into scripts that will sell and succeed on the screen."[101] Each of the craft manual authors

seeks to advise on how to crack the code, as it were, on crafting a "good" story, a compelling cinema experience, and a unique offering in the marketplace. Certain manuals become film bibles as successful screenwriters and filmmakers cite them as major influences, which sells more books and in turn influences more filmmakers.

It is interesting that in spite of this quite remarkable examination of story-craft (with its substantial offer of financial reward for definitive answers and good scripts), with rare exception there has been little advance in defining the qualities and the structures of the canonical story since the time of Aristotle. Both theorists and craft writers describe, in not dissimilar terms, the need to set up the initial state of the hero's world, move quickly into the state of disruption, and resolve the disruption either happily or not.

Further, although some have considered the notion of nonlinearity as a narrative form, the dominant structure in commercial feature-length fiction film remains reasonably faithful to Aristotle's beginning-middle-end, even if in some instances the *syuzhet* is such that only in the last frames is the spectator in a position to make the linkages to form the whole. In commercial cinema, the whole itself, however its portions are presented, most often will conform to the classical narrative structure.

In "After the Classic, the Classical and Ideology: The Differences of Realism," Christopher Williams challenges Bordwell's theory of classical Hollywood cinema, but primarily on the grounds of its claims to "realism." Williams questions whether there ever truly was "a meaningful entity, effective on either the practical or the theoretical level which could honestly or adequately be called Classic Hollywood cinematic form" and makes the point that "[Hollywood's] work is by no means so unified in its language as to function as one style. And even if it were, there are other styles culturally, socially and even economically different and vigorous enough to make the labelling of Hollywood as mainstream a crude and misleading reduction."[102]

At the basis of this argument is the view that the very definition of the Hollywood film is not so straightforward as might be thought and that films emanating from Hollywood are not so rigidly bound by the tenets of Bordwell, Staiger, and Thompson's theory. However, while Williams might argue with the scope and the pervasiveness of the classical Hollywood cinema's model and principles, the structural definition of the classical narrative is not at issue, nor is there a failure on the part of most other theorists to recognize this structure in their discussions of narrative.

In describing the classical Hollywood model, Bordwell builds upon the arguments he presented in *Narration in the Fiction Film* in regard to the category of classical narration. While there may indeed be wider issues about the ideological assumptions based upon Bordwell's model (as Williams is more interested in addressing in his paper), the definition of the canonical story—those narratives that conform to the structure of a beginning, middle, and end—is essential to the consideration of fiction-film storycraft.

As study of the craft manuals reveals, fiction-film storytelling techniques adhere quite closely with the principles identified in the *Poetics* nearly 2,500 years ago. It is also fairly clear that no matter how many authors have since tried to elaborate upon these principles, for the creators of new and reworkers of inherited story materials, the task of creating "a good story well told" is far from simple or formulaic. However, while we can accept the structure of a beginning, a middle, and an end, and a journey from one state of equilibrium to another as *an* answer to the question "What is story?" the answer to the question "What is a good story?" remains.

In addressing the auteur theory in his work "Signs and Meaning in the Cinema: The Auteur Theory," Peter Wollen remarks upon "the problem of evaluation."[103] He states that, "The good work is one which has both a rich meaning and a correspondingly complex form, wedded together in a unity (Romantic) or isomorphic with each other (Classical)."[104] He adds that "an artefact can . . . convey to us a meaningful truth, an insight, which enables us to go back to the real world with a reordered and recycled experience which will enable us to cope better, live more fully, and so on."[105]

These comments stand well beside the views raised earlier by Bettelheim and others, and give support to the structural observations made by both theorists and craft manuals. However, the issue of evaluation remains a problem as many standards can be formed and applied in support of different arguments. By way of example, it can be argued that the box-office results are the ultimate test of a film's success, giving an objective measure of how the film has been valued by audiences. Another measure is the degree of critical acclaim a film can earn in the form of awards and prizes, either through the film-festival circuit or in numbers of Oscars™ and various guild awards. The test of time is another measure that has raised films once regarded as failures to positions of the highest regard, for example, *2001: A Space Odyssey* (1968, Kubrick) and *Blade Runner* (1982, Scott).

The difficulty in providing a universally appropriate and definitive answer to the question "What is a good story?" can be gauged by the wealth of analysis

and examination undertaken by the best in the fields of theory and craft. Certainly, for the purposes of considering the impact of DVFx on storycraft the qualities of "a rich meaning and complexity of form," as described by Wollen, pose a credible framework. The consistently made point that a good story has something of value, counsel, and wisdom also speaks to matters of quality and so these qualities also are applied in making assessments of the films that form the case studies in this book.

Yet the test of "good" is not so simply measured. The classical Hollywood cinema is often recalled as the "Golden Age" of Hollywood and great filmmaking. Bordwell, Staiger, and Thompson consider that this period ended in the 1960s with the breakup of the studio production system. The period that followed is referred to as the New Hollywood and is characterized by the growth of independent production and experimentation with structure and themes. Material that would not have been permitted in the studio system found support from independent producers, and the 1970s have been described as another great period in American filmmaking—great because it did *not* conform to the strictures of the Hollywood-studio style.

This raises an important matter. For many the studio films represent the time when storytelling was at its finest. For others, the independent films of the 1970s presented the best era of American film. Yet the 1970s often are cited as the decade when quality filmmaking ended because of the rise of the blockbuster and the event film—especially the special-effects–filled event or action film.

For every author who argues that in the days of the studio system scriptwriters did their best work because they had the support needed to develop and polish a script, there is another who will argue that the more competitive pressures of the independent market ensure a higher standard of writing. Critics have argued that star vehicles, corporate owners, the emphasis on deal making, teams of writers, anxious executives, and a lust for franchises are new factors that are destroying the quality of films—but this overlooks the facts of history. None of these criticisms are unique to the New Hollywood. Star vehicles did not emerge when Bruce Willis, Arnold Schwarzenneger, and Sylvester Stallone arrived in Hollywood, although it may be fair to observe that they earn more money than Gene Kelly, Judy Garland, and Doris Day did. Likewise, the *Thin Man* (1934, 1936, 1939, 1941, Van Dyke; 1945, Thorpe; 1947, Buzzell; 1957–1959, TV series), *Charlie Chan* (30 titles between 1931 and 1949), *Nancy Drew* (1938, 1939, 1939, 1939, Clemens), and other franchise films predate *Lethal Weapon* (1987, 1989, 1992, 1998, Donner), *Halloween* (1978, Carpenter; 1981, Rosenthal; 1982,

Wallace; 1988, Little; 1989, Othenin-Girard; 1995, Chappelle; 1998, Miner; 2002, Rosenthal), and *Star Trek* (1979, Wise; 1982, Meyer; 1984, 1986, Nimoy; 1989, Shatner; 1991, Meyer; 1994, Carson; 1996, 1989, Frakes; 2002, Baird).

Thomas Schatz has more than adequately detailed the history of these practices in *The Genius of the System.* He describes these aspects of filmmaking in the early days of the studio system and says, "the prospect of anything truly innovative or distinctive being produced in Hollywood was becoming more remote by the mid-1930s."[106] He also notes that "a single blockbuster, if properly exploited and released, could outperform a dozen top features combined at the box office."[107] So these problems are not a new feature of the film industry.

In her book *Storytelling in the New Hollywood,* Kristin Thompson examines the post-studio era and assesses to what extent the classical narrative has altered. She finds that what are often called post-classical traits—for example, "high concept" films, and the goal of making universally appealing and comprehensible films—are not departures from classical narratives. In fact, she argues "that modern Hollywood narratives are put together in much the same way they were in the studio era."[108]

The changes she notes are that in the post-studio Hollywood, the strictly demarcated quality films versus Saturday matinee films, the "A and B filmmaking gave way to . . . a more hit-or-miss blend of big-budget, superstar-oriented 'event' movies with lower-budget fare, including the occasional 'sleeper' that hits box-office gold."[109] She also observes that there has been an increased reliance upon violence and sex scenes, particularly in action films, and considers this a factor in their overseas success.[110]

Further, Thompson states that "there is some evidence that by the mid-1990s some of the more formulaic advice of . . . [storycraft] manuals was actually having a negative effect on the films coming out of Hollywood."[111] As cited earlier, this is the problem that Stemple remarked upon and it is one that critics like to blame for all that is wrong with film storycraft. Clearly, in some quarters the ultimate filmmaking error is the formulaic film script full of DVFx. In Thompson's analysis of this issue she discovers the rigid adoption of page counts over the dramatic needs of moving action through the development of goals and their cause-and-effect linkages (qualities cited as the cornerstone of classical narrative structure) appears to be the basis of the problems arising from formula-based storytelling.[112]

Analyzing the use of DVFx within the context of general special effects practice, she concludes, as I have already argued, that narrative clarity dominates re-

gardless of the increasing use of special effects.[113] Addressing the criticism that "'post-classical' films favor spectacle over causal logic"[114] Thompson analyzes Steven Spielberg's film *Jaws* (1975)—a particularly apt choice because the box-office success of this film, alongside of *Star Wars,* often is cited as the reason that blockbuster/summer-event films have been given such great priority, often to the detriment of "real" films with stories. She concludes that the action scenes in *Jaws* conform to classical narrative structure and that ". . . we are a long way from seeing formless series of pure action sequences. . . ."[115]

However, Thompson does recognize that "In recent years . . . some films in genres dependent on action and suspense have added more high points after the climax has apparently already resolved the action."[116] This problem could be a consequence of filmmakers seeking to add "twists" to take audiences by surprise, foiling their expectations and providing an element of surprise or uniqueness to an otherwise standard genre piece. Or it may be the result of poorly judged pacing, especially in those stories that commence with fairly high-octane action sequences and thus require that the rest of the story keep "topping" the previous scenes. Thompson's conclusion is that these endings ". . . seem to reflect Hollywood's traditional search for novelty within standard formulas, but taken to an occasionally ludicrous level."[117]

She also raises the "whammo" factor, recounting an anecdote[118] that supports Syd Field's claim to having invented the whammo chart.[119] According to Field, his employer Fouad Said demanded a whammo chart be created identifying how often something occurred in a script that propelled the action forward, setting the ideal rate at one whammo every ten pages.[120] This method of assessing scripts apparently gained considerable currency, with both Thompson and Field claiming that Joel Silver continues to rely upon whammo charts for his productions.

Both piling on of climaxes and the application of the whammo are pacing factors that may relate to some digital-visual-effects practices. Digital visual effects can be used to create a whammo and also can help to drive up climactic action scenes. As a consequence, they frequently are cited as the *reason* for these kinds of narrative structuring. Thompson assesses the allegation that ". . . the primary traits ascribed to 'post-classical' filmmaking are the breakdown of coherent plot development and character traits by the increasing dominance of spectacular action and special effects."[121] She adds that, "[her] analyses of representative films have shown that this breakdown is far from widespread."[122]

Thompson makes a compelling argument that the issue is one of narrative competence, and it can be drawn from her discussion that these kinds of

narrative structures may indeed be the reason for the use of DVFx, and not the other way around. She also argues that ". . . the action-packed special-effects film may have been one of Hollywood's usual cycles rather than a new approach that has permanently replaced classicism."[123] These cycles, as Schatz has noted, are part of the industry and have been for most of its history. He describes the success of prestige films in the 1920s and 1930s as being followed by "over-priced, over produced deadweights. . . ."[124] That the system managed to survive and thrive until the 1960s suggests that the capacity for Hollywood, and mainstream cinema in general, to reinvent itself either through technological discoveries or changes in film style should not be underestimated.

The vast body of argument about spectacularity stands in contrast to this view about New Hollywood's continued engagement with classical narrative and the ability of its narrative conventions to dominate. Annette Kuhn, in her introduction to the second *Alien Zone* collection of essays, comments upon the self-reflexivity at work in science-fiction films that rely upon state-of-the-art technology and states, ". . . when such displays become a prominent attraction in their own right, they tend to eclipse narrative, plot and character. The story becomes the display; and the display becomes the story."[125]

This statement is very much in line with the criticisms that the films were all effects and no story. In terms of science fiction however, a closer reading of this statement could argue that the images and the technology used to create them have a level of thematic resonance. This is not the same as saying that there is no story.

In "After Arnold: Narratives of the Posthuman Cinema," Roger Warren Beebe suggests that, at least in the genres of science fiction and action films, special effects offer a new kind of narrative. This is one that asks the audience to observe the pacing and the images as a new kind of narrative and, in particular, it is a narrative that does not require the ". . . plights and adventures of a single human subject."[126] His arguments return us to Tom Gunning's original theories on the "cinema of attractions" and also to the arguments that there is an emerging return to the loosely structured, multilayered "baroque" in contemporary film narratives.

Steve Neale raises this idea within the context of "machines for the production of spectacle"[127] and goes on to describe eighteenth-century instruments designed to present spectacular images and events. Sean Cubitt also raises the idea of the Hollywood baroque. He cites Thomas Elsaesser who "summarizes the attributes of the 'New Hollywood' under four headings: a new generation of

directors, new marketing strategies, new media ownership and management styles, and new technologies of sound and image reproduction."[128] Cubitt ties to the Hollywood baroque the impact of steadicam technology and captures the issues of the imperatives of classical narrative and spectacle in his statement:

Contemporary cinema, for reasons both commercial and ideological, offers itself to a double audience, one that succumbs to the spectacle and one that appreciates it. The bulk of any given audience will enter the film with this double vision in place, pleased to be connoisseurs of effects and their generation, but equally delighted to be suckers for the duration, enjoying both spectacular technique and the spectacle itself, illusion and the machinery of illusion.[129]

Norman Klein has taken up the idea of the world of illusions tracing spectacle from the baroque of the seventeenth century to the electronic baroque of Hollywood. Describing the chase cartoon, he invites readers to choose their "favorite chase in a special-effects action film circa 1995"[130] and says that "characters inside this . . . Baroque apparatus, move like folk heroes."[131] He claims that the "special-effects film is a hybrid of both [elemental and dramatic stories and that] . . . in the mix, each tends to erase the other, leading to a very diminished sense of character. Perhaps this amounts to an allegory about diminished individualism, that the self, as an industrial myth about freedom, cannot survive the effects of the electronic workplace."[132] He summarizes, saying, "Special-effects films, for all their gaudiness, have become the portable cathedrals for this integrated, weirdly disengaged Electronic Baroque civilization."[133]

Angela Ndalianis, discussing the development of the baroque, cites Lynne Elizabeth Overesch, who defines "features of a baroque poetics [that include]: . . . lack of concern with plot development . . . and a preference for a multiple and fragmented structure . . . ; open rather than closed form; a complexity and layering . . . in the merging of genres and literary forms . . . ; a world in which dream and reality are indistinguishable; a view of the illusory nature of the world . . . ; a virtuosity revealed though stylistic flourish and allusion; and a self-reflexivity that requires active audience engagement."[134] It is Ndalianis's argument that the commercial interests for the cross-media exploitation of entertainment products is shaping the content, moving it to a baroque aesthetic that does not conform to the narrative closure of classical story structures and that the use of spectacle is part of "the entertainment media's (striving) to obliterate the frame that demarcates a distance between reality and fantasy."[135]

Michele Pierson has also explored one of these baroque qualities, the connoisseurship described by Cubitt, and states in relation to connoisseurship that "the experience of wonder depends on knowing enough to be surprised. Wonder, in this sense, is taking delight in having one's expectations met."[136]

Many writers attribute the phenomenon of blockbuster/event-movie/game- and comic-book-source/attraction-park-ride feature films as either new to film or part of a much earlier tradition. The baroque school of thought sees film, especially film with spectacular special effects, belonging to this latter category. To what extent this is tied specifically to the use of DVFx varies from writer to writer. However, I would argue that DVFx, when used in this way, are part of the long-established histories of spectacle that Winston, Pierson, Klien, et al. have described so well. When taking up the issue of spectacularity, most authors stop at reference to early cinema's prenarrative form and argue that effects sequences fulfill the purpose of interrupting the narrative, of stopping it and forcing the spectator to observe and acknowledge the technology of cinema.

As Williams notes, "Awareness of the operations of the devices may also be part of the pleasure of the spectators."[137] He raises this to challenge Bordwell's theory that classical Hollywood cinema's use of technical devices seeks to be self-effacing, preserving the "realism" of the diegetic world. However, one of the measures of spectacularity for DVFx is the extent to which they are "realistic." On the one hand, the effects are designed to meet the highest standards of photorealism so that they can maintain the diegetic world without drawing attention to themselves, yet on the other hand even the desire to examine the images to determine whether or not they have attained a sufficient degree of convincingness serves to distract from the narrative engagement.

This tension between spectacular usage and self-effacing usage is of interest not only to theorists but to filmmakers. For example, in an interview about his film *The Sixth Sense* (1999), M. Night Shyamalan discusses horror-film special effects and remarks, "You're just watching it as spectacle, and because it could never happen to you, you won't feel any kind of connection with it, so you're just observing it as you would observe a laser show or fireworks."[138] For Shyamalan, spectacular usage of effects is an acknowledged practice, but his comments suggest that spectacularity is an *option* for a filmmaker, not necessarily an unavoidable consequence of using effects.

Of further interest is Shyamalan's comment that "it could never happen to you," which makes the same sort of distinction that Bettelheim made in comparing fairytales with myths. Bettelhiem's view that fairytales, unlike myths,

concern people much like ourselves also resonates with the kind of advice provided by the scriptwriting manuals, which encourage writers to make characters believable, consistent and someone the audience can relate to and understand.

Although the events that happen after the state of equilibrium is disturbed may be quite beyond the ordinary, and are expected to be so in order to test the character, the characters themselves should be convincingly real. For example, Indiana Jones, although introduced as an adventurer, is also established as a professor of archaeology whose adventures might reasonably unfold from his line of work. His capacity to deal with these adventures may be closer to fantasy than reality, but his decisions and his actions show him to be courageous, quick witted, and resolute. And while his behavior toward sites and artifacts probably does not demonstrate the standards and values required of a good archaeologist, his other qualities might recommend him as a role model in the manner of a fairytale hero.

There are many respects in which classical fiction films bear a closer resemblance to fairytales than they do to myths. Given the discussion in the first part of this chapter, examination of digital-visual-effects impacts also will consider the extent to which the stories analyzed are of fairytale or mythic dimensions. Analysis of impacts on narrative also will test the accuracy and appropriateness of the assertions about the role of spectacle and DVFx, analyzing the extent to which they draw away from the narrative (i.e., constitute spectacular usage) or add to it in order to preserve narrative integrity (à la classical narrative model).

In summary then, while storycraft writers and narrative theorists may approach the issue of story with different agendas, an area of common ground to their disparate approaches is the canonical story: the classical narrative with a beginning, middle, and end. The structure of the classical narrative—despite "New Hollywood"—is an enduring form even when other factors, such as baroque poetics, might be in play, extending the application of narratives to wider and diverse means of commercial exploitation. The quality of classical narrative in its traditional form is related to its ability to convey some wisdom or "rich meaning" and this depends upon engaging the audience with a convincing, recognizable, yet unique story that they can understand and relate to their own experience (whether as lived or at least consistent with how they perceive or imagine experience might be in the extraordinary circumstances presented).

Richard Kearney describes storycrafting as, "A tale . . . spun from bits and pieces of experience, linking past happenings with present ones and casting both into a dream of possibilities."[139] Here he captures again the issue of wisdom and

the necessity of hope. He observes that, "There is no narrated action that does not involve some response of approval or disapproval relative to some scale of goodness or justice—though it is always up to us readers to choose for ourselves from the various value options proposed by the narrative."[140]

In the commercial world of classically structured feature-length fiction film one might ask how wisdom arises if commerce is focusing on form over substance. The application of whammos and piled-on endings, and their adoption by the form, must raise the question of whether they are a measure of poor craft or a substitute for wisdom in a time of confused values. This confusion of values in Hollywood films—where stories attempt to hedge their bets regarding the resolution by having a prevalence of acts that lack consequences—may be arising in stories because they are arising in our lives.

Aside from the very large issues that this raises philosophically, it has implications for our assessment of "what is wrong" with film storycraft. The glib allegation has been that special effects–filled blockbusters have undermined "real" stories by substituting spectacle and empty action sequences for substance. Kristin Thompson asserts that the classical structure has not been altered by the use of DVFx—at least not to the point that there have emerged films that are simply an unmotivated and unlinked series of spectacular and action sequences. Those theorists embracing the baroque aesthetic point to wider political and economic factors that still draw upon "a good story, well told" for inspiration in the development of their particular interests.

Therefore, it seems clear that this matter of values is fundamental to the discussion of storycraft. In considering whether DVFx have had influence within narrative feature films, the handling of values and wisdom within the story also will need to be assessed. The purpose behind storytelling is the conveyance of something of value, of use, of wisdom. The storycraft writers hold this form as an ideal toward which to work. Narrative theorists recognize the significance of value in forms of narration and have critical discourses to examine the ideological masking of values, or their subconscious repression, and so on.

This book does not dispute the approaches taken by either the theorists or the craftmasters. Rather, it seeks to address the areas of common ground in classically structured Hollywood films, holding that this is where the point of power resides, regardless of the descriptive approach and purposes for which the two groups apply their observations. It is on this common ground that it will be possible to consider how DVFx are being used and to what story purposes, if any.

As for the future of story, Kearney makes the following interpretation of Walter Benjamin's declaration:

[Benjamin] was signalling the imminent demise of certain forms of remembrance which presupposed age-old traditions of inherited experience, seamlessly transmitted from one generation to the next. This indeed has come to an end. We can hardly deny that the notion of continuous experience associated with traditional linear narrative, has been fundamentally challenged by current technologies of the computer and the internet.[141]

Kearney concedes that "such innovative experiments are still linked to the extended narrative family"[142] and the "simple fact that story-forms mutate from age to age does not mean that they disappear."[143] However, to challenge is not to conquer; a challenge may force a combatant to find new strengths, new resources to survive and emerge triumphant. Thus it would seem that story too must make its heroic journey.

As Kearney notes, "One of the most basic tasks of storytelling, argues Tolkien along with Levi Strauss and others, is to provide narrative solutions to conundrums of time and death."[144] Thus, in our stories are our philosophies and so we must return to some of our earliest recorded philosophers. According to Anthony Kenny, "Philosophy . . . goes in pursuit of truth, and hopes to make discoveries."[145] And so it would seem do we in our lives and in our stories.

Plato argued that "we have the capacity to see such truths because we carry the image of truth in us, and we do so not by chance and natural selection, but from our origin, which is also the world's origin."[146] This origin and this essential truth are both objects of our eternal questions. Therefore it would seem appropriate that we continue to ask questions about truth, realism, and so forth, and that the very materials of our storytelling reflect these larger issues.

This questioning and creative exploration of our deepest concerns seems as congenital to our state as does our pleasure in examining our condition. If we are now in a time of change that makes us question our values or fail to enunciate them, this does not mean that we will not emerge from this time with a clearer sense of what we believe in or aspire toward. Therefore, it is likely that we, and story, will continue until the truth is found or we have ceased to be bound by time and death.

3

I'm Sorry Dave, I'm Afraid I Can't Do That: The Technology of Digital Visual Effects

> One of the greatest misconceptions about modern movies is that visual effects are generated by computers. Nothing could be further from the truth. Human inventiveness is the most important ingredient and it always will be.
>
> —PIERS BIZONY, *DIGITAL DOMAIN: THE LEADING EDGE OF VISUAL EFFECTS*[1]

Establishing the common ground of the classical narrative is only a beginning point for examining the extent to which DVFx have affected storytelling in film. To address how they make a difference to either the structure or the quality of storycraft, it is important take into account the history of computer graphics and how they came to be such a significant part of film production.[2]

Computer graphics emerged from scientific studies in the 1940s and 1950s, when computers were used to drive mechanical means of producing graphic images. In the early 1960s, Ivan Sutherland's Sketchpad graphic interface would lead to the CAD (computer assisted design) and CAM (computer assisted manufacture) applications of the automotive, naval, and aeronautics industries. Sutherland is a pivotal figure in the development of computer graphics, and his graduate students from the University of Utah include the leading developers of the major computer-graphics advances that have changed the world.

Before long, architects and artists adopted new CAD and CAM techniques for their own uses. The brothers James and John Whitney Sr. are recognized as being among the first to create computer assisted art. Interested in the relationship between music and abstract imagery, they built their own equipment from repurposed computers and optical printers to create short films combining

music and images, developing techniques copied by those who followed in their footsteps.[3] Most famously, the star-gate sequence of *2001: A Space Odyssey* used the Whitneys' slit-scan system—holding open the shutter while moving artwork held behind a slit in a screen to create the flowing images of light.

Corporate, military, scientific, and academic research all contributed to the establishment of the computer science discipline and the breakthroughs needed to make it one of the most powerful influences in the latter half of the twentieth century. For example, Bell Telephone Laboratories funded an extensive research-and-development program in communications technology. The brief to researchers was broad, including everything from visualization of satellite technologies to collaborations between artists and researchers to create new uses for the technology.[4] In the late 1960s and early 1970s, several short films using computer-assisted-art techniques gained recognition. Peter Foldes's *Hunger* was even nominated for an Academy Award in 1974 and won a jury prize at Cannes.[5]

At the same time, key figures such as Ed Catmull, Alvy Ray Smith, and Jim Blinn were developing the programs and graphic-imaging techniques that would lead to fine-art and feature films created with computers. Another key figure to shape this developing use of computer graphics was Robert Abel, who was an early adopter and pioneer using computer generated images at video resolution for use in advertising. In 1983, Abel's company created the "Sexy Robot" ad that used live-action footage with markers that the computer artists used as a reference in creating an animated robot, and the ad was something of a *Metropolis* (1927, Lang) homage. Thanks to early hierarchical programming techniques, the robot's performance was convincingly human.[6]

Feature films also were making tentative use of computer graphics, but it was not until *Tron* (1982, Lisberger) that computer graphics were a main component of a movie. While the "first all-digital computer-generated image sequence"[7] was created by George Lucas's Industrial Light & Magic (ILM) for *Star Trek II: the Wrath of Khan* (1982, Meyer), the shot itself was embedded within a movie franchise that was characterized by special-effects usage. Thus, the Genesis Effect—as the sequence was called—fit neatly into the film's narrative, whereas the computer images in *Tron,* while essential for the film's premise, were not supported by the strong narrative needed to engage audiences. In Frank Foster's documentary *The Story of Computer Graphics* (1999), Richard Taylor, one of the CG team members involved with *Tron,* observes that "if (a film) doesn't grab you by the heart, it doesn't matter technically how it looks. In the end, a film is a story and . . . the density of visuals in films or the look of the film

doesn't guarantee success at all."[8] Abel, who also contributed to the film says, "the bottom line of *Tron,* I think that we all learned . . . it's the story and the involvement with the characters that really makes or breaks a film."[9]

Many blamed computer graphics for the failure of *Tron* at the box office, and it would take films like *Willow* (1988, Howard) and *The Abyss* (1989, Cameron) to persuade filmmakers to risk using computer generated images in other projects. Thereafter, the firsts and the greats followed in rapid succession. *Terminator 2, Jurassic Park* (1993, Spielberg), and *Toy Story* (1995, Lasseter) all established that computer generated images could do better at the box office than films made exclusively with human stars. Indeed, by the mid-1990s, films vied to achieve greater and greater breakthroughs in digital computer imagery—both in terms of technological significance and of spectacle.

As computer capacities grew to meet the data load for film-resolution images, and as effective ways of getting film in and out of the digital medium became readily available, the cost efficiencies of doing digital optical work came within reach. With the volume of work growing and as training programs providing a base-level skilled workforce proliferated the resulting drop in production costs made digital solutions attractive to many more filmmakers. Dust-busting (removal of dust and specks from film negatives), wire removals, simple composites, and very basic CG enhancements of live-action footage became commonplace.

Errors such as booms in shot, crew reflections in windows, inappropriate signage, and continuity problems from changed weather conditions all could be addressed with a quick, and relatively easy, digital fix. As these kinds of practices infiltrated the production process, more imaginative and creative approaches also became common. For example, making cost comparisons of digital set extensions and composites of second-unit live-action plates with bluescreen studio performances versus location shooting became a reasonable way to find budget savings.

For lower- and midrange-budget productions, script elements that might once have been discarded because they would be beyond production funding— such as snow scenes, boating scenes, or wilderness shots—could be weighed in terms of story value because digital visual effects might make it possible for such images to be attained at a reasonable expense. The growing expertise and numbers of effects houses also made it possible for productions to shop around and find experienced effects artists who were prepared to take on projects below cost for the value of a feature-film credit on their showreels.

Summarizing the impact of this period, Carl Rosendahl of Pacific Data Images says, ". . . what we've seen happen is special effects films have gone from films that have ten, twenty, thirty special effects shots to films that have 800 special effects shots in them and more and more you know you're seeing not just that the films are using the technology but they're using them in huge ways. So live action films are becoming more and more computer generated."[10]

To what extent this is apparent is another matter altogether. A list of special-effects films would, of course, include titles such as *Star Wars* (1977, Lucas), *Jaws* (1975, Spielberg), *Jurassic Park,* and the *Terminator* films (1984, 1991 Cameron; 2003, Mostow). Films such as *Citizen Kane* (1941, Welles), *Gone with the Wind* (1939, Fleming), and *The African Queen* (1951, Huston), though all used optical effects. Herein lies an important point. What is identifiably "spectacular" is not the full measure of special-effects usage, let alone digital-visual-effects practice.

In keeping with the long tradition established by the use of optical and other special effects throughout the history of film, DVFx are not the exclusive domain of certain genres or styles of films, even though they may feature more heavily in some. The addition of DVFx expands the repertoire of special effects techniques in traditional filmmaking broadening the representational tools of filmmaking as a whole.

Although many in-camera techniques are still preferred, DVFx have quickly replaced the majority of traditional optical and photographic techniques. Digital visual effects both extend traditional techniques and allow them to be used with greater complexity, flexibility, and precision. Similarly, 3-D modeling has built upon a tradition of animation, claymation, and puppetry to create new kinds of images. Now filmmakers can manipulate images by removing from, adding to, scaling, warping, and grading images obtained photographically. They also allow the creation of entirely digital images that are practically indistinguishable from traditional photographic images. Further, computer graphics allow the addition of simulated camera moves, lens effects, color manipulations, digital lighting, and other details such as grain to emulate photographed imagery.

In applied terms, DVFx can be used to achieve a range of narrative purposes, some of which are self-effacing, others of which are deliberately spectacular, as chapter 4 details. Traditional special effects served narrative purposes in these same ways, however the control and invisibility of many digital-visual-effects techniques has extended the self-effacing qualities of effects work in the same ways it has extended its spectacularity.

At the most basic level, simple image corrections such as removing dust specks or repairing scratches on the negatives of otherwise standard photographic images are among the most common of invisible practices. Generally, these techniques restore a damaged image and make it useable, and their application is virtually undetectable.

Effects also can remove unwanted portions of images, such as wires used in stunt work or inauthentic elements for period detail in films (for example, TV antennas, power cables, etc.). Removing of advertising information for which clearances cannot be obtained or other brand names and public signage from images is common also (as is the opposite, the insertion of product placements). These kinds of treatments preserve the diegetic world and amend images for commercial and legal purposes.

This first usage shows the narrative uses of DVFx, the latter example highlights issues that arise in filmmaking that might require pragmatic digital image manipulation. Generally, removing signage or similar image alterations to protect privacy, prevent legal disputation, or achieve other, similarly benign, intentions is accepted as a matter of course. However, digital product placement is a matter of some controversy.

The introduction of product placement has always raised ideological issues, and now DVFx offer an unlimited capacity to manipulate the contents of the frame. However, the use of DVFx to support the practice of product placement is not demonstrably different from any of the other means of introducing commercial interests into movies, such as the inclusion of a particular brand of sneakers as part of a lead actor's costume and the addition of commentary on them within the dialogue. This application of DVFx is simply an extension of the larger practice of product placement and is not specifically characteristic of DVFx per se, although it is indicative of yet another means by which commercial and marketing influences can be advanced. The use of DVFx for product placement is not a specific narrative issue in the context under discussion in this book. The practice of product placement overall has narrative implications—ones that are worthy of examination—but it is outside the parameters of this topic, even if DVFx are used to extend the practice.

Returning to the range of digital touch-up techniques and some of the reasons why they are used, it should be noted that when removing elements from an image, it becomes necessary to add back to the image—either by painting over the unwanted element or by compositing another image in its place. Composites are one of the most extensively used DVFx. A composite takes multiple

images to create a new, unified image from the separate elements. This technique can be used to insert sky replacements (substituting night skies, sunsets, weather changes, etc.), or to add synthetic realities (such as computer-generated sets or landscapes), or performers (for example, merging scenery with bluescreen footage of actors or CG performances and characters).

Increasingly films contain composites with hundreds of separate images and layers of effects, a level of complexity that would have been impossible for even the greatest optical technicians.[11] Assessing the use of composites requires contextual analysis to determine their role across genres and kinds of narrative. A framework for such an assessment is the focus of chapter 4, but the important point for the current discussion is that composites are as capable of being self-effacing as they are of being spectacular.

Digital visual effects can also entail the use of CG elements that range from minor enhancements and manipulations of photographically obtained materials to fully CG environments, objects, and performers. The narrative usage of these elements must be assessed contextually because even fully CG characters can appear in films without their synthetic qualities being readily apparent. While characters such as Gollum in the *Lord of the Rings* trilogy (2001, 2002, 2003, Jackson) celebrate the animators' achievements and the motion-capture performance of a human actor, many films have fully synthetic performers interpolated between stunt-performer and actor footage with such success that the digital effects house's element tapes (tapes that show each of the separate elements used in the composite and the different stages of image construction) must be slowed down for the subtle blending of images to become detectable by the human eye.

Unique Techniques

The range of digital effects practices and the instances of them are vast. As Rosendahl has indicated, the prevalence has grown not only in numbers of shots but also in numbers and kinds of films. A contributing factor to this is the unique techniques that digital effects offer to filmmakers, which include: virtual camera moves and digital lighting, synthetic realities, full CG imagery of photoreal standard, motion capture of performances, and CG characters.

For film theorists and filmmakers, the virtual camera is one of the most significant features of digital visual effects. The virtual camera is a computer-generated camera effect that can range from simulated camera moves, focus-

pulls, and lens effects such as halation. It also refers to the fact that the length of shots generated or enhanced by the computer are not constrained by the amount of film a camera magazine can hold. According to Alvy Ray Smith, the aforementioned Genesis Effect for *Star Trek II,* won approval from George Lucas because it comprised sixty-second virtual camera move that simply could not be achieved with a real camera.[12] The ability to zoom out from the subatomic level to outer space, and to do so in a single shot without any traditional editing and constrictions on shot duration because of physical limitations, transcends standard cinematography and offers an array of storytelling benefits.

For example, the film *Fight Club* (1999, David Fincher) opens with a shot that commences deep inside the main character's brain and ends at the barrel of the gun jammed in his mouth. This shot provides an early clue that much of what will be seen in the film is happening inside the character's head but, as such images were so uncommon at the time, the audience was unlikely to understand the sequence until the shot ended. The significance of the shot in terms of what it reveals about the story is not clear until the last act of the film, where the revelation has the most dramatic power and the first shot delivers its payoff. Interestingly, this once-innovative technique is used now commonly in standard television dramas.

Another example of a story-driven virtual camera shot and the seamless of use of CG images can be found in *Panic Room* (2002, Fincher). As the mother and daughter settle in to sleep in their new house for the first time, the camera flows from one storey to another, ranging through the house to show the intruders and their attempts to break in. The camera tracks smoothly through walls and floors, into keyholes, and back up to the roof, unrestrained by the physical world. This omnipotent point of view, this transubstantiation, frees the storyteller, allowing images to flow smoothly and seamlessly, drawing the narrative point of view where it needs to go without limitations from the amount of film in the can, scope of a physical set, or location. The tension that this shot creates for the audience is quite powerful and engaging. The ability of the camera to intrude, impervious to physical barriers, signals that the woman and child are vulnerable, that the locks and bars will not keep the men from getting inside the house.

The acceptance of these kinds of virtual camera moves has been conditioned by their similarity to familiar physical cinematography using aerial, steadicam, tracking, and crane shots. These techniques have explored many ways of creatively moving the camera and established cues for audiences over a number of

decades. For example, using a crane shot to push in through a window to enter a scene sets up the now-familiar stylistic convention that makes the digital shot in *Panic Room* a reasonable point-of-view (POV) for a spectator.

However, physical limitations are exactly that—they are limitations. Leo Braudy and Marshall Cohen quote René Clair, who observed, "If there is an aesthetics of the cinema . . . it can be summarized in one word: 'movement.'"[13] Up until the advent of DVFx, the movement of the camera was realistic at least in the sense that there had been a camera in relationship to the material being filmed, but it was limited by the physical reality that it had to be placed somewhere. With the advent of virtual camera moves, microscopic and telescopic views, X-ray, and God's-eye POV shots are now integral to the canon and thus, in keeping with Clair's observation, the aesthetics of the cinema have been enhanced dramatically.

This is not to say that physical camera moves failed to take up these points of view. Edward Branigan's book *Point of View in the Cinema* examines camera movement in great detail, and he notes that a point-of-view shot is not limited to humans or even to living things.[14] However, the virtual camera opens up the moves and POVs that are attainable with its ability to move between well-established camera positions and more imaginative framings (ones that can be imagined rather than creative exploitation of those that are actually physically accessible). These expanded possibilities have made the virtual camera considerably more commonplace.

The Virtual Camera and CG Performances

In discussing the CG camera positioning in *Tron,* Scott Bukatman comments that "the camera finally serves to give the viewer a place in this computerized world, *a place* defined almost solely in terms of spatial penetration and kinetic achievement."[15] He argues that this kinesis is "fundamentally bound to narrative"[16] and is also a factor that some critics say contributes to spectacularity and "excess."

An example of how the virtual camera has changed cinematographic storytelling conventions is the fairly standard shot of tracing a telephone call. Shots often have tracked down from the telephone receiver, along the cords, up against a wall, and then along more wires, moving next from an outlet in a wall, back along another telephone cord, to the receiver in another character's hand. The digital version—perhaps like the digital transmission of calls themselves—has changed. Now the POV is capable of entering into the mouthpiece, traveling

through the wire, and through a visualization of the computer chip's interior and transmission of data, back out from the phone, perhaps into the ear and brain of the other character, and finally taking the POV of the character looking out at his image in a mirror as he holds the phone, giving the perspective as though the camera were placed inside the character's head.

Consider then the different kinds of story information that these two shots can convey. In a story that calls for the voice on the phone to have great significance for the receiver of the call, the traditional method of shooting would require some other means, perhaps as part of the dialogue, to indicate that the caller's words had the power to affect the receiver in such a way that he looked at himself differently. In the digital shot, however, it would be possible to show this—to provide a representation of this idea—through visuals alone.

This concept is at the heart of the film *Being John Malkovich* (1999, Jonze), where effects sequences depict travel through a portal to the masked camera view from within the consciousness of John Malkovich. The combination of effects and camera POV readily communicates the concept of the "journey" from the physical world to the physical perception from within the consciousness of another. The narrative makes a parody of the spectacularity by openly commenting on the voyeurism as the characters go into business and sell the opportunity to "be" John Malkovich.

Thus, on a practical level, almost every kind of imaginative and difficult shot now can be accomplished by using a digital suture to blend live action with CG enhancements, creating convincingly photoreal environments and mise-en-scene. Underwater shots, subterranean shots, extraordinary angles, transitions to and from different points of view, and visual links between settings in a form of montage can be made without any restrictions except the imaginations of the director and the director of photography (DP). The value that this freedom has for filmmakers is difficult to overstate. James Monaco has noted that camera "movements and their various combinations have . . . an important effect on the relationship between the subject and the camera [and therefore the viewer], . . . [and so] camera movement has great significance as a determinant of the meaning of film."[17]

Monaco's discussion of meaning draws upon semiotics, and he states that the paradigmatic and the syntagmatic, represented by the directorial decisions how to shoot (paradigmatic) and how to present what has been shot (syntagmatic), are the key elements in determining what a film means.[18] In addressing the matter of framing, he refers to Rudolf Arnheim's work citing balance, shape, form, growth, space, light, color, movement, tension, and expression as key

qualities for analysis of film images.[19] Monaco holds that "two aspects of the framed image are most important: the limitations that the frame imposes, and the composition of the image within the frame."[20]

He also identifies three sets of compositional codes: plane of the image, geography of the space photographed, and plane of depth perception, stating that "the closer the subject, the more important it seems."[21] He goes on to discuss the various camera moves and lens techniques, maintaining that their uses indicate relationships and cues needed for the viewer to read the images presented.

David Bordwell also has documented camera movement and shot composition. In *Film Art,* he and Kristin Thompson have defined film form as "the total system that the viewer perceives in the film," drawing particular attention to narrative and stylistic elements.[22] Further, they suggest the following criteria in order to "assess films as artistic wholes: complexity, originality, coherence, and intensity of effect (for example, vividness, strikingness, and emotional engagement)."[23]

In terms of cinematographic qualities, they define this as "control over three features: (1) the photographic qualities of the shot; (2) the framing of the shot; and (3) the duration of the shot."[24] In respect of these qualities they make the following observations pertinent to the argument at hand. They note "that framings have no absolute or general meanings . . . [that] meaning and effect always stem from the total film, from its operation as a system. The context of the film will determine the function of the framings, just as it determines the function of mise-en-scene, photographic qualities, and other techniques."[25] They also observe that "camera movement illustrates very well how the image frame defines our view of the scene."[26]

Branigan also has identified many conventions of camera use and includes optical-effects techniques alongside of "the dolly, track, crane, pan, tilt, and lateral tilt."[27] He has addressed the "impossible" placement of the camera, stating, "To the extent that the camera is located in an 'impossible' place [he gives the example of a shot from within a fridge], the narration questions its own origin, that is, suggests a change in narration."[28] He goes on to say, "In evaluating a text, one must consider the interrelations of all the levels of narration."[29]

As these film theorists show, the way cameras are used, how images are created, and the qualities that these images possess have been the subject's of extensive analysis. Nonetheless, as with the discussions of writers on film storycraft and narrative theorists, the interests of cinematographers and film theorists are related but are not the same. Cinematographers and filmmakers, like script

writers, are concerned with the creation of the shot and how to tell the story. Film theorists seek to analyze the how and why of the filmmakers' achievement.

Much of the documentation and analysis of physical camera techniques and their effects pertains to computer-generated camera practice, if for no other reason than that these techniques and the artifacts of the physical technology have set the standard for how the virtual camera is used. Indeed, as Lev Manovich has noted, "we are witnessing . . . the translation of a cinematic grammar of points of view into software and hardware. As Hollywood cinematography is translated into algorithms and computer chips, its conventions become the default method of interacting with any data subjected to spatialization."[30] Yet the scope of the camera in the digital environment is considerably greater than that permitted by the physical world, even if the conventions established there are becoming determinants of the virtual camera's abilities. In spite of the incorporation of these conventions, the virtual camera opens up whole new vistas of creative opportunity and room for theoretical analysis.

This raises a number of interesting questions. Do CG artists and directors with a good understanding of DVFx define their shots with a freer sense of camera movement? In the broader debate about norms of classical narrative, should classical cinema moves be preserved or should we allow the extra-natural abilities of the CG camera to add to our perspective/film language?

Branigan's exploration of the relationship between narration and point of view addresses these questions almost exhaustively. He identifies "six elements of classical representation in the arts,"[31] which he describes as "origin, vision, time, frame, object, and mind."[32]

Bordwell argues that classical narrative is essentially omniscient: "The most evident trace of the narration's omniscience is its *omnipresence*. The narration is unwilling to tell all, but it is willing to go anywhere. This is surely the basis of the tendency to collapse narration into camerawork."[33] And while he has noted that night shoots once were an expensive novelty[34] and that camera movement was once a form of spectacle,[35] the capacity for classical narration to appropriate the unusual to serve narrative purposes can be seen to apply to virtual camera moves also.

In *Making Meaning: Inference and Rhetoric in the Interpretation of Cinema,* Bordwell notes some of the major critical stances regarding camera use. In particular he argues that the "camera construct allows the critic to posit the image as a perceptual activity . . . as a trace of mental or emotional processes . . . [and that] the critic personifies the camera in order to link it to the narrator."[36] He also

summarizes Laura Mulvey's critical work on visual pleasure and quotes "there are three different looks associated with the cinema: that of the camera as it records the profilmic event, that of the audience as it watches the final product, and that of the characters at each other within the screen illusion."[37]

For Mulvey, the significance of the looks she defined offer a means to examine feminist issues, just as other theorists have used her framework to identify racial issues. Applied to the consideration of digital-effects usage, where digitally created images apply the same methodologies and techniques of physical camera practice, the same analytical approaches hold. Where the camera is used in new ways, new questions arise. For example, in a shot where the camera looks out through the eyes of a character at his own reflection in a mirror, there is more than one "look" in operation. This is especially the case given that such a shot can have many computer-generated cues tied to it, enhancing the verisimilitude of the idea of looking through the character's eyes. Thus there is the look of the camera and the look of the character, but in this example the images preceding the final shot make it clear that the camera (we) are looking out from within another—at least, we are to assume that this has happened.

Traditional filmmaking also has undertaken shots of this kind, using framing to suggest that the camera is a character looking into a mirror, and camera movements such as pans and tilts can be associated with these mirror-image shots to enhance the impression that the camera represents the character's POV. Branigan explores this issue of point of view and cites the experiment of *Lady in the Lake* (1947, Montgomery), which attempted to tell the story entirely in the POV of the lead character.

But the limitations of the physical camera mean that these images usually are not accurate in the way that a CG camera image from within a character's POV can be. Where traditional shots can suggest such a look, a digitally enhanced shot preceded by images that set up the concept of entering the brain can more accurately portray this point of view.

How such camera usage could be interpreted in light of the kinds of issues Branigan and Bordwell note regarding states of mind and narrator view is one of the matters that needs to be addressed by theorists who are prepared to look beyond the spectacle of camera movement freed from physical constraints. The Genesis Effect, with its impossible camera move, was made twenty years ago and many, many more films since then have used DVFx to extend camera movement; such moves are now an integral part of the classical narrative's storytelling technique.

The virtual camera's freedom and omnipotence are but two of the new qualities DVFx bring to filmmaking. Shots can be relit digitally to change the direction and source of the lighting in a scene, either to change the mise-en-scène or to make separate shots match up better. It is possible to regrade the image and create day-for-night footage and thereby substantially alter the time frame or mood of a scene. Filmmakers also can manipulate the color of the image and can do this selectively within the frame, a practice that has been used for narrative and thematic goals such as the addition of color in the black and white world of *Pleasantville* and in *Schindler's List,* as the case study in chapter 9 shows.

It also is possible to manipulate qualities of the photographic image and add camera moves to manipulate time, extending the traditions of slow-motion and fast-motion images, including time-lapse photography. The Bullet Time images in the first film of *The Matrix* (Andy Wachowski/Larry Wachowski 1999, 2003, 2003) trilogy are possibly the most readily recognized instances of this kind of time manipulation, but slow-motion shootouts have featured in films that predate digital technologies.

As Monaco summarizes:

Film . . . is a tool that can be applied to time in the same ways that the telescope and the microscope are applied to space, revealing natural phenomena that are invisible to the human eye. Slow motion, fast motion, and time-lapse photography make comprehensible events that happen either too quickly or too slowly for us to perceive them, just as the microscope and the telescope reveal phenomena that are either too small or too far away for us to perceive them.[38]

In her paper "Cinematography: The Creative Use of Reality," Maya Deren examined slow-motion imagery and, paralleling Monaco's view, describes it as "a time microscope."[39] She also describes the use of reversal of motion photography as "an undoing of time."[40] Deren discusses the optical processes that can be used to extend time by adding additional frames and using editing techniques such as those that use different takes from different angles to extend scenes to give the sensation of an act or a moment being prolonged. These techniques and her observations of them remain relevant to digitally created images, but the ability of DVFx to go beyond the techniques she has noted offers additional scope for examination.

Digitally created images permit the revelation of subatomic or extraterrestrial images, the ability to stop an image in time and space and examine it from

any angle, of any level, and at any speed and degree of detail. These abilities and the capacity to transition between any of these states with fully visualized representations can confer extraordinary powers of observation. As Arnheim has said, "The motion picture has broadened not only our knowledge but also our experience of life, by enabling us to see motion that is otherwise too fast or too slow for our perception. . . . The acceleration of natural motion, in particular, has impressed our eyes with a unity of the organic world of which we had at best only theoretical knowledge."[41]

The ability of DVFx convincingly to portray theoretical and speculative imagery extends this power of observation. Such imagery is a time and space *hyperscope* that allows time and space to be tangible, elastic, and controlled. As the *Fight Club* and *Panic Room* examples given earlier in this chapter show, it is possible for the point of view to be taken from positions that are grounded in, or in some instances exist solely in, imagination.

One of the best demonstrations of this power is the interactivity that digital visual effects shots allow between levels of time and space. It is possible for an element to allow for interactivity between live-action footage and CG imagery composited into the frame to a degree that traditional methods did not allow, with elements frozen in time becoming accessible and manipulable by other portions of the image, portions allegedly in a different time/space.

By way of example, in the third series of the *Star Trek: Enterprise* television series, Captain Archer reenters his cabin where a cup of coffee is suspended in midair, with the coffee spilling into the air, frozen in time. This image is offered as visual proof of the time/space anomalies taking place on the ship, a narrative construct indicating danger to the crew. As Archer walks into the room, his image is visible through the liquid that is suspended in the air. He walks around the cup and the trail of coffee as if it were a physical object, then, to show his annoyance, he plucks the cup from midair and puts it back down on his desk. The spill of coffee remains suspended in time and space, its perspective changing as the camera moves.

This scene conveys important story information, visibly demonstrating the presence of a strange force on the ship. It plays with time, giving symbolic indication of the "out of the ordinary" environment of the *Enterprise* and its crew, pointing to the larger questions and theories about what is to be in space should we ever venture so far. It also reveals the character's state of mind by giving him an action to demonstrate his frustration and his desire to be back in control of the events on his ship. In storycraft terms, the ability to show spatial distor-

tion—a fairly complex concept for a mainstream television series—and the state of a character's emotions and thoughts would suggest that this digital-visual-effects shot provides a valuable storycraft tool. It is more than a simple composite of CG elements with a live action shot because in addition to being convincingly executed, it imparts crucial story information. As Branigan has noted, "Time . . . exists in a text only as constructed by the text itself, i.e., through narration. . . . Devices like slow motion, the freeze frame, or superimposition in film narration often function to break one temporal unity in order to introduce a different unity and often a different narrational level."[42]

Another significant addition to storycraft that DVFx offer is the ability to generate images either totally digitally or by digital enhancement of live-action footage. The range of shots that this would encompass is extensive, including establishing shots; scene and set extensions; composites of generated images, such as screen graphics or models; and treatments of images such as the addition of smoke, particle effects, or weather elements. These examples are not exhaustive but indicate the broadness of the potential application of these kinds of DVFx.

One of the most common of these practices is the digitally enhanced or fully CG establishing shot. Computer-generated elements can blend into live action footage by playing upon the established technique of an aerial flyover but adding CG elements to create the diegetic world. For example, a scene can commence with a live-action aerial shot over a field and river, the camera movement flowing smoothly toward a town that nestles in the bend of the river. The shot can linger to reveal the town undergoing the changes of seasons, with the camera flying closer and closer to the buildings, revealing the narrow streets, establishing key buildings and exteriors and then, without any cuts, enter into a building where the first scene of live performance begins.

This shot might be composed of real aerial footage of a river and surrounding fields, motion-control images of miniatures of the town backed by a CG matte painting that draws upon some of the photographic elements of the aerial photography, CG shots of specific buildings created in 3-D, and CG treatments of the miniature shots to allow gradual revelation of the seasonal changes. This all can be composited, with CG camera moves masking the transitions between forms of image creation or image capture, ending with a transition to traditionally obtained on-set performances.

If the time and place of the story are fantastical, then it is likely that the viewer will assume that the techniques described above have been used, although

the expertise of the effects house may make it difficult to discern exactly which processes were employed. If the time and place of the story are contemporary, "real world" settings the entire sequence may pass undetected as a digital visual effects sequence.

These two examples highlight the difference between DVFx that either conform to spectacular usage or reflect the self-effacing devices of classical Hollywood narrative. The technology and the practices used to obtain, create, and combine images could be the same in either case. For the fantastical setting, the intention most likely would be to create a spectacular delight. For the contemporary setting, the intention might be to establish the diegetic world in a convincing manner with the use of DVFx being driven by the impossibility or impracticality of obtaining suitable location footage, the desire to create an opening sequence that cannot be obtained with traditional cinematographic methods, or the need to maximize production efficiencies.

Between these two story examples lies a host of narrative settings and requirements that can be achieved with the same range of digital techniques. It is in this way that the story determines the DVFx. Common to all stories would be the camera movement and the sensation that it provides in easing the story from the wider setting of the world that surrounds the specific circumstances and needs of the actors in the room, to the drama that unfolds between them.

These settings, these worlds surrounding the drama, might range from Middle Earth to modern middle class societies, but they are important to the storyteller and to the audience. Where is the story taking place? To whom is the story taking place? When is the story taking place? Why is it taking place? All of these questions address the story elements that need to be pulled together just as the physical elements of the image must also be created.

The ability of synthetic realities and full CG imagery to "pass for real" is not simply a conceit of DVFx artists. Referring to *Appllo 13* (1995, Howard), Piers Bizony quotes Digital Domain's Scott Ross:

We went through a phase with *Apollo 13* and other projects where it wasn't obvious to audiences that we'd done such marvelous work. Even some veteran lunar astronauts who maybe should have known better, congratulated us on having cleaned up NASA archive shots so beautifully, which, of course, is not at all how we did that movie.[43]

Rosendahl's estimate of a film including up to 800 digital effects shots may include some obviously spectacular sequences that draw attention to them-

selves as digital magic, but most of the shots in such a film may be ones that do not betray their digital origins. This photoreal quality extends itself to performers as well as buildings, vehicles, and geographic vistas.

Digital performers, once the subject of extensive discussion and concern in the industry, are now so prevalent they no longer merit remark unless they hold a major character role. While the debate as to whether a digital performer will ever hold a starring role is moot, given the achievements of characters in the *Star Wars* and *Lord of the Rings* films, the question of whether such a character could "pass for real" remains.

In the devices of CG bit parts, stunt performance, digital crowd extras, and live-action manipulations—such as the performances by the animal characters in the *Babe* films (1995, Noonan; 1998, Miller), or the historical characters in *Forrest Gump* (1994, Zemeckis)—the achievements are many and readily accepted. Although resorting to rows of painted cotton buds or cardboard cutouts to fill out crowd scenes is not entirely a thing of the past, digital CG crowd replication is now a standard production practice and is the kind of effect that can be used with seamless precision in virtually any film that has call for a great number of background extras. One of the more famous instances of digital extras is that of passengers on James Cameron's *Titanic* (1997).

Although *Titanic* enjoyed a high level of interest because of its use of DVFx, in another filmmaker's hands (and with a less spectacular budget), a period film that used the digital-visual-effects techniques that were in *Titanic* might have been able to enjoy less scrutiny for its technical standards, with many of the effects being accepted at image value. In other words, the same DVFx used in a movie-of-the-week shipboard romance would pass almost without notice, so closely do the effects fit with the classical narrative traditions.

For the most part, it was traditional special effects (including enormous feats of practical, mechanical, and modeling effects) and simple matters such as building an entire studio that took the budget and the spectacularity of *Titanic* into the history books and far beyond the scope of most productions. The DVFx however, although executed with superlative precision and experience, are not groundbreaking, nor are they now—less than a decade later—beyond the means of most period films.

As Cameron himself has noted, *Titanic* is not a blockbuster style film. It is a period romantic drama. In the *Cinefex* special edition on the film, he is quoted as saying, ". . . we do a movie that has no franchise potential whatsoever, no merchandising potential, that's about people and emotions, and not one

mindless action sequence after another—and we get pilloried for being typical of what's wrong with Hollywood."[44]

Primarily, it was viewed as an effects extravaganza. And while *Titanic* is a technical masterpiece—with such budgetary largesse, it should be spectacular!—the truly impressive use it makes of DVFx are the ones least likely for audiences to have noticed. The film had only one fully CG shot (an underwater view of the ship). The remainder of the work involved motion capture and character animation, the digital ocean, data integration, the digital ship (although a great proportion of the shots involved physical models and sets), and digital finishing—those elements needed to blend the variously created and obtained images and finesse them to an integrated photoreal standard.[45]

While a number of these shots involved elements that have already been discussed, such as virtual camera moves and establishing shots or set extensions, one of the outstanding capacities provided by DVFx is that of motion capture and CG characters. Motion capture is a means by which the physical performance of an actor (or dancer, gymnast, martial arts expert, etc.) can be recorded as data and then plotted to a wireframe model to form the basis of a CG character's performance. This data is amazingly accurate and convincing to viewers.

Whether using motion capture or traditional techniques, character animation is one of the most difficult of the visual representational arts because people can read and understand minute details of body language and physical communication. Of course, there are many factors that affect such awareness and communication, but from an animator's point of view, the task of creating a believable, engaging character is an enormous challenge. Motion capture, however, offers a direct tap into that certain something that communicates a human essence that a viewer can read and believe.

Digital Domain used motion capture as the basis for extras in *Titanic* and André Bustanoby has commented on the subtlety the technology records:

When a real mother picked up her equally real young child, the mother's body instinctively relaxed when the youngster was safe in her arms, and the performance-capture system picked up on a subtle nuance that even the most experienced traditional animator might have found hard to create from scratch.[46]

He goes on to discuss the recording of friends and coworkers in extras roles and the experience of animating them and discovering that as the data is used, the individuality of the people shines through, revealing "the humanity that

you've captured."[47] Remington Scott, responsible for the motion capture for both *Final Fantasy: The Spirits Within* (2001, Sakaguchi and Sakakibara co-director) and the *Lord of the Rings* trilogy, commented on the performance obtained and created for the *Lord of the Rings* CG character Gollum.

The power of motion capture, as demonstrated through Andy's [Andrew Serkis] performance, is one in which an actor can expand beyond traditional typecasting and play a character that is completely different in physical appearance. This is pushing the boundaries of film technology and the relationship between the actor and the audience.[48]

The blending of animation and motion capture often is used to persuade audiences that what they see is a human performance and not a computer-generated animation and, to some extent, it is true. There are implications for the use of interpolated CG images in stunt work that are addressed in chapter 5, but the key point here is that performance is no longer an image on screen that reflects solely the qualities of the recording arts. Increasingly, the representational arts are factored into what is seen and believed to be photography.

Although digital visual effects cannot lay first claim to having fooled an audience (indeed, Stanley Kubrick's *2001: A Space Odyssey* failed to receive an Academy Award nomination for costuming, it is believed, because the Academy assumed that the film had used real apes),[49] it has introduced synthetic performances that are not recognizably digital. Even for performances that are fairly fantastical—such as the stunt work in a film like *Blade II* (2002, del Toro), it is likely that even an audience familiar with digital visual-effects techniques might assume the performance is primarily a composite of wire removal and frame-rate manipulation devices, when, in fact, digital performer interpolation is used.

The use of computer-generated performances brings into question assertions such as John Ellis's that "what the film performance permits is moments of pure voyeurism for the spectator, the sense of overlooking something which is not designed for the onlooker but passively allows itself to be seen."[50] In the case of digitally created performances, *everything* is designed for the onlooker, absolutely every nuance is created with the express purpose of being seen and being believed. While Ellis's comments retain pertinence for live-action performances, the increasing use of CG characters raises other questions and considerations regarding theory of performance in filmmaking.

Fully CG characters and performance—once thought to be either a dire threat or a complete impossibility—also have become an accepted practice. As

with their human counterparts, they are limited by the quality of the role as developed in the script, the performance itself, and support provided by the other performers and the mise-en-scène. Animated characters have a tradition of acceptance. Mickey Mouse, Bugs Bunny, and Lara Croft have legions of fans who are little influenced by the fact that the characters are not "real." Although a great deal more could be said about why and how animated characters have obtained this acceptance (almost enough for a chapter all of its own), the pertinent issue to address is that CG characters have been subjected to considerably different kind of analysis rather than those created with traditional animation.

Final Fantasy, an entirely CG-generated feature film narrative based on a computer game, represented the first attempt to present fully CG characters as photoreal human character performance. This hyper-real representation drew a great deal of interest simply because it was an attempt to introduce human CG characters and test their acceptance by audiences. Other notable CG performances such as Jar Jar Binks in the *Star Wars* prequel *Phantom Menace,* the Troll in *Harry Potter and the Sorcerer's* [or *Philosopher's*] *Stone* (2001, Columbus), or the Balrog and Gollum in *Lord of the Rings* did not attempt to "pass for human," although there was an intention to "pass for real" in the sense that these performances sought to be convincing representations of alien, fantasy monster, or epic fantasy characters. In the case of Gollum, some reviewers consider the performance to be the star role of the trilogy.[51]

However, a CG performance is as dependent upon script and direction as any live-action human performance. The desire to create a CG human indistinguishable from live-action performers remains a goal of DVFx, one that is being achieved bit by bit, and in so doing it is creating the cues needed to convince audiences to accept that what they see is so. One way this is being achieved is by subtle manipulations of live-action materials. For example, in *Matrix Reloaded* (2003, Wachowski and Wachowski), Trinity's stunts involved not only wire removals but also digital extension of her legs to create a smoother line of action. This kind of manipulation is not uncommon and indeed is becoming increasingly prevalent in feature film work and all manner of photographic retouching.

This raises an extensive array of philosophical issues when what we view in images moves from recording to representational technologies, substituting idealized and stylized imagery for the indexical record. In an article in *The Age,*

these matters are raised in relation to the growing use of hyper-real digital models in games, telecommunications media, and photographic stills. The article makes the point that many advertising images have been retouched to the point where the original human image is not necessarily the greater portion of the final product and that, increasingly, our acceptance of these representations informs our expectations of the physical world.[52]

Needless to say, such factors should be of interest to feminist theoreticians for, as the article in *The Age* notes, "all but one of the digital models (in an exhibition) are women and all of the creators are men."[53] In his discussion of female superheroes in comic books, Bukatman has observed in relation to these characters, "Female desire is absent—when male creators design women characters, they continue to indulge male fantasies. The new power of the female hero is cosmetic surgery, and the halo of power just adds a further level of exoticism to the spectacle of the female form."[54] Yet, as discussed in chapter 5, these fantastical images, and their redefinition of expectations, extend male and female performances beyond human physical reality, and they do so with the convincing power of photorealism.

In some respects, this extension is related to one of the earliest digital-visual-effects techniques used to create digital performance—the morph. A morph involves manipulating imagery, which in 2-D is warped and cross-dissolved to conform to another image, or by using 3-D techniques that can be blended with a variety of animation and optical treatments to move from one image to another, and can persuasively represent the concept of shape-shifting and physical transformation of extraordinary magnitude.

Vivian Sobchack and her colleagues have addressed many of the theoretical implications of the morph in *Meta-Morphing: Visual Transformation and the Culture of Quick-Change.* Tracking the conceptual history of the morph from myths about shape-shifting and Cartesian mathematics, the authors identify the morph as significant, pointing to its relationship to wider issues of self-identification and cultural identification in a changing world.

In "Taking Shape: Morphing and the Performance of Self," Bukatman observes that "morphing is a way of seeing over time."[55] He notes that "images of reality, identity, and history are put up for grab" and that "movement becomes *effectively* continuous . . . an act . . . of consciousness."[56] The first use of morphing in a feature film was used in *Willow* to represent shape-shifting in the fantasy-adventure films, which was set in a pseudo-mythic time. Accordingly,

its use fit narratively and conformed to a long history of shape-shifting mythologies. Morphing technology made another breakthrough with the creation of the T-1000 Terminator model in *Terminator 2* and its portrayal as a machine that can be what ever it chooses to be, including convincing and superior versions of humans.

Yet as morphing became almost cliché, its use for obvious shape-shifting was restricted to narrative contexts that called for such images. In his article "A Brief History of Morphing," Mark Wolf noted, "The fantastic nature of the morph and the need to rationalize its occurrence in the narrative have until now limited the genres in which it is found to animation . . . horror . . . and fantasy."[57] This bears true for its use as a technique to visualize physical alteration of a character from supernatural causes, however morphs also can be applied to transformations in time and place, albeit usually through a more subtle application of the technique.

Two examples of this technique can be drawn from *Titanic.* In the first, the transformation of an individual in time is demonstrated by the transition from the young Rose posing for Jack Dawson on board the Titanic to the old Rose recounting her experience to the crew of the salvage team. The shot moves from a close up of the young woman's eye to that of the old woman's, and along with fine wrinkles deepen to demonstrate the passage of time, and its metamorphosis of the human body, morphing creates a physical linkage for narrative purposes to sell the two actors as one person. That the shot was achieved by digitally integrating the eye of the young actor in the older woman's face as part of the morph deepens the linkage and the physical bond for narrative as well as representational purposes.

The second example is the set of the Titanic, which twice transforms from old into new and new into old—an image made more poignant by the fact that the footage of the ruin is of the ship itself where it came to rest at the bottom of the Atlantic Ocean. The digital morph between its ruined present and its glorious past give a sense both of travelling in space as well as in time, much as Bukatman has observed the morph has the power to achieve. While such emotive and narrative images have been alluded to in traditionally crafted films through the use of dissolves, the experience of watching the physical transformation of a place, showing the physical impact of time rather than relying on its implication, is wonderfully expressive.

These tools of visual expression that DVFx have brought to filmmaking, thereby extending the traditional special effects practice, are the means by

which filmmaking has become both a recording and a representational art form. Manovich has gone so far as to say, "Cinema can no longer be clearly distinguished from animation. It is no longer an indexical media technology but, rather, a subgenre of painting."[58] Although in the past representational art has been recorded in film to create images, many of the images created by DVFx never appear before a camera, even if they do incorporate photographically obtained elements. In effect, the process has been reversed with recording arts media being digitized for representational enhancement.

In an interview included in the *Alien* DVD box set release H. R. Giger, whose art provided the basis for the *Alien* films (1979, Scott; 1986, Cameron; 1992, Fincher; 1997, Jeunet), observed that, "in this century movies are more important than paintings."[59] This may be so, not only because they have "exhibition value" as Walter Benjamin has described it[60] but also because they provide epic scope and a capacity to work in time-based media with all the sensibilities of fine art.

In *Myths To Live By,* Joseph Campbell described the six canons of the painter's art as defined by the Chinese. These comprise: rhythm, organic form, trueness to nature, color, placement of the object in the field, and style.[61] Each of these canons applies directly to the creation of CG imagery.

In some ways, the evolution of our ability to create convincing CG elements has mimicked natural evolution, and in others it has been reversed. It is fairly straightforward to create a convincing insect, fish, or reptile but still out of reach to create a convincing human being for any sustained period of screen time, although *Final Fantasy* was certainly a brave attempt in this direction. Yet, on the other hand, CG buildings and interiors, vehicles, and other man-made objects are extremely persuasive. It is the elements of nature that have been harder to achieve.

In "The Ontology of the Photographic Image," André Bazin describes the impact of perspective drawing on art and states, "Thenceforth, painting was torn between two ambitions: one, primarily aesthetic, namely the expression of spiritual reality wherein the symbol transcended its model; the other, purely psychological, namely the duplication of the world outside."[62] His discussion is in relation to photography but, with the advent of digitally created images, these ambitions remain of influence. Arnheim also refers to the "striving after likeness to nature which has hitherto permeated whole history of the visual arts. Among the strivings that make human beings create faithful images is the primitive desire to get material objects into one's power by creating them afresh."[63]

This certainly has been an impetus in the development of computer-generated imagery. At the very outset, it was used to visualize leading-edge scientific models for the express purpose of gaining control over the physical world, even if only on a conceptual basis. That the film industry has appropriated the technology to create new worlds, populate those worlds, and manipulate the recorded images of the world in which we live gives support to Arnheim's observation. Stanley Cavell has said that "a painting *is* a world; a photograph is *of* the world."[64] What then is a digitally enhanced photographic image?

Brian Henderson compared painting and cinema:

Cinema, like painting, is a two-dimensional art which creates the illusion of a third dimension. Painting is limited to its two dimensions; cinema is not. Cinema escapes the limits of two dimensions through its own third dimension, time. It does this by varying its range and perspective, by taking different views of its subject (through montage and/or camera movement).[65]

He went on to observe that:

the difference between montage and collage is to be found in the divergent ways in which they associate and order images. . . . Montage fragments reality in order to reconstitute it in highly organized, synthetic emotional and intellectual patterns. Collage does not do this; it collects or sticks its fragments together in a way that does not entirely overcome their fragmentation. It seeks to recover its fragments as *fragments.* In regard to overall form, it seeks to bring out the internal relations of its pieces, whereas montage imposes a set of relations upon them and indeed collects or creates its pieces to fill out a pre-existent plan.[66]

Yet DVFx rise above these distinctions, allowing composites (collage) to have the impact of montage and for painting to incorporate different views of its subject. The impact DVFx may offer, then, is of a significant order. As later chapters show, for narrative purposes DVFx and the synthesis of recording and representational arts offer new means of expression that allow greater imaginative and expressive means by which to transmit straightforward narrative material as well as complex thematic and conceptual materials.

It may be that one of the impacts of DVFx is the achievement described in "The Work of Art in the Age of Mechanical Reproduction" by Benjamin: "The history of every art form shows critical epochs in which a certain art form aspires to effects which could be fully obtained only with a changed technical standard, that is to say, in a new art form."[67]

Before proceeding to the next chapter, it would be remiss to overlook one of the other major factors in the adoption of DVFx in filmmaking, which is the production benefits and impacts upon the production process itself. As previously mentioned, Bordwell has identified three reasons a technology is adopted: it leads to greater efficiency, it offers an edge in the market through product differentiation, and it allows the product to meet the prevailing quality standards. In the case of DVFx for Hollywood filmmaking, this means that they would have to allow a film to be made more efficiently in terms to shooting time, expense, or difficulty; to be able to point to the effects usage in the marketing of the film; and to support classical narrative traditions. As the discussion has indicated so far, DVFx appear to meet these criteria with ease; in fact, they could not have been better designed to meet the needs of Hollywood filmmakers and, indeed, their development has been driven by the demands of one production after another.

In the first instance, the impact of DVFx on production practice is driven by the script elements. In traditional filmmaking, for example, a shot that calls for a dangerous wild animal to appear in frame with performers might involve staging the shot in such a way that perspective or editing could be used to bring the creature and the performer into the same frame without requiring risky proximity. Using DVFx, the ability to obtain the animal performance and the actors' performance separately and then digitally combine them in an apparently close interaction has a number of distinct advantages. Safety is an obvious advantage, as are the cost efficiencies that might be possible in shooting the animal element in second unit, where the use of a smaller crew and studio environment saves time and money. The main advantage is that the final image, when done well, allows a more convincing and engaging narrative outcome, as later examples show.

As previously mentioned, another major difference in the production process is that, unlike optical work, DVFx are *not* a postproduction practice. Digital visual effects, because they require a different kind of planning than standard postproduction practices—for example, a shooting schedule for the digital production—are part of the initial storyboarding practice and are influential in determining the camera position, movement, and mise-en-scène. These effects can inform production-design decisions on matters including makeup and costuming. They can set standards for props, set construction and design, and set dressing. They also will be the determining factor in deciding which shots are animatronic, which are miniatures, models, and so on. And they

influence direction of actors and stunt work where there are extensive digital components in a scene.

What is fundamentally important is that DVFx are *image creation* and differ very little from physical studio practices. The structuring of a digital studio is very much like the structuring of the work undertaken on a sound stage or on location, although the work is undertaken using computers. Digital crews are set up to create sets, performances, camera, and lighting departments, and their collaboration is very much like that of "real" crews shooting physical elements. The visual effects supervisor on a feature film is a key creative department head ranked alongside the cinematographer and the production designer. This department's input is as crucial to the realization of the story as the camera and production design departments. If there are digital character elements, then the animators as well as the actors on the set have performances to contribute.

What once might have been an extension of the postproduction process is now a full-fledged production environment that can have more power in determining the conditions and schedule of the physical crew and performers than any other factor in the film. In some ways, the introduction of DVFx can be compared with the introduction of sound. As discussed in chapter 1, it has had similar impact on the physical practices of the set. For example, as with the introduction of sound, in the early days of their use it was common for DVFx to restrict camera movement. However, as the technique and technological prowess of DVFx changed—comparable to the separation of sound recording, mixing, and editing—then digital visual effects allowed for increased camera freedom and expressiveness in the elements that form the final image.

Another factor, based on spectacular DVFx usage, is the box office return. When films converted to sound, box office returns doubled within two years.[68] However, the box office is not simply the money handed over at the cinema cashier. Box office now takes into account home-viewing rentals and purchases. In a speech to the Screen Producers Association of Australia in November 2003, Mark Pesce reported that DVD sales are higher for films that feature extensive DVFx and that this is influential in whether or not a project will be greenlighted for production.[69] This point was taken up by *The Guardian,* which reported in January 2005, "More people bought DVDs than cinema tickets last year—and more film flops are turning into hits after being released on disc."[70] The article shows that DVD sales in the United Kingdom jumped from 16.6 million sold in 2000 to 197 million sold by 2004, out of a global sales total of

1.9 billion DVDs, figures that do not take into account the "lost" sales of pirated products.[71]

As further examples will show, DVFx do not necessarily mean explosions, outer-space fight scenes or 3-D sci-fi environments but, as Pesce observed, the DVD has become a financially powerful delivery mechanism, and DVFx are a key marketing product. This, of course, returns discussion to the point that filmmaking is now a data industry and DVD and digital delivery sales, game spin-offs, and other repurposing opportunities are now a consideration in feature-film production. Indeed, in some cases, the theatrical release is becoming an abridged version of the film, with DVDs offering the full "extended" and alternative versions of the story; the special editions of the *Lord of the Rings* trilogy are a good example of this phenomenon.

Thus the development of DVFx has had impacts upon the production process, changing the way films are planned and shot. They can have either a positive or negative effect on a film's budget, allowing economies if used judiciously or taking a film's budget into the history of film financing. They also can influence to what extent the material will have a second life in the DVD and other media markets.

Digital visual effects also have broadened the scope of narrative expression, offering the best of recording and representational tools to storytellers. By extending control over every aspect of the image, DVFx offer additional means of visually representing concepts and creating environments and performances. Their usage is part of the language of cinema, drawn upon by writers in the scriptwriting process, relied upon to find new ways to "show, not tell," as forthcoming examples reveal. They are accessible to most filmmakers—for even low- to no-budget films—so directors no longer need to have the vision and experience of Kubrick to create visual effects and provide the kinds of mise-en-scène that, in the last twenty years, have become integral to the world of film images.

Where Monaco asserts that camera movement equals meaning in film, Bordwell claims that narrative context provides meaning for camera movement. It is narrative context that also provides the function, meaning, and, by and large, motivation for digital-visual-effects usage. This issue of narrative context is the focus of the next chapter.

Digital visual effects, and the processes by which they are created, require us to examine the world around us in the finest detail so that we can better understand how the world works and how it is structured, then use this to imagine

new creations, things we have not seen nor experienced. To create the dinosaurs of *Jurassic Park* or the detailed images of the solar system that are so common to science-fiction films, detailed research must call upon the latest theories and findings of the scientific community. Through this process of researching and imagining, we are again philosophizing and creating in the truest sense of the word. No matter what the dystopian foreshadowings of the T-1000, it is not the machine that is capable of being whatever it chooses to be; we are the ones imagining what else, where else, and who else we would choose to be.

Trick or Treat: A Framework for the Narrative Uses of Digital Visual Effects in Film

With quality movies such as *The Eternal Sunshine of the Spotless Mind* and *Lord of the Rings,* why is there still a perception that there are so few "good" effects films? My own movie experiences argue against the view that it is sufficient for a movie to have good effects. And I certainly consider mainstream films that do not have the story elements in place to be extremely disappointing, no matter how impressive the effects or the box office earnings. Given that there is a wealth of information that describes the structure of the classical narrative, the problem with films that fail cannot be that no one knows how a story should be crafted. And there is an impressive track record of extraordinary technical achievements in the craft of digital visual effects. So why does this perception persist? In my view the crux of the problem lies in how digital visual effects are used in the storytelling.

A tension exists between the narrative intents of DVFx creators and the perceived value that effects offer in terms of spectacularity. The question of whether DVFx are capable of serving traditional narrative practice given their perceived inherent spectacularity must be confronted. As later discussions of the literature on science fiction shows, special effects are still considered to be "special," identifiable, and it is argued that they single themselves out as apparent to the spectator. However, evidence suggests that the narrative uses of DVFx moves them away from this "specialness" and inherent spectacularity.

In his paper, "True Lies: Perceptual Realism, Digital Images, and Film Theory," Stephen Prince argues that digital effects raise new issues about realism and the photographic image because DVFx are not always apparent and because, by their digital nature, digitally composed images challenge the ontology of

indexical photographs.[1] By achieving photorealism, DVFx imagery questions the "realism" of all photographs.

As Prince notes, "even unreal images can be perceptually realistic." In discussing the dinosaurs in *Jurassic Park,* he observes that the CG images "acquire a very powerful perceptual realism, despite the obvious ontological problems in calling them 'realistic.' These are falsified correspondences, yet because the perceptual information they contain is valid, the dinosaurs acquire a remarkable degree of photographic realism."[2]

This level of perceptual realism extends not only to fantastical elements such as dinosaurs and disasters but to the very cues we have learned to accept as "proof" of an image's veracity. A good example of this kind of effects usage is the CG work for the feature film *Apollo 13.* To enhance the verisimilitude of the space-launch shots, lens halation was added to insert "camera real" cues into digitally created frames. Thus, blended and intercut with NASA footage, the perceptual realism these shots attained is such that not even visual effects artists are able to discern the "real" from the "photoreal" in some instances (nor are astronauts, as the earlier reference to this film indicated).

Indeed, the prevalence of certain kinds of CG shots—for example sky replacements, set extensions, object removals, and subtle composites—is such that even traditionally obtained images can be called into question with scrutiny being brought to bear on the "real" based on the assumption that the images must, or at least might, be CG. Whereas once upon a time serendipitous moments of elegant symbolism caught by the camera were part of the magic of filmmaking, the capacity to create and control those moments now casts doubt upon those instances where "everything just comes together naturally" in front of the camera. Because the perfect day can be digitally produced, audiences are able to, and perhaps invited to, question every element within the frame—from the shape of the clouds in the sky to the majesty of a sunset.

That it is even possible for digitally created images to compare so closely with the "real" thing would suggest that special effects—in particular, digital visual effects—do not always serve as spectacle if it is not possible to discern them as effects. Even if one takes into account their capacity to raise questions about the veracity of all photography and that their prevalence may offer the consideration of spectacularity in relation to "real" as well as CG images, it is more likely that perceptual realism (the sensation that one is seeing something that is photographically obtained) will lead to images being accepted at face value in most narrative contexts.

Stepping aside from discussions about all filmmaking being an effect and a spectacle, and from the wider philosophical issues of "realism" in general, what is at issue here is the question of how to distinguish spectacular uses from other uses and, also, the narrative purposes digital effects serve overall.

When invited to comment on effects work, creators of the effects invariably make the assertion that effects use is dependent upon story requirements. Narrative determines the effects in terms not only of the descriptive brief for specific CG elements but the stylistic approach also. Spectacularity, while a stylistic option for some genres (most commonly, but not exclusively, science-fiction and fantasy narratives), is not the intention in a great number of instances. Further, as the case study discussions will show, there is a range of narrative purposes that can be fulfilled by spectacular images.

Spectacularity can be part of the story, integral to establishing the diegetic world—such as the opening shot of *Star Wars,* a film which, narratively, has been described as *American Graffiti* in space (1973, Lucas). Spectacularity can be driven by stylized displays of violence that, even if enhanced by DVFx, often are included for the voyeuristic and kinetic value of the violence. Spectacularity also can be used to slow or stop the narrative, not to provide a substitutional element in place of story but a beat of pacing so that the emotional load or intellectual weight of a narrative moment can be experienced by characters within the narrative and/or by audiences. There are instances where spectacularity is not necessarily in the tradition of the "cinema of attractions" but more in keeping with Hollywood's "magic of the movies" and its power owes something more to the classical narrative tradition.

This view is almost directly opposite to that posed by Brooks Landon in "Diegetic or Digital? The Convergence of Science-Fiction Literature and Science-Fiction Film in Hypermedia."[3] Landon's paper explores the idea that the growing use of DVFx is a return to Tom Gunning's "cinema of attractions" and asks, "Could the spectacle of production technology, increasingly a kind of digital narrative, deserve and reward our attention just as surely as do narratives about the impact of technology?"[4] He argues that his concern

is not whether special effects scenes are interruptive or whether such interruptions are "good" or "bad," but with several important independent functions of these scenes. And here I would suggest that special effects events in science-fiction film can be profitably considered as self-reflexive celebrations of film technology itself, as a kind of counter-narrative that often conflicts with the ostensible discursive narrative.[5]

Landon's argument draws upon the literature on science fiction that reads nondiegetic functions for spectacle that are, as he says, "special effects [that] can be thought of as existing not to support the narrative or the plot, but to provide their own formal rhythm and logic—the special effects story that the film is 'really' built around."[6]

It should be noted that Landon is speaking specifically about science-fiction films, and especially about what these films mean in a technological society. This is a very specific kind of reading of these narratives, so his case for "a kind of techno-narrative that exists in parallel relationship to the film's plot- or story-based narrative"[7] has to be respected for what it is saying about science fiction, but it is of value to the wider arguments about DVFx because the views he raises have been generalized to all forms of digital-visual-effects practice.

It is his kind of argument that is taken up by film critics who then argue that "effects-laden films" are simply spectacles that have no relationship to story. And this is not quite the same thing as saying, as Landon does, that in science fiction the spectacle of effects practices points to specific thematic interests of science fiction. These themes are addressed in chapter 7 on genre and the use of effects, but the distinction between what Landon and other science-fiction writers have said about spectacle and my argument about the narrative uses of spectacle needs to be highlighted.

Perhaps one of the reasons these narrative patterns of spectacularity emerged from my research is that my sample is not restricted to "effects" movies but covers all manner of narrative films. Essentially, if digital effects are used in a film, that film qualifies to be part of my sample. As a result, I have reviewed films that usually would not be subjected to consideration as "effects movies," and it has struck me that most of the examples that are usually used to discuss "effects" films are science fiction or action-adventure films. As soon as one moves into the wider field of filmmaking, the nonspectacular uses of effects become more apparent and the nonspectacular uses of effects within the traditional genres also becomes obvious.

This is not a unique observation about the use of effects in films. As early as 1920 the distinction was made between those effects that were meant to be seen and those that were not. Norman Klein summarizes these as: a special effect, a hidden effect, and a scene change, such as the device of a turning page.[8] However, the discussion here is not simply about special effects extravaganzas versus the use of set wet-downs and wind machines to create a rainy setting. The framework that follows examines the narrative functions of

DVFx within films and how they are used as storytelling devices, as well as identifying changes to categories of film that have resulted from the use of digital visual effects.

An examination of how effects have been used in nearly 500 feature films, revealed a number of patterns. First, some effects techniques that are primarily about the way certain story elements are handled. An example of this is the cheating of danger by compositing live-action bluescreen performances against separately shot pyrotechnic effects plates. The story element in such a case is the placing of lead characters in extreme physical danger, very often a massive explosion that engulfs them and then throws them clear of the blast with barely a mark except perhaps a well-placed smudge to highlight their cheekbone structures.

There are also a number of emerging practices, such as the increased use of virtual camera moves in all kinds of narratives and the introduction of CG characters, either as identifiable characters in themselves, or as interpolated imagery to enhance human performances. However, aside from these patterns, which are mentioned in chapter 3, review of the narrative and stylistic uses of DVFx reveals eight categories of effects usage: Documentary, Invisible, Seamless, Exaggerated, Fantastical, Surrealist, New Traditionalist, and HyperRealist.

These categories describe the narrative and practical applications for digital-visual-effects usage, factors that may vary over the course of individual films. Thus, the categories describe the narrative purposes of usage rather than categorize the films themselves, as it is quite common for more than one category to apply within individual films, as the following descriptions and examples demonstrate.

Documentary

This style of usage is characterized by open and apparent incorporation of the range of digital-effects techniques. It is sometimes used within narrative feature films as "documentary" footage, for example the theme park's interactive film in *Jurassic Park* that explains the science behind the park's creations. This is a narratively powerful use of documentary footage and apparent display of computer graphics because it operates within documentary traditions and the conventions of theme-park instructional films to deal with otherwise awkward expositional material.

The value this offers in terms of scriptwriting and the reflexive nature of this part of the film was not lost on scriptwriter David Koepp: "Once we had that

idea, everything just fell into place and we were able to do in about three pages what I was afraid was going to take fifteen."[9] He adds that the reflexivity of what he was doing was strange: "Here I was writing about these greedy people who are creating a fabulous theme park just so they can exploit all these dinosaurs and make silly little films and sell stupid plastic plates and things. And I'm writing it for a company that's eventually going to put this in their theme parks and make these silly little films and sell stupid plastic plates."[10]

Other films use documentary-style graphics in much the same way, usually to deal with what would be heavy exposition otherwise but also, in science fiction, to underline the thematic interests of the story much as Landon and other science-fiction theorists have argued. In the same way that the reflexive nature of the *Jurassic Park* example speaks about the commercial thematic material of the story, it also speaks about the scientific and state-of-the-art computational and technological power that is thematic to the story.

In both feature-film applications and formal documentary uses, full CG animations often are employed to demonstrate everything from scientific models of complex concepts to straightforward representations of archaeological reconstructions. Although less common, invisible effects also provide the means to restore stock footage and support instances of dramatization that require "realistic" settings. In general, the narrative purpose is to reveal information, to fulfill educational, rhetorical, and in some instances artifactual intents.

In the documentary television series *Seconds from Disaster,* in one episode alone the filmmakers used CG visualizations of theories to explain how the disaster might have occurred; CG models of technical explanations such as how the rails flexed in a train derailment; CG re-creations of events, which were used in slow-motion and image fragments to enhance the exposition; and CG landscapes, water, bridges, and trains.[11] These kinds of examples are common to documentary filmmaking, and one only need watch a documentary channel for a few hours to see how computer-graphics techniques are used to provide visual representations of everything from scientific theories to animated graphics of statistical information or historical timelines.

Figure 4.1 shows an example of this type of use, from the IMAX feature *Solarmax* (2000, Weiley). In this image from the film, Earth is shown ringed by circles of satellites, each of which is named in the CG depiction. This image commences as simply an image of Earth with the rings of satellites appearing

Figure 4.1 Documentary usage of digital visual effects. An image of earth with its rings of satellites. From the IMAX feature film *Solarmax*. Courtesy of John Weiley, producer/director: *Solarmax*.

one after the other, conveying with great efficiency and clarity the extent to which we have become reliant upon these devices.

As an even more interesting example of the impact of digital visual effects on documentary filmmaking, *Solarmax* was obliged to provide an intertitle at the beginning of the film advising audiences that the images of the sun were, in fact, real images and not computer generated (figure 4.2). As indicated earlier, one of the consequences of the increased use of effects and their perceptual realism, is that they cast doubt upon the veracity of images in general. When a sky can be replaced without leaving a clue that a digital creation has been added, how does one know if any image of the sky in a film is a digital addition or an indexical photograph? In the instance of *Solarmax,* it was vital that

Figure 4.2 Documentary usage of digital visual effects. An intertitle from the IMAX feature film *Solarmax*. Courtesy of John Weiley, producer/director: *Solarmax*.

audiences understand that what they were seeing was a true image of the sun and, given the use of other obvious digital effects in the film, clarification was required.

Invisible

As with Documentary use, invisible techniques are drawn from the entire digital palette. The usage, however, is neither open nor apparent; it is deliberately concealed, and detection of the techniques is considered by effects artists to be a failure to achieve the necessary standard. Indeed, invisibly introducing effects into a film and having them go unnoticed is considered to be "the best" use of this type of DVFx.

Accordingly, it is difficult to describe examples of this kind of usage since good examples will not have been noticed in the first instance. However, the ex-

amples are there and readily lend themselves to clarifying the effectiveness of invisible digital visual effects.

The first example is from the Australian film *The Dish* (2000, Sitch), a dramatic comedy that used sky replacements to ensure scene continuity when changeable weather made reverse shots of a critical conversation identifiably inconsistent. The footage with the two actors in shot was taken on a cloudy day, but the shots of the conversation with only Sam Neill in frame took place on a sunny day. This problem was solved with a sky replacement, substituting footage of a cloudy sky into the shots of Neill taken on the sunny day. As a result, continuity editing practices prevail and there is nothing in the film's construction of the scene that reveals that the performances took place on two separate days and on one of those occasions with only one of the actors in front of the camera. By ensuring the weather conditions appear constant through the employment of sky replacements, the diegetic world of the film remains complete, thus preserving narrative integrity.

Similarly, the use of day for night in the film *Rabbit Proof Fence* (2002, Noyce), allowed responsible management of child actors without sacrificing story requirements. In addition to providing a boon to the production by allowing day shoots instead of extensive night shoots, which would have required meeting very strict child labor requirements, extensive digital relighting of the scene enhanced the realism of a "night" search for the young girls who are the heroes of this epic journey. The result is perfect verisimilitude that does not draw attention away from the narrative; rather, the effects serve to engage the viewer in the events of the story without ever revealing the artifice used. The relighting of the shot also allowed a kind of painterly control over the mise-en-scène without sacrificing the gritty realism and sense of place that the shots possess.

An invisible effect can be as simple as the removal of a flinching eye-blink by a stuntwoman—as was the case in the film *Adaptation* (2002, Jonze), where the stunt performer telegraphed the impending impact of a car crash and DVFx were used to remove the blink. Although such a detail might sound trivial, it is exactly the kind of moment that can break the audience's engagement with the narrative and is a performance detail that tends to be beyond the control and notice of the filmmakers on set.

In all these cases, the purpose of the effects usage is to preserve the diegetic world as well as deal with practical implications of filmmaking. In instances like these—when films remove unwanted modern infrastructure, extend locations with matte paintings, or add story-driven elements in the form of weather,

time of day, and similar factors—the intent is to preserve story coherence and support contexted verisimilitude. These DVFx do not adhere to spectacular-effects usage, indeed are antithetical to such purposes.

Visual effects supervisor Kevin Haug, whose credits include *The Game* (1997, Fincher), *Fight Club, The Cell* (2000, Singh), *Panic Room,* and *Finding Neverland* (2004, Forster), says, "Invisible effects are actually invisible now. I can't find them."[12] This can be true not only for spectators but also for people involved in making the film. Academy Award–winning visual effects supervisor Eric Brevig, in an interview with *Cinefex* magazine, recounts the experience of negotiating with *Pearl Harbor* (2001) director Michael Bay, who was adamant that he would not use CG planes in the film because they would stand out as CG. Brevig's strategy to deal with this was to put CG planes in a shot with real planes and invite the director to pick which planes were real and which were not. When the director could not pick the CG work, CG planes were allowed in the film.[13]

The basic quality of an invisible effect is that it should be completely unde-tectable. There should be no reason for the audience to suspect that effects have been used at all. Everything about the shot must be physically possible. For ex-ample, digitally added rain must conform exactly to the principles of real rain and, from a narrative point of view, rain must be possible and plausible within the world of the story in the context that it is used.

Figures 4.3–4.8 are a series of shots that show a range of invisible effects in before and after views. As these examples indicate, there is nothing that would draw attention to the digital elements as they fit within the narrative setting, and they are all images that could occur naturally in front of the camera. The decision to use DVFx has been based on production needs and the desire to con-trol mise-en-scène elements.

Seamless

The Seamless use of effects is continuous with Invisible usage, but seamless effects are discernible if subjected to scrutiny and consideration. In this cate-gory effects also draw from across the range of techniques and, as with the in-visible category, seek to pass unnoticed. The distinction between these and invisible uses is made on the basis that given reasonable consideration, their usage is detectable.

By way of example, the matte painting in *The Pianist* (2002, Polanski) that depicts the destruction of Warsaw was added seamlessly to live-action material, but while well executed its usage can be discerned because it is apparent that

Figure 4.3 Invisible use of digital visual effects. Background plate for the feature film *House of Flying Daggers.* Directed by Zhang Yimou. Visual Effects by Animal Logic. Image courtesy of Animal Logic. © 2003 Elite Group Enterprises Inc.

Figure 4.4 Invisible use of digital visual effects. Composite of background plate and CG arrow for the feature film *House of Flying Daggers.* Directed by Zhang Yimou. Visual Effects by Animal Logic. Image courtesy of Animal Logic. © 2003 Elite Group Enterprises Inc.

Warsaw in 1945 is not an accessible environment. It is fairly easy for the audience to conclude that the filmmakers have re-created the environment through a set extension. However, the narrative intention is clear. For story purposes, it is imperative that the audience be given both an accurate visual representation of the diegetic world and the emotional impact of the extent of destruction.

Figure 4.5 Invisible use of digital visual effects. Background plate for the short film *Filatelista.*
Image courtesy of the Australian Film Television & Radio School.

Figure 4.6 Invisible use of digital visual effects. Composite of set extension for the short film
Filatelista. Image courtesy of the Australian Film Television & Radio School.

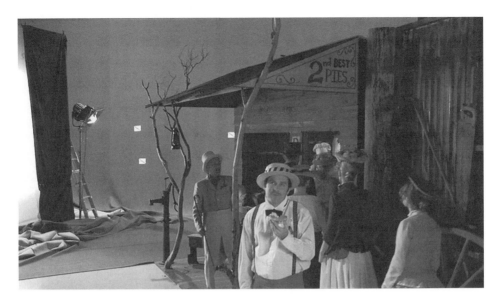

Figure 4.7 Invisible use of digital visual effects. Bluescreen plate for street scene in the film *Crooked Mick*. Image courtesy of the Australian Film Television & Radio School.

Figure 4.8 Invisible use of digital visual effects. Composite of bluescreen and CG set extension for the film *Crooked Mick*. Images courtesy of the Australian Film Telelvision & Radio School.

A Framework for the Narrative Uses of Digital Visual Effects in Film

This effect achieves these results but does so Seamlessly. It does not seek to draw attention to itself for spectacular purposes; rather it seeks to ensure the narrative coherence with classical Hollywood storycraft.

Another example of Seamless usage can be found in the film *Gladiator* (2000, Scott). The filmmakers went to great lengths to mix real locations with digital extensions so that the sense of place created by the mise-en-scène sustained the narrative. The re-creation of the Colosseum is essential to the story and the narrative impact of the hero's sacrifice for the glory of Rome.

This category is of particular interest in consideration of how narrative is supported by DVFx because the range of effects applications and the kinds of films that use them are quite broad. For films like *Braveheart* (1995, Gibson), *Pearl Harbor,* and *Saving Private Ryan* (1998, Spielberg), effects are used to underpin the period in which the story takes place and to create realistic war scenes upon which the narratives depend. The mix of practical and digital effects makes the seamless blend of the images easier to achieve and often it is the camera move that reveals the digital nature of specific shots.

In some cases, such as *A.I.* (2001, Spielberg), the removal of blinks, a practice that is Invisible in the film *Adaptation,* straddles the border between Invisible and Seamless because the removal of blinks in *A.I.* is intended to make the performance of the robotic toy David seem less human. It is not the kind of effect that would be noticed consciously, but the cumulative impact of a character's "unnatural" performance might be sufficiently disturbing to have the effects be considered Seamless rather than Invisible. This kind of example shows how the narrative context is crucial to the reading of digital-visual-effects work.

The historical accuracy of images and blending of live action with digitally created images and background plates in *Titanic* however, is another example of how effects are used for narrative purposes but also highlights how spectacular issues enter into even this category of usage. For films such as *Master and Commander* (2003, Weir) or *The Perfect Storm* (2000, Petersen), the use of DVFx to create the world of the story was absolutely imperative in order to show the scale of the dangers posed to the characters, but every effort was made to ensure that the images conformed exactly with the realities of a story set at sea. These dangers exist in the real world and are in themselves spectacular events. To convey the experience of sailing into a "perfect storm" as anything less than spectacular would be to fail to serve the drama's requirements.

Similarly, with a film such as *Fly Away Home* (1996, Ballard), the intention of the effects is to keep the action of the story convincing, as the narrative was based

on a "true story." Dramas often call upon DVFx to work in this way, protecting the diegetic world and seeking to preserve the coherence of the narrative in order to persuade audiences of the story's loyalty to events that have occurred.

In this category, because it is often apparent that effects must have been used, the spectacular attraction is the photoreal standard of the imagery, its imperceptibleness being the measure of its quality. It is possible for those who are attuned to visual-effects techniques to seek out evidence of their usage, focusing on the technology at the expense of narrative connection. This, however, is a reflection of spectatorship issues rather than of the narrative purpose served by the use of the effects themselves.

In many films using Seamless digital visual effects, the smooth blending of separately obtained images to create a coherent diegetic world is the goal. In this instance the preservation of the coherent narrative world dominates. Stunt work must appear plausible and physically real. Even if the hero is placed in a position of absolute physical peril, it must adhere to the standard of perceptual realism and cognitive realism. An example of Seamless effects is shown in figure 4.9 from the feature-film *Chopper* (2000, Dominik), where CG blood is added to enhance a fight scene.

As the foregoing would suggest, and as is true for all of the categories, the distinctions are not absolute. Within films the changing narrative needs dictate different effects usages. Thus, individual films will quietly use invisible effects to secure diegetic coherence for some aspects of the story but also readily exploit Exaggerated or Fantastical uses for spectacular purposes as required. As the case study of *Mission to Mars* (2000, DePalma), in chapter 5 shows, the film provides a number of instances where digital visual effects are used to create Seamless narrative results but then moves on to offer highly spectacular Fantastical digital effects where the narrative demands require them.

Furthermore, audience perceptions are not uniform but reflect the experience of each individual, her knowledge of the world, and her familiarity with production processes and engagement with each text. What will pass unnoticed by one person will be subject to scrutiny and detection by another.[14] This is true for many aspects of film production. Where one person will watch a film blissfully unaware of camera moves, another will monitor not only camera position, depth of field and lighting, but framing, editing decisions, and the punctuative effect of dissolves, fades, and cuts.

Whatever the range of audience attentiveness to such details, it is possible to distinguish between effects used with the intention of being observable and

Figure 4.9 Seamless use of digital visual effects. Composite of live action and CG blood for the feature film *Chopper*. Directed by Andrew Dominik. Visual Effects by Animal Logic. Images courtesy of Animal Logic. © Mushroom Pictures 2000.

those that seek to efface themselves and allow the domination of narrative. Yet there are also effects practices that lie at the boundaries of these categories, effects such as stunt work, crowd replacements, and set extensions.

In some films these uses will pass undetected, in a spectacular usage they will be an attractive factor with behind-the-scenes infomentaries providing detail on the particle-effects programs and algorithms used to make the crowds move in a visibly random manner. However, unless something is startlingly new on a technical level, attention usually is not drawn to the use of these kinds of effects.

For example, a set extension for a melodrama's tearful conversation in a graveyard might pass for invisible usage or at least seamless usage if employed in a period film but if the set extension is of city being destroyed, then it has

spectacular value and fits more comfortably in the next category of effects usage, exaggerated effects. It is in this category that spectacular intentions begin to emerge in their own right.

Exaggerated

The exaggerated category straddles the fine line between "real" world narrative and "extraordinary" tales. Figures 4.10 and 4.11 from the film *Hero* (2003, Yimou) show how finely that line can be straddled. The final image is not impossible, but it is certainly a forceful statement. Similarly, comedy, although unlikely to be the first genre that comes to mind when DVFx are discussed, often uses effects to heighten comedic value of sight gags. An example of this is Eddie Murphy and Robert De Niro, held together by a pair of handcuffs, hanging from a skyscraper at the end of the film *Showtime* (2002, Dey). Steven Chow also takes great advantage of DVFx for comedic value in his films *Shaolin Soccer* (2001) and *Kung Fu Hustle* (2004). Even though comedies generally do not seek to draw audiences on the basis of their spectacular-effects prowess, they do not hesitate to enhance humor with either Seamless or Exaggerated effects.

However, action or disaster films provide the most widely known examples of Exaggerated effects. *Dante's Peak* (1997, Donaldson) and other disaster movies aim to portray what it would be like in the event of a volcanic eruption or similar physically possible circumstance. But in a film like *The Day after Tomorrow,* while the story takes place in a "real world" setting, the events are ones that are unlikely to happen and, although realistically depicted, the audience knows these events are not "real." In a disaster film like *The Day after Tomorrow,* the point is to watch "what would happen" realistically in the unreal circumstances presented by the story. The use of effects in this case is an exaggeration of real weather conditions, in order to depict environmental weather change.

Action-adventure films also rely upon exaggerated uses of DVFx to enhance the dangers faced by the protagonist and to escalate the visual impact of events such as explosions, avalanches, and so forth. Films such as *The Professional* (1994, Besson) tend more toward Seamless use of effects compared with, say, the more Exaggerated effects in a *Bond* film. Often action films start with seamless use of effects to represent events but, as the pacing of the events ramps up, the use of effects becomes Exaggerated.

This is especially the case when effects are used to extend the action beyond physical realism and into the realm of perceptual realism but cognitive improbability. For example, while many scenes in *Dante's Peak* depict visually and

Figure 4.10 Exaggerated use of digital visual effects. Background plate for the feature film *Hero*. Directed by Zhang Yimou. Visual Effects by Animal Logic. Images courtesy of Animal Logic. © 2003 Elite Group Enterprises Inc.

physically realistic shots, there are scenes, such as the family's extended drive through the lava flow, that exaggerate events and seek to heighten the dramatic tension. This attempt to heighten the drama to a point beyond what can actually happen is the most common kind of Exaggerated usage. Other examples of Exaggerated effects would include films such as *Eraser* (1996, Russell), where the protagonist hangs onto the door of the plane with a flaming jet engine behind him posing the threat of immediate death should he be incapable of holding onto the plane, a feat that would require super-human strength.

Rob Coleman (animation director at Industrial Light & Magic), describing the experience of being asked by directors to push the limits on the physically real, says, "Directors are always asking animators to make CG characters do these physically impossible things—things that, in reality, would rip their shoulders

Figure 4.11 Exaggerated use of digital visual effects. Composite of background plate and CG arrows for the feature film *Hero*. Directed by Zhang Yimou. Visual Effects by Animal Logic. Images courtesy of Animal Logic. © 2003 Elite Group Enterprises Inc.

out of their sockets."[15] Visual effect supervisor Tim McHugh, commenting on *The Bourne Identity* (2002, Liman), says, "In one scene, Matt Damon grabs this guy, throws him down a stairwell, and rides him down six stories, while shooting. I stared at it in disbelief. This was a realistic, gritty, spy drama—and here's a scene that wouldn't have worked in a Roger Moore Bond film! And I thought, 'Well, now I don't trust these people [the filmmakers] or the rest of the movie.'"[16]

Essentially, the Exaggerated use of DVFx creates a perception of verisimilitude in extraordinary circumstances but not necessarily in fantastic or fantasy worlds. The techniques used can involve wire removals, composites, additions of fully CG elements (including performances such as the interpolation of digital doubles in stunts), and most of the other digital effects practices. However, even when the spectacular value of these effects is intentional, often it is not the

prime purpose of their usage. As the discussion so far has suggested, the narrative does not stop so much as get driven along by the action sequences, and the criticisms that these kind of films are more of a thrill-ride than a story should be given fair consideration.

These effects practices also may give support to Kristin Thompson's discussion of the "stacking up (of) climactic scenes."[17] The role of DVFx in assisting films to achieve this result is quite clear. In order to keep upping the ante of dramatic action, effects can create ever more dangerous and unlikely, albeit visually convincing, perils that allow for extended chase sequences and improbable escapes that draw upon spectacular demonstrations of visual effects technology. However, there are consequences for this kind of usage. As Coleman says, "When a character breaks the laws of physics, you are breaking the illusion. Nobody is going to believe in that character if he does these amazing things. And, worse, they are not going to believe that character is in peril. If he can leap 65 feet from one building to another, he is no longer like us, and we can't empathize with him."[18] As the Exaggerated category of effects applies to the extension of "real world" environments, taking stunt work, physical survival of disastrous conditions, and chase sequences to levels beyond the physically possible compromises the narrative. The extent to which this is done deliberately for spectacular purposes or is simply proof of poor storycraft is hard to determine in general terms and has to be assessed on a film-by-film basis. However, as a consequence, criticisms about films that use DVFx in this way are inevitable and often justified.

Visual effects supervisor Mark Stetson, who won an Academy Award for his work on *Lord of the Rings: The Fellowship of the Ring* (2001, Jackson), has said,

Some directors choose to go over the top. I've actually been instructed in the past: "Go over the top. If we lose some of the audience, that's okay. This is what I want." Sometimes they just have to get it out of their systems. I've worked for more than one that just wanted every single cool effect that he'd ever seen in his movie. But then he learned from that; and having done it, he said, "Okay, I've done that. Now let's make a movie with a story."[19]

Cinematographers also experience this kind of poor direction and are asked to compromise motivated camera work so that "cool" shots can be included regardless of their contribution to story. Similarly, soundtracks full of directors' favorite songs are not uncommon. When over-the-top use of any facet of filmmaking takes precedence over the story—in a classical narrative film—then the

lack of balance will become obvious. The injudicious use of DVFx in these situations should not be confused with deliberately spectacular uses where effects are used creatively to enhance the narrative. The next category of effects is one where this is more common.

Fantastical

When it comes to spectacular uses, compelling as many Exaggerated effects sequences tend to be, most would cite films that fall within the category of the Fantastical as the exemplars of sublime or excess imagery. Fantastical effects sequences in films use DVFx to create images of astonishing qualities and realize the impossible to the highest standards of perceptual realism. Albert La Valley has remarked upon this kind of effect usage as the ability to use images that "show us things to be untrue, but show them to us with such conviction that we believe them to be real."[20] As the discussion on genre in chapter 7 shows, contrary to widely held views, Fantastical effects are not restricted to science fiction.

Certainly science-fiction films have provided ample justification for the development of DVFx. In these cases there is no doubt that the DVFx are expected to be of the highest standard and to use the most state-of-the-art technological prowess. As Annette Kuhn has commented, these films *are* science fiction and the stuff *of* science fiction.[21]

Furthermore, DVFx also have been crucial to the realization of fantasy films such as the *Harry Potter, Babe, Lord of the Rings,* and *Stuart Little* series. In these instances the range of effects uses varies. For films such as the *Harry Potter* or *Stuart Little* series, the usage is often openly fantastical and celebrates the technology. However, films such as the *Babe* and *Lord of the Rings* movies rely as heavily on the Invisible and Seamless effects as they do the Fantastical to achieve narrative purposes. There is no question that these films are set in fantastical circumstances and deal with fantasy elements. Nonetheless, considerable effort is made to quickly establish the diegetic world and to support it with every trick in the digital-visual-effects arsenal.

This category demonstrates the issues Prince raises in regard to "perceptual realism and the referentially unreal."[22] For example, a film such as *Forrest Gump,* while neither science fiction nor traditional fantasy, remains an example of essentially Fantastical use of effects. Yet, as with *Jurassic Park,* the realism of the images is not the cue. The narrative material of the film is itself fantastical. Like *Babe, Forrest Gump* uses effects to manipulate real-world imagery to relate an

extraordinary tale. Further, in the case of *Forrest Gump,* there is additional interest because, like *Zelig* (1983, Allen) before it, it toys with the indexical record and raises, by its very nature, questions about the implications of perceptual realism in a digital world.

A film such as *Big Fish* (2003, Burton) uses effects to portray fantastical events, and their use has thematic resonance in a story about a man whose life has been portrayed as fantastical and for whose son the events are viewed as illusory. The film *Hero* also makes a poetic statement about the prowess of its warriors as the images in figures 4.12–4.14 show.

In terms of other Fantastical uses of effects, supernatural thrillers and dramas such as *The Devil's Backbone* (2001, del Toro), *What Lies Beneath* (2000, Zemeckis), or *The Sixth Sense* also judiciously use digital visual effects to extend

Figure 4.12 Fantastical use of digital visual effects. Background plate for the feature film *Hero*. Directed by Zhang Yimou. Visual Effects by Animal Logic. Images courtesy of Animal Logic. © 2003 Elite Group Enterprises Inc.

real-world settings by introducing fantastical elements. It is this distinction that categorizes the usage in these films as fantastical, no matter how subtle the effects and how otherwise mundane and real the settings for the narrative.

When such effects are used in the Seamless category, they are restricted to real-world, physically possible usages. They create and preserve the diegetic world. When they are used to Fantastical ends, the techniques are used to extend the real world into the realm of fantasy but without necessarily disrupting the diegetic world for spectacular observation.

It is in these types of films that tension between the pleasures of the spectacle and the captivating power of classical Hollywood narrative is apparent; as is the use of digital-visual-effects work to support *both* spectacle and narrative cohesion. For example, in *Fairy Tale: A True Story* (1997, Sturridge)—based on a real

Figure 4.13 Fantastical use of digital visual effects. Greenscreen live-action plate for the feature film *Hero*. Directed by Zhang Yimou. Visual Effects by Animal Logic. Images courtesy of Animal Logic. © 2003 Elite Group Enterprises Inc.

Figure 4.14 Fantastical use of digital visual effects. Composite of background plate and live-action plate for the feature film *Hero*. Directed by Zhang Yimou. Visual Effects by Animal Logic. Images courtesy of Animal Logic. © 2003 Elite Group Enterprises Inc.

story about two Victorian schoolgirls whose trick photography created a sensation—the spectacle of the fairies asks the audience if it believes in fairies in three ways: literally with the line from *Peter Pan,* narratively within the story of the two girls' experience of the fairies, and technically as the images of the fairies invites scrutiny of the standard of the digital visual effects executed. The technical standard of the effects is very good. The fairies move freely and convincingly and are composited into the scenes in such a way that scrutiny is directed toward them much as they would be scrutinized if they appeared in the real world. This is particularly the case in the opening shots where they fly above the forest. Once the opportunity to examine the technical standard has been satisfied and the question of their believability is answered, the audience need no longer examine the images for credibility and can move on to consid-

eration of the thematic and narrative aspects of the film. As a result, the use of the effects is a trick about a trick, and a very good one.

Likewise, with *Babe* the initial impressiveness of the talking animals is quickly enjoyed and then, as Vivian Sobchack notes, "one looks through them while focused primarily on narrative elements."[23] As with well-executed Seamless effects, the capacity for Fantastical effects to work supportively with the narrative depends upon their thematic appropriateness and their quality as effects. If we are persuaded by them, if we find them perceptually real, then we are inclined to suspend disbelief and allow narrative to dominate.

In a weak narrative setting, even good DVFx are forced into a position of heightened scrutiny because they might be the only thing offered as a reward for audience attention. If the effects are of a poor standard in a weak narrative setting, the audience is offered neither the pleasure of spectacle nor the captivation of narrative.

Surrealist

The surrealist use of effects also relies upon quite spectacular effects and uses them with great imaginative flair in order to make conceptual statements tied to the theme of the narrative. In figures 4.15–4.17, the short film *Filatelista* (2004, Zaremba) used DVFx to express the performer's emotional state and thoughts.

The opening shot of *Fight Club* with the astonishing track from deep within the lead character's brain, is a shot that makes a strong statement about the film's premise and works as a set-up or clue to what is going on in the story. Another scene in the film, the "IKEA catalogue" scene, uses graphics to comment on the ideological themes that the narrative addresses. It conveys thematic material in a clever visual statement that would probably require tedious exposition if left to dialogue. As digital artist Nick Brooks has described, the shot involved going "from the completely clean living room all the way through every object that's put on into that room, including CDs in their racks and pepper pots on the table."[24] The furnishing of the room with "illusory" set dressing fits with the politics of a story that describes apartment buildings as filing cabinets for people.

The Eternal Sunshine of the Spotless Mind uses both digital and analog effects to comment on the bittersweet process of remembrance and forgetting that is integral to relationships. The film, taking its title from a poem, is a poetic science fiction and its effects present images that make powerful statements about memory and consciousness. The digital effects used to physically alter

Figure 4.15 Surrealist use of digital visual effects. Composite image of absinthe dream from the feature film *Moulin Rouge*. Directed by Baz Luhrmann. Visual Effects by Animal Logic. Images courtesy of Animal Logic. © 2001 20th Century Fox.

and erase Clementine are materially a comment on the narrative themes. The idea that a relationship can be altered or erased is given realization when photographic images of the actor are taken apart and reconstructed with some parts removed completely.

Pleasantville's use of digital visual effects served to withhold and introduce color as a metaphor for themes about individuality and personal freedom. In *The Bank* (2000, Connolly), fractal images are used to express, in imaginative terms, fairly complex mathematical information that is important to both the story and the understanding of the protagonist's mental abilities (figure 4.18). In *American Beauty* (1999, Mendes), the rose-petal sequences have metaphoric and character significance that resonate throughout the film, as a case study in the next chapter shows.

Figure 4.16 Surrealist use of digital visual effects. Bluescreen plate for the film *Filatelista*. Images courtesy of the Australian Film Television & Radio School.

Figure 4.17 Surrealist use of digital visual effects. Composite of CG background plate for the film *Filatelista*. The backdrop inserted into the set is used to express the performer's emotional state and thoughts. Images courtesy of the Australian Film Television & Radio School.

Figure 4.18 Surrealist use of digital visual effects. Fractal images used in the feature film *The Bank*. Images courtesy of producer John Maynard. © Arena Films.

Joel and Ethan Coen, who have used effects across the range of film genres that their work embraces, made subtle stylistic use of DVFx in *O Brother, Where Art Thou?* (2000). Prince has described this film as "historically important . . . because it was the first time that an entire major feature film was subjected to digital color correction as an ordinary part of postproduction (i.e., the goal not being the creation of evident special effects)."[25] As he describes, "The dust-bowl look, the hand-tinted postcard quality of *O Brother*, are, of course, effects, but they do not advertise themselves as such."[26] This kind of treatment of the visuals gives the film a stylized reality that is congruent with the Coen brothers's stylized history in which the story takes place. The "postcarding" of the images suggests a framed and selected moment in time and place and so comments on the narrative while setting up the diegetic world as a uniquely envisioned place.

Another filmmaker who takes this surreal and stylized approach to storytelling using DVFx is Jean-Pierre Jeunet. It is almost fair to call *Amélie* (2001) "effects-laden," since those effects shots appear regularly throughout the narrative. The story, touching as it does on themes of destiny and the exploration of

observation and understanding of human behavior uses digital effects to achieve an unusual narrational style.

In *Point of View in the Cinema,* Branigan discusses how mental states and other forms of subjective point of view have been represented in the cinema. Many of the devices in *Amélie* reflect Branigan's ideas of mental-process structure and shifts in narration.[27] The digital visual effects shots in *Amélie* convey story information, subjective points of view, and moments of metaphor that approach the audience with quite direct address. In *Amélie,* Jeunet's voice-over narrator establishes an inclusive narration, one that acknowledges the audience as an observer. In a story that relies for the advancement of its plot upon the fact that everyone watches everyone else and knows about them, it would almost seem wrong to treat the audience any differently. The digital-visual-effects shots reveal much to the audience: the young Amélie's perception of rabbits and teddy bears in the clouds; the blind man's reaction to her impromptu tour (the warm glow he experiences is visually represented by beatific enveloping light); the revelation of her emotional state when she sees Nino for the second time (and the image of her heart beating is shown like a saint-card image of the Sacre Coeur); the copied key in her pocket that glows as if revealed by X-ray sight; the Michael Sowa drawings on her wall that come to life and comment on her as she sleeps; the photographs that speak to Nino and amongst themselves; the superimpositions of the cast-off, torn photos of the mystery man when Nino meets him at last and "the pieces all come together"; and the moment when Amélie "turns to water" when she sees that Nino has left the cafe.

The metaphorical moments, such as the one where she "turns to water" owe much to the world of surrealist painters, which makes the inclusion of Sowa's art in the film particularly apt. The film also draws on highly developed storycraft skills; it takes a special kind of insight to recognize that the life of a photobooth repairman is a mystery upon which a love story can hinge.

Other films also use effects in this way. *Finding Neverland,* for example, reveals J. M. Barrie's perception of the audience's reaction to one of his plays when he looks out at the audience and sees a metaphorical deluge over the audience. As the example of Invisible effects stipulated that rain must conform to the exact possibilities of the story world, when used Surrealistically rain can fill a theatre in a period film without detracting from the story. Another moment in the film uses effects to reveal that he and his wife live in different worlds. A film set in Victorian England might not be making a statement of this kind if the husband

and wife say goodnight to each other on the landing and retreat to separate bedrooms, but when the husband's bedroom door literally opens into another world and hers merely opens into a mundane bedroom, then important story information is being conveyed.

In this category of use, the best DVFx are used as E. H. Gombrich has described:

The true miracle of the language of art is not that it enables the artist to create the illusion of reality. It is that under the hands of a great master the image becomes translucent. In teaching us to see the visible world afresh, he gives us the illusion of looking into the invisible realms of the mind—if only we know, as Philostratus says, how to use our eyes.[28]

While Surrealist use of effects serves spectacular purposes, it does so in a quite meaningful way. Often the films that employ effects in surrealist ways do so because the narrative themes encourage a more detached consideration of the film and its deeper meanings. Effects in these cases play with narrative traditions and use spectacle deliberately as a tool of expression in itself. On other occasions, they offer a means by which to deliver a form of exposition revealing, or at least visualizing, the kinds of concepts that are not traditionally filmic.

New Traditionalist and HyperRealist

The two remaining categories address the use of DVFx in feature-length animation. Here there are the enormously popular New Traditionalists led by the works of Pixar, and the more ambitious HyperRealist projects such as *Final Fantasy* and, to a lesser extent, *Sky Captain and the World of Tomorrow* (2004, Conran).

In the first instance, New Traditionalists bring extraordinary visual style to the well-established narrative traditions of long-form animation (see figures 4.19 and 4.20). The ongoing success of the filmmakers at the Pixar production studio has inspired a new willingness for studios to back long-form animation, a genre of filmmaking that once was considered too expensive and of a limited market.

Pixar's success is not the only reason this form of filmmaking has been rediscovered. The growing interest in Japanese animation, particularly the work of Hiyao Miyazaki, has been influential also. The extraordinary visual style of Miyazaki's work has informed the aesthetics of long-form animation which, for commercial audience markets, had been dominated by the house style of Disney. When the first Pixar films were released, they succeeded not only in theatres but in the DVD market also, and it was this technology as much as the computer graphics in the films that made CG animation so successful.

Figure 4.19 New Traditionalist use of digital visual effects. Images from the short film *Birthday Boy,* nominated for an Academy Award for CG animation. Images courtesy of the Australian Film Television & Radio School.

Nonetheless, neither Pixar nor Miyazaki relies upon visual style to carry films. The storycraft that underpins these filmmakers' works is fundamental to their achievements. In the years following the success of *Toy Story* and *Spirited Away* (2001, Miyazaki), others have tried to capitalize on this area of filmmaking with significantly less success. So, it would seem, since other projects in this genre certainly have achieved similar standards of computer graphics, that the storytelling is the crucial factor in this category.

In the second instance of new categories of animation, the makers of Hyper-Realist projects seek to create perceptually realistic works using animation techniques. This is a slim category of work, so far, but one that may grow as the seductive appeal of the complete control afforded by digitally created images is satisfied with results that achieve the standard of perceptual realism. At this point, the attempt itself is sufficient to draw interest for spectacular purposes alone. The images are scrutinized with intense interest, their perceptual realism tested.

The ability to create convincing CG characters is the most crucial part of this process, and while the success of the character Gollum is hailed as a breakthrough, CG humans have fallen well short of the mark. As visual effect supervisor Ben Snow has said, "It's a robotics theory called the 'Valley of the Uncanny' and what it refers to is that the closer a robot gets to having human features, the

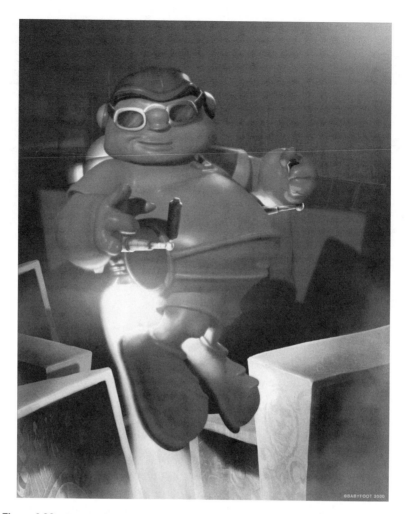

Figure 4.20 New Traditionalist use of digital effects. Image from the short film *Babyfoot*. Courtesy of producer/director Michael Gracey.

scarier it is. And we've seen that with computer graphics. The closer we get, the harder it is to accept them."[29] Andy Jones, the animation director for *Final Fantasy,* has said, "My biggest fear . . . was that if the characters looked perfectly real on still frames, we'd be in even more trouble—because the more real it looked, the more perfect the animation had to be. Because if it isn't perfect, it looks a bit like you're puppeteering dead people. They look like zombies, because they don't have that spark of life, that soul."[30]

It was this "lack of spark" that was cited again and again as the reason for the box office failure of the performance-capture-animated film *The Polar Express* (2004, Zemeckis), despite Tom Hank's multiple roles. Although the images were more stylized and suited to New Traditionalist than HyperReal, the use of extensive performance capture (a process that uses motion-capture techniques for facial expressions as well as body movement), gave the film aspects of HyperRealism.

Performance capture is remarkably accurate, so much so that people regularly recognize friends' performances animating simple wire-frame skeletons. Yet, even with the ability to capture slight nuances of facial expression, the "hollowness" of the characters combined with the recognizably human performance behind the animation has proven less successful than stylized traditional character animation for people. It would seem that the fully CG human performer that sustains a feature-length performance without being recognized as such is still beyond reach. However, to say that a CG human performer will never be achieved with credible success is to step into dangerous territory. It was once thought that computer graphics, after *Tron,* would never find their way into movies but that prediction proved to be nay-saying, and it is most likely that when there emerges a narrative impetus that makes such a character convincing—much as morphing technology has required narrative context to be used openly—then it is likely that the CG human will find its place.

Thus, while there are not many completely HyperRealist films, and there remain limits to the use of photorealistic performances, there is a growing use of completely animated sequences within films. *Panic Room* uses sequences of this kind in a manner that is in keeping with the narrative intentions of Invisible and Seamless usages. Only the impossibility of the camera move reveals the digital substance of the shots as the presence of the intruders and the action within the house is tracked through walls and other physical structures.

While audiences expect and are attuned to digital environments and, increasingly, to digital characters in Exaggerated and Fantastical usages of effects, the use of fully CG environments and characters in some films is moving toward the time when the HyperRealist and the Invisible may yet meet in a realization of photorealism that is cognitively indistinguishable from analog images. As has already been established, the substitution of entirely CG characters in stunt work is currently of a level that requires close and intentional scrutiny with the benefit of frame-by-frame analysis to detect the interpolation of the digital performer with that of the real.

Whether DVFx, even in their most spectacular uses, will become as commonplace and unremarked as sound, color, and moving cameras remains to be seen—literally and figuratively. However, it is clear that the extensive usage of digital-visual-effects techniques in all manner of film narratives, in addition to posing valuable questions in regard to "the real," is establishing storycraft norms that are open to categorization beyond spectacularity or simple narrative suture.

Kuhn has remarked, "It has also been suggested that special effects sequences play on spectatorial credulity, eliciting an oscillation between knowledge on the one hand (that this is an illusion—special effects sequences being always at some level self-referential) and willing suspension of disbelief on the other—an oscillation characteristic of fetishistic forms of looking."[31] Again, such an observation relies upon the spectator having knowledge that the specific imagery is an illusion where, as the framework and examples provided would indicate, this very often would not be the case. Kuhn's observation is appropriately addressed to a very specific instance of special effects usage—which may include some instances of digital-visual-effects usages—but cannot be applied to *all* instances of digital-visual-effects practice.

Her comment is of interest because it cites the frequently applied condition of "special effects sequences being *always* at some level self-referential." In science fiction, the genre to which Kuhn addresses her comments, very often the use of special effects is deliberately spectacular, but very often the use of effects is also a form of spectacularity that works within narrative, delivers story information, or seeks to establish and preserve the diegetic world. The issue then becomes the extent to which the spectacularity under examination is narratively motivated or truly designed to effect the sublime in keeping with the idea of excess. My research indicates that this must be answered by considering its contextual relationship to the story, and assertions about spectacularity of DVFx in films also needs to be provided the context of specific instances in order to clarify the nature of the spectacularity. The importance of this distinction is that, while in discussion of certain generic practices the singling out of spectacular visual effects as a defining trait with thematic significance is appropriate to those discussions, the assertions that *all* effects work *always* has these kinds of connotations and roles is limiting and, if accepted, precludes consideration of the other impacts and significances that might pertain to effects usages overall, beyond generic conventions. I argue that in some instances even the most spectacular images are not about the effects themselves but are spectacular as a consequence of the content of the images and the narrative moment that these images create.

5

If You Are Falling, Leap: The Hero's Journey

Both narrative structure and the development of digital visual effects have impacts on storycraft in filmmaking, but one element of story allows us to examine some of the most telling impacts of DVFx. That element is the hero.

The writing manuals have differing views regarding the hero's role in storycraft. For some, including Aristotle, plot—the ordering of the events—is the crucial factor in the story. For others character is story. This difference need not be resolved to assess the role of the hero because focus on either plot or character is but one choice in how to approach scriptwriting or textual analysis. Whatever approach is taken, at some point the hero's role, the values that the hero's struggle represents, and the qualities of the hero's character will be significant to the story.

Hollywood has always been in search of heroes. Although the distinction between the star persona and the character-as-written is often a difficult one to make, at the storycraft stage creating a character that is compelling and believable is no small feat. Two of the most common dramatic structural situations are extraordinary characters in an ordinary world and ordinary people in extraordinary circumstances. In either instance, the character must make choices, ones that will reveal their integrity and values, thus conveying much of the meaning to be found in the story.

As Robert McKee states, "Values, the positive/negative charges of life, are at the soul of our art. The writer shapes story around a perception of what's worth living for, what's worth dying for, what's foolish to pursue, the meaning of justice, truth—the essential values."[1] Stories have long taken the role of conveying

values so that audiences can consider their own beliefs. For modern audiences these issues are increasingly complex. As McKee adds "ours has become an age of moral and ethical cynicism, relativism, and subjectivism—a great confusion of values."[2] This confusion has an impact on the writer's task. McKee cites the modern values, remarking, "The compulsive pursuit of contemporary values— success, fortune, fame, sex, power—will destroy you, but if you see this truth in time and throw away your obsession, you can redeem yourself."[3] Significantly, he argues that between good and evil, right and wrong, there is no choice at all.[4] In his view, as Aristotle also indicated, tragedy is a choice between two desirable outcomes where only one can be achieved.[5] It takes a skilled writer to craft such a tale.

Kristin Thompson also discusses heroes, focusing mainly on the classical narrative's goal-driven quest to restore equilibrium and the action that arises from this pursuit. James Monaco considers the political implications of the hero in the Hollywood film and notes that "the best evidence we have that film has radically altered traditional values lies in the phenomenon of celebrity."[6] He describes how film fused the formerly heroic models of fictional characters and real people of achievement by making fictional characters of real people.[7] Monaco indicates that "Star cinema—Hollywood style—depends on creating a strong identification between hero and audience."[8] He also turns to the matter of values and the relationship between the hero and values, stating, "To a large extent, at least in nations in which film is dominant, the cinema helps to define what is permissible culturally: it is the shared experience of the society."[9]

Robert Warshow, analyzing the Western, discusses the hero of these films and observes that "it is not violence at all which is the 'point' of the Western movie, but a certain image of a man, a style, which expresses itself most clearly in violence . . . [a style that shows] how a man might look when he shoots or is shot. A hero is one who looks like a hero."[10]

Peter Wollen also addresses the issue of the hero in classical narrative film in his analysis of the work John Ford, Budd Boetticher, and Howard Hawks:

All these directors are concerned with the problem of heroism. For the hero, as an individual, death is an absolute limit which cannot be transcended: it renders the life which preceded it meaningless, absurd. How then can there be any meaningful individual action during life? How can individual action have any value—be heroic—if it cannot have transcendent value, because of the absolutely devaluing limit of death?[11]

He summarizes these directors' answers to the questions, stating, "Hawks, unlike Boetticher [who looks for values in the encounter with death itself], seeks transcendent values beyond the individual, in solidarity with others. But, unlike Ford, he does not give his heroes any historical dimension [Ford's answer], any destiny in time."[12]

This choice between two goods—the needs of the community versus the needs of the individual—provides an enduring conflict that arises repeatedly in film. For every story where the individual learns to sacrifice his individuality and find harmony with the community, there is another where an individual finds the strength to resist the coercive power of the community and discover her own path.

Joseph Campbell, whose work inspired a rediscovery of the term "hero," analyzed the myths and folktales of cultures from every age and society and distilled a number of common factors. In a lecture he gave in 1966, he commented on the shift from community as the ideal focus to "the development and protection of the individual—the individual, moreover, not as an organ of the state but as an end and entity in himself. This marks an extremely important, unprecedented shift of ground."[13] He relates the heroic tradition of the individual as unique to European cultures[14] and defines the hero as "the man of self-achieved submission."[15]

The monomyth he defined in *The Hero with a Thousand Faces* traced the journey of the hero from the moment adventure presents itself to the hero's return bearing the elixir needed to restore the world. On the journey the hero encounters helpers, endures tests, and undergoes a death and rebirth that allows him (and it is usually a *him*) to return with the means to save his community. In this way there is a marriage of both the individual path and the return with the boon for the community, resolving the two potentially opposing drives.

Campbell's focus was on heroes of folktale, legend, and mythology, and he included ones that tended to be superhuman, possessing from birth extraordinary gifts. He analyzed the phases hero stories represented from childhood to death. Christopher Vogler's approach in *The Writer's Journey,* however, conformed more to the standard advice about creating characters generally found in storycraft manuals, a focus primarily on the qualities needed to create believably human roles. There is a considerable gap between these two standards, although Campbell's other writings do not suggest that heroic behavior is beyond the reach of ordinary mortals; quite the contrary. Yet there is still a gap that needs to be addressed.

As indicated earlier, the scope of mythology is cosmic, whereas the scope of the fairytale is mundane in that the fairytale deals with humans and their experiences on earth and their desire to live happily ever after. In film, the lead character is not necessarily heroic. However, as Vogler's text gained popularity and Campbell's work enjoyed a new level of fame in the 1990s, the "hero" and "hero's journey" became a highly influential template applied to a wide range of films and scripts.

The application of the heroic journey to all story structures was perhaps ambitious and unnecessarily proscriptive. Generally, it justified simplifications of character development and a focus on a fairly predictable and largely action-driven "journey." Thus, the characters' inner journey, the reveal of emotional or spiritual growth gave way to a proliferation of action-adventure stories with physical dangers being foregrounded over internal turmoil and moral dilemma. The face-to-face with death—a scene easy to write and to film—became the order of the day, with the monomyth's steps of the journey a ready validation. This was not necessarily a new approach to male heroes in film. Thomas Schatz has described the 1930s Warners Brothers's pictures, saying, "As in so many of Warners' male-oriented sagas, the subtleties of character development and narrative complexity—and ultimately of visual technique—give way to a curious momentum, with the hero's obsessive, hell-bent quest moving the picture along at a frantic pace."[16] It is possible, then, that the reinvented heroes of the 1980s and 1990s action films were simply the result of a reapplication of old formula being justified by high-sounding rhetoric.

However, more than overcoming physical danger is essential to meet the standard of truly heroic behavior, as Schatz's observation seems to suggest. The degree to which a character undertakes decisions and acts in a manner that reveals values—the wisdom that forms an important quality in a "good" story— is also integral to the quality of the canonical tale, especially one following the fairy-tale structure, and is certainly of fundamental importance to mythic tales.

In order to assess whether the use of DVFx has had an impact on this aspect of storycraft, a number of films are examined in this chapter, with attention to identifying the nature of the protagonist's role and how that role has been established, realized, and enhanced by the use of digital visual effects. The emphasis here is on the story elements of the films and how the DVFx work to support the diegetic world, and whether or not they influence the realization of the heroic achievements. One of the most obvious examples is *Star Wars*, regarded by many to be a perfect match for the Hollywood version of the hero's journey.

Star Wars in its first iteration was a pre-digital-effects feature film, although computer graphics were used in the film (primarily as on-screen computer graphics). Nonetheless, one of the important achievements the film realized was the use of moving-camera-effects shots using motion control to document camera passes for composites. Ultimately the look of the film, and the resurrection of many long-discarded optical effects techniques, led to the establishment of Industrial Light & Magic as the world's premier effects house. With the success of *Star Wars,* ILM was sought out by many other filmmakers eager to realize stories that could not be told pro-filmically.

George Lucas's *Star Wars* "script reworked old movie themes and fairy tales, incorporating essential precepts of Joseph Campbell's essays on myths and their power. The result was a story of . . . Luke Skywalker embarking on the hero's journey to rescue a princess and vanquish an evil fortress, along the way discovering his true nature and the power of the mystical 'Force.'"[17] The effects are used primarily to establish "a galaxy far, far away" as pretty much an ordinary place where young boys stuck on farms in the middle of nowhere dream of studying at "the academy" and of becoming a pilot. The weapons used, the starships, and the extra sun on the horizon seem only a tad exotic once the impressive opening shot has firmly placed us in the diegetic world. There are treats—the hologram message from the princess, the stop-motion holographic chess players superimposed over the live-action sequence, the speeder scenes, and the moving camera dog-fight, that zooms along the trenches with computer displays of the targeting. Yet there is enough about Luke's world and adventures that are sufficiently familiar to allow the action to start with little story time expended on setting up the world and how it works.

In terms of the hero's journey Campbell defined, although Luke yearns to escape the farm, he refuses the first call to adventure when Obi-Wan Kenobi insists he must learn the ways of the "Force" if he is to accompany Obi-Wan on the quest to find the princess. Only when Luke returns to his home and finds his uncle and aunt killed by imperial forces does he agree to join Obi-Wan. Thereafter, Luke is committed to the quest; he harbors no doubts, makes no further choices that call upon him to demonstrate any moral stance—he is simply on the side of the princess and uses ingenuity and courage to free her and destroy the Death Star.

Han Solo, on the other hand, is required to step away from his mercenary, individual path and join the rebels, which he does at the last moment, saving Luke from Darth Vader so that Luke can fire the winning shot. Together, these two

roles fulfill the heroic journey, although at the end Han Solo remains an ordinary man while Luke, with the benefit of his father's light sabre and Obi-Wan's training, is on the path to attaining superhuman gifts. Thus Han is the everyman of the fairy-tale whereas Luke is the one who will become a Jedi and, later in the series, will offer his own sacrifice to save the rebel cause and redeem his father, gaining the ability to commune with those who have transcended death. Luke will become a figure of mythic proportions, always at one remove from the lives of those around him.

The success of this film in story terms is that it mixes both the fairy-tale and the mythic elements. It presents the moral dilemma requiring the hero to choose his path and addresses both the needs of the individual and the community. Luke is able to undertake his individual quest because it fulfills the needs of the greater good and Han finds the moral fiber to abandon his solitary ways and join the rebel cause. This choice between individual and community is elegantly drawn into unity when the solution to destroying the Death Star comes from the realization that its fatal flaw lies in the imperial forces' not anticipating the threat that can be posed by "one man who can save us all."

Further there are other characters who also undertake heroic choices—Princess Leia is forced to choose between her home planet and the rebel base the Death Star has targeted for destruction, and she is betrayed when she apparently gives up the location of the rebel base to Darth Vader. Obi-Wan chooses to face Darth Vader and willingly sacrifices himself, allowing the others the opportunity to escape and take the elixir (in this case, the Death Star plans) to the rebels so that the galaxy can be freed of imperial tyranny.

The effects used in the film serve to demonstrate the Fantastical element of Luke's talent with the Force—for example, his practice session with the light sabre on board the Millennium Falcon. The computer graphics of the Death Star borrow from Documentary exposition and are used to explain the fatal flaw that will let them destroy it. The models, the planet imagery, all of these effects serve to establish a convincing setting yet do so without being so spectacular, so cosmic, as to remove the story from human scale. They are Fantastical elements, but ones that serve narrative goals over pure, nonnarratively motivated spectacle.

Thus, while many consider *Star Wars* to be an exemplar of all that special effects do to detract from classical filmmaking, in real terms the effects have, Thompson notes, elevated the "B" film to "A"-film status, but it is not a new kind of narrative made up solely of spectacular effects shots that lack narrative basis. *Star Wars* followed classical narrative structure and used its effects to

make real the world of its story, to convey elements about the characters and to make the fighter scenes as realistically like World-War-II dogfights, and therefore human experience, as possible.

Twenty-two years later, another film set its story in space, in an even more believable diegetic world, that of astronauts on a mission to Mars. Set in 2020, *Mission to Mars* seeks to tell the story of Jim McConnell, a top astronaut who has been selected to lead the first human mission to Mars. He and his wife Maggie, another top astronaut who is especially committed to the Mars mission, cannot join the mission because Maggie develops a terminal illness and Jim sacrifices the career opportunity of a lifetime to nurse her through her last days. The film opens at the party being held to send off another team, instead, and Jim shows himself to be a decent guy offering well wishes to his best friend Luke, who will lead the mission in Jim's place.

On Mars, the first mission is wiped out by a sandstorm and reduced to but one survivor—Luke—so a rescue team is dispatched from the World Space Station. This time, the team includes Jim, and there are many scenes where Jim demonstrates "the right stuff" and is praised by others as "the best we've got." The team as a whole seem like remarkably wonderful people, and they repeatedly demonstrate their commitment to the project and each other. When trouble hits and sacrifices are called for, they all show great resolve and courage, with Woody, the team leader, quickly sacrificing himself to prevent anyone else in the team from risking herself or the others to rescue him. That the team includes Woody's wife (his would-be rescuer) and that his display of bravery is watched by his close friend Jim (who knows the pain of losing a soul mate), is a setup calculated to raise the emotional stakes of the scene.

Finally, once they have landed on Mars, worked out the test left by the original inhabitants, and discovered that the Martians seeded Earth with DNA, Jim decides to board the Martian spacecraft to find out where the Martians went after they left their once-fertile but meteor-destroyed home. The rest of the team head back to Earth, seeing Jim off to discover what lies at the other end of the universe. In their farewell scene, Jim repeats Maggie's prophetic words, which are the message of the film: "It's what I was born for . . . to stand on one world and look beyond it to the next one"—and the theme that "life reaches out for life."

The DVFx used in this film are of a high standard. They include the requisite planetary and model shots, enhanced by digital camera moves, and NASA images to maximize verisimilitude. There are digital set extensions, CG character

replacements for some of the outer-space shots, extensive compositing of live action with motion control and background plates, sandstorms using real dust and digital particle effects, CG elements blended interactively with live action (such as the blood particles that free-float in the cabin of the spaceship), morphing of Woody's face when he sacrifices himself by removing his helmet in outer space, and an impressive visualization of evolution of life on Earth from paramecium to hunter-gatherer humans. The movie also has a CG representation of a holographic Martian.[18]

The effects' usage in the film is primarily to create a sense of verisimilitude and reasonably accurate visualization of scientific concepts—such as accurate starfields, atmospheric conditions on Mars, DNA, and representations of the planetary system and evolution—as needed to provide the expositional information required to follow the narrative. Some of these elements are of a Documentary-style usage of effects and borrow heavily from the established traditions of scientific modeling using computer graphics.

There is also expositional use of computer graphics and what I describe as *the magic computer,* a story device in which a computer provides graphic images and text that helpfully gives authority to plot points or other story information needed to justify the action. For example, in *Mission to Mars,* the crew are equipped with computer armbands that convey information such as fuel capacity, trajectory status, and, at one point, the phrase "point of no return," so that the dramatic stakes are clear.

As an aside, this film also provides an excellent example of the "data" industry mentioned in the opening chapter, the view that the industry is entering a new phase of evolution in which it is based on data instead of chemistry or electronics. In this instance, the images of the sandstorms were built using data sets of sandstorms created for other films. Thus, the images we see represent data—a commercially valuable asset—that can be reused and manipulated endlessly in the manner of most digital assets.

In contrast, using negatives from other films—such as stock footage, outtakes, or reprinted footage—is unlike data-based reusage because with a negative the original material remains recognizable as itself, even if it fits nicely into other footage. For example, even the digitally reworked images used in *Forrest Gump* retained their essence (a factor somewhat necessary for the purposes of the narrative). However, images created from digitally reused data can be reworked to be unrecognizable from their previous incarnation and printed image. Similarly, scans of actors, models, sets, terrains, and so on also form data sets that can

be drawn upon and manipulated for reuse. Motion capture data, and therefore performance, can also be re-presented in this way. The DVFx in a film are not simply a piece of negative that forms part of an original film, they are a database and an endlessly reusable and mutable resource. In *Mission to Mars* the reuse of data does not draw attention to itself as a reflexive incorporation of another film's material. Its use is invisible, even though the images are spectacular.

Returning to the matter of storycraft, the hero of the film is ostensibly Jim (played by Gary Sinese). Yet, in spite of Jim having faced a moral dilemma in the backstory to the film (the decision to sacrifice his place on the mission to care for his dying wife), he does not really encounter any other such decisions in the course of the narrative contained within the film. The choice to enter the Martian ship rather than return to Earth is almost a foregone conclusion. It is not presented as a matter of great weight for his conscience.

Indeed, none of the characters is called upon in this way. There is a moment when one of the characters is under instructions to leave for Earth if the team has not returned by a set time, but the crew make it back as he is preparing to leave, sparing him the need to choose between following orders or following his loyalties. The hero's journey does not appear to apply to this story, although there is certainly an attempt to convey mythic themes.

The encounter with the Martian is, in effect, an encounter with the creator, and Jim's decision to take the Martian spaceship and be reunited with the Martian ancestors is an attempt to fulfill the charge: if falling, leap. Yet it is made clear throughout the film that Jim has been disassociated from life since the loss of his wife. He goes through the motions and gives his all to help others and be a good friend, but there is an emptiness that cannot be filled with continued existence on Earth.

His experience of being readied for the journey is symbolic of rebirth. He is re-wombed in a cylinder filled with fluid and then beamed into the ship in a tunnel of light. He is to be elevated beyond humanity, to be reunited with the cosmos and make the journey between one world and the next. This is part of heroic mythology, but it is not a journey of action/adventure; it is a quasi-religious/pseudoscientific tale. There is no sense that Jim will return to tell the world of its Martian relatives at the other end of the universe. He is simply leaving Earth behind to discover what is next—an answer only he will know, one that will not be shared as wisdom for the benefit of the audience.

As for those who return to Earth, they are essentially a swell group of people who will face danger bravely; all will do their part to save the team—at great

risk to their own personal safety—and they demonstrate nothing but respect, understanding, and extremely good manners in their dealings with each other. In essence, this is a film without conflict. There is no real antagonist. There are minor arguments about whether the rescue mission will be approved and whether Jim is ready to take on such a mission, since he failed to undertake the necessary psychiatric clearances, but these are mere obstacles and not major forces of opposition.

The planet itself and the sandstorm might create a man-against-nature struggle, but none of the traditional setups for such a narrative structure are employed. Essentially, there is a disaster that wipes out the first mission, but the aim never was to colonize Mars and tame its sandstorms, and the second mission is simply to rescue Luke and answer the mystery of the face in the sand. No force operates against these goals except the inherent difficulty in making the journey to Mars and the question of whether or not they have the ingenuity to figure out the mystery (which happens with astonishing ease). The film instead strives for the mythic and the epic by making clear its theme of "life reaching out for life" yet does this without successfully enfolding it within the classical story structure. The hero starts out as a great guy and then becomes one with our alleged cosmic inheritance; a guy who represents "the best of us" ascends to the cosmos.

The visuals in *Mission to Mars* are spectacular, and the camera work is powerful, but the well-crafted verisimilitude has no story to support. Great care has been taken to ensure that the images reflect what would occur on such a mission, and so the purpose of the effects is to Seamlessly support the diegetic world, at least while the characters are within the bounds of current experience of space travel. When the story moves to its Martian setting, however, the Fantastical elements and visuals are given greater dominance. The image of the face on the planet, the interior of the face, and the visualizations of Mars's history and human evolution clearly are intended to be spectacular—but not with the intention of stopping the narrative. The spectacularity is *part of the narrative experience of the characters* and so is part of the story, with the images being artistically motivated, a quality in keeping with the classical narrative form.

Thus, in spite of the spectacularity of the images in the latter half of the film, it is hard to argue that the film aims to present a new form of narrative, a form comprised of spectacular images that build upon each other to create their own narrative structure. There is too much exposition, too much time dwelling on the human moments, too much dedication to setting up the relationships

between the characters, to place this film in such a new narrative category, although it must be reiterated that the narrative structure fails to offer the dramatic tension expected of classical narratives. Even when characters sacrifice their lives to save the others—as noble and heroic an act as one could ask for—there is little sense that they have any choice in this act.

This is not an uncommon kind of dramatic vacuum where, although values are stated, and there is extensive dialogue clarifying the thematic content of the film, there is little in the action that shows characters making choices that force them to grow from one state of internal equilibrium to a new and different state as a consequence of their decisions. This produces the kind of film in which, because of the high standard of DVFx, the accusation that it is "all effects" seems to be a fit. Yet, as the discussion so far argues, this is not the case. The film's effects do fit with the science-fiction traditions of foregrounding state-of-the-art moments of spectacularity, but the failure to provide the cause-and-effect action elements of the classical narrative is not so much a case of telling a nonnarrative story as one of failing to achieve the classical standards.

Final Fantasy, a completely CG feature film, follows a similarly weak narrative path. Based on a computer game, the characters inhabit an Earth that has been maimed by a meteor that has brought to Earth phantoms capable of infecting humans. The remaining uninfected humans live in barrier cities and use advanced technology to fight the phantoms with one exception—the team of Dr. Aki Ross and her mentor, Dr. Sid. In their search for a nonviolent way to remove the threat, they find six spirits that possess wavelengths that can be used to contain the infestation and, once two remaining spirits give them a complete set of wavelengths are found, this will provide a cure.

Opposing them is General Hein. Motivated by the desire to revenge the deaths of his wife and child, Hein wants to use the Zeus cannon to violently eradicate the phantoms from Earth. In an attempt to force the council to support his plan, he introduces a phantom to the barrier city, but his plan goes awry and the city is quickly overcome. The drama then unfolds as a race between Aki and Hein to implement their different solutions to either save or destroy Earth.

The film is completely generated by CG technology. Although human performances are represented on-screen via motion capture, the characters themselves are animations with very closely photorealistic qualities. Many of the images in the film are outstandingly beautiful, demonstrating a high standard of artistic representation. However, the story and the representations do not "work." There is something inherently lacking in terms of emotional engagement, a

quality that has been described as a consequence of the computer-generated humans failing to connect convincingly with the audience.

The previous chapter presents the "uncanny valley" theory of robotics as an explanation for why photoreal humans do not connect. However, to be fair to a film, story issues also must be taken into account. Part of the problem with the lack of emotional engagement in *Final Fantasy* results from the limitations of the story rather than flaws in the images themselves. If it were simply the case that audiences do not engage with CG characters, films such as *Toy Story, Shrek* (2001, Adamson and Jensen), and *Monsters Inc.* (2001, Docter/Silverman/Unkrich) would have failed at the box office instead of setting new records. Although it is easy to reflect on the extent to which the characters do not convincingly represent humans to a photoreal standard, at the heart of *Final Fantasy*'s difficulties is that the characters do not undergo any personal dilemmas about their roles any more than do the crew of *Mission to Mars.* Had the story elements been stronger, it is possible that the CG performances might have been accepted as animation, and the impetus of the narrative might have drawn audiences past the point of looking at the CG to looking at the story.

Like in *Mission to Mars,* in *Final Fantasy* there is a scene set up to be emotionally engaging when Aki and her former lover Grey, finally reconciled, are separated by his sacrificial death, yet it has no more resonance than the scene in *Mission to Mars* where Woody and his wife are parted. Dramatic ploys are used, such as Grey becoming infected and leaving Aki only minutes to kill the phantom and save Grey's life, but there is no sense that she will fail or that other pressures might influence the outcome. Although there is more conflict between the characters in *Final Fantasy* than in *Mission to Mars,* and there are apparently forces working against them, Aki, Grey, and his crew appear to be acting out roles more than experiencing risk, threat, and emotional growth.

The characters are given no *moral* dilemmas to face. Although Grey is told to arrest Aki and refuses, it is fairly clear that in spite of their personal history Grey is unlikely to turn against her, given that he risks his life to save her in the opening sequence. Unlike *Mission to Mars,* the film has an antagonist, General Hein, and there are obvious attempts to round out his character by introducing the backstory about his wife and child having died, so his manic obsession with destroying the phantoms is motivated. Yet, perhaps because the film seems to be working through the standard elements of a storycraft formula, there is little sensation that there will be any outcome except that Aki will be able to understand what her dreams mean in time to save Earth. Grey's death is not so much

a "twist" as a token provided to demonstrate the theme that even in death one is part of Gaia.

Final Fantasy seems neither myth nor fairytale. It follows the classical narrative structure, almost to its disadvantage, but if it fails, it is not because its form—computer generated animation—is not a form that can convey story successfully. Nor can the quality of the animation—the fascination with whether or not the characters can "pass for human"—entirely be held to blame for the film's deficiencies, for the same storycraft problems exist in live-action projects that also seek to convey epic themes of great wisdom (life reaches out for life; even in death one is part of Gaia), without the necessary underpinnings of a well-crafted story. These movies show that for a film to resonate with meaning, the explicit statement of its thematic intents will not be sufficient unless the actions of the characters resonate with the consequences of making decisions that impact upon them in ways that reflect those larger values and themes.

In the case of *Final Fantasy,* it is not so much a matter of CG realism versus classical narration as much as Western studio influence versus Japanese traditional animé narration. Colin Kennedy interviewed Hironobu Sakaguchi, the creator of the *Final Fantasy* game and director of the film, for *Empire* magazine. Sakaguchi summarized the philosophy behind the film: "The story of *The Spirits Within* keeps faith with *Final Fantasy*'s first principles: spirituality, nature, sacrifice."[19] An interview with members of the film's CG team (including the codirector Motonori Sakakibara, CG artist Roy Sato, and CG producer Junichi Yanagihara),[20] revealed that much of the original story was altered in the revision process initiated by the distributors. As a consequence of this intervention, the team found itself forced to make significant storyline changes and reworking performances right up to the final delivery date.

According to the CG team, the changes were made to move the story toward a more conventional Western structure and ending, which altered the meaning of the original story. In general, such changes are less likely to be made in a live-action film so late in the production. When such alterations are made throughout shooting and into the editing process in a live-action film, it is usually considered a bad sign and rarely results in an outstanding film. However, as *Final Fantasy* was wholly CG, such changes were infinitely more achievable than would be the case with live-action filming. That these changes could be achieved, however, does not mean that they should have been made, especially without a clear sense that story integrity was being served. These problems also must be taken into account in the assessment of the film, but it would appear that in this

case again, the flaws in the film can be traced to the scriptwriting—and rewriting—process and are not integral to the use of CG animation itself.

The three examples discussed so far have been drawn from the genre of science fiction, one long associated with special and digital visual effects—especially the achievement of new technological feats in these areas. Even in this genre, which is known for its spectacular use of DVFx, the underlying practice is to have these effects serve the narrative—even when these effects are openly fantastical and spectacular. However, to give full consideration to the use of effects and the relationship they can have to the role of the hero, it is important to look to other film genres, ones not necessarily traditionally associated with effects.

The next example is an epic—so-called "large canvass"—period drama with an openly classical narrative structure. The story is of a man who serves his community, subjugating his personal desires to fulfill the needs of his nation, and who is betrayed, losing everything, yet through individual strength and courage rises once more and again sacrifices himself to serve his nation, dying a hero. The film is Ridley Scott's *Gladiator*.

The Roman Empire has featured in films from Hollywood's earliest days, with some of the most well-known of these films calling upon all manner of special and optical effects to realistically convey the majesty of a time long past. While *Ben Hur* (1959, Wyler), drew on optical techniques, Stanley Kubrick's *Spartacus* (1960), limited itself to a few matte paintings and thousands of extras.[21] In some respects, although *Gladiator* is a triumph of digital-visual-effects usage, Ridley Scott's approach was quite in keeping with that of Kubrick. In summarizing the film for *Cinefex,* author Kevin H. Martin remarks, "For all its epic scale, *Gladiator* was deliberately designed as a film that would not call attention to its visual effects."[22]

The film uses effects because, as Martin has noted, "the rising cost of filmmaking virtually eliminated the option of mounting a period epic using traditional approaches."[23] To recreate the Roman Empire, Scott and the DFVx house Mill Film used synthetic realities (to extend sets and create images of Rome), digital characters (to replicate crowds and add bit parts), composites of animal work with live action (to enhance proximity and danger), virtual camera moves (to stitch together extended scenes), digital extension of action elements (for safety reasons and verisimilitude), color treatments (to mark out Maximus's visions of his wife and dying), sky replacements and animation of cloud sequences, a digital shot of Maximus's POV in the Colosseum, and vultures composited over scenes to add a symbol of "foreboding and death."[24] The film also

employed composites to compensate for the untimely death of Oliver Reed, who portrayed one of the major characters.

For the most part the effects, if not altogether Invisible, are at least Seamless. Many of the elements that might have been done on sets or digitally were actually filmed on location, with the action sequences being undertaken with little enhancement. As a consequence, it is difficult to identify when effects are being used and, if scrutiny is not being applied, most scenes would pass unnoticed except for those that logically cannot take place without digital effects—for instance, the rebuilding of the Colosseum and the image of Ancient Rome on the hillsides.

Of special interest are those shots that enhance the proximity of the tigers in the arena during one of the most important fight sequences. This usage is one of the most frequent narrative uses of DVFx—the heightening of the danger posed to the hero. One of the key aspects of the hero's journey is the risk encountered by the hero on his journey, the sense of danger that must be evoked. While it was once possible to put performers into genuinely dangerous situations, now—Jackie Chan's stunts aside—it is generally the practice either to use doubles and shoot wide or to use DVFx to cheat the proximity of danger and exaggerate the magnitude of explosions, falls, and perilous states.

This is crucial to the pacing of action sequences and portrayal of the character's courage and fortitude, and it also enhances the emotional stakes to physically show the nearness of the brush with death. In *Gladiator*, Maximus is fighting against the only gladiator never to have been beaten but, to further tilt the playing field, the Emperor has arranged for trap doors to open, releasing tigers whenever Maximus comes within certain areas of the stadium, giving his opponent an additional weapon. It is necessary that these tigers be seen as a ferocious and direct threat to Maximus so that the Emperor's treachery is magnified and Maximus's danger is heightened, increasing the tension in the scene and the level of the action.

Nonetheless, it is simply not practical to have a dangerous animal in close proximity to the lead actor. Nor, in the case of *Gladiator*, was it creating a satisfactory on-set result because the tigers were not acting sufficiently ferocious. A digital-effects approach ensured that a sufficiently ferocious tiger performance could be selected and that proximity could be brought convincingly close to the actor in order to achieve a result not practicable in front of the camera. For the story, it created an exciting moment and added another level of drama to differentiate this scene from other gladiatorial matches in the film.

As a character, Maximus is the epitome of the heroic individual. He is extraordinary in that he has achieved greatness, yet he longs only to be a simple farmer, at home with his wife and son. Having finally won the decisive battle that will end the fighting on Rome's border to the north, Maximus believes he will be allowed to return home. But Commodus kills his own father in order to become emperor—the power of which has been offered to Maximus, who is reluctant to take it. Commodus offers Maximus the opportunity to acknowledge Commodus as Emperor, but Maximus's integrity will not allow him to countenance Commodus's act. For this decision, Commodus sentences Maximus to death and orders that Maximus's wife and son be slain. Only Maximus's desire to reach them before the soldiers do and his fighting skills save him from death, but he is too late to save his family.

Having lost all, he again faces a choice: to give in to his grief and die or to live and fight on. He chooses life and, once he has attained greatness as a gladiator, he is given the chance to avenge himself against the emperor. He does not do so out of anger though. He does so only when the emperor challenges him, cheats, and it becomes clear that slaying the emperor is the only way to save Rome.

The film has many instances of characters facing moral decisions and their actions leading to consequences that demonstrate the values of strength and honor that underpin the film's themes of mortality and family. To single out one of these instances (in the interests of brevity), in one scene Maximus and his fellow gladiators are sent into the arena to face a certain death. They are to reenact the fall of Carthage, and a deal has been struck to ensure that Maximus and the gladiator slaves will be slaughtered. But Maximus does not accept this prearranged defeat, so he uses his skills as a general to lead the others, saying, "If we stay together we survive." Then he takes them to victory, rewriting history.

Both his act and his statement make it clear that he is not simply fighting to save his own life; he is at heart a man who defends his tribe, his community, and knows how to inspire those around him to be the best of themselves. Again the opposing themes of individual path versus duty to community are worked together in a unity: in order for Maximus to fulfill the duty to the community placed on him by Marcus Aurelius (the murdered emperor who had been like a father to him), Maximus must rediscover himself as a champion in the arena and earn a personal following from the people of Rome. It is this following that will stay Commodus's hand against him—at least overtly.

Although the effects are hard to identify, as previously mentioned, they are essential to position the story in time and demonstrate the sheer scope and

power of what once existed. Here, spectacularity works to provide a representation of history and the magnitude of the force that Maximus confronts. Steve Neale has written of epic films that in general their displays are "motivated quite specifically as displays of power."[25] He adds that "In the epic, these moments are part of an overall process in which cinema displays itself and its powers through the re-creation of a past so distant that much of its impact derives simply from the evidence of the scale of re-creation involved (from details of costume and decor to the construction of whole cities)."[26] In addition to this kind of display, the digital visual effects in *Gladiator* serve the narrative, giving perspective to the question that Maximus asks: "I'm a slave. What difference can I make?" They also work to establish the context so that he can prove true his own call to battle, "What we do in life echoes in eternity." In this way, the acts of individuals are given scale in this story of one man who, in defying the emperor, stood alone in the defense of the glory of Rome and perhaps seeks to speak to audiences of today about their role as individuals.

The film uses DVFx to represent the enormity of the empire's mobs and armies, its monuments, and the peril into which it placed its martyrs and warriors. Where period dramas, no longer able to afford the lavish expenditures of the productions of the 1950s and 1960s, often are limited to tight shots on location and costume displays in carefully decorated sets, *Gladiator* uses the power of DVFx to offer synthetically crafted but historically persuasive environments in ways that can be invaluable for establishing and maintaining the diegetic world. In the case of *Gladiator,* the narrative is sustained and strengthened by this capacity to craft the world in which the story takes place.

Another example of the hero's role, from a more typical effects-based genre, is the film *Swordfish* (2001, Sena). An action-thriller, the script plays with the conventions of filmmaking not only by opening with a flash-forward, something David Bordwell has identified as being out of character for classical narrative, but also self-reflexively within the story itself. An example of this is the ongoing discussion about how events would work out "in a film."

The film opens with this kind of discussion on how *Dog Day Afternoon* (1975, Lumet), should end with Gabriel Shear (John Travolta) proposing an amoral ending to *Dog Day Afternoon* only to be told that it will not work because the bad guy cannot win. Apparently a truism of film narratives. This comment harkens back to the production code requirement that "the sympathy of the audience should never be thrown to the side of crime, wrongdoing, evil, or sin."[27] In this way, and throughout the film, the moral dilemma is thrown open for

discussion with debate of the value of individual lives compared with the value of the greater good. This dialogue within the film is a demonstration of conflict between the characters and is also a commentary on the roles they play. But it has the further role of being a commentary on filmic expectations and is played as a device with the idea that audiences might wonder if the film is going to step beyond the "rules" of what happens to "bad guys." Representing the individual and a "good guy" is Stanley Jobson (Hugh Jackman), a hacker who has been reduced to trailer trash because he acted against the government in his attempt to destroy a plot to track the e-mail of all Americans. Stanley literally is living in a trailer, unable to keep his daughter out of the danger posed by his ex-wife's having taken up with a pornographer, and he is forbidden by court order to use his amazing gifts as a hacker. Stanley's gifts are depicted as superhuman—he simply sees the code in his head—and he does not know how he does what he does.

His opponent is Gabriel, a man described as "existing in a world beyond your world; what we fantasize, he does." He possesses incredible wealth, power, and ruthless determination. When they meet, Gabriel forces Stanley to decrypt a code within an impossible time frame while a gun is being held to his head and one of Gabriel's female accessories is giving Stanley oral sex. Stanley proves that he is extraordinary by being able to achieve this impossible result.

Amid a high-action, slick production full of violence, sex, and extravagant displays of material wealth, the argument is that Gabriel's bank robbing, coercion, murdering, and high-living are justified because he is defending the American way of life in his mission to seek out and punish anyone who threatens it—specifically terrorists who strike out at American targets. Contrasting this view is Stanley, who, for all his genius, without money is nothing; he is a man unable to protect the only "innocent" female in the film, his daughter, because the government (which is repeatedly shown to be corrupt and prepared to sacrifice the American way for personal gain and security) has deprived him of the right to use his gifts.

Stanley is repeatedly forced to act to fulfill Gabriel's requirements or lose all hope of saving his daughter. He is offered money and the best lawyers, and later is forced to comply because his daughter is being held hostage by Gabriel. The task is to steal money earned by a covert drugs fund set up by the government so that Gabriel can continue to fund his missions. Stanley succeeds and, although he is led to believe that Gabriel dies when Stanley shoots down his helicopter following the bank robbery, Stanley has doubts about Gabriel's death.

Yet that does not hold him back from enjoying his new wealth and the custody of his daughter (Gabriel helpfully murdered the ex-wife and the pornographer in order to take the daughter hostage as leverage). As Stanley and his daughter take an idyllic Route 66 tour of America, she assures him that everything is going to be fine. Meanwhile, Gabriel has escaped with the money and is continuing his mission to preserve the American way—leaving the body count of terrorists mounting in the wake of his luxury yacht.

Swordfish is a film that demonstrates the blurred values McKee cites as fundamental to the problem with New Hollywood storycraft. As McKee would have it, not only should the bad guy not win, but that the winner should not simply be the least bad of the guys. Produced by Joel Silver, *Swordfish* packs in the whammos. Opening with the bank robbery and an impressive digitally enhanced explosion, it races from sexually charged scene to action scene with only brief moments of pause for discussion of how film endings should happen and setups of the stakes, such as the scene of Stanley visiting his daughter.

The DVFx are used primarily to Seamlessly enhance the danger and the action levels of the film, although they move from Seamless to Exaggerated usage as the action progresses. Using composites and stunt support, it exaggerates the risk posed to and undertaken by the key actors—who are most certainly not heroes—in order to ramp up the pace and the spectacularity of the action. For example, in a car chase, the bus with Gabriel and the hostages does not simply weave through the traffic and undertake a few fancy maneuvers; it is airlifted onto a rooftop where helicopters await Gabriel and his henchmen.

The film also makes extensive use of "the magic computer." In order to give authority to Stanley's talents, computer graphics are used to "show" how he is decrypting the codes that are set as tests of his skills. The flashy graphics and set designs are important, as the action of these scenes is little more than typing (in other words, see the hero type then, see the hero type faster while he remonstrates with the computer). This is hardly the stuff of champions and does not compare with fighting undefeated warriors in the Colosseum. Thus, the graphics are necessary not only to convey expositional information but also to lend some sense that something is happening in the scene.

The values in this film are exactly the ones McKee lists as destructive—success, fortune, fame, sex, power. Everything is done to establish Gabriel as a charismatic, powerful man who can do anything he wants because he has the money and to represent the impoverished Stanley as incapable of doing anything, especially not those things he most desires or needs to do. In the end,

Stanley has been complicit in supporting Gabriel's mission, ostensibly because he had *no choice* if he wanted to save his daughter.

Ultimately it is suggested that the only way Stanley's daughter can be kept innocent is if the Gabriels of the world are allowed to undertake their secret missions to defend the community. This is a stark contrast to the public contest between the emperor and the gladiator. Both stories convincingly portray societies where politics and corruption are rife, but the central characters of these stories exemplify quite different ways of acting in these circumstances, based on quite different codes of honor.

It is possible to argue that *Gladiator* is, if not mythic, at least in the realm of fairy tale, whereas many would consider *Swordfish* to portray a more likely outcome, a reality in which the father will have to compromise himself, to sully himself, and accept monetary reward instead of personal integrity. However, as the film has observed in its own discussion of film values, this is not in keeping with classical narrative standards. In canonical story terms, the need for justice to prevail or at least for the story to reveal wisdom that offers hope for the future, is considered essential to crafting of a good story.

This is not to say that other kinds of stories cannot be told, and most certainly not all classically structured narratives impart wisdom. Nonetheless, in this case no one wins in the sense of "rightness" triumphing, but the characters get away with it because, on the one hand the artifice (as represented by Gabriel) is successfully deployed, and on the other no one cares (as represented by Stanley's willingness to let himself be hoodwinked about Gabriel's death). In this sense, the DVFx are thematically congruent and therefore a good use of effects; they serve the story, such as it is. They work to lull us with style and deploy novel bursts, such as the airlifting of the bus, in an attempt to suggest clever plot twists and a new take on the cliché of the car chase. And yet these effects do not succeed entirely, perhaps because they so cynically—as the opening dialogue suggests—seem to convey the view that audiences are so conditioned by genre clichés and narrative traditions that they are easy to surprise and impress.

In this sense, it would seem that *Swordfish* is simply poor storycraft (in spite of its regular distribution of whammos). There is no argument that the film's DVFx work to provide impressive imagery with photoreal representations of substantial acts of violence and demonstrations of physical destruction. However, as the team that created the graphics for *Tron* found, story overrides stylistic excellence and *Swordfish,* in spite of its highly stylized use of digitally-enhanced action and violence, does not deliver a story with a clear thematic statement of its values.

A final example of how DVFx can be used to support the hero's role in film is *American Beauty*. Lester Burnham is not typically heroic. He is an ordinary person in an ordinary world. He has no supernatural gifts, no mentor, no adversary that he must face. Yet he has extraordinary insights into this world that transform it from venal, mundane existence into something of beauty. The three acts of the film are marked out by an aerial shot and a voice-over by Lester. The dramatic tension is set up in the first narration when Lester reveals that in less than a year he will be dead. The equilibrium of Lester's world is characterized by a morning masturbation session in the shower that will be the highlight of his day. His wife and daughter hold him in contempt, his job is under threat from the scrutiny of a new efficiency expert, and he has the choice to write a job description for the position he has held for years or face termination.

His life changes when he, reluctantly, goes to his daughter's cheerleading performance and sees the teenage Angela—a moment that makes him feel like he has awakened from a coma. He then meets Ricky, the young dope dealer next door, who casually blows off his job, impressing Lester while they share a joint. That night Angela stays over with Lester's daughter Jane, and Lester overhears what it would take to win Angela's interest: muscles. Later, a fantasy of Angela leads to a masturbatory session that results in a confrontation with Carolyn, his wife. Lester finally stands up for himself and is changed by the experience.

At the beginning of the second act, Lester has a new goal—he wants to look good naked, so he starts working out and buys some dope from Ricky. He recalls that the happiest summer of his life was when all he did was flip burgers and get laid, so he decides to quit his job (after extorting a year's salary from the efficiency expert, who, shocked by Lester's threats, is surprised to hear that Lester is "just an ordinary guy with nothing to lose"). The second act reveals the tensions in all the character's lives and the changes in Lester, who is back to flipping burgers and spending all his time working out and getting high. His wife is having an affair, his daughter is falling in love, and Angela is disconcerted to find that her sidekick friend, Lester's daughter Jane, is the one Ricky is noticing.

At the top of the third act, Lester is transformed, running like a machine. He finds out that the object of his hopes, Angela, will be staying over that night and, after discovering his wife's infidelity, he feels free to pursue his desires. Topping it all off, his new friend Ricky brings him more dope. Then, just as Lester's fantasies all seem to be unfolding into possibility, in the background the madness of others is seeking to undo him. There is a strange encounter with Ricky's father, Col. Fitts, who misunderstands Lester's compassion in the face of Col. Fitts's

awkward sexual overture. Lester's response reveals to the audience how alive he has become, not only to himself but also to the pain in others, but this is not how it reads to Col. Fitts. And just as this has occurred, Angela becomes available.

The love scene provides Lester with his final opportunity to choose what he should do—fulfill his desires or act with understanding and compassion for another. Angela reveals that she is a virgin and Lester's response is to give her the love she needs. He holds her tenderly, unable to take advantage of her. He covers her nakedness, cooks her a meal, and talks with her, discovering that his own daughter has found love. Delighting over this revelation, and the realization that he is finally "great," he is murdered.

The conclusion to the film is Lester's voice-over confiding to us his discovery (the wisdom) of the preciousness of life and the inevitability of death, and that, somehow, this is okay.

Although Lester is considered by some to be an antihero, his moral choices and his discovery of the kind of wisdom that applies no matter how morally blurred the values of the day make him heroic. His journey is to arise from his coma, to discover life and connect with those around him, to rediscover himself, and to transform his life—his body, his relationships, and his perspective. At forty-two (the number novelist Douglas Adams has identified as representing the meaning of life), Lester Burnham, like Jim McConnell in *Mission to Mars,* steps from one world into the next, but he speaks to us from that last second, the one that stretches out like an ocean, and he comforts us with the insights he has gained, telling us not to worry, that someday we will understand.

Lester's journey is supported by a major digital-visual-effects shot—the moment that transforms his life and awakens him to the journey. When he sees Angela for the first time, in his fantasy she does a sensuous striptease, opening her top and revealing not breasts but rose petals. In this scene, in the first act, it is revealed that Lester is not looking for mortal pleasure but transformative romance, for love and beauty. The petals spill out of her top, blood red—the color of the door to Lester's house, the color of his wife's roses that line the picket fence, the color of his car, the Firebird (the symbol of the phoenix, representing his new life), the color of the roses in the vase on the table as Lester and Angela come together in the last act of the film backed by the rainy night and the curtains that frame them in the act Joseph Campbell has called the meeting with the goddess in a mystical marriage—appropriately, she is his ultimate test.

The use of digital effects in this case is Surreal. They are used to convey a poetic thought, symbolic material, and to surprise the audience, not with

voyeuristic pleasure of the young woman's breasts but with a moment of lush beauty. In this usage the digital effects are spectacular; they do stop the narrative, not for thrill ride escapism but for the sublime wonder needed for the truth of Lester's insights to have something against which to resonate.

It would have been possible for the filmmakers to deliver some of the story information through exposition instead of using the image of the rose petals falling out of Angela's top. Having already established the convention of the voice-over, Lester could have had a fantasy about seeing Angela reveal her breasts and then reject this image and comment that he wanted more, that he wanted to feel alive again, that he wanted a connection. Of course Lester could not make such a comment, and the reason the image is spectacular is not only because it is a beautiful image but because it is a surprise—to us and to Lester. It is the image from his own imagination that awakens him to a new life. It is a vision in the old fashioned "biblical" way—a metaphor and a mystery, something that inspires the inner journey that a hero must make. This image is metaphorical; it requires thought, consideration of the meaning that it conveys, and so the narrative—and the moment in Lester's life—requires that everything stop so that the image can connect.

The heroes in these films are quite different. Luke Skywalker fulfills his aim to leave the farm and find adventure, ending on the path to greatness beyond everyday human powers. Han Solo steps away from his mercenary individual path and supports the needs of others. Jim McConnell is spared the emptiness of life without his partner and is elevated to cosmic union. Aki Ross finds the answers to her dream but loses her lover so that he can finally see the truth about the power of the life energy in all things. Stanley Jobson, typing very quickly and using a gift he does not truly understand, fulfills the dreams of mass-murderer Gabriel Shear in order for Stanley to gain custody of his daughter and enough money to live independently. Maximus sacrifices his life to save his nation and is rewarded for fulfilling his duty by a reunion with his dead wife and son. Lester Burnham learns how to live and understands how to die.

Confrontation with death is addressed in these films. Obi-Wan Kenobi's sacrifice, Woody Fisher's sacrifice, Grey Edward's sacrifice, Maximus's sacrifice: all are the heroic offering up of one's own life for the benefit of a greater good. Lester Burnham's death is not a sacrifice in the same sense, but it is a representation of the ultimate truth that death comes to find us in our ordinary lives (albeit for him a considerably more dramatic realization than most of us face). For Stanley there is only the threat of death and the false death of Gabriel. *Swordfish*

seeks to face moral issues with a hedged bet, a sophistry that does not dare to come to terms with either of the issues that underpin great stories: how to live wisely and how to die well. If Campbell, Bettelheim, and the many others who have written on this topic are right, stories work when they address how to live in the face of the inevitability of death.

Viktor Frankl, author of *Man's Search for Meaning,* survived Auschwitz and became a renowned psychiatrist. He describes an epiphanous moment he experienced in the depths of hell, the realization of "the meaning of the greatest secret that human poetry and human thought and belief have to impart: The salvation of man through love and in love."[28] This insight speaks directly to the issue of "wisdom" that stories seek to convey. Frankl's experiences taught him that "everything can be taken from a man but one thing: the last of the human freedoms—to choose one's attitude in any given set of circumstances, to choose one's own way."[29] Again, the matter of choice is raised as the crucial factor. He observed that "the sort of person the prisoner became was the result of an inner decision, and not the result of camp influences alone."[30] This inner decision, what Campbell describes as the inner journey, is fundamental to the qualities required of real heroes. Frankl asserted that "It was this spiritual freedom— which cannot be taken away—that makes life meaningful and purposeful."[31]

He discussed the value that can be achieved through creative work that expresses this truth but adds, "there is also purpose in that life which is almost barren of creation and enjoyment and which admits of but one possibility of high moral behaviour: namely, in man's attitude to his existence, an existence restricted by external forces." This assertion speaks directly to the kind of circumstances presented to the character Stanley Jobson in *Swordfish* but also to the wider concerns of character development in general.[32] Frankl's argument is that "Life ultimately means taking the responsibility to find the right answer to its problems and to fulfill the tasks which it constantly sets for each individual."[33] This statement would be relevant to any scriptwriter struggling to shape a character's progress through a plot.

Frankl's statements that "No man and no destiny can be compared with any other man or any other destiny. No situation repeats itself, and each situation calls for a different response"[34] also would resonate with many of those who write storycraft manuals but fall on deaf ears of those who read those manuals in order to use them as formulas. The stories in the case studies presented here that actually work do work because they have found a way to communicate something unique yet universal. Those that fall short do so because they have

not told stories that connect, that show the characters facing their individual destiny with the courage to make the choice of what kind of person to become regardless of the external forces.

Frankl also notes that "What man actually needs is not a tensionless state but rather the striving and struggling for a worthwhile goal, a freely chosen task."[35] He describes three ways one can discover meaning in life as: "(1) by creating a work or doing a deed; (2) by experiencing something or encountering someone; and (3) by the attitude we take toward unavoidable suffering."[36] These also can be considered three options open to the hero, three purposes that can be fulfilled in a hero's story. Thus the idea that a hero is a someone who can convey how she would look when she shoots or is shot, is perhaps an expression of iconic imagery but hardly a definition that encompasses the range and depth of our cinematic heroes.

According to the American Film Institute (AFI), the greatest screen hero in the American cinema[37] fires a gun only once, and does so reluctantly. He does not kill the antagonist. He does not kill in a blaze of fury. He kills to protect his children and his community from a mad dog. His name is Atticus Finch, and his heroic act is to be a man of decency and integrity in a world of blurred values.

The AFI's selection of Atticus Finch is an interesting choice. In a scene that appears in the book but not the movie, Atticus requires his son Jem to read to an elderly neighbor, a terminally ill morphine addict who wishes to die free of her addiction. Atticus explains himself to Jem saying, "I wanted you to see what real courage is, instead of getting the idea that courage is a man with a gun in his hand. It's when you know you're licked before you begin but you begin anyway and you see it through no matter what. You rarely win, but sometimes you do."[38] The tenor of this sentiment is reflected in Atticus's demeanor in the film, and he is described by Miss Maudie to Jem when she says, "I simply want to tell you that there are some men in this world who were born to do our unpleasant jobs for us. Your father's one of them."[39]

To Kill a Mockingbird (1962, Mulligan) does not use special effects to tell its story. It is an emotionally driven court drama seen through the eyes of a young girl. Were it to be remade, with studio funding for wide release, it is likely that DVFx would be used, if only Invisibly to create a realistic period drama. A good team of filmmakers might find inspired Surrealist imagery to share Scout's point of view or, more likely, the mad dog scene would be beefed up with a snarling, CG-enhanced monster. But even if the drama were handled sensitively and intelligently, where would one find an equal to actor Gregory Peck? The

inclusion of the film in this discussion is because its hero is so unlike many post–*Writer's Journey* depictions of heroes.

In recent years, most often heroes in films are depicted leaping from danger and undertaking quests in a vaguely thrill-seeking, apparently unassailable manner. Digital visual effects accentuate this, with composites of explosions and leaps allowing a perceptual realism that may not be reflected by performance realism. Yet, as *To Kill a Mockingbird* and *American Beauty* so eloquently show, to convey that the hero's task is a difficult and unpleasant one requires more than mere representation of physical danger. Some sense of the inner struggle and desires is necessary to give meaning to the encounter with danger.

In *To Kill a Mockingbird,* Atticus is confronted by the hateful Bob Ewell and also by the mob. In the confrontation with "Mr. E," who insults him by spitting in his face, Atticus does not betray his dignity by responding. When he is faced with the mob, he is resolute but his fears are made apparent when his children run to his side and are thus also facing danger. Atticus is a man who will readily face danger himself, but when his children are at stake his fear for their safety makes him vulnerable. Then his values save him. His daughter Scout, acting on what he has taught her in the opening scenes of the movie, is polite to one of the men in the mob. This simple act, reminding him of the relationship she has with him and his son (a relationship that has come about solely because Atticus has demanded that she act with the grace and dignity he himself possesses), is all that it takes to turn the mood of the mob.

If there is doubt about the quality of New Hollywood films that rely upon exaggerated images of danger to evoke emotion, maybe it is because such images, while visually stimulating, do not compare with resolutions that arise out of the plot itself, as Aristotle has described it. In this scene with the mob, there is a resolution that has been sown and tended throughout the story without being obviously set up. Yet when such a resolution happens, it rings true. Similarly *Gladiator, Star Wars,* and *American Beauty* are crafted with a fine sense of resolutions that emerge from the plot and the characters—to greater and lesser degrees, depending on the conventions that fit with their genres.

As these case studies have demonstrated, DVFx can serve narrative purpose but, because they serve the narrative, they are as limited by the script as any other major creative element. There are films that have brilliant cinematography, amazing production design, astonishing performances, or clever editing yet still lack story substance. As mentioned in the opening chapter, it is interesting that these films rarely are described as instances where the production de-

sign or the cinematography have become the reason for the films and that they are, by their usage, detracting from the film. Yet DVFx, perhaps because they are comparatively new or often used to market a production, are considered in this way. What does seem clear is that poorly crafted scripts cannot be overcome with technical excellence alone and well-crafted scripts can use DVFx to enhance the quality of the storytelling.

In relation to the issue of narrative versus spectacularity, the case studies in this chapter show that, in looking at the role of the hero, spectacularity can have narrative motivation. Moments of spectacularity achieved through DVFx are either there to represent spectacularity that is part of the story and presents moments that have impacts on the hero's experiences (as in the cases of *Mission to Mars* and *Star Wars*), spectacularity that is about the diegetic world (as in the glory of Rome or the might of the empire forces), spectacularity that exaggerates violence and elevates it (as in the case of *Swordfish*), and spectacularity that stops the narrative not necessarily to celebrate the technology or draw attention to it but to let the deeper thematic material resonate (as in the case of *American Beauty*).

Another factor in the presentation of the hero influenced by DVFx is the female hero. One need only compare the So/ummers women to see the difference that can be achieved with wire removals and composites. Jamie Sommers, the bionic woman, was a creature of technology. Her machine-enhanced, man-made powers gave her extraordinary physical prowess, which usually was demonstrated by slow-mo and editing with a few sound effects to indicate that she was using her superpowers to overcome a villain.

Buffy Summers, twenty-five or so years later, is a much more convincing warrior. Supernaturally fitted with the destiny of being the chosen one, she has the duty to protect the world from vampires, demons, and a variety of other sinister forces (including a government-funded mad scientist). Hers is a power granted by the universe, part of the "natural" order of things, something that is her birthright.

The fight sequences these two women engage in are demonstrably different. Jamie uses karate chops and super-hearing to defeat her antagonists. Buffy is typically described as "kicking ass." She uses all manner of martial arts, gravity-defying leaps, wall-cracking physical force, and convincing demonstrations of superior strength to overcome an evil—earthly or otherwise. While her physical feats usually fall somewhat short of those of, say, Trinity in the *Matrix* series, she is an example of the new female warrior. She can fight like a man—better

really—and she has physical power that allows her to take on feats of extraordinary danger. Buffy is but one of many new female fighters on the screen. These women have one thing in common, they are not women who would struggle futilely when tied to the railroad tracks.

The reason these female warriors are able to fight with such impressive force is that they do so with the benefit of digital-visual-effects techniques that allow a representation of performance beyond what is physically achievable. Admittedly, their male colleagues also enjoy this benefit, but the representation of male physical strength is as old as story itself. Great acts of physical strength are expected of male heroes. Great acts of physical strength are new qualities for females unless they are achieved by supernatural effect, and even then it is not common practice for this power to be demonstrated by having the female become masculinely active.

Barbara Paul-Emile raised the matter of the female warrior in her paper "Warriors of the Spirit: Women's Mythic Inner Journey."[40] She observed that the qualities of the hero/warrior are not traditionally considered the attributes of women. Yet she argues that the *character* qualities are not different, that women also must be strong and show courage, fortitude, endurance, and integrity. She asserts that these are *human* qualities, not solely those of male heroes. It is her argument that the hero (or heroine) must demonstrate alignment with who they really are or, as Lester Burnham stated, have the ability to look good naked—spiritually naked.

While the emphasis often has been on physical nakedness for women portrayed in film, the new physical prowess demonstrated by female cinematic heroes can be looked upon as a fight for a different kind of regard. *Crouching Tiger, Hidden Dragon* (2000, Lee), has three major female roles: the young woman who faces the choice of love, marriage, or adventure as a warrior; the older warrior who has lived a life of duty and honor, which is compromised by the young woman's theft of a sword entrusted to her care; and the nanny who has trained the young woman and who is the arch-rival of the warriors the young woman most admires. Each of these women has extraordinary physical powers. They are equal to or better than the men they face, and the story honors their moral dilemmas and the consequences of their actions. Their nakedness is emotional, their journeys—although demonstrated by physical acts—are spiritual. The DVFx used to represent their powers fall well within the traditions of Chinese mythical and martial-arts films, but this mythical quality does not remove the drama from human experience so much as frame it for contemplation. The imagery is

spectacular with the intention of evoking wonder and spiritual meditation because the themes, as represented by the moral choices that the three women make, are ones that have grave consequences and therefore merit contemplation.

While most of the new female warriors do not enjoy scripts any better than those offered their male counterparts, a film like *Crouching Tiger, Hidden Dragon* demonstrates that female heroes can be something other than merely female versions of standard action-heroes. However, in most cases the physical prowess that DVFx make possible for female characters is deceptive, not only because it is digitally altered performance, but because, much like the "jobs but not equality" of the corporate and corporeal world, the images of power demonstrated often are unachievable. The ideological intents of these displays can be looked upon with suspicion, and it is hard to argue against the inherent voyeurism offered when, almost inevitably, these women warriors are fighting in figure-hugging, flesh-revealing outfits. When a female character fights in a mini-skirt and four-inch heels, comment is being made about expectations of her that are different from James Bond fighting and emerging with his tuxedo unsullied. Both represent fantasy images, but although a man can emerge from a fight unruffled and in cool self-possession, a female is expected to keep her sexual appeal even as she is brawling in the street.

Two female heroes that do seem to stand on their own power are the characters of Sarah Connor (Linda Hamilton) in the *Terminator* films, and Ellen Ripley (Sigourney Weaver) in the *Alien* franchise. In both of these cases, the women possess physical stature: actress Linda Hamilton transformed on screen from a spunky young woman on the run to hard-bodied mother/protector, and Sigourney Weaver's height and demeanour fit perfectly with her role even though it was originally written for a male (there is further discussion of this role in chapter 8). As these women (with the exception of Ripley's performance in the fourth *Alien* film) do not display extraordinary feats of physical strength exaggerated by DVFx, they are physically convincing in their roles. Furthermore, there are deeper motivations for their acts, and this speaks to the emotional and spiritual aspect of the hero that Paul-Emile describes.

So, the real issue is that, whether male or female, a hero must be able to achieve more than physical prowess and a close escape from danger, which is the primary quality provided by DVFx in most action films. And in those cases, it would appear that DVFx are regularly used to enhance and prop up action sequences in otherwise poorly developed stories. Yet this is not the limit of their contribution or potential, as the examples in this chapter show. In the

hands of a good storyteller, DVFx can add enormous expression to a film, can extend its diegetic world, and can heighten drama, but only if the drama arises out of the plot as a natural consequence of the decisions made and actions taken by the characters.

If a character is beamed aboard a spaceship and transported to another world, the hero's journey requires that we benefit from his sacrifice. The individual path must return to the community—if not in physical terms, at least in terms of a legacy that will endure for the benefit of others. No amount of photoreal compositing can make a fall from a great height the leap of faith and self-achieved submission needed to make a hero worthy of our admiration. Only great acts of character can earn this respect.

6

The Teller and the Tale: The "Chinese Whispers" of Adaptation

Never trust the teller, trust the tale.
—D. H. LAWRENCE[1]

In making assessments about anything, it is important to avoid unfair comparisons. "Well, it ain't *Citizen Kane!*" is only a reasonable criticism if the film under scrutiny has sufficiently similar cinematic intents and stylistic and thematic substance. Obviously, this makes direct comparisons between films rather difficult. On one hand, the issue of subjectivity can color reception. On the other, such a wide range of factors influence the making of a film that direct comparisons rarely are objectively fair because establishing the objective criteria is quite difficult, if not impossible.

So when examining whether DVFx have impacted storycraft directly, one way of avoiding unfair comparisons is to focus on how different storytellers deal with the same story, comparing versions that used DVFx extensively with those that used few special effects at all. To do this, it is important to track the variations in the narrative structure between the versions of the story and assess to what extent the incorporation of DVFx materially altered the story itself from one version of the tale to another.

Telling and retelling is integral to storycraft. It is how stories have come down through the ages and, with the advent of filmmaking, storytellers were as eager to realize age-old tales on celluloid as early scribes were to commit traditional tales to writing. As already mentioned, the very act of creating a written or filmed version of a story often is considered a way of killing the oral tradition.

Further, recent releases of film versions of popular children's books have led to criticisms that once a story is captured in film, it can destroy the imaginative value of reading an original text. Accordingly, a filmmaker who adapts a successful and well-known story is in a difficult position. Yet it is a position familiar to any storyteller attempting to tell a revered tale. The simple truth is that storytelling is a difficult craft.

Capturing the essence of someone else's story while still making it a personal expression is an unenviable task and there are particular dangers in the area of retelling. Expectations are high. Audiences expect to hear or see their favorite elements and have them conform to individual recollections of those tales.

Remakes of stories in Hollywood deal with this in many ways. There is often a close retelling with only minor variations to the story itself but inevitable changes because of performance. There can be an update with a "twist." Baz Luhrmann's successful *Romeo+Juliet* (1996) is a good example of this approach. Or there can be a completely new take on the story, to update it to conform to its times, or presenting a story that is more "inspired by" the original version than an actual retelling of the same story. Whatever approach is taken, when an audience has an earlier version of a story informing its reception, the storyteller is under additional pressure.

There are many films that have been remade since the advent of DVFx and evaluating the extent to which they have been used to support or enhance narrative power offers an additional means of assessing the storycraft of the text. The first step in such an analysis is to identify the elements that are particular to the tale. It is then necessary to compare and contrast the versions, identifying the significant changes in the narrative and the impact these changes have wrought. In some instances, a later version improves on an earlier one. In other cases, crucial elements are overlooked and the story loses its original power. It is then necessary to consider how the introduction of DVFx has influenced the expression of the narrative, in storycraft terms.

For some narratives, the use of DVFx is essential to realize the story. The *Lord of the Rings* trilogy relied heavily on DVFx to achieve the imaginary world of Middle Earth. Similarly, film adaptations of books such as those in the popular *Harry Potter, Narnia,* and *Lemony Snicket* series have drawn on the world-crafting power of digital artists. Digital visual effects also are crucial to period films, and comparisons between films such as *Titanic* and *A Night to Remember* (1958, Baker) are inevitable. There also have been remakes of famous special-effects films such as *Dr. Dolittle* (1967, Fleischer; 1998, Thomas), *The Parent Trap*

(1961, Swift; 1998, Meyers), and of course *King Kong* (1933, Cooper and Shoedsack; 2005, Jackson) that highlight the advances in effects.

In choosing a story for demonstrating this kind of analysis, the priority was to find a project that was not greatly influenced by the use of special effects in its first film version but relied upon them in a remake. Comparing two films that both use effects too easily could have become a discussion about the standard of the effects and the relative value of digital technology versus traditional effects work, though this is not an uninteresting comparison to make. However, the salient issue is storycraft and how DVFx impact on storytelling and so the focus is on narrative structure and how the effects contribute to, or fail to contribute to, storytelling.

This chapter examines three versions of one such story, *The Haunting.* There are the original novel, its first film adaptation, and a remake. The story is one that traditionally relies on an audience's imagination. The original film version understood this fact. The remade film version did not.

The first version is Shirley Jackson's short 1957 novel, *The Haunting of Hill House.* [2] The second version is Robert Wise's 1963 film, *The Haunting,* [3] which is a classical Hollywood film shot in black and white and using only the barest of traditional special effects. The third is the 1999 Jan de Bont film remake, also called *The Haunting,* [4] which makes extensive use of the most technologically advanced digital effects available at the time of production.

Across the three versions of this haunted-house tale, certain aspects are told with a fair amount of consistency. A group of strangers is brought together in an old house with a bad reputation. There is, in at least two instances, a sinister history of previous habitation, and the group is comprised of individuals brought to the house for their traits and past experiences rather than joining the scientific research project for professional reasons of their own. In all cases, in charge of the group is a man of science whose research is considered unconventional and whose goal is to prove something that is yet to be confirmed by science. Upon arriving at the house, the strangers meet and form tentative relationships before finding themselves confronted by events they cannot explain. The sense of danger becomes palpable, escalating until it ends tragically.

In this sense, it could be argued that the lack of a happy ending does not meet the requirements of the classical Hollywood cinema. However, classical Hollywood films do not stipulate *only* happy endings—even though those may predominate. What is required is that the story plotlines be resolved, that the story make sense to the audience, that regardless of an unhappy ending the film's

thematic premise be expressed, and that it resolve in the communication of either hope or wise insight.

Filming well-regarded novels is a practice common from Hollywood's earliest days.[5] As with most adaptations, story changes were made for *The Haunting's* first film version and again for the 1999 remake. Commenting on the issue of adaptations, Thomas Schatz referred to an exchange of correspondence between Alfred Hitchcock and David Selznick. In this exchange Selznick indicated that he considered that adaptations should strive to remain faithful to the original version of a story because even the author could not know which of the details of a story had struck a chord with its existing fans.[6] The details specific to *The Haunting's* story, as opposed to any number of haunted-house stories, include: the house, built by eccentric Hugh Crain, is the setting for a scientific experiment; Eleanor, now homeless after spending eleven years looking after her recently deceased mother, arrives before the others to find the gates locked; Eleanor is passed in through the gates by the caretaker, Dudley, and meets his wife and then the next guest to arrive, Theodora; Mrs. Dudley, in each version of the story, introduces the guests with a warning that they will be alone and beyond help from outside; she delivers a key line, "In the night. In the dark."

Eleanor's relationship with Theodora is always a curious mix of attraction and repulsion, and it is Theodora who is most aware of Eleanor's moods and thoughts. The events in the house are so apparent to Eleanor that she feels she is the focus of the house's intentions; and her engagement with, indeed surrender to, the house is such that the others fear for her and insist upon her leaving. But Eleanor never leaves the house. In every version of the story, she dies and remains there, in the place she came to believe she truly belonged.

The Jackson version of the story is the one most open for reading on many levels. At the most basic it can be interpreted, in strict story terms, as a tale about a house that genuinely harbors sinister qualities. But, at least in the novel, the experience of Eleanor is that of a mental breakdown. Even though Theodora also is witness to the most distressing of unexplained events, Eleanor's behavior and final act can be read as stemming from her guilt about her mother and her terror of a future that cannot offer even the most reasonable prospect for happiness. Ultimately, Eleanor's reliance on fantasy proves to be her undoing. In this way, the story appeals to two resolutions: her death can be seen as an act of self-destruction or a result of the house's malign intentions.

The novel's subtexts offer a mine of possibilities for psychological, literary, and visual interpretation. Keeping with the traditions of the horror genre, there are

rich cues in omens and symbols demonstrating the author's mastery of her craft. The parallels between the fathers and daughters, the reference to Eleanor's childhood as a sunny idyll until her father's death (the timing of which is closely related to the mysterious poltergeist rain of stones), and so on, are skilfully woven into the text but only partially explored in the film adaptations. There is, of course, a degree of excision necessary for a film adaptation, but changes to the fundamental story details have important impacts upon the filmed versions. Adaptations based on superficial readings of an original text risk presenting as hollow. Adaptations that try to capture all of the complexity of a novel can end up being slow and cumbersome film narratives. Striking the balance is very difficult.

Wise, who undertook the first film adaptation, met with Jackson to discuss her intentions, and he changed the movie's title based on her suggestion.[7] In a sense, he is much like the first person in line in a game of "Chinese whispers." His interpretation is close to the source—in terms of release date and access to the author's intent—and it shows in the adaptation he has made. Wise remains faithful to the novel's casting of Eleanor as the hero, in the sense that it is her story. In his paper on the Wise film in *Cinematic Hauntings,* Bryan Senn goes so far as to suggest, "recognizing the self-destructive path she's taking, Eleanor sees herself as having no alternative and so intentionally steps into the lion's den."[8] In effect, Senn is describing the heroic act of leaping into the void and accepting what will befall, the self-subjugation of the hero.

Yet this act is not the sacrifice of a hero on behalf of the community but an act of one whose guilt takes her beyond redemption and union with community. Eleanor's sacrifice of her youth while caring for her invalid mother culminates in a death for which she feels inescapably guilty, and she is unable to take up her life with the faith that she has fulfilled a duty and is now free to begin again, fresh and innocent. This inner turmoil is the true essence of the story, the haunted house and the fellow members of the occult investigation simply provide the form that allows the complex examination of a troubled soul. Wise deals with this inner turmoil by maintaining Jackson's narrative voice, giving access to Eleanor's troubled thoughts and false perceptions.

There are many touches of virtuosity in Wise's handling of the first film version of Jackson's novel. The crucial relationship of fathers and daughters is dealt with by shifting Eleanor's romantic hopes from Luke (a young man who participates in the gathering as the representative of the house's owners) to the doctor (the older man conducting the experiment). The doctor's marital status and age present him as the distant and unattainable figure of the father, deepening

the psychological forces at play within Eleanor's guilty conscience. She *has* killed her mother, the act traditionally associated with the childish desire to obtain the father (Electra complex). This guilt and her fear that her deed will be revealed and thereby condemn her, drive Eleanor to respond to the experiences in the house in a way that ultimately sparks her self-destruction.

Wise's mastery of storycraft is displayed in his technical devices, also. The camera work and lighting helps disorient and destabilize perceptions, feeding into the assertion that the house has been built at odd angles to create constant distortion. In the opening shot a light comes on in the supposedly empty Hill House, revealing that something is inside, while the narrator states that the house is bad. Wise, through the use of infrared film, gives the exteriors a disturbing, unnatural look.[9] He also negotiated the use of a 28mm lens for its distortion properties, which was experimental at that time.[10] The effect of climbing the spiral staircase was achieved with a specially built railing to allow a small dolly to capture the footage, which then was reversed to create the disorienting images for one of the most powerful scenes.[11]

His foregrounding of statues, and the implication that they represent past inhabitants, is used effectively, as are the moments when the occupants are under attack. The subtle use of special effects—the doors that close of their own accord and the one that bulges during the siege in the parlor—are practical (physical) effects that are used sparingly but with excellent timing. The motif of the mirror, which in 1963 was not such a well-worn device, is used to show Eleanor's deterioration—her timid arrival, her embrace with Theodora in the bedroom, her as the distraught woman under attack, and finally her shattered image at the end.

This last image symbolizes Eleanor's psychological break, the shattering of her fragile ego; and the subsequent shot, where she walks away from the others and they fade to black—with only Eleanor and her thoughts revealed—is a significant moment. It demonstrates her complete separation from them, a state of having stepped beyond their reach and beyond their help. In a novel, this state is more easily expressed. In a film this kind of inner turmoil is particularly difficult to convey, but it is an important factor in portraying the complete character of the hero, especially if that hero is a tragic one.

The director uses all of these means to construct a tight version of the story with fairly minor variations to the original. Indeed, the introduction of the sexual tensions among Eleanor, the doctor, and Theodora (the only other female participating in the experiment), is probably the most significant variation that

Wise made. The change in the role of the doctor's wife, also significant, appears to be intended to strengthen the idea of sexual competition and to introduce the psychological subtext of desire for the father. Ultimately the lover that Eleanor's journey brings her to is the house, where she can remain innocent and apart from the physical world.

Eleanor's goals shift from wanting to escape her past, to wanting to win the doctor's affections, to wanting to stay at Hill House, the latter of which she achieves. The last two goals run parallel for some time as Eleanor struggles with her fear/attraction to the events in the house and her need to be cherished, culminating in her making a choice at the climax of the film, when the revelation of the doctor's marital status forces her to surrender to the house. In effect, she decides to remain a child, rejecting the necessity of accepting adult life through the only means of avoiding it: death.

Wise's version is a mature and considered adaptation that draws upon the deeper psychological matters that underpin the novel and that respects the structure and premise, using it to advantage. His use of special and cinematographic effects is similarly constrained but effective. He does not rely upon shock tactics or extensive chase-and-action elements to add pace, but slowly builds the tension and the stresses within and between the characters until a climax arises out of the events themselves. His camera placements and use of optical techniques (such as the fading out of the other characters when Eleanor walks away from them), support the narrative at crucial moments, revealing inner states of significance for the story's action and interpretation.

Almost four decades after Wise's film de Bont's 1999 remake, although sticking to the broad outline of a haunted-house tale, makes substantial alterations to the story, even though the credits insist that it is based on the book. The director's separation from the original source is much more like that of the person sitting at the far end of the chain in Chinese whispers; his version is so different as to bear almost no relationship to the source document. The passing of time and lack of direct access to the author turns the telling into a completely new statement. In de Bont's version, the entire history of the house is changed and the characterization of Eleanor is altered from unstable victim to self-possessed, crusading martyr.

Indeed, many of the narrative changes made in the 1999 version are hard to rationalize and impact significantly upon the quality of the film. For example, it is possible that the issue of Eleanor's guilt about neglecting her mother is removed from the story because of an assumption that contemporary audiences

would not relate to the character; this is one way that the passing of time and the changes in society might have influenced this telling of the tale. However, without this aspect, much of the backstory about Hill House is irrelevant, motivating the need to create a new reason for what happens in the house. The creation of the child-murdering Hugh Crain is one that would resonate with a contemporary audience, but the linkage of Hugh to Eleanor requires the invention of details—the mysterious phone call, the necklace, and the identical room in the house—that present themselves as obvious expositionary devices and are almost nonsensical upon examination. Further, the removal of elements such as Eleanor's guilt, the issues of absent fathers, and of daughters incapable of finding a place in the real world takes away much of what gave the first and second versions thematic and symbolic value.

The introduced devices of the ghost-child guides, the photo album, and the hidden room all require the audience to suspend disbelief from a great height. Having Eleanor climb the staircase without any clear motivation, and without the tension from showing her make her way up the dangerous structure, suggests de Bont may have included it as homage to Wise's iconic scene and, even more tenuously, for the narrative purpose of putting the doctor at risk, and as a way to destroy his cell phone. It is a wasted scene; although Eleanor's saving the doctor demonstrates her strength, the next scene shows her uncharacteristically bedridden with distress, suggesting that her being bedridden is merely another plot device, this time to set her up for the attack in her bed.

These and many other departures from the original story take away most of the dramatic moments and themes that work in both Jackson's novel and Wise's film. They also serve as set-up devices to bridge other scenes without having any emotional or narrative purpose of their own. As to the impact of the effects themselves, it is fair to observe that their usage demonstrates a poor understanding of what CG does well to support narrative. In particular, the literalness of the imagery creates more of a cartoonish, thrill-ride bogeyman than presenting any real peril.

The October 1999 issue of *Cinefex,* states, "Jan de Bont considered the house itself—imbued with the spirits of both Crain and the murdered children—to be his movie's main character."[12] It is interesting then, that this film foregrounds the house less than either the novel or the previous film. Where the others made it clear that Hill House was a bad house, an abstract force of evil, the exterior shots of the house in the de Bont film are misty and benign. The reactions of the characters to the house are positive instead of the absolute and

immediate dislike in the earlier versions, thus losing the powerful psychological aspect of characters trapped in a deadly place. The focus is placed instead squarely on the character of Hugh and his evil deeds, an aspect that did not figure in either of the earlier versions in the way that de Bont has crafted them.

Where previous versions have allowed the view that something was wrong in Hill House to work alongside the idea that Eleanor's guilt and fear drove her to her own destruction, the 1999 version does not offer that latitude. Several events—including the stone giant's attack on the doctor—make explicit the physical forces at work in the house, ones that Eleanor is not privy to and which deny ambiguity from the audience's perception that physical events of supernatural origin are in fact happening in the house. Of fundamental difference is the premise that these forces are driven by Hugh's evil, not an inherent evil built into the very structure of the house, as both the novel and the earlier film assert.

It is this literal, confrontational approach based on an anthropomorphized spectre that is the crucial difference between the three versions. In altering the storyline so profoundly, the de Bont version is forced to keep escalating the story's drama through action sequences because the psychological elements of the earlier versions are gone.

As Joel Black observes, "the graphic imperative in present day cinema whereby everything must be shown and as little as possible left to the viewer's imagination"[13] forces filmmakers into tighter and tighter corners. By its nature film serves the graphic imperative and while de Bont's script decisions do reflect the kind of situation Black describes, DVFx can serve the graphic imperative in innovative and compelling ways, but only when the script provides the dramatic foundation to do so.

Filmmakers routinely construct stories that test the highest technical standards for effects. Yet the success of effects is only partially based on the extent to which they are visually convincing and achieve perceptual verisimilitude. Of greater importance is the fact that they also must meet the requirements of cognitive verisimilitude, and this depends upon narrative context and dramatic integrity. In other words, we have to believe that what we are seeing really could happen within the world of the story.

In dramatic terms, DVFx must be experientially convincing and emotionally honest within their context. They not only must persuade that they reflect "real" life within the narrative world in which they appear, but they also must be truthful to the story and to the audience's demands for narrative integrity. As the discussion of the hero has argued, at the moment of crisis it is imperative

that the danger to the protagonist be accepted as genuine, inescapable, and potentially lethal. Very often a DVFx shot will be visually persuasive on the level of perceptual verisimilitude but fail to convince on a cognitive level. For example, it may be visually convincing that the hero has narrowly escaped from the engulfing flames, but if the audience knows through sheer commonsense—and the narrative has not given any other reason to believe that the laws of biology and physics are different in the narrative world—that the extent of danger is physically impossible to survive, then the filmmakers have broken trust on narrative terms.

Indeed, in many instances technically weak DVFx will be forgiven if they are narratively congruent; it is the strength of the narrative that will carry them, rather than the other way around. When the requirements for both perceptual and cognitive verisimilitude are not met, it is often because the filmmakers have attempted to fulfil the graphic imperative only by driving up the action. This is a problem that Kristin Thompson notes in her observations of New Hollywood's trend toward escalating crises and climaxes in action and thriller films.[14]

Certainly the 1999 version of the story moves as quickly as possible to reveal supernatural events and then works to increase the pacing by adding more and more threatening and overt attacks on the group. De Bont commences with gentle approaches by ghost children that lead to Eleanor finding out the truth, then swiftly replaces them with increasingly ferocious supernatural attacks by Hugh's ghost.

A series of hunt-and-chase sequences unfolds, almost all of which are major digital or special-effects scenes. Eleanor runs from a vision of the dead Mrs. Crain to the discovery of skeletons in the hearth, then she is attacked by the nursery door and confronted by the threatening frost face in the window. She then runs from this to a scene at the top of the unstable iron staircase. As mentioned, this scene on the staircase is pivotal in both the novel and the Wise film but becomes meaningless in this film because the motivational context has been removed.

There is a moment of brief respite in the hard-driving action while Eleanor is left alone in her room before she is attacked by the bed and the ceiling. Even though the group escapes from the house following this attack, their efforts to leave are frustrated by the estate's locked gates and then by Luke's being trapped and nearly killed in the car. The return to the house and the second escape sequence provides another roller coaster of action scenes: doors slam on them, Luke is decapitated, bones fly out at them from the fireplace, the portrait of Hugh attacks the doctor and Theodora, the statue of a griffin attacks Eleanor,

the monster image of Hugh emerges from the portrait and attacks, and the ghost passes into the gates of hell. This chain of action scenes provides an excellent example of Thompson's assertion about escalating final acts.

As Thompson comments, "An imbalance induced by a lack of information and a superabundance of action runs counter to the guidelines of established classical storytelling."[15] In this instance, these escalating events in the final act of the 1999 film are not a challenge to the structure of classical storytelling so much as a failure to achieve its standards. For want of real dramatic tension driven by character development and psychological motivation (something both the novel and the first film use very well), the story relies upon racing from one thrill-ride scare to another. When Luke is decapitated, the others are barely affected. When Hugh reveals himself, he is unable to do more than rage and swirl in menacing confrontation, like a fairground horror-train ghoul.

De Bont's film seems to conform exactly to the criticisms that effects are driving stories instead of being used to tell stories well. It might indeed be a fair example of the "swamping of story by technology" that Paul Byrnes cites in relation to *Van Helsing*. However, close analysis of the film reveals again that the primary weaknesses are inherent in the 1999 script and stem from the decision to make substantial changes to the structure and characterizations of the original novel and previous film. A film based on this script would have been just as limited had traditional effects, or judicious cheats through camera and editing techniques been used instead of DVFx because de Bont's revisions to the foundation story removed the details crucial to storytelling success.

The difference between this film and *Van Helsing*—and many other examples of films that engage in excessive action and effects sequences—is that, as the previous versions of the story demonstrate, *The Haunting* is a strong, well-crafted story that could have been used as a basis for DVFx that are thematically rich and visually powerful. In fact, the 1999 film was greatly anticipated by fans of the Wise version who hoped de Bont would use DVFx to build upon a masterfully crafted horror story. The Wise version demonstrates that well-chosen special effects can work powerfully in such a story. But in the 1999 version, the effects are used to realize a poorly constructed narrative. It can be argued that the changed focus of the story led to an inability to go anywhere but a direct, face-to-face confrontation between Eleanor and Hugh's animated image.

This in itself presents one of the problems of DVFx. The creation of CG characters is one of the most hotly discussed issues. In the classical Hollywood film, as Thompson states, "characters are expected not only to motivate causal action

but to do so in an engaging way."[16] Ian Brown, a 3-D Animator and CG artist whose credits include *Moulin Rouge, Hero, The Fellowship of the Ring,* and *Birthday Boy* (2004, Park), has commented that it is extremely difficult to create a believable CG character that our brains will respond to as truly frightening.[17] The visual representation of Hugh showed the range of interactions that make the credibility of, and response to, the character difficult.

Rob Legato (Academy Award–winner for *Titanic* and nominee for *Apollo 13*) has extensive experience in creating effects for films with supernatural elements. His credits include *Interview with the Vampire, What Lies Beneath,* and the first *Harry Potter* film. He argues that if there had been a CG shark in *Jaws,* it would not have been scary let alone a classic film. He says, "Seeing the monster true-to-life is not scary. When you see monsters too much, they don't work. Limitations forced Steven Spielberg to create something that was truly terrifying."[18]

Seamlessly blending the live-action elements (the environments and the actors) with the CG creation is always difficult. They are created in different spaces (one the physical world and the other the world of data) and uniting them in digitally enhanced 2-D space requires subtlety and planning for effective storytelling. The main issues are the realism, credibility, and interactiveness of the images. It is crucial that there be no sense that the elements originated in separate realms and are only somewhat combined (that is, present together) in the final image. Verisimilitude, especially in the case of fantastical images of the kind in *The Haunting,* is absolutely essential for credibility and suspension of disbelief. There is simply nothing to be achieved in an attack by a force observably unable to connect with the characters at risk.

Another consideration is that at some level our cognitive skills track and measure minute details trying to keep us from being fooled by digital creatures and certainly by their representation as "present" and "real." Thus, by choosing to represent the forces of Hill House with a physicality, de Bont had to work with a bogeyman image made apparent instead of the quiet, creeping dread of something that sneaks up and can be seen only from the corner of the eye—the approach used in the first two versions of the story.

By comparison, the realization of Gollum in the *Lord of the Rings* series has elevated the degree of acceptance of fully digital characters, and the morph of his transformation from hobbit (portrayed by an actor) to corrupted lost soul assists in audience acceptance of the CG performance. Further, he is beautifully realized using motion capture, animation, and, in most shots, verisimilitudinous compositing. Another example of a convincing CG character is Gollum's

ally Shelob. The CG spider that attacks Frodo is impeccably married to the live action performances so that when the spider bites, members of the audience not already squirming in their seats are given good reason to jump with surprise. The timing of the action is matched between live and CG performance in a way that is innately consistent with a physical attack.

Peter Jackson again demonstrated his mastery of bringing CG characters to life in his remake of *King Kong*. His achievement is that he does not try to make the ape a scary monster but focuses instead on making him alive and true to our experience of life. The standard of effects throughout this film meets the requirements that they interact and feel present. There is every sensation that the humans are in grave danger on Skull Island and that the many CG characters confronting them could mean certain and unpleasant death.

However, in de Bont's literalization of the Hugh Crain character, the degree to which this level of timing and matching with live action is achieved is questionable. This poor visual representation is further weakened when Eleanor's defeat of the apparition is achieved simply by direct confrontation and a speech about the haunting of Hill House "all being about family." The monstrous Hugh, it would seem, simply needs a good telling off to be overwhelmed and destroyed. Thus, even though the apparition does pull Eleanor into the doors to hell, her sacrifice and death are not perceived as *its* triumph, but as *hers.* The confrontation is a token one, and the physical threat of the monster is secondary to the need to defeat it morally. The stake is the release of the children's souls from purgatory, not Eleanor's life. Thus, all the action scenes that have preceded this final act are of superfluous value.

Making physical the imagined is one of the great abilities of the CG image, and, as the *Lord of the Rings* and *King Kong* examples show, this can work effectively within story. Yet in the de Bont version of *The Haunting,* the CG sequences create what Martin Brown calls a "modality shift" in the narrative. The digital effects are quite distinct from the live-action sequences, and piling them in at the end (to meet the demands of the script's structure) makes the events in the house seem less real than what is needed to inspire full engagement with the fate of the protagonist.

Another factor working against the 1999 script is that by making literal and graphic the force in the house, the filmmakers insist on the audience's acceptance that the supernatural events are purely physical and not psychological. It is possible, as Wise's version offers, to present the events at the house in such a way that the audience can resolve the story in keeping with a range of belief

systems: mental breakdown versus supernatural force or a sinister combination of both. In the 1963 version, Luke's suggestion that Eleanor acts deliberately is as strongly supported by the narrative as are the supernatural theories proposed by Theodora and the doctor. This clever offering of the alternative approaches is quality classical storycraft that allows for a resolution of the plotlines by a wide demographic.

Whereas the de Bont version with its goal-oriented Eleanor may appear to be in line with contemporary classical Hollywood cinema (she wants a new life, she goes to Hill House, she fathoms there is a mystery to be solved, she discovers the truth, and she acts to save children from an eternal purgatory of torment), its straightforward conformity does not suffice. Like a game of "Chinese whispers," the attempt to update the statement in this case fails because the crucial elements are left out. As Selznick notes, a story often works because of the unity of its elements, and in updated versions of stories these elements frequently are left out. The drive to make Eleanor a woman of the 1990s lost sight of the story about a troubled, guilty soul (a human condition that certainly remains relevant to any contemporary story). The desire to create an external, demonstrably evil opponent overlooked the aspect of recurring tragedies. By taking a story that is rich with metaphor and symbolism and reducing it to its literal elements, the underlying themes and the value of their insights are simply lost.

The de Bont film insists that the house and the events that unfold can happen only one way, and the graphics are used to make this "real" instead of allowing that they may or may not be possible. Much is made of Hollywood classical cinema depending on believable stories, albeit exaggerated versions of them. In this instance, the literality works against credibility although it was reaching to enhance it. The 1963 Wise version, certainly at its time, pushed the boundaries of the classical cinema. As noted, the story does not have only one resolution, nor a happy ending. It uses unconventional camera angles and lighting, but they are subordinate to narrative purpose and their usage occurred at the edge of one of Hollywood's adaptive cycles where the influences of the avant-garde and art-house filmmakers were incorporated into mainstream cinema. Furthermore, the story changes are effective, the character motivations are clear and plausible, and the story follows a strong cause-and-effect structure that is well paced, convincing, and generally credible.

In comparison, by emphasizing the CG representation of Hugh and the other supernatural events at the expense of the main theme—that of a troubled

soul—de Bont's use of effects occurs because they are *events* structured in the script not because the *effects* are constructed in this way. This, combined with the escalating climaxes, means the resolution—built upon fairly slim motivation and coincidence more than classical cause-and-effect—relies upon imagery that is not convincing for *the purposes of this story*. In another film, especially a comedy, the CG representation of Hugh and many of the other effects might be perfectly appropriate and work to sustain narrative events.

Character creator Stan Winston (who, with three Academy Awards and six nominations, is almost royalty in the business of special effects), remarks, "*Jurassic Park* wasn't successful because of the effects. *Terminator* wasn't successful because of its effects. *Lord of the Rings* wasn't successful because of its effects. They were all great stories. Yeah, there are good effects in all of them, but that's not what made them a success. Too often, a visual effects movie is a big success, and not-too-bright studio executives think it was due to the effects. They think, 'Ah, people want to see the spectacle!—and we do. But we want to see spectacle supported by substance."[19]

No filmmaker can overlook the fact that they are always, first and foremost, storytellers. To become distracted by the graphic imperative is to lose sight of the filmmaker's primary responsibility in classical storytelling. Both elements—story and image—are necessary to filmmaking but they must work together. Digital visual effects derive from their narrative imperative. To use them—or any technical craft of filmmaking (including cinematography, sound, and music)—with virtuosity requires a deep understanding of the story being told. For example, in both the *Lord of the Rings* trilogy (an adaptation) and *King Kong* (a remake of a revered Hollywood classic), Jackson demonstrates both the ability to get to the heart of the story and its deepest themes and also complete awareness of how to use DVFx to meet narrative drive. In *Kong* he makes extensive use of virtual camera moves and first-person POV shots to take the audience into the experience and to reveal character. These are primary aims of film storycraft and require that a filmmaker understand the story being told in order to achieve these aims.

The Haunting in its first telling was a great achievement. It was good ghost story, one of the hardest stories to tell, and in this case particularly compelling because it drew its strength from the character's motivations. Sitting alongside of the master, Shirley Jackson, Robert Wise passed on this tale with accuracy and compelling clarity. His Eleanor is a troubled and guilty soul and her inner

journey is convincingly expressed in his representation of the events in the house. In translating this tale, Jan de Bont misses these crucial details and makes up new elements to fill out the story.

As the comparisons of these versions of *The Haunting* show, regardless of the visual power that film offers, especially where DVFx are concerned, to have good effects—ones that reach audiences emotionally and memorably—they, like the events in the story, must also arise out of a good script. It is in the telling of the tale, in capturing those fundamentals necessary to expressing the whole, that success lies.

It Goes Like This: The Relationship between Digital Visual Effects and Genre

As a story evolves through repetition, emulation, and stylization, it becomes a "type" of story, often considered a *genre*. What this means however, varies from specialty to specialty. The approaches to genre definitions by the film industry's marketing practitioners are different than by academics, and again different by scriptwriters. From the academic perspective, genre theory is one of the most extensively developed areas of film studies. In his book *Genre and Hollywood,*[1] Steve Neale traces genre from attempts to identify iconographies that relate to specific genres through to the linguistics-based theories. He summarizes that "there is a difference between academic or programmatic aesthetic formulae and formulae which arise as a result of commercial conditions."[2] Neale categorizes film genre theories into "those which deal with the aesthetic components and characteristics of genres, and those which deal with their social and cultural significance."[3]

For the purpose of this discussion, *genre* refers to "types of films" and relates to traits that are usually defined by the industry, a point I take up later in this chapter. However, in relation to this matter of types of films, Neale also makes a point relevant to this discussion when he says, "if (for the moment, at least) we accept that genres are simply types or kinds of films, there is no logical reason for excluding either such non-American instances as the Indian mythological, the Japanese samurai film, or the Hong Kong *wu xia pan* or swordplay film, or such 'non-commercial' or non–feature length instances as the documentary, the animated short, the avant-garde film or the art film," and adds "Genre is, of course, an important ingredient in any film's narrative image."[4]

In discussing genres as types of films, a category-oriented definition would say that a genre is determined by "repeated plot motifs, recurrent image patterns, standardized narrative configurations, and predictable reception conventions."[5] Tom Ryall notes that the critical writing on genres focuses on actual films and historical categorizations[6] and makes the further distinction of those analyses that define the generic system, concentrate on individual genres, or analyze specific films relative to genre categories. [7]

As both Neale and Ryall have noted, genre theorists have focused on generic categories and sought to identify the social, ideological, and cultural issues that arise from within the films that conform to the categories, and reflect upon the historical implications of those categories that have enjoyed particular favor at certain times. This is a quite different approach from that of the marketplace. In the marketplace, genre is a categorization aimed at securing a deal, reaching a demographic, and garnering publicity. Indeed, Neale has observed that the "industrial and journalistic labels . . . offer virtually the only available evidence for a historical study of the array of genres in circulation or of the way in which individual films have been generically perceived at any point in time."[8] It is in the marketplace that audience responses to films are felt most keenly and that response often leads to quickly made, copycat offerings that, while they usually do not exceed the success of the inspirational film, can contribute to genre conventions.

Writers approach the matter of genre from a different angle. A writer seeking to create a genre film is in the position of trying to accommodate genre conventions while crafting something unique within those conventions, or as an extension of those conventions. When Robert McKee talks about genre, he identifies those qualities a scriptwriter must keep in mind to develop a good script that will fulfill the audience's expectations for the kind of story the script is seeking to tell. The goal remains, nonetheless, to achieve an original piece of work. In McKee's view, genres are "a system that's evolved from practice, not theory, and that turns on differences of subject, setting, role, event, and values."[9]

This is a view supported by Thomas Schatz's study, *Hollywood Genres*. Schatz observes that a particular film's popular success will lead to its emulation by others, creating a style or generic pattern. He observed, in realization of the influence of the marketplace, that "Film genres are not organized or discovered by analysts but are the result of the material conditions of commercial filmmaking

itself, whereby popular stories are varied and repeated as long as they satisfy audience demand and turn a profit for the studios."[10]

Schatz also notes, "our familiarity with any genre seems to depend less on recognizing any specific setting than on recognizing certain dramatic conflicts,"[11] an observation consistent with Ronald B. Tobias's scriptwriting text, *Twenty Master Plots,* which outlines story structures based on the nature of the conflict and argues that twenty basic structures form the foundation of all classical narratives.[12] Schatz considers the "identifying feature of a film genre is its cultural context, its community of interrelated character types whose attitudes, values, and actions flesh out dramatic conflicts within that community."[13]

Accommodating these different perspectives to some extent, David Bordwell observes, "There is no single principle by which genres can be defined."[14] He goes on to say, "the best way to identify a genre is to recognize how audiences and filmmakers, at different historical periods and places, have intuitively distinguished one sort of movie from another."[15]

If defining *genre* has proven difficult, so has demarcating the genres themselves. Vivian Sobchack has demonstrated this problem in *Screening Space: The American Science Fiction Film,* which commences with a discussion of the different definitions that have been framed for science fiction.[16] For example, some have said that films with spaceships are science fiction; but if spaceships are part of the iconography of science fiction, what does that mean for science fiction films that do not have spaceships? Most would agree that films like *The Eternal Sunshine of the Spotless Mind* and *Donnie Darko* (2001, Kelly), with narratives based on the fictional science of memory erasure or time-travel, are science fiction even though neither has any spaceships. At the same time, *Apollo 13,* even though much of the action takes place on a spaceship in outer space, is not science fiction but historical drama. *The Day after Tomorrow,* which has fictional science in some of its projections of what would happen in a situation of climate change uses the scenes set in the space station as a marker for realism in order to sell the feasibility of the science-fiction elements of the story. From these examples alone, which discuss only one iconographic aspect of only the genre of science fiction, it is easy to see that simple definitions of genres are either impossible, if they are to be accurate, or that they must be necessarily simple and general, in order to facilitate easy—if imprecise—discussion.

While defining *science fiction* is not essential for this discussion and, judging from Sobchack's documentation, is possibly beyond the scope of any one

text, the relationship between science fiction and special effects is one that must be examined.

Further, commentary about the use of DVFx in relation to science fiction also is of relevance to genres such as action-adventure, fantasy, and horror. This discussion relies upon the assumption that, regardless of the continued debates about certain genre definitions and historical and ideological rationales that may pertain to the emergence and popularity of certain kinds of films, the broad genre categorizations such as those listed above can be used without necessarily challenging genre theory as a whole.

In looking at DVFx and storycraft, the widely held perception that DVFx are used primarily in science-fiction, action-adventure, fantasy, and horror films is an issue that must be confronted. Many have claimed that DVFx are limited to, or at least most influential in, certain kinds of stories. Another common issue that is fundamental to these arguments is that spectacularity is integral to the usage of DVFx and that, as a result, classical narrative norms are being challenged by the use of DVFx in the genres that rely on these effects. Some writers, as mentioned earlier, argue that these moments of spectacularity—especially in relation to effects—are a kind of narrative structure in themselves: an effects story.

Discussion outside academic circles of these "effects stories" often arise in the form of criticisms like that of *Van Helsing* cited in the opening chapter, where the film seems to move from one effects sequence to the other with only flimsy narrative justification for the fantastical images that appear. Some argue that this results from the primacy of the desire to use DVFx and that story itself is becoming secondary to the display offered by spectacular sequences in certain genres of films. Yet, a number of factors influence these kinds of displays of effects usage.

First, as has already been discussed, bad scriptwriting is never in short supply, nor is the willingness to resort to cliché and style over substance. And while there is no need to incur the expense of DVFx to achieve style in a film, impressive DVFx are something the marketing department can promote if the film has few other virtues. Second, as previously mentioned, some directors lack maturity and want to use every cool effect, every iconic shot, and every pop song or film reference that has captured their fancy. In these moments, story certainly does come second to the effects, the cinematography, the "look," or the host of other, narratively unmotivated elements that have been included in the movie. Finally, some films do lurch from one kind of spectacular sequence to another and priv-

ileged action, musical sequences, or other featured elements. Musicals often struggle to find a narrative framework to justify the song-and-dance sequences.

Yet, there is also an increasing imperative to show, to visualize and represent graphically the story elements and not just fantastical elements such as ghosts, monsters, and alien places. Indeed, this graphic imperative applies equally to sex, violence, and action sequences such as chases. The observation already has been made that sublime cinematography and production design are less likely than DVFx to be cited for stopping the narrative when the images arrest audience attention for solely spectacular purposes. Similarly, sex and violence also tend to go unexamined in relation to spectacularity, perhaps because they have given rise to so many other lines of discourse. Sex, at least at this point, has managed to hold its place on the screen without the enhancement of DVFx, but the screen representation of violence is a significant part of DVFx practice.

This is so much the case that it has to be asked whether scenes of violence that rely upon DVFx are a demonstration of the effects or an indulgence of the spectacularity of violence. Similarly, one could ask whether science fiction and fantasy films enjoy popularity because of the effects or because the effects are used to show something integral to those genres that is particularly attractive to their audiences.

With the genre of science fiction, the academic discussion of its conventions and the use of effects by science-fiction filmmakers has been plentiful. For example, in the *Alien Zone* essay collections, series editor Annette Kuhn remarks in her opening discussion for the first in the series that "science fiction cinema distinguishes itself . . . by its appeal to special effects technology in creating the appearance of worlds which either do not exist, or cannot for one reason or another be recorded, as it were, live."[17] While she admits that "not all science fiction films use special effects,"[18] she argues, "For the fans, special effects are the *raison d'etre* of the genre"[19] (emphasis mine).

She notes that science fiction uses effects to ground the diegetic world in keeping with classical narrative traditions, yet she also argues that "special effects in science fiction films *always* draw attention to themselves, inviting admiration for the wizardry of the boffins and the marvels of a technology that translates their efforts onto the screen"[20] (emphasis mine). She further argues that "there is *never* any pretence that special effects spectacles are anything other than artefacts; and yet at the same time . . . the illusion of classical cinema works to persuade us otherwise."

In "You've Got to Be Fucking Kidding: Knowledge, Belief, and Judgments in Science Fiction," Neale makes the same point—special effects in science-fiction films are meant to draw the spectator's attention for the effects themselves and that this is part of playing with the levels of awareness that exist for the spectator.[21] It is his view that suspension of disbelief, which is intrinsic to narrative fiction, is especially crucial to science fiction because the events that unfold are usually extraordinary to human experience.[22] He refers to Christian Metz's "trucages" using this to make the distinction between the kinds of effects that are meant to be seen and those that are not. In relation to this he comments, "while there is always a degree of duplicity, of secrecy, of the hidden attached to the use of special effects, there is always also 'something which flaunts itself.'"[23]

As previously mentioned, these discussions arise from the foundation laid by Tom Gunning's "cinema of attractions." While originally addressing the attraction of the cinema's spectacle in and of itself prior to its development as a narrative medium, the concept of the cinema of attractions now applies to film's voyeuristic opportunities and those instances where the visually sublime qualities of film are suggestive of excess, of usurping the dominance of narrative purpose.

There is extensive academic discussion of the "spectacular" nature of special effects in the analysis of their usages, particularly in relation to science-fiction films. For Gunning, the cinema of attractions "addresses and holds the spectator, emphasising the act of display."[24] These qualities have been applied to special-effects usage, arguing that the very purpose of special effects is to stop the narrative and draw the spectator's attention to the technology of the cinema. In these arguments, discussion of special effects addresses what Albert La Valley describes as "the extraordinary use of props and optical devices . . . [where] [t]here must be a significant and important gap between the illusion of what we see on screen and what was used to produce it."[25] He proposes, "Special effects thus dramatize not just the thematic materials of science fiction and fantasy plots, but also illustrate the 'state of the art'"[26] of the technology itself. He cites this kind of usage in contrast to the use of effects in other genres where the effects are intended to be unseen. In Angela Ndalianis's paper "Special Effects, Morphing Magic, and the 1990s Cinema of Attractions," she posits that "contemporary cinema asks its audience to be astonished at its special effects, and to reflect on the way special effects films have become venues that display developments in new film technology."[27]

In *Neo Baroque Aesthetics and Contemporary Entertainment,* Ndalianis states, "Like its seventeenth-century counterpart, science fiction cinema relies upon visual spectacle that themselves embody the possibilities of 'new science.' The neo-baroque nature of science fiction cinema partly resides in a magical wonder that is transformed into a 'spiritual presence'—a presence effected by scientifically and technologically created illusions."[28] Sobchack also refers to this "spiritual presence" and notes, "From *Close Encounters [of the Third Kind* (1977, Spielberg)] on, then, special effects in mainstream SF have been transformed from signs of a rational and objective science and technology to representations of a joyous, and 'sublime,' intensity—thematically linking postmodern culture's new 'detached,' 'free-floating,' and 'liberated' sense of emotional transcendence with the transcendental."[29]

These arguments succinctly capture the broad relationship that exists between effects and the pleasures of spectacle and the display of cinema's technological prowess. Further, as indicated earlier, Martin Barker has expressed the view that "special effects have to be *signalled* as special, in whatever film they are used."[30] Reiterating the views that effects stop the narrative for spectacular purposes, Barker goes on to state that effects also serve to mark out moments in the narrative where "modality shifts *take place* . . . [and] we are invited to respond to the films at a new level."[31]

Concurrent with these theoretical positions is the view that special effects are more than stopping the narrative, they are becoming a substitute for it, upstaging actors and plot lines, becoming in and of themselves a reason for making the film—thereby creating, as Beebe has suggested, a new form of narrative structure.[32]

Commenting on science-fiction films, Neale said, "narrative functions largely to motivate the production of special effects, climaxing either with the 'best' of those effects (*Close Encounters of the Third Kind*), or with the point at which they are multiplied with greatest intensity (*Star Wars*)."[33]

Yet, for all the many assertions that special effects are an emerging narrative form, no one has proposed the narrative structure that this new form demonstrates. It would seem that, aside from bad scriptwriting and indulgences of immature filmcraft, if there is a counter-narrative comprised of nonnarrative elements (whether effects-driven or based on other forms of spectacularity), it is not clear that they are sufficiently patterned to form a definable usage. To examine this idea in relation to DVFx, it is possible to propose a series of typical

narrative events and the kind of digital-visual-effects techniques that might be required to realize the events. This list of narrative events and effects techniques then can be examined to determine what might present itself as a common pattern or an emerging narrative structure. Such a series might resemble table 7.1.

As the list of plot elements in table 7.1 demonstrates, the first part of each of the preceding points provides a narrative outline not uncommon for a typical science-fiction/action film. The list of elements in the second column of the table thus would represent the typical digital effects sequences that could be used to create or realize these plot elements. The first column could be handed to a scriptwriter (although one would suspect they would find it a fairly dubious honor). The second half would be meaningless. A description of effects shots means nothing descriptively and, excised from the narrative motivation, visually it has no more to offer than a screen saver or shots reel.

On the other hand, the first half of the list, it could be argued, aligns with the "whammo" approach to storycraft and points again to Kristin Thompson's and Tom Stempel's observations about the impact of formula on storycraft. As James Monaco has commented:

By far the leading genre of the 1980s and 1990s has been the Action-Adventure film, which, because it relies so little on character and character development, lends itself so well to sequels, and which exploits to the limit the rapidly developing sophistication of Hollywood's now digitized special effects industry. Characterized by a thin veneer of science fiction and fantasy, which gives the effects specialists the excuse to ply their trade, contemporary Action movies succeed by exploiting a deeply felt need for visceral excitement and the thrill of violence.[34]

This summary raises a number of interesting points, including the notion that the genre does not depend on deep script development. Monaco is not the only one to make this observation. Kuhn also has remarked that "narrative content and structure per se are rarely [science fiction films'] most significant features."[35] Likewise, Schatz has argued that "a genre film . . . involves familiar, essentially one-dimensional characters acting out a predictable story pattern within a familiar setting."[36] Thus, it would appear that a poor standard of storycraft is an accepted practice for the science-fiction/action-adventure genres or, as Schatz has it, for most genres. I am not convinced that genre films are doomed to one-dimensional characters or predictable story patterns, but in specific instances where genre films do fit this description, this in itself suggests that the attraction for the audience must lie in other factors. The main arguments sug-

gest that, in the case of science fiction, it is the spectacularity of the effects, or as Kuhn has suggested the appeal of other worlds on display.

Sobchack suggests that science fiction's characteristic themes "[have] to do with technologies on the one hand and with modes of societal organization on the other."[37] While the matter of technology is considered more fully later in this chapter, her other theme—the modes of societal organization—supports Kuhn's "other worlds" theory. These comments suggest the level of attractiveness science fiction has as a genre when it is not wholly based on visual spectacularity. To what extent science fiction achieves this is somewhat off topic here, but the ability of DVFx to provide visual representation of these concepts is likely to be linked to the extent that the story upon which the effects is based has achieved this within itself.

The second point worth noting is Monaco's assertion that the genre exploits the talents of the growing digital-visual-effects industry, although in the next breath he remarks that a thin veneer of science fiction or fantasy is "an excuse" for digital effects artists to ply their trade. It is hard to assess if filmmakers are exploiting the talents of the effects professionals to tell their poorly developed stories or whether canny effects artists are taking advantage of the filmmakers by laying on the effects. Regardless, a symbiotic relationship between the creative elements is implied, one in which the inherent weakness of the scripts gives scope for the "exploitation" of the effects. Yet, it should be noted that a weak script also might rely upon other means of "filling the screen," including extended love scenes, car chases, fight scenes, or pop-song-montage sequences.

Another of Monaco's phrases to note is the "thin veneer of science fiction or fantasy" that he asserts is used to dress up basic action-adventure stories. This suggests that some films classified as science fiction do not keep with the genre's underlying themes. Essentially, Monaco appears to say that setting a film in space or having scientifically grounded premises for a story can be little more than colorful set dressing, as it were, for ordinary action-adventure fare, suggesting that the factors that make action-adventure films successful also must have some impact on the genre of science fiction—or at least those films using the trappings of science fiction to serve up standard action-adventure stories. It would seem that the factors that might be common to both science fiction and action/adventure films are at the heart of the next point.

Finally, Monaco's last line should be noted: he observes that action films succeed because of their exploitation of the "need for visceral excitement and the thrill of violence." Likewise, Barry Keith Grant argues, "Because of the science

Table 7.1 Narrative events and their related effects techniques.

Narrative event	Effects technique
Establishing shot of the diegetic world as the fantastic city of the future	CG matte painting with a virtual camera move through models and integration with live-action blue screens and background plates
Display of the amazing vehicle of the future	Composites and 3-D models
Presentation of the basic premise of the narrative with some "magic computer" exposition, giving authority to the stakes	Composite of various CG images and graphics of the expositionary materials
Interruption to the scene resulting in a chase sequence that demonstrates the powers of the amazing vehicle of the future and allows an escape	More composites with matte paintings, model work, and set extensions; perhaps pyrotechnic shots added where required
Period of respite, perhaps in an astonishing synthetic reality	CG set extensions and composites of live action
Decision to pursue the matter at stake, leading to a confrontation and a demonstration of firepower showcasing the amazing weapons of the future	Pyro shots and composites of live action, 3-D elements, and rotoscoping of firepower elements
Many explosions and a close call for the main characters, and perhaps the loss of minor characters	Composites of pyro and live-action elements, potential for 3-D elements to visualize spectacular death and injury in supplement of on-set practical and makeup effects
Another escape sequence	Composites of live action and background plates
Revelation of information crucial to the stake and another pursuit leading to confrontation	3-D computer-screen graphics, composites of computer-screen graphics, and composites of live action and background plates
Another fight, with even more impressive weaponry, greater explosions, and highly choreographed physical fighting	CG stunt performer interpolation, wire removals, composites of live action and background plates, CG models of weapons, rotoscope of firepower elements, and pyro plate composites
Jeopardy for the main characters, who are at the mercy of the antagonist	CG set extension; possible composites of "dangerous" elements

Table 7.1 (continued)

Narrative event	Effects technique
Escape, explosions, more chase sequences, and a confrontation, culminating with a face-off between the protagonist and the antagonist (quite often as a fist fight, even in the most high-tech of environments)	CG stunt performer interpolation, wire removals, composites of live action and background plates, CG models of weapons, rotoscope of firepower elements, and pyro plate composites
Final escape and the destruction of the antagonist's lair	CG stunt performer interpolation, wire removals, composites of live action and background plates, and CG models of lair with composites of pyro plates with live action of models being blown up
Return to the fantastic city of the future	CG matte painting with virtual camera move and composites of live action, crowd extensions, and background plates

fiction film's emphasis on special effects, the genre's primary appeal has been the kinetic excitement of action."[38] However, Monaco's observation fills out Grant's comment by adding to visceral, kinetic excitement the "thrill of violence." As previously mentioned, Thompson has not discovered any breakdown in the basic structure of the classical narrative, but she has noted that scenes of sex and violence have increased. As Sobchack notes in "The Virginity of Astronauts: Sex and the Science Fiction Film," sex is not a subject matter that abounds in science-fiction films[39] (although reproduction most certainly is). Violence, on the other hand, is so prevalent that we have come to accept and expect the physically impossible iconic imagery of fireball explosions in space where there is no oxygen to permit the pyrotechnic displays that are so very prominent and dutifully rendered by the CG teams.

Violence in film, as in life, often is the easy answer. The scriptwriting manuals express the need for scenes to have conflict, for expositional material to arise from conflict, for character revelation to arise from action. This is the old maxim: *Show don't tell.* Action—such as chase scenes—can give a story pace and has been a staple of film from its earliest days. Further, many digital-visual-effects techniques are used to extend scenes and images of violence. As discussed in the framework of narrative functions, these scenes can be extended by exaggerating proximities of danger that are otherwise physically impossible for people to survive (for example, those shots showing actors being thrown through the air by

the force of an explosion that, in reality, has been composited against their stunt jumps onto an airbag). Scenes of violence also are extended by temporal and spatial manipulations, such as *The Matrix*'s slowing down bullets or tracking bullets through space.

Violence, be it an epic battle scene or the customary third-act fist fight, can account for some of the attraction of many action-adventure and science-fiction films. What Scott Bukatman, Grant, and Monaco recognize and describe as kinetic thrills, from a scriptwriting perspective, often are tied to acts of violence or chases and escapes related to threats of violence. This makes perfect sense, since the very foundation of many stories is the risk of death and how to deal with this threat. Many effects are used to heighten this sense of threat and exaggerate the closeness of the hero's brush with death. However, while effects are materially responsible for creating the images and heightening the verisimilitude of the action, they are not the *reason* for the action shot, they are the *means* by which it is achieved. The reason for the protracted scenes of violence and physical peril is considerably more complex and, in all likelihood, is fundamental to our natures. There have always been filmmakers who have scripted these elements into films to capitalize on kinetic thrills.

By way of example, the first film in the *Matrix* series is but one of many popular science-fiction messiah stories. This film, however, presents a messiah who cartwheels while he kills with awesome firepower and little apparent concern that—by the film's own reasoning—he is killing innocent, unaware, virtually embryonic humans. While the messiah dispenses death with acrobatic flair, the spent cartridges rain down, the sound effects providing a metallic Ave. For all its philosophical exposition, *The Matrix* is a celebration of violence—almost a pornography of violence—and its effects work to support the idea of how a man looks when he shoots or is shot, indulging in a kind of Ghost Dance/Boxer Rebellion fantasy of how bullets might miss someone who has downloaded the right level of training.

While the effects in *The Matrix* are not solely directed at supporting visions of violence, they do provide ample demonstration of the difficulty in separating effects from violence and of the graphic imperative that drives contemporary filmmaking. It is likely this graphic imperative, and the previously mentioned tendency of escalating climaxes that Kristin Thompson noted, that is informing the counter-narrative form that is of interest to so many authors. Yet I suspect the effects of interest to these authors are often those effects that represent an escalating violence, a kinetic thrill associated with a close brush with death,

or the violent destruction of an enemy. From the perspective of the effects artist and the filmmaker, these effects are motivated by story-based elements and simply are a more graphically realized and detailed representation of fairly classic story elements.

Turning to the issue of the relationship between effects usage and the science-fiction genre, an examination of the films featured in *Cinefex* provides an interesting breakdown of the kinds of films that have been recognized as landmark achievements in special-effects filmmaking since the 1980s. *Cinefex* is perhaps the most widely known of the professional special-effects industry journals, and as such it provides a ready resource for considering the genres featuring major effects sequences and a means of assessing—in broad terms—the content of the effects employed.

Of the 291 films reviewed in *Cinefex* (from its inception through the end of 2005), 116 likely would be classified as science-fiction films (see Appendix A for the full list). Of these, 63 films are straight science fiction and the remaining 53 are at least some hybrid of science fiction, such as sci-fi/comedy, sci-fi/horror, or sci-fi/thriller. The rest of the films covered by *Cinefex* would be categorized as fitting into the following broad genres: children's (43), action (29), horror (28), fantasy (26), drama (18), comic-book adaptations (16), and period (15).

This breakdown appears to support arguments that rely upon a relationship between science-fiction films and effects, but it also highlights that 175 of the 291 films featured are *not* science-fiction films. In fact, 33 of these groundbreaking effects films are period and drama productions. This speaks to the diversity of films using DVFx and, as the list reveals, the shift from effects being of groundbreaking nature primarily in science-fiction films in the early 1980s to the more diverse spread of genres that exists now, something which began in the 1990s.

This diversity, embracing films that are squarely within the classical narrative tradition, tests the idea that DVFx are necessarily bound to the genre of science fiction and its companion horror and fantasy genres. The arguments that favor this relationship are built upon tying the effects to certain science-fiction genre trademarks: the aforementioned kinetics, the reveal of other societal structures or worlds, and the self-reflexive display of technology.

The sample of films in *Cinefex* shows that most of the science-fiction films use effects to provide convincing representations of outer space, alien worlds, aliens/creatures, the future (including representations of Earth, its technology, vehicles, and weapons), or representations of natural phenomena (such as the interior of the human body or the core of the planet).

The action films use effects to create the illusion of danger and destruction, as do many of the fantasy films, which often also depict exotic sets and locations, creatures, and supernatural events. A number of films also depict physical transformation and altered mental states, but the majority of effects are aimed at crafting a convincing diegetic world, enhancing performances in dangerous situations, and depicting extraordinary events or forces that are often of a supernatural quality. In this sense, then, increasingly the general practice of DVFx to realize story information and story elements in keeping with the basic traditions of the specific genres.

In relation to the discourse on science fiction, however, there remains the matter of the display of technology that has been argued as fundamental to the genre of science fiction, an element that does not have comparable relevance to other genres. Kuhn, referring to Brooks Landon, has stated, "in science-fiction cinema the point is not so much the story as the response invited by the film's visual surface and the ways in which the film depicts technologies and deploys them in its production."[40] She goes on to cite his conclusion that "science-fiction narrative is both discovered in, and shaped by, special effects technologies."[41]

The purpose of this foregrounding of technology and the self-reflexivity of its use is to underpin the thematic matter of the narratives themselves. Science fiction often presents a conflicted stance for its representations of technology. In some narratives technology is presented as the potential savior, for example, the "magic computer" that uploads the virus into the alien spaceship in *Independence Day* (1996, Emmench). Conversely, in others, human meddling—especially against nature—is viewed as akin to Icarus's wings, and our technology undoes us or at least puts us in grave danger, as in *Jurassic Park*. Hugh Ruppersberg states this more strongly:

Science fiction cinema often assumes a rather confused attitude toward science and technology. On the one hand, it views them as redemptive forces that can lift humanity out of the muck and mire of its own biological imperfections. On the other, it sees them as potentially destructive forces, inimical to humanity. What small hope there is, here on earth or elsewhere, lies in the human imagination and heart.[42]

He argues that contemporary films indicate doubt about our ability to solve our problems and are an expression of a need for superhuman aid.[43] His discussion is in relation to the messiah figure in science-fiction films and how effects are used to represent the technological marvels that provide the messianic fig-

ure with its remarkable powers. As an aside, it is interesting to note that the popularity of the *Matrix* series seems to be almost a direct response to Ruppersberg's observations.

This relationship between science fiction and technology is long-standing. Yet, while not losing focus on the relationship between technology and the role it has played in science fiction—especially in an historical context—it is also worth considering to what extent these observations have currency for technically sophisticated audiences, at least in relation to the use of effects.

Many of the effects that once were foregrounded in a synthesis of theme and content are now the stuff of everyday experience. The images of outer space that were extraordinary in 1967 are, if not the day-to-day experience of most individuals in urban settings, accepted as such for some. Space travel, and a world in which live footage from Mars can be viewed on a laptop while waiting for a bus, no longer holds the same sense of "someday." As technology becomes so thoroughly integrated with daily experience, its presence in science-fiction films has to be of an exceptional level to be thematically remarkable.

Space travel, views of other planets, creatures, vehicles, technology, and dystopian representations of a future Earth are well-known parts of popular culture. Film representations of technology are not so much startling as suggestive of what is next. This is so much the case that advertizers have sought to interpolate their ads for technology among cinema trailers in an attempt to suggest that their current products are "the future, here today." Thus science fiction is confronted with need to return to its roots and present stories that deal with the themes behind the technology or be reduced to hybridized versions that use the genre's iconography to present action films or creature flick versions of crime author Agatha Christie's *Ten Little Indians.*

All this is perhaps on the way to digression, but technology's advance into the commonplace of the family living room during the period that DVFx have evolved has rendered technological displays not sufficiently awesome for their own sake. Well-rendered images of space have become expected in a world where people have their own "magic computers" that can pull up images from the far reaches of the galaxy. Simple displays of technology for the sake of spectacularity are becoming difficult to achieve and hard to use without some inference being drawn. So there is an increasing need for the narrative to draw out the thematic conflicts between technology as a potential savior and technology as our greatest threat.

Accordingly the matter of narrative, the means by which the thematic issues and images are given context and expression, again presents itself as a fundamental concern regarding the use of DVFx. Once more, the commentaries in *Alien Zone* on science fiction capture the arguments that need be addressed.

Whenever cinema exhibits its own distinctive matters of expression . . . there is a considerable degree of self-reflexivity at work. Indeed, when such displays become a prominent attraction in their own right, they tend to eclipse narrative, plot and character. The story becomes the display; and the display becomes the story. Does it really matter, for example, that a film like *2001: A Space Odyssey* effectively lacks a plot? The enticement is not narrative involvement, nor even identification with characters, but rather the matters of expression of cinema itself, and this film's awe-inspiringly unfamiliar imagery. Spectators are invited to gape in wonder and abandon themselves to the totality of the audiovisual experience.[44]

The argument in favor of the nonnarrative science-fiction spectacularity of special effects is often cited in the case of *2001*. However, looking through the films with the major effects achievements of the last twenty years, as documented by *Cinefex,* shows that most employ classical narrative structures. Some are better realized than others, yet there is almost always an intention to address classical narrative and these films are ultimately judged on whether they have met narrative standards. In effect, if they are judged to be poor films it is because they do not deliver a satisfactory standard of classical narrative storycraft.

This does not detract in any way from the impact that *2001* has had on the iconography of science fiction, nor does it deny that these once awe-inspiring images have become the simple standard by which even low-budget films are measured. That these images can be achieved by meagerly funded productions is an indication of the extent to which DVFx have become an established and accessible level of technology.

In discussing the academy's approach to mass culture as realized through theme parks, science fiction, Hollywood blockbusters, and comic books, Bukatman argues that these studies have a "reliance on (or faith in) highly linear narrative structures as the overriding, deterministic, and teleological locus of 'meaning.' Objects involving multisemic forms of address are routinely reduced to their narrative 'functions' or, worse, the stasis of narrative 'closure.'"[45] His argument is not with narrativity per se but the refusal to consider these media from a nonnarrativist approach. In relation to this he raises the view that the

term "excess" is misused because the "entertainments do not exceed themselves but rather the arbitrary conditions of narrative's hierarchical dominance."[46]

The tendency to measure a film (and other entertainments) by narrative standards is a frustration for those who seek to consider these forms by new approaches. The arguments proposed by Bukatman, Landon, Ndalianis, and others commenting on the extra-narrative aspects of spectacularity or the baroque nature of spectacle primarily are not necessarily arguments about storycraft. Most often they are not denials of storytelling but are about other readings that films can offer when nonnarrative examination is undertaken. It is because of the consideration that the effects are about "other things" that critics reduce these much larger discussions to dismissals of films with effects as "spectacle in place of story." The elements of films always can be read in wider contexts than story, but that they are read in these ways is not proof that it does not retain fundamental value for what it has set out to achieve as a narrative.

Nonetheless, what must still be answered is the question: Is spectacularity at odds with classical narrative? Discussion of spectacularity and the foregrounding of the technology, which has dominated the discussion of science fiction, argues both for the fact that this is a means of stopping the narrative and also a means of fulfilling the purpose of the science-fiction story: the wonder and magnificence of the material presented. However, as with the earlier example of *Mission to Mars,* the intention can be not only to create a visual wonder for the audience, but also to have the visual wonder of the experience for the characters be implicit within the action of the story.

Like Sobchack, Bukatman observes, "The precise function of science fiction, in many ways, is to create the boundless and infinite stuff of sublime experience and thus to produce a sense of transcendence beyond human finitudes."[47] As the increasing diversity of films using effects indicates, this is not the function of science fiction only. Other genres also create moments of the sublime and arrest the narrative to allow contemplation. In *American Beauty,* the image of rose petals cascading toward Lester from Angela's top is narratively and thematically a spectacular moment, one that is necessary to accepting his assurance at the end of the story that someday we will understand that it will be okay when death comes to us.

Bordwell notes that special effects were essential to the creation of the genre of science fiction,[48] but he also cites that special effects have been "crucial to the development of not only science fiction and fantasy genres but historical epics as well."[49] As the *Cinefex* filmography indicates, the vast opulence of the Titanic,

the glory and tragedy of the Colosseum, and the impossible odds of doing battle against the armies of Mordor are digitally created and enhanced cinematic representations that also seek to "create the boundless and infinite stuff of sublime experience."

What is perhaps singular in the discussions concerning the use of DVFx and science-fiction films is the embedded relationship between science-fiction themes and the technology used to create the films. Bukatman comments, in relation to this, "The reflexivity of special effects (a technology of technology, a cinema of cinema) indeed encourages some sense of identification and mastery. The effect is possessed of its own hypnotic grandeur: it is designed to inspire awe, but always within a reassuring sense of play."[50] While much of Bukatman's discussion is aimed at the need to look beyond the narrative purposes of the effects usage and consider "a phenomenological approach," he observes that the categorization of effects usage as "spectacular" is in fact the principle consideration given them in the discourses. In his view:

Despite the seemingly inexorable movement toward a narrative structure that could ground these effects, this "aesthetic of astonishment" should neither be discounted nor relegated to the realm of "excess." Special effects emphasize real time, shared space, perceptual activity, kinesthetic sensation, haptic engagement, and an emphatic sense of wonder.[51]

This is not at odds with narrative.

There appears to be a view that narrative—especially classical narrative in film—requires an exclusive engagement of the spectator in the experience of the story and that this somehow precludes experiencing moments of sublime, spectacular contemplation. Bordwell acknowledges the artistic motivation that is at work in the classical narrative, and narratives such as *Mission to Mars* and *American Beauty* show that these narratives also require of both characters and audiences moments where spectacularity *is* the story element. In such instances, where these moments are achieved through the use of DVFx, it can be argued that use of the effect is not necessarily intented to stop narrative and engage the spectator on a nonnarrative level but to fulfill the purpose of spectacularity as part of narrative.

Bukatman's work supports this argument: "The cosmic displays of science fiction cinema, produced by technologically advanced optical effects, surely derive from a similar drive for scopic mastery. The overwhelming perceptual power granted by these panoramic displays addresses the perceived loss of

cognitive power experienced by the subject in an increasingly technologized world."[52] He argues that the function of science fiction as a genre is "to compensate for the loss of the human in the labyrinths of blip culture by transforming it into an arena susceptible to human control,"[53] a view that would no doubt be supported by examination of the *Matrix* films. At the essence of his observation is the realization that films can offer a means to confront those aspects of life that are most distressing, and historical analyses of genres have given much attention to the social and cultural concerns that have informed the development of the films in their time.

Although it is always difficult to comment objectively and accurately on the social and cultural concerns of one's own times, it is intriguing that Bruno Bettelheim observes, "Many young people . . . who in some other fashion escape from reality into daydreams about magic experiences which are to change their life for the better, were prematurely pressed to view reality in an adult way."[54] This appears to be echoed in La Valley comments, "One feels that at present there is a yearning for the real to disappear or for the imaginary to become real. Recent large-scale science fiction films move strongly toward fantasy."[55] The rising popularity of films with fantasy themes, especially those that suggest a desire to secure superhuman aid, speaks to Bukatman's observation on the "loss of the human" and the drive to regain a sense of power or assistance, and it is perhaps an indication of the social and cultural forces that have been informing filmmakers during the development of DVFx. That this technology presents the most perfect means to realize such stories is unlikely to be coincidental.

Schatz has commented that "a film genre is both a static and a dynamic system. On the one hand, it is a familiar formula of interrelated narrative and cinematic components that serves to continually reexamine some basic cultural conflict. . . . On the other hand, changes in cultural attitudes, new influential genre films, the economics of industry and so forth, continually refine any film genre."[56]

In *Alien Zone II,* Kuhn paraphrases Grant, who "argues that the distinctiveness of science fictions, in whatever medium, lies in their *expansiveness—* their opening out of new worlds, new ways of seeing and being."[57] As already noted, she has cited these new worlds as being one of the key appeals of the genre. The argument that science fiction has aimed to change world views either to influence cultural attitudes or to inspire contemplation is not unique to the genre although the iconography and thematic material it has employed may indeed be so.

Scott McQuire has argued that, "CGI is largely being deployed to remake older genres 'more realistically.'"[58] In agreement with this, Roy Vallis, in his paper, "The Future of Popular Film Tradition," has argued that "the role of advancing technology has forced even greater reliance on traditional narrative structure"[59] and that older kinds of stories (he cites the *Star Wars* movies and the *Lord of the Rings* trilogy) are now more capable of being realized because of DVFx. One of the great strengths of DVFx is their capacity to create perceptually realistic images of the stuff of legends and mythology. Tolkien's stories draw upon classic tales of dragons, trolls, wizards, and dwarves; and Lucas's galaxy far, far away, while considered the stuff of science fiction, compares with the adventures of *Jason and the Argonauts* (1963, Chaffey). As Vallis observes, "the more we are technically able to represent the real, the more we are attracted to the fantastic."[60] These fantastic stories are often exemplars of classic narrative, with *The Lord of the Rings* being but the most recent.

Further, while many authors feel narrative is overprivileged in the considerations of various film texts, their desire to see other aspects given recognition does not remove the standard of narrative coherence, thematic contexts, and deeper readings that are inherent to storycraft and interpretation. They are, instead, an additional measure or means of interpretation. As Bukatman argues that we should look beyond narrative to appreciate the kinetic thrill of the spectacular display, I argue that we also must look to the spectacular display to consider its narrative import. This does not negate those moments of sublime rapture nor the need for them but suggests that they also can have narrative context and purpose, especially on repeated viewings and as the images move, with time, from the extraordinary to the iconic and expected. This process of incorporating the spectacular into the mundane has accelerated over the last decade. Hollywood's capacity to absorb and represent the novel approach or technique is well documented. David Bordwell, referring to Otto Durholz, the inventor of camera lens technology, says, "One inventor put it well: 'The persistent demands upon motion picture production for novel effects and broader methods of story-telling have necessarily instituted rapid and revolutionary developments in technique.'"[61] This holds true not only for the development and adoption of technology but also for ways to play with story structure, as many of the recent "nonlinear" but classically complete narrative films have demonstrated.

The rise in popularity of genre films, the elevation of the B movie to the A-list, perhaps results not so much from the spectacularity of the effects but from

the straightforwardness of these genres in dealing with societal concerns. Schatz comments that "the sustained success of any genre depends upon at least two factors: the thematic appeal and significance of the conflicts it repeatedly addresses."[62] He also points out that the oppositional conflict—such as the community needs versus individual path of the hero—is an aspect that genre films address as a matter of course.[63] Given his view that Hollywood film genres work "as formal strategies for renegotiating and reinforcing American ideology,"[64] it follows that, for the domestic market, films that allow such negotiation to be enacted would gain popularity at times when the very values of American society are undergoing, if not massive reworking, certainly massive challenges. This also speaks to the matter of "blurred values," an issue that is of global interest, and it might be reasonable to consider this as another reason for genre films' rise in popularity. Films that offer clarity and identifiably "good" and "bad" oppositional discussions are likely to find an audience seeking something that addresses their expectations in the way that genre films do. In summary, as Schatz observes, "movies are made by filmmakers, whereas genres are made by the collective response of the mass audience."[65] The rise of the hybridized genres—the horror/comedy and the science-fiction/action films—might also be a reflection of the hedged bet approach to themes and values, which is another sign of the times.

Although Schatz is dismissive of *Star Wars, Jaws, The Godfather* (1972, Coppola), and *The Exorcist* (1973, Friedkin)—considering their success more a result of marketing than content[66]—the fact is, time has proven each of these films to have reached classic status, and two of them have enjoyed theatrical rereleases with DVFx updates. The "collective response of the mass audience" Schatz talks of has voted strongly in favor of genre films, and their use of digital effects has largely been in support of genre traditions.

In summary then, the perception that DVFx primarily are used by science-fiction, action-adventure, fantasy, and horror films is only conditionally correct, and it is a condition that is undergoing change. Over the last decade, films that are not from the genres of science fiction and fantasy have used DVFx, and this appears to be a growing trend. As for the argument that DVFx use is changing the structure of the narrative form, the discussion so far suggests that the escalation of scenes of violence has more to do with their kinetic attraction than the technology by which these scenes are crafted. There also appears to be a relationship between the formulaic "whammo" approach to scriptwriting and the

rise of violence in films, but, as that is not the direct focus of this book, it is possible to observe only that this relationship appears to be borne out in the course of the research undertaken here.

In answering whether scenes of violence that rely upon DVFx are a demonstration of the effects or an indulgence of the spectacularity of violence, I would suggest that the spectacularity of violence is the *substance* of many DVFx shots. This does not argue with the spectacularity of the shot, but it does specify that it is the content of the image that is spectacular, not necessarily the technology behind its realization. Such an examination is a secondary appreciation, and perhaps a shorthand way of indicating that the images are impressive. The use of the term "good effects" to convey "really awesome explosions" is perhaps sometimes closer to what is really meant by spectacularity being "effects driven."

However, the argument is not as clear cut regarding whether science-fiction and fantasy films enjoy popularity because of the effects or because the effects show something integral to those genres that is particularly attractive to their audiences. Where the effects work thematically to underpin the science-fiction narrative, there is no need to make a distinction between the effects and other factors integral to the genre. However, if the effects simply are used to add kinetic thrills for scenes driven by action/adventure thematics and do not enjoy the thematic relationships associated with science fiction per se, then other attractive factors probably prevail.

Although this discussion is not intended as an assessment of the science-fiction genre, audiences do appear to be attracted to more than simply the effects. Many authors propose quite convincing alternative attractors and, in considering the use of the effects, I have found the issues of technology and expansiveness to retain a number of relevant influences. The display of technology may have, if not changed, at least broadened to include issues that are less concerned with the brave new technology of the future than with the implications of living in a highly technologized world. This may be a factor in why the technology used to create so many film images are now being used across genres, including their use in what appear to be fairly typical dramatic films. Technology is simply an integral part of our way of looking at the world now. Thus, where science fiction once gave us new ways of seeing—and new ideas and worlds to see—and did so through the use of effects, these effects now also offer us a way to express what we are experiencing and, in the case of period films, understand where we have come from and what we may have lost in the process.[67]

So Here's the Deal: A Case Study Considering the Influence of Franchise Filmmaking and Its Relationship to Digital Visual Effects

When a particular film is reprised in the form of a sequel it opens the way toward becoming a franchise—one of the most lucrative and highly prized of Hollywood products. Franchise films, although not new to Hollywood, certainly became attractive to investors in the 1980s, and the opportunity to make a sequel became a standard consideration for many successful films. Some have argued that as sequels became common, it led to story structure changes. In fact, one of the main criticisms against the franchise film is the issue of the open-ended narrative. Such a structure is considered to be contrary to the classical narrative structure, which traditionally requires narrative closure.

This chapter examines the issue of franchise through a case study focusing on the *Alien* films, a genre-crossing series that evolved from 1979 to 1997—the period when DVFx came to prominence in filmmaking. In discussing the neo-baroque and the open-endedness of narratives in a baroque framework, Angela Ndalianis cites the *Alien* franchise, specifically in relation to what she refers to as "the commercial program."[1] In her view, "neo-baroque seriality is the end product of an industry that is driven by cross-media extensions and cross merchandizing."[2] Her arguments, which focus on much wider issues of globalization and exploitation of products for commercial benefit, reference franchised and cross-medialized products such as the *Alien* films in order to show this baroque environment that she and many others believe characterizes our times.

Although I do not disagree with these premises, I argue here that although the *Alien* series is very much a product of the times—including the commercial imperatives that have extensive impact on filmmaking—at the point of

origin it is based on an original and resonant source product in order for such exploitation to have, as the business puts it, legs. This is certainly true for *Alien,* which is not an open-ended story. In fact, across the franchise, there has been a consistent effort to ensure narrative closure—a matter that is discussed in some detail in this chapter. The point here is that while many films become franchises, they are only rarely crafted with this intention, even if often there is hope that the story can be opened up in this way. To achieve the level of success needed to make a franchise possible, it is usually necessary for the first installment to stand on its own as a narrative. Then, once it has proven itself at the box office, there is a move to extend the story and exploit the original material for further commercial benefits. A great many of the ongoing franchises have emerged from these kind of surprise successes—*Star Wars* included. While George Lucas argues that it always was part of a much bigger story, he did craft the original *Star Wars* film as a story that could have stopped at the end of the first film and still have worked narratively. Even within an established franchise, usually there is some attempt to have each of the franchise installments provide a compelling narrative that, while enhanced by knowledge of the whole, is not necessary for the story to seem complete within itself.

There are, however, films that have extended across a number of installments—the most obvious are the *Lord of the Rings* films, or the second and third installments of the *Matrix* series. In the case of *Lord of the Rings,* the originating source—the books by J. R. R. Tolkien—always have been known to the public as a trilogy, and for the films to succeed they were created with the intention of retaining faithfulness with the source. In terms of the *Matrix,* the second and third films were planned and shot to complete a set of film stories (as well as a number of other cross-media products), including the *Animatrix* short films (2003, Chung, Jones, Kawajiri, Koike, Maeda, Morimoto, and Watanabe). Had the first film failed at the box office, however, it is unlikely that *Reloaded* nor *Revolutions* would have been made—or at least, not so swiftly. As with most franchises, follow-up films depend on the success of the one that immediately precedes it.

The *Alien* franchise—a very good example of a successful franchise—is of interest for a number of reasons. First, it was not created with the intention of establishing a franchise. The original script, penned by Dan O'Bannon and cowriter Ronald Shusett in 1976, was called *Star Beast.*[3] Retitled *Alien,* the script was optioned by Brandywine Productions within the year, largely on the strength of the chest-buster scene.[4] Picked up by Twentieth Century Fox, the

project was put into development and passed on to director Ridley Scott. By this stage Ron Cobb and H. R. Giger already had undertaken significant design work, and the script then underwent further revisions by Walter Hill and David Giler, who made the recommendation that two of the crew be played by females, and in fact they cast the lead role of Ripley as female.[5] The film owes its success to many factors, as the many analyses of the film have agreed, Ridley Scott's inspired direction and the masterstroke of casting Sigourney Weaver in the role of Ripley created a landmark in filmmaking. One thing is likely: neither Shusett nor O'Bannon could have imagined the impact their low-budget science-fiction thriller speculation script would have on the history of film.

The second factor that makes this franchise of interest is that four different directors have brought their quite disparate talents to bear on the original premise. This arrangement does not always apply to franchise productions but is one aspect of their nature that makes the strength of the original premise particularly important. Unlike genres, which start with a fresh story within an established generic style, franchises must work within the boundaries set by the original story (even though, in a baroque context those boundaries are increasingly flexible). If chapter 6 examines the different versions of a single story, and chapter 7 examines kinds of films that have evolved into generic groupings, this chapter examines a middle ground—different stages of a story, often based on a central character, and the sometimes genre-jumping, stylistically unalike variations that can arise over the course of the franchise's history.

The third factor is that the *Alien* franchise has been the subject of considerable critical analysis and therefore can be argued to represent a body of work that is substantial and thematically remarkable as well as immensely popular.

In "Internet Fandom: The Continuing Narratives of *Star Wars, Blade Runner,* and *Alien,*" Will Brooker states that as a consequence of the four different directors' visions, "Ripley is therefore flung not just across massive gulfs in time and space but from one aesthetic and generic universe to another, with only her alien nemesis providing continuity."[6] He goes on to note, "The four films are united by two central characters, Ripley and the xenomorph in all its forms, and by a science fiction setting and mise-en-scène, beyond this, however, each is a mutant crossbreed of genres."[7] He describes *Alien* as a horror film, *Aliens* as a Vietnam War film, *Alien*[3] as (British show) "Porridge" meets "Jeanne de Arc," and *Alien: Resurrection* as "something of a European science-fiction art-horror with an injection of black comedy."[8] Stephen Mulhall writes of the four films, "Each film sits more or less uneasily within the genre of science fiction, with

more or less strong ties in any individual case with the adjacent genres of horror, thriller, action, war and fantasy movies."[9]

In her examination of post-classical Hollywood, Kristin Thompson observed, "Both *Alien* and *Terminator 2: Judgment Day* are based on the idea of a cold, grasping firm that is willing to tinker with a species (*Alien*) or a technology (*Terminator 2*) that could be fatal to humanity."[10] She goes on to analyze *Alien*, describing it as "a shooting gallery in space"[11] and notes the skill with which Scott keeps secret the identity of the potential survivor[12]—observing that the marketing campaign focused not on the actors but on the image of the alien egg,[13] which was lit as if were a planet in space, an image not too far removed from the iconic embryo shot in *2001: A Space Odyssey.* Thompson also recalls her experience of believing that the director might go so far as to let there be no survivors and the impact that this had for her on suspensefulness of the film.[14] Indeed, Thompson notes, when the most obvious lead character, Dallas, is killed, "Traditional science-fiction conventions came to seem unreliable guides as to what might happen next."[15]

Thompson comments of the ending that it "hints at the possibility" of what was to come, citing the posing and lighting of Ripley's hand on her chest as a potential prefiguration of her future.[16] It is an image that with hindsight does suggest the future, but it does not of itself constitute an unfinished, open ending to the narrative, and so it would appear that the first installment, at least, conformed to classical narrative structure. Of the final film in the series (to date), Thompson notes, "The action-packed, overblown, and inexplicably overrated third sequel to *Alien, Alien: Resurrection,* suggests that the exponential need to raise the level of action with each successive season of filmmaking has by the late 1990s reached absurd heights."[17] As she remarks, *Alien: Resurrection*'s "concentration on action does not represent a post classical approach so much as incompetence."[18]

The response to the individual films also has followed a fairly typical pattern for franchise products. In 1979 the first film was a box-office success but it was not followed up until 1986. This second film's success rivaled the original's and has become a classic collector's edition DVD release. The third film (in 1992) was considered a disappointing addition to the series, and the death of Ripley gave audiences reason to believe that the franchise was at an end. When the most recent version was released in 1997, initial interest was swiftly followed by almost rancor at the interpretation it offers. This pattern, of surprise success followed by repeat success and then disappointment leading to outright dislike,

is not unusual. Franchises often are sparked by an excellent originating premise that deserves further development but winds up being milked of its originality and promise over the course of the franchise's exploitation.

In this case, across the series the films touched on issues that prevailed in the wider community: technology, corporate greed and amoralism, globalization, mad science, and the ongoing popularity of prehistoric monsters. The first film followed hard on the heels of a film that is considered to be responsible for triggering a new cycle of the horror-film genre: John Carpenter's 1978 classic, *Halloween*. As *Alien* combined the already popular science-fiction genre with the emerging cycle of horror, it satisfied two trends and cleverly used a marketing tag line that signalled this: *In space no one can hear you scream.*

When the second film came out in 1985, action films were enjoying great success and the sequel's director, James Cameron, had earned his reputation with his science-fiction/action success, *The Terminator.* The film's tag line—*This time it's war*—promised plenty of firepower and a monster that had already pushed a great number of psychological buttons, and the sequel delivered box-office success. Cameron remarked that while Ripley survived physically in the first film, the second film offered psychological survival;[19] her accepting responsibility for the child, Newt, and the image of the "family" escaping the threat to its survival suggests both resolution of her inner qualms and restoration/preservation of the family unit.

With the popularity and substantial financial return of the first sequel, it is surprising that it took another seven years for the third film in the series to reach the screen. In keeping with the approach of taking on directors early in their careers, *Alien³* director David Fincher came from music videos and commercials, but the tag line's promise—*The bitch is back*—did not deliver the level of action, horror, and spaceship vulnerability of its predecessors. Its downbeat ending, while offering narrative closure, does not offer a happy resolution, and the film did not attain the level of audience support achieved by either of the previous films. It is therefore somewhat understandable that *Alien: Resurrection* would have to invite audiences to believe the impossible—*Witness the resurrection*—its tag line challenging the legions of fans to believe that they could bring not only Ripley but the franchise back from the dead. As Brooker's many-genred description suggests, the generic hybrid/clone fourth film was as ill-conceived as its versions of Ripley herself.

Alien relies upon traditional special effects to achieve its results, something Scott comments upon in the DVD release.[20] Indeed, at a number of points

he remarks that with the benefit of CG so much more could have been done. Cameron also comments that to push the effects further, he used every trick in the book—camera speed manipulations, wires, and even turning the camera upside down—to push the action in *Aliens*.[21] However, by 1992 DVFx were beginning to come into their own. *Alien*[3] uses a strong mix of traditional effects and DVFx to achieve its results. The alien is a combination of puppets and actors in a suit. Matte paintings, rotoscoping, virtual camera moves, miniatures and models, composites, and motion control also are used. The most notable use of DVFx, though, is the image of Ripley diving into the liquid fire in the furnace, clutching her alien spawn to her bosom; fulfilling the heroic challenge to leap, if falling.

Resurrection is the first in the series to be a full-scale DVFx film while still relying, where appropriate, on all the usual traditional special effects.[22] Although this version also uses puppet/animatronic aliens and actors in suits to create its monster, *Resurrection* is the only film in the series to have a fully CG creature blended into the action. The film also uses DVFx to sell the idea of Ripley's hybrid/clone nature: the morphs of her maturation, the CG of her hand being pierced by Call's knife, the acidic properties of her blood, and her superhuman leap from the docking pier to the ship. In broad terms, the DVFx are used to convince the audience that the CG alien is natural and that Ripley is not. The other uses are of a more commonplace nature—the Seamless use of matte paintings and set extensions needed to provide the scope of the interiors, the diegetic world of outer space, and composites enhancing the level of danger posed to the humans, including in this last instance, a virtual camera move providing an internal view of a chest-buster scene.

It is not only in its extensive use of DVFx that *Resurrection* is a work in contrast to the previous films. Where the ship *Nostromo* was claustrophobic, the *Auriga* is huge; where the computer in *Alien* is called "Mother," in *Resurrection* it is "Father"—a highly suitable choice given that the alien and Ripley are manmade offspring, the monstrous hybrid/clones of science. Where *Alien* deals with the irrepressible urge of Nature to reproduce, *Resurrection* deals with the irrepressible urge of Man to meddle.

In his paper "The Mummy's Pool," Bruce Kawin comments, "Horror emphasizes the dread of knowing, the danger of curiosity, while science fiction emphasizes the danger and irresponsibility of the closed mind. Science fiction appeals to consciousness, horror to the unconscious."[23] *Alien*, as a science fiction/horror film, offers something to both conscious and unconscious needs.

That it set up a powerfully attractive "world" for so many variations on its themes is hardly surprising.

Mulhall examines the series in his book, *On Film.* He comments, "From beginning to end, the *Alien* films present us with small, isolated groups of human beings framed most immediately against the infinity of the cosmos."[24] The appeal of such films to audiences in a world that has entered the space age and that has been the first privileged with a view of Earth from space, is fairly obvious. Against this cosmic background is another theme that links the four films: reproduction.

The first film emerged when feminist influence was finally beginning to make an impact, and the most recent film was made when the impacts of feminism were beginning to be measurable. Central to both the films and feminist interests is the question of reproductive power. It is interesting that the casting of a woman in the lead role for these films shifts the context from fairly straightforward arguments of Nature versus technology, or simply monsters versus humanity, to more complex issues or aspects of these issues.

Critical studies of the series have assessed the themes of motherhood; Nature versus science; fertility versus celibacy; masculinity and rape versus femininity and purity. Much has been made of the sets for the first three films, comprising as they do so many tunnels dripping with the monster's mucous. In her book *The Monstrous-Feminine,* Barbara Creed cites *Aliens* as representing "the amoral, primeval mother."[25] She argues, "when woman is represented as monstrous it is almost always in relation to her mothering and reproductive functions,"[26] and she states, "It is the notion of the fecund mother-as-abyss that is central to *Alien;* it is the abyss, the cannibalizing black hole from which all life comes and to which all life returns that is represented in the film as a source of deepest terror."[27] Yet the stake in these films is always survival and it takes survival of the female to guarantee this. As Joseph Campbell notes, women are born heroes with their heroic journey clear: the trial of birth and motherhood that has traditionally been a woman's proving ground, whereas men need quests and rings to destroy because they cannot give birth.[28]

Ripley, in the first film, is indistinguishable from the males. All of the characters are treated with nominal workplace equality, although the gender tensions are allowed to surface. As a member of the crew she demonstrates competence and loyalty to the protocols (over which she is challenged and defeated), and there is no romantic plotline to interfere with the main task of escaping from the alien and defeating it. In the first film it is a male who "gives birth," and at

the end Ripley is safe in the womb of the emergency evacuation vehicle (EEV), like an egg in her hypersleep capsule. All of these images and themes conform well with the issues that faced women in the late 1970s—the idea that motherhood was best avoided while achieving equality in the workplace and that things might be different if men had to give birth (an idea that obviously worked well as a horror-film concept for the men in the audience). For many women the goal was to prove that they could indeed be equal to men in their own arena and that one of the ways to achieve this was to downplay femininity and accentuate technical competence.

By the mid-1980s sex roles had changed slightly, and thematically there was an attempt to reconcile the demands of motherhood with those of a career by showing Ripley escaping into the EEV with a "nuclear family." The bitch fight between the two mothers, where Ripley is given advantage by assuming her place in the machine (at which she has demonstrated her technical prowess earlier in the film) helps sell the idea that a masculinized woman is a better mother, better able to protect her young. In this film the android is her ally and her fight is with the Queen, the monster that breeds in great numbers. Creed says of this, "the Mother Alien represents Ripley's other self, that is, *woman's,* alien, inner, mysterious powers of reproduction."[29]

In the third film the brute realities of the masculine world are brought to the fore. Bereft of her "family," Ripley is stranded in a double-Y-chromosome–populated frozen hell where the dregs of the world are awaiting their end, engaged in a self-sustaining brotherhood that considers her "the intolerable." Her mere presence is anathema to them and the Company—the firm that has always prized the weapon potential of the alien over the lives of the humans—is en route to take her prisoner. Where in the previous films Ripley is always able to defeat the Company's ploys and maintain her integrity, this time she must destroy herself because she—having finally become sexually active—is bearing the monster and will not surrender her offspring to the Company. Here Creed remarks, "Ripley/woman is betrayed by her body, unable finally to preserve her own flesh from contamination by the abject, alien other—the monstrous fecund mother."[30] By 1992 statistical information was beginning to emerge that while women were in employed in a wider range of fields, their representation and their remuneration had not attained the level of equality feminism had argued could be theirs. Furthermore, a generation of women was facing the possibility that significant numbers of them may never have children.

Seven years later, as in-vitro fertilization becomes common practice and clones become a viable technology, *Resurrection* brings forth its own version of Ripley, and this time she is the monster and the monster is her. In this film, the alien must now reproduce through gestation and delivery of live young. Once more, Ripley must kill her kin. Gone are the sets full of dark, wet tunnels. In their place are laboratories and gleaming technology.

The choice of a female hero for these films is apt, and it is worth noting that Sarah Connor (*Terminator* series), one of the few other female leads in a franchise, was also defined by her reproductivity and role as a mother. In the *Alien* films the themes have been enriched immeasurably, and the struggle of Man against Nature is a quite different fight than that of Woman at battle with the irrepressible breeding power of Nature. In *Aliens* there is Newt, the substitute daughter; in *Alien³* it is a prison colony of rapists, and Ripley pitches herself into the flames to kill the offspring she bears; in *Resurrection* she is the manmade reconstitution, and the tubes of mutants show what happens when Man meddles with Nature. The setting of this small group of humans against the backdrop of the cosmos—a cosmos that humanity is beginning to see firsthand and to appreciate from its experience of this vision the meaningfulness of Kubrick's embryo in space—is not simply exotic or spectacle for spectacle's sake, but integral to the deep issues being faced and explored within the stories.

Mulhall also comments on this impact of casting Weaver in the lead. As he puts it, "one of Scott's most effective subversions of the hybrid genre in which he is working (his association of femininity with heroism rather than victimhood) turns out to be dictated by the logic of his monster's monstrousness."[31] It was a decision that made for dramatic as well as thematic impact and turned the face-off between the protagonist and antagonist into a "fair" fight, one that was both meaningful and necessary for narrative completeness. For him the alien represents "Nature incarnate or sublimed, a nightmare embodiment of the natural realm understood as utterly subordinate to, utterly exhausted by, the twinned Darwinian drives to survive and reproduce."[32] As a result, the confrontation is more than the customary third-act fistfight, it represents a fundamental battle that still rages. He argues, "Ripley's denial of her maternal drive is integral to the themes. She is in opposition to the monster's need to reproduce.[33]

He also notes the significance of the change in her role in the second film, stating, "Her accelerating inhabitation of the role of mother to Newt is, however, central to the film's development throughout."[34] He interprets this as a further

development of Ripley's role as hero, one that supports Barbara Paul-Emile's theory of warrior women. As Mulhall says, "Certainly, on the film's view of the matter, if the true warrior is nurturing, the true nurturer is a warrior."[35] This warrior, however, will have other battles to fight and not simply with the irrepressible reproductive monster but with the masculine world and the Company's obsession with ultimate weapons.

In comparing the second and third films Mulhall observes "Cameron presents his film as giving Ripley the therapy she needs to wake from such nightmares; Fincher presents his film as awakening Ripley from Cameron's dream."[36] One can see this according of a family in *Aliens* representing an answer to the corporate, masculinized woman's dilemma, with the "therapy" being the fulfillment of a dream to achieve both warrior and nurturer roles, then as the third film depicts, an awakening to the nightmare that the world does not easily allow such things to be fulfilled. As Mulhall observes, "For Fincher, nothing— not even achieving the requisite degree of emotional resilience, the ideal combination of male warrior and female nurturer—can guarantee anyone a happy ending, or render them immune to accident or ill-fortune."[37]

Ripley realizes that, as Mulhall puts it, "she is the alien; it incarnates the nightmare that makes her who she is, and that she has always been incubating."[38] This is a realization that many modern women also reach. It can be read that whatever choice a woman makes, her decision will bear the seeds of her own disaster. By breeding she becomes the monster, in failing to breed she defeats herself. As Mulhall argues, "Since the alien itself originates from within her, since it is an incarnate projection of her deepest fears, she can succeed in eliminating it only by eliminating herself."[39]

As Mulhall remarks, "Fincher's primary preoccupation as a director is with closure."[40] For many corporatized women the closure of experience is the fate of never achieving motherhood. Mulhall's comment on the third film is that, "The achievement of closure here, so absolute and on so many levels at once, has an elegance that almost disguises its nihilism."[41] He then goes on to describe the final scenes of the fourth film in a particularly grim account:

As she soothes the child's fears and frustrations in the Betty's cargo bay, she uses her own acidic blood to incise a small hole in one of the windows, and the monstrous infant is gradually sucked through it, its pleading wails eventually silenced as the last particles of its body are squeezed into space. This climax is an inflection of a familiar trope of the series: the first two films culminate with an alien's ejection into space through an airlock, the third with the alien queen's ejection from the universe as such.[42]

While Mulhall likens this ejection to "a grotesque parody or inversion of its birth, and hence of birth as such,"[43] in truth, it is more akin to an abortion—as a result of its mother's actions, the child is sucked from the safety of the womb and reduced to particles in an environment in which it cannot live. Potentially, this is another statement on the issue of reproductive power, or power over reproduction.

In relation to the *Alien: Resurrection,* Mulhall also makes the observation that "Jeunet's film thus finds a way of grafting two apparently opposed or contradictory modes of reproduction onto one another. Cloning suggests replication, qualitative indistinguishability, whereas hybridity suggests the cultivation of difference, a new creation."[44] This hybridity, this impetus to create something new, is intrinsic to genre filmmaking and speaks directly to the appropriateness of the evolution in the technology used to create the images for these films.

From a beginning reliant upon traditional special effects techniques to a conclusion (or not) powered by digitally assisted techniques, the path is similar: natural reproduction evolving into scientifically created reproduction. Where the alien in the first film is someone in a suit or a puppet, the alien in the last film is a CG construct, generated entirely by the machine. The CG performer, as discussed previously, is not always apparently "the other" but often can be crafted from human performance and animation, creating an eerily hybrid presence or, in some instances, performances that are indistinguishable from live action.

This is of interest not only because of the implications it has in connection with this series of films, but for the wider concerns of franchise filmmaking. Christine Geraghty discusses Harrison Ford's performances in a number of franchise films, observing that "stars such as Ford, who work within the star-as-professional category, operate for cinema/video in the same way as a character in a television series, providing the pleasures of stability and repetition and the guarantee of consistency in the apparent plethora of choice offered by the expanding media."[45]

This "guarantee of consistency" is an important quality as one of the "expiration date" factors for a franchise is, of course, the lead's lifespan—or role-credibility span. For most men, this is a measure of their ability to undertake action roles, something DVFx most certainly can prolong. Needless to say, digitally created characters do not have such limitations although, outside of animation, there have been no comparable digital "stars" on offer for franchises as yet. The closest thing to emerge have been the dinosaurs in the *Jurassic Park* franchise but, as James Monaco notes, the James Bond series—which has cheerfully

substituted Bonds for over four decades—appears to be leading the franchise pack.[46] Further, as the technical standard and acceptance of digitally enhanced performances grows, it is not beyond the bounds of possibility that digital extension of actors' performances will find the means to overcome some of the issues of aging actors.

This success would appear to support Mulhall's observation that "An important issue here is the way in which a 'franchise' can renew itself over time, in part by explicitly reflecting upon what is involved in inheriting a particular set of characters in a particular narrative universe—the constraints and opportunities internal to . . . that inheritance."[47] A few franchises—such as the *Bond* films or the *Star Trek* films—draw upon a wide fan base that is open to new characters or new actors in set characters' roles. However, these examples aside, franchises generally appear to follow the pattern described earlier, with stories reaching a natural conclusion if for no other reason than exhaustion of the original premise. The baroque exploitation and cross-media development of franchise elements described by Ndalianis and Norman Klein highlights the extension of franchises across other platforms, ones that allow greater scope once freed from the linearity of a film or TV series, and these products are emerging as a lucrative commodity for commercial interests. Nonetheless, film products have not been as swift to discard the need for continuity with earlier versions, even as sequels numbering in the double digits are only tenuously linked to the source version.

In discussing a similar evolution within genres, Thomas Schatz turned to the work of Henri Focillon, who identified certain stages in works of art:

[Focillon] . . . observes that the continual reworking of a conventionalized form—whether it is in architectural style or a genre of painting—generates a growing awareness of the conventions themselves. Thus a form passes through an experimental stage, during which its conventions are isolated and established, a classic stage, in which the conventions reach their "equilibrium" and are mutually understood by artist and audience, an age of refinement during which certain formal and stylistic details embellish the form, and finally, a baroque (or "mannerist" or "self-reflexive") stage, when the form and its embellishments are accented to the point where they themselves become the "substance" or "content" of the work.[48]

Remaining within the scope of Schatz's reading, the *Alien* series can be seen as conforming to these stages. *Alien,* with its cast of relative unknowns, offered an experiment in science fiction/horror that led to the "classic" offering of *Aliens.* This was followed by the "refined" version of the story, *Alien³,* in which

the stylistic details of the previous films were the primary linkage between the films, and then finally the "baroque" offering of *Alien: Resurrection*. This view offers the franchise as a body of work that can evolve in its own right. Mulhall comments of the *Alien* franchise that "these films do genuinely form a series (a sequence in which each member appears as generated by its predecessor, and generative of its successor."[49]

From this it is obvious that the franchise need not simply be a means of extending the box-office take on a good idea. When a film is particularly resonant, as *Alien* appears to have been, the franchise can offer a means by which an emerging and significant issue or set of issues can develop and explore the concerns of the wider community. Much as happens in the evolution of independently crafted stories in genres, within franchises a more specific set of issues can be confronted and commented upon.

Specifically, the *Alien* franchise also shows how the themes of the film can be underpinned not only by the use of the technology but by the technology's development over time also. While many authors have noted that this is integral to the science-fiction genre, generally this has been in relation to the display of technology within the film. In regard to the *Alien* films, however, the nexus is particularly meaningful. Starting from a point of natural production and ending with scientifically crafted production as a narrative theme, the coincidental development of DVFx and the franchise's culmination in a CG alien and multiple versions of Ripley show us that our stories can speak to the heart of our experiences and our fears about their implications. As Schatz quotes Leo Braudy, "Genre films essentially ask the audience, 'Do you still want to believe this?'"[50] It would seem that a purpose of the franchise is to pose the same question but perhaps in relation to a much more specific set of circumstances.

9

ET 2 AI: Steven Spielberg

Many factors impact upon storytelling, including the story itself, the kind of story being told, and who is telling the story. Within each of these facets are additional aspects that can be of influence. Previous chapters examine different storytellers dealing with ostensibly the same story and different stages of a story told by different storytellers. This chapter shifts focus to one storyteller's approach to different stories.

Some directors are primarily "effects" directors. Others have a particularly unique style that incorporates DVFx in innovative ways. And a few are famous for especially important DVFx films. Within this diversity, one director's work stands out because it is well versed in special effects, commences prior to the emergence of DVFx, spans a wide range of film types, and has enjoyed critical and box office success. That director is, of course, Steven Spielberg.

However, no discussion of digital visual effects would be complete without first giving some consideration to two other directors whose work has been cited as most influential on the development and acceptance of digital visual effects: George Lucas and James Cameron. Their names are synonymous with effects films, and they have made quite different contributions to the history of DVFx.

Lucas remains the undisputed champion of digital filmmaking not only for his advances in the development of DVFx but for his achievements in nurturing developments in digital sound and in editing, and for the creation of Lucasfilm Computer Graphics Division, the computer animation studio that later became Pixar. Lucas is unreservedly supportive of digital effects as a key approach to filmmaking and has consistently pushed the technology to attempt

major innovations. While many of these innovations, including the integration of CG characters in live-action films, are elements of his own films—most notably in the *Star Wars* series—his DVFx company, ILM, also has provided groundbreaking images for a great number of other filmmakers.

A graduate of the University of Southern California's film school, Lucas earned his reputation with the edgy science-fiction film *THX1138,* which he made during his student days in 1971, but his first Hollywood success was the small-town-America drama *American Graffiti* (1973). Considered one of the new Young Turks in town, Lucas was able to negotiate a considerable amount of creative control over his next project, *Star Wars,* a film that would earn him financial and creative independence and a global following.

Of *Star Wars* Lucas says, "There was no modern mythology to give kids a sense of values, to give them a strong mythological fantasy life. . . . Westerns were the last of that genre for Americans. Nothing was being done for young people that has real psychological underpinnings and was aimed at intelligent beings."[1] His childhood film-going inspired a desire to re-create the experience for a new generation. Many people working in the DVFx industry call *Star Wars* a film that "changed my life" and say it inspired them to work in DVFx, even though many of these artists entering the industry now were not even born when the original film first screened in a movie house.

While *2001* reinvented science fiction, *Star Wars*—building upon the foundation Stanley Kubrick established—reinvented special effects. The use of special effects in Hollywood had reached such a low by the time Lucas began *Star Wars* that, as John Baxter says, "studios spent most of the decade closing their special effects and animation departments. In 1973 and 1974 the Academy didn't even bother to award Oscars for special effects."[2] Lucas's dedication to the craft and his ability to use effects in projects that struck a chord on a narrative level thus changed the filmmaking landscape.

In an interview before the film was released, Lucas says, "We went into this trying to make a cheap, children's movie for $8 million. We didn't go in and say that we were going to make the perfect science fiction film, but we are gonna make the most spectacular thing you've ever seen!"[3] From the opening shot audiences knew they were in for something entirely new. Where Kubrick mesmerized with brilliant images and an intellectually intriguing nonnarrative, Lucas married brilliant images with classical narrative. He remarks, "I . . . tried to stay with universal themes apart from violence and sex, which are the only other two universal themes that seem to work well around the world. My films

aren't that violent or sexy. Instead, I'm dealing with the need for humans to have friendships, to be compassionate, to band together to help each other and to join together against what is negative."[4]

As previous comments indicate, a great deal is made about the relationship between *Star Wars* and Joseph Campbell's work. As Lucas's biographer documents:

Lucas invited Joseph Campbell to lecture [at Skywalker Ranch], impressing John Williams, [who said]: "Until Campbell told us what *Star Wars* meant—started talking about collective memory and cross-cultural shared history—the things that rattle around in our brain and language, the real resonance of how the whole thing can be explained—we regarded it as a Saturday-morning space movie."[5]

Baxter goes on to observe that "Campbell argues that every epic, no matter what culture created it, rests on two or three characters and a personal conflict, usually between father and son, which embodies the eternal battle between good and evil."[6] The father-and-son relationship, however, is unknown within the first film, and had the film not enjoyed the success it did, the revelation may never have come out. Whatever the extent of Campbell's influence, or whether his work simply rings true in this narrative as in so many others, Baxter makes an important observation. As he notes, "Critics of Lucas's *Star Wars* concept almost never grasped the two fundamental differences that separated it from other science fiction films of the seventies: it was optimistic, not dystopic; and it took place not on a planet, but mostly in space."[7]

Lucas's optimistic take on the future was as refreshing as Spielberg's take on aliens as friendly. Creating a galaxy "far, far away" where space travel was as common as our air travel and life on another planet was as familiar as life in Everysmalltown, USA, Lucas offers, as he subtitled his script, a new hope. Yet while both directors show a similar ability to put a new view forward in relation to traditional science-fiction themes, as Baxter observes, "Spielberg wanted to show how an ordinary man reacted to the arrival of galactic beings. Lucas dreamed of extraordinary people on planets and galaxies distant in both space and time."[8] In this way, then, Lucas's aim is to mix both mythic and fairytale elements, as previous discussion notes.

Cameron's work stands apart from other effects directors because of his use of traditional romance in his storylines. *Titanic,* for all its use of technology, is essentially a period romance. Underpinning his script for *Strange Days* (1995, Bigelow) are some very complicated personal relationships. Even *Aliens* suggests that Ripley has left her "sole survivor" persona in the past and is escaping

into the future with her new family. This approach is wonderfully effective for winning audiences. While *The Terminator* exceeds all the usual expectations for action sequences, the story is also about the guy from the future who comes back in time *for her.* In marketing terms it's a perfect date movie: action, gory hold-my-hand killings, and time-traveling romance.

Although Cameron's early film experience was in production design, his focus was scriptwriting and, following the success of *The Terminator,* he has written all of his own feature-film scripts. He also has earned a reputation as one of the most expensive filmmakers in Hollywood although, unlike many others granted access to large budgets, Cameron's box-office returns have been commensurate with his spending excesses. His use of effects is highly innovative, and *The Abyss* and *Terminator 2* are considered two of the most pivotal moments in the development of DVFx.

Cameron's body of work, however, is not broad. Since *The Terminator* in 1984, his credits as a narrative feature-film director include only *Aliens, The Abyss, Terminator 2, True Lies* (1994), and *Titanic* (1997). Although other projects have taken his attention (the 1996 *T2-3D* theme park project, *Dark Angel* TV series (2000–2002) he created, and his 2003 *Ghosts of the Abyss* documentary), like his feature films these projects largely fall into the science-fiction and action/adventure genres. Within these genres he is undoubtedly a respected filmmaker whose use of some of the most astonishing DVFx effects are a consequence of his narrative demands. However, Cameron does not work in a wide range of story types.

Thus, where George Lucas's feature film directing since *American Graffiti* has focused almost entirely upon the *Star Wars* films, and as James Cameron's work mainly has been restricted to two genres, excepting the period romance *Titanic,* for a more extensive range of work attention must turn to Spielberg.

Spielberg probably is the most representative of his generation of filmmakers. Although *Duel* (1971) and *The Sugarland Express* (1973) received renewed attention in light of Spielberg's later success, it was *Jaws* in 1975 that elevated him to the ranks of the major filmmakers. He followed this success with *Close Encounters of the Third Kind,* a film that portrayed the meeting of alien and human as a potentially positive and enlightening experience. The next film, *1941* (1979), was not a success but his direction of a Lucas script a few years later was so successful that he overcame any criticism that might have been forming against him. While the *Indiana Jones* film *Raiders of the Lost Ark* (1981) returned him to box-office success, *E.T.: The Extraterrestrial* (1982) kept him there.

E.T. was the last feature film Spielberg made before DVFx started to find their way into feature films and, like Lucas with *Star Wars,* Spielberg later would return to *E.T.* in order to make changes using DVFx. Some of these effects were Seamless, to correct the look in order to heighten verisimilitude, as in the flying scenes where Elliot's cape did not billow in the first version of the film. However, more crucial, Spielberg was able to make a change that his conscience dictated. In the first, nondigital version of the film the government agents tracking the children have guns. Spielberg regretted showing children being put under armed threat, so the guns were digitally removed in the amended version. Had it not been so well-known, the change would pass as an Invisible use of effects.

He next directed one of the segments in *Twilight Zone: The Movie* (1983, Dante, Landis, Miller, and Spielberg) and then returned to the *Indiana Jones* franchise with *Indiana Jones and the Temple of Doom* (1984). This film, a darker offering than the first, was successful but did not enjoy the warm reception the first in the series received. Spielberg's next film, *The Color Purple* (1985), is considered his attempt to prove that he could make serious dramas. The African-American story—directed by a white director—attracted a fair amount of controversy, but the film earned box-office and critical success, including eleven nominations for Academy Awards.[9]

He followed *The Color Purple* with *Empire of the Sun* (1987), another drama, which included a CG "squadron of aircraft flying over Shanghai, a wide aerial view of a stadium and the blinding light and shock waves of the Nagasaki bomb."[10] These effects showed his ability to use effects Invisibly and Seamlessly to enhance the diegetic world, an approach many would consider out of character for an "effects director." Yet it is exactly this ability to use effects with sensitivity to the narrative's needs that makes Spielberg's work exemplary in DVFx practice. *Empire of the Sun* was not a box-office success for Spielberg, and in a town that judges its denizens by their last production, he wisely moved on to the third in the *Indiana Jones* films. *Indiana Jones and the Last Crusade* (1989) also used DVFx in a controlled way, stitching stills together to demonstrate the destruction of Indy's nemesis, Donovan. The film had Spielberg back on top in the box office, and continuing what was becoming a pattern, he followed it with a riskier project, the melodrama *Always* (1989).

Although *Always* does rely on effects to carry its aerial sequences in an understated and Seamless way, it was *Hook* (1991) that saw a return to the kind of children's film full of effects with which Spielberg is generally associated. By this stage the evolution of DVFx had reached a point that allowed convincing

representations of the characters flying. The lavish Fantastical effects were in keeping with the narrative and also with the industry's desire to push what could be achieved with the new technology. However, the good returns at the box office fell below the level of a Spielbergian success. That would be corrected with the film that followed, *Jurassic Park*.

Jurassic Park's CG dinosaurs were undoubtedly the stars of the film. Their creation, building upon the work undertaken in other films of the period—not the least of which was *Terminator 2*—introduced another round of major technical breakthroughs, the full realization of which still is being enjoyed in films being made now, more than ten years later. Animators and programmers worked to ensure that the CG dinosaurs behaved in physically persuasive ways and, supported by the live-action performance elements in the background plates, their integration with the environment sold the diegetic world.

The "clash between human and nonhumans" has been identified as a recurring theme in Spielberg's films.[11] And, as Ian Freer states, "Visually *Jurassic Park* follows the Spielbergian tenet of locating the fantastical in a believable setting."[12] The film achieves both the fantastical in the believable setting and brings humans and dinosaurs together, again believably, through the use of a convincing scientific argument and DVFx that are as scientifically valuable as they were cinematically spectacular.

The script is a very tightly constructed classical narrative that draws upon a meticulously researched novel by Michael Crichton. The theory that dinosaurs could be cloned using DNA in blood extracted from mosquitos caught in amber seems plausible considering a scientific community that has cloned animals and grown human ears on the backs of laboratory rats. Having established the possibility that science could create such a scenario, the question then became: If this were to happen, what would they look like? It is here that the link between cinematic realization and scientific modeling is made.

The film itself is something of an elaborate narrative cogitation on the ethics of scientific experimentation and human folly. *Jurassic Park* is both a standard monster chase-and-attack film and a morality play about commitment and parenting. The "A" plot is ostensibly the theme-park adventure and the survival test of encountering the dinosaurs, with the "B" plot focusing on the betrayal by the computer expert who is selling the dinosaur eggs to the competitor. The "C" plot attends to the relationship between Ellie (Laura Dern) and Alan (Sam Neill) and allows the morality play to unfold by exploring the themes of Ellie wanting to have children and Alan being the male who threatens the species

by not being willing to fulfill the responsibilities of breeding and caring for offspring. The interworking of these three plots allows the subtext of Alan's character development to be realized in his actions in protecting the children throughout the chase-and-attack sequences of the main plot and also to offer a counterpoint argument about "life finding a way," the movie's stated theme. The subplot concerning the betrayal of the company secrets triggers the crises in the main plot and so each of the plotlines works to support and underline the other themes and narrative threads.

Similarly, the effects themselves—both special effects and digital effects—work to underpin the themes and the narrative requirements. The use of the "magic computer" to convey expositional information about the science crucial to the understanding of the narrative is a cinematic tool and a typical Documentary use of digital technology to demonstrate scientific principles. Thus it is an example of the technology being used for narrative *and* technological purposes, that is, storytelling and the documentation of scientific ideas. Digital visual effects routinely serve one or the other of these purposes, but within this film they achieve both. The narrative also relies on computers as a plot point to trigger the circumstances that allow the dinosaurs to gain access to the humans—just as computers are used to clone the dinosaurs and make them accessible to humans. That massive computing power was required to bring the dinosaurs to life is mentioned within the narrative, yet this is also a statement about how the dinosaurs are brought to the screen.

Further, the dinosaurs themselves work narratively and as scientific revelation. The images revealed in the movie were the first public screening of CG-modeled dinosaurs. The first sight of dinosaurs in the movie is of CG characters created uniquely for this film. It is a moment in the narrative where the characters themselves stop to experience the awe of their first sight of the science that has shaped their careers and also, for the audience, it is the first sight of dinosaurs as science would have them represented to us. This twinned moment of spectacularity serves both the narrative and the lived experience of our study of dinosaurs.

Their representation in a narrative does not take away from the significance of their depiction as a scientific representation of dinosaurs. Thus, through narrative, members of the audience are given an opportunity to have the experience of seeing dinosaurs themselves for the first time. This point is made within the narrative by Hammond, the creator of the theme park, when he says, "I wanted to show them something that wasn't an illusion." In some way, the use of CG to

portray these creatures is a step beyond the traditions of clay dinosaurs and toward a level of representation that is closer to science; it is an attempt to present a visual depiction that is a demonstration of scientific knowledge more than cinematic fancy. Yet the film does not take itself so seriously that it is unable to make the self-parodying display of merchandizing in the set where the final dinosaur attack will take place.

It is this deft shifting among exposition, philosophizing, and storytelling that makes *Jurassic Park* an interesting film for analysis of the relationship between its narrative and its effects practice. Just as the text of the film shifts between textual states, the shifting between kinds of effects practice—the use of animatronix and CG images—reflects a debate that was very contested at the time the film was being made. The argument that natural, crafted effects were better than artificial CG effects had many followers. Many filmmakers thought that CG would never be able to portray a convincing living creature, yet "the results [of the test shots for the gallimimus herd sequence] were so amazing Spielberg wrote the sequence into the script."[13] Further, "Encouraged by the CG team's progress, Spielberg eventually devised a new ending for the film in which computer generated raptors would be joined by the computer generated T. rex in a showdown between the fierce predators in the visitor center rotunda."[14] The results are so persuasive that Mark Dippe says, "With *Jurassic Park,* we've created something that is in a direct line of the evolution of creature work."[15]

Indeed, CG has become the most common means of creating dinosaurs and many other life-forms for films as well as for scientific and educational documentaries. In the wake of *Jurassic Park,* numerous documentary projects, such as the BBC's *Walking with Dinosaurs* (1999, Haines and James) could be realized because the technology finally had evolved to the point where it could create credible representations of the latest scientific thoughts on prehistory and the fossil record. The film has left an amazing legacy of technological achievement for filmmakers and documentarians, and many directors would be satisfied to have accomplished so much. In the same year, however, Spielberg released the profoundly moving film *Schindler's List* (1993), demonstrating that while he still is master of the blockbuster, his intentions to make critically successful dramas also would be realized.

Once again he proved his ability to use DVFx to support narrative by drawing upon digital rotoscoping to inject crucial elements of color in the otherwise black-and-white footage. This carefully selected use of color—to highlight scenes of great emotional and symbolic impact—shows his mastery of effects

and, more important, his discretion in using them. Where many critics argue that in Hollywood effects are used for deliberately spectacular purposes, in *Schindler's List,* Spielberg shows they can be used to underline themes and ensure emotional resonance.

The film is a powerful character drama. Oskar Schindler starts out as an opportunistic manipulator, a master of social engineering. In Krakow to make a name for himself in business, he is shrewd enough to see that opportunity lies in obtaining a Jewish business and he cultivates the local Nazi officers to ensure he has the connections he needs to realize this ambition. Itzhak Stern, a Jewish accountant, at first refuses to promote the deal Schindler has to offer the local Jewish businessmen, but desperation ultimately forces them to accept his proposal. Schindler achieves his dreams of wealth and thinks of the war simply as a condition necessary for his success. Then one of his workers insists on thanking him for a job, the job that provides protection with its "essential worker" status. The worker is an elderly one-armed man, and it is obvious that he has been found a job within the factory to save him from being shipped off by the Nazis. This moment represents a turning point because it makes Oskar complicit in Itzhak's cunning manipulation of the system to save his fellow ghetto inmates. Later, when the Jews are stopped en route to work and forced to dig snow, Oskar confronts the Nazis and demands compensation for their lost productivity for his factory. He also defends the one-armed man who, having been accused of falsely obtaining papers as an essential worker, is shot. Then Itzhak is taken up by the Nazis for transportation to a camp, and Oskar must move from complicity to action on his own part. He uses his not inconsiderable skills of manipulation to have the train stopped and Itzhak released. This becomes a turning point for Itzahak who, seeing how easily his own life is put in the balance, has reason to be grateful to Oskar. Time passes, a labor camp is built nearby, and Nazi Amon Goeth is in charge. To ensure that he retains his workforce, Oskar assiduously cultivates Amon, for whom Itzhak now works. By this point Oskar is actively working to save Jews with Itzhak's guidance. It is only when the ghetto is liquidated that Schindler's point of view is revealed—through the use of DVFx—to signal his changed perceptions and the major shift in his character.

At first glance, the decision not to use color film seems a straightforward directorial choice. Black-and-white footage is known to lend an atmosphere of authenticity and period detail, especially for this particular historical period. The most memorable images of the Holocaust are the documentary recordings of the camp liberations and the horrors that existed behind the fences, so this film

stock is effective in taking the audience back to the time of the Holocaust. However, the Nazi era also is remembered for its emblematic use of the colors black, white, and red. For theirs was a black-and-white world in the sense that there were those who were valued and those who were to be annihilated, and the shocking red was the color of the blood that would be spilled to make the world over in the image they desired to establish. Oskar moves from seeing the world in monochrome when the ghetto is cleared of Jews. Among the crowds being herded through the street, he catches sight of a little girl in the crowd whom he sees in color. Her coat is red. It catches his eye and makes individual the crisis unfolding before his eyes. Only the audience shares this point of view, on two occasions without the mediation and direction of Oskar's gaze.

The child in the red coat is seen seven times. First, Schindler sees her in the crowd. The second time is a long shot where she walks alone. The third time, she is walking with those being driven through the streets while Jews are being executed by soldiers. During the fourth, she walks along unseen by others and enters a house. Then, in the fifth and sixth shots the audience sees her climb a staircase and find a hiding spot under a bed. As she crawls under the bed, her coat loses its color, and the film returns to black and white once she reaches the safety of her hiding place. The last time we see the little girl, her coat red again, her body is being carted from a mass grave to a bonfire so that Amon can carry out his orders to destroy the evidence of the killings at the camp. Shortly after this moment, Oskar and Itzhak acknowledge that the end has arrived. Oskar admits that he has earned more money than he can spend in a lifetime, and much of that money at the expense of others' suffering. The men drink together and then Oskar returns home. The next morning he packs his money into suitcases and uses his relationship with Amon to buy the lives of the people on a list of names he and Itzhak compile. This last act will beggar him, but it will save 1100 lives—and his soul.

The use of DVFx to reveal a character's inner journey is one of the most complex and creative ways to employ these tools narratively. Edward Branigan remarks on this kind of approach in his discussion of point of view, saying, "when confronted by an anomalous device [inexplicable color changes], one of the hypotheses we try out is a metaphorical application directed toward the nearest sentient agent, usually a character."[16] The choice of color for the child's coat in an otherwise monochrome film draws on powerful cognitive signals. The narrative film also is bracketed with color documentary footage that speaks of the life that was and was lost, symbolized by the burning candle and the flame that

is extinguished in the opening scene and the life that went on to flourish as revealed in the last scenes where the survivors return to honor the real Oskar Schindler's grave. While these color sequences mark out the time before the Holocaust and the time after, the black-and-white footage stands out as most "realistic" in that the scenes are graphic portrayals of events that occurred, whereas the color sequences are of symbolic value. Only the child's red coat—the moment that signals Schindler's profound insight—links the past and the future and stands out in the graphic portrayal of events. This child is marked for Oskar's and the audience's attention because she represents the precious life, the future that all children symbolize, the blood of her heritage, and the future that he saves for the few who became many because of his change of heart.

These two films capture Spielberg's duality best of all. *Jurassic Park,* playing into his reputation as a blockbuster-maker, filled box-office coffers and set entirely new standards for CG characters. Yet *Schindler's List* is the film that—also drawing upon CG to fulfill its vision—won him the Academy's Oscar for best director.

In 1997 he returned to the franchise to direct *The Lost World: Jurassic Park.* It was hugely successful at the box office and offered finessed versions of the CG dinosaurs. In that same year, his serious dramatic offering was *Amistad.* As in *Schindler's List,* the effects were subtle, enhancing the veracity of the period settings and helping to preserve the diegetic world of the narrative through Invisible and Seamless effects. The film was not a major success, but he followed it with the 1998 war drama *Saving Private Ryan.* Once again, his use of DVFx proved extremely skillful.

In *Saving Private Ryan,* Spielberg used special and DVFx to re-create the field of war in a spectacular fashion, making real the brutality, the futility, and the horror of the war experience. Using his most powerful images in the earliest sequences, he does not so much as stop the narrative as delay it for the purpose of ensuring that, for the remainder of the story, the audience has been given every reason to believe in the stakes set for the characters in the story. The harrowing images of soldiers under fire and the kinetic impact of the powerful sound mix and graphic depiction of violence work to shock the audience. The sequence is exhaustingly long, perhaps with the deliberate intention of making the audience feel that the violence will never end. The film won him his second Oscar for directing and achieved great results at the box office.

His next feature film project was a film left unfinished when Stanley Kubrick died in 1999. The project, *A.I.: Artificial Intelligence,* had been the subject of

rumor for years, with Kubrick investing in extensive development of the project. For Spielberg, *A.I.* was perhaps his most ambitious project so far—an attempt to marry the wonder of his films for children with the deeper themes of his dramatic works. It is also an attempt to marry the sensibilities of Kubrick's legacy with Spielberg's own values.

Although remaining faithful to many of Kubrick's already developed sequences, Spielberg wrote the script of this future-day version of Pinocchio based on Brian Aldiss's short story *Supertoys Last All Summer Long.* It displays many of the traditional qualities of science-fiction films: the depiction of technology in a highly stylized fashion, the presentation of a post-apocalypse dystopian world with lavish realizations of New York after the deluge caused by global warming, and the pitting of human against the "other" in a narrative that raises again the question of what it means to be human.

This last question, if not one of the great questions of philosophy, is one of the perennials of science fiction. The pitting of human against "other" in a consideration of the measure of humanity is thematically rich and, as Stephen Mulhall observes in his discussion of *Blade Runner,* presents the opportunity for the profound insight that "a refusal to acknowledge another's humanity constitutes a denial of humanity in oneself."[17] *A.I.* is not the first time Spielberg addresses this theme, of course. *Amistad* and *Schindler's List* both concern the need to recognize the humanity of those designated "other," as does *E.T.* in many respects.

The effects in the film are particularly well realized and should not be underestimated. As Stan Winston, one of the longest serving and most experienced masters of effects in the industry, remarks, "*A.I.* eventually used a combination of every technique we've ever tried, sometimes in ways we'd never imagined before. We had prosthetics, character makeup designs, animatronics, puppetry, combinations of character makeups with CG, *and* we designed complete CG characters. *A.I.* was a challenge beyond anything we'd ever done."[18]

The effects constitute a significant standard both on a technical level and a narrative basis. The CG characters are not only a visual representation of characters within the story but a representation of the themes as well. In a film with a narrative about man-made/machine characters that seek to pass as human, there are CG characters throughout the film that seek to pass as live actors. Where many films seek to display how well—how spectacularly—they have realized a CG character, the majority of the CG character images in *A.I.* are meant to blend Seamlessly without drawing attention to the nature of their creation.

Unless one receives a list of which frames are those of a human actor portraying a robot and which ones are those of a CG interpretation of that human actor, it is impossible to distinguish the image. This happens in other films—far more often than most audiences would be aware of simply on an initial cinematic screening. However, within the context of the *A.I.* narrative, being unable to discern what is truly human and the desire to create a convincing human representation is the essence of both the film and its use of effects.

Kubrick had researched the possibility of using a real robot, but as Dennis Muren observes:

I think Stanley kept going around in circles about David because he couldn't bring himself to address the real story of A.I. . . . He had a heart-wrenching story about a kid who wanted to be real, like Pinocchio, and I believe that was a conflict for him; so he focused on what the robot looked like, rather than what it was feeling. That's why he offered the project to Steven [Spielberg], I think; and he was right to do that. It was a big relief when Steven went with Haley [Joel Osment], because that whole problem that had stopped Stanley was gone.[19]

What remains is, in some ways, a more complex outcome, especially in view of the use of CG to enhance the actor's performance. For example, as mentioned earlier, one way that the human actor is "sold" as the robotic child David involves the use of Invisible effects to remove eyeblinks, a technique deemed necessary to add a subtly unreal detail to convince audiences that he is not "natural."[20] Similarly, the scene where his "mother" abandons him in the forest also is digitally retouched to remove his exhalations—apparent in the cold temperature on location—so that only the human mother's breath is visible.[21] This type of almost subliminal cue works persuasively to portray the diegetic realism by removing details from the images that disclose reality. That they—and most of the CG interpolations—are achieved Invisibly, or at least Seamlessly, also underpins the themes of the narrative; that is, technology can create better humans or humans, better. Although the definition of "better" always is up for negotiation, the goal to create an "other" that can be "us" certainly is one CG aspires to and, at least in limited circumstances, achieves at this point.

Subtle and invisible manipulations of human actors also are used to preserve the diegetic world and blend the CG elements in *A.I.* Thus, when Professor Hobby holds up a cube he has pulled from within the face of the mecha (robot) so that he can display it while discussing the future of mecha, the scene required

digital manipulation of the actor's hand and repositioning of his fingers to ensure perfect verisimilitude for the image of him holding the CG cube.[22] These Invisible DVFx used in this film and others are meant to go unnoticed, even when they are part of Fantastical effects and are crucial to make the more Fantastical elements work.

Representations of other characters perform in this way, too. The teddy bear was achieved using a mix of animatronic/puppet and CG animation.[23] This kind of DVFx practice is neither unexpected nor remarkable per se, yet given the nature of the narrative additional meaning manifests. Teddy is a supertoy— the embodiment of the next level of technological achievement in toys—and he is visualized using the same technology being used in real-life scientific and industrial settings to create that next level of technological achievement. In this way, A.I. fulfills one of the basic science-fiction genre traditions—especially the tradition that is attributed to the use of special effects—that they serve to demonstrate the state-of-the-artness of technology.

The movie also has CG images of humans manipulated to represent mecha, as in the scene where a woman's face opens up to reveal her robotic interior[24] and the scene where the mecha Gigolo Joe transforms from brunette to blond.[25] Indeed, the scenes in the dump where the mecha reconstruct themselves from junked parts involve some of the most deliberately spectacular moments in the film.

Two of these characters—the nanny and the burned chef—are tour-de-force moments in CG spectacularity. Their "otherness" is accentuated, using their apparent (and real) humanity juxtaposed with physical impossibility. The chef, whose burned face has the voyeuristic appeal of a car accident, serves to highlight "otherness." The nanny robot, however, is a mother substitute. Her appearance, while possessing all the spectacularity of the chef's, is to be of only momentary interest for the audience because she has a much greater part to play than mere spectacularity. Her role is to offer a nurturing female to turn to so that this will lead to David's capture, which is crucial to his meeting Gigolo Joe, the mecha who will serve as David's mentor in the strange outside world for which his mother has not prepared him. When David sees the destruction of the nanny in the Flesh Fair, he responds emotionally, sparking the empathy of the crowd that does not believe that mecha can plead for their lives. This human trait is what frees him and returns him to his journey. Thus the mecha nanny's "otherness" is valuable because it serves to highlight David's ability to see

"humanity" in her and thus provides proof of his own "humanity," sparking humane response from the human spectators.

Of course, many moments in the film are genuinely spectacular. In one scene the moon rises but proves to be a balloon used by humans hunting down the mecha for the Flesh Fair. The moon, courtesy of NASA and then animated in 3-D and composited onto the gondola,[26] is visually superb but also narratively significant later, once Gigolo Joe and David have escaped the Flesh Fair, because the "real" moon is what they must head toward. A symbol of both danger and also the direction that must be followed in order to find the Blue Fairy, the moon, which typically is associated with the feminine, speaks to the mythological theme that a meeting with the Goddess is fundamental to the making of the man.

Other effects worth noting include the use of CG in the Flesh Fair scenes, where digital effects enhance the representation of the mecha being destroyed in the tortures devised by the humans to "celebrate" human, nonartificial life.[27] Later, in the escape from Rouge City, the amphibian helicopter flying sequences are comparable to the same sorts of scenes in standard, earthbound action films where DVFx work to create a Seamless impression of something physically possible. However, as this film is representing future technology, the images are Fantastical; they mix references from action films that add a degree of conviction with spectacle that derives from the fantasy element of the vehicle.

Rouge City itself is an interesting use of effects. It is an artificial place, populated artificially. Looking like a pinball-machine version of Las Vegas, the characters are Seamlessly composited into a massive CG environment.[28] Once again, images of the feminine abound with Gigolo Joe enticing a carload of eager adolescent boys to take him and David into the city, entering through the gate shaped like the mouth in a woman's face. It is here that David finds Dr. Know and a rhyme telling him how to find the Blue Fairy. The holographic Dr. Know is a cartoon-style piece of animation. It fits with the style of Rouge City: overly bright and over-the-top. The abrupt change to the rhyme that contains the clues needed for Gigolo Joe and David to continue their journey is very much in keeping with fairytale traditions where solving the puzzle reveals the necessary answers.

The next stage of their journey takes them to the ruins of New York. A CG image of Lady Liberty's hand rises from the water, and set extensions mixed with fully CG sets create the sense of somewhere frozen in place and time and held separate from the rest of the world, a kind of Atlantis. Here David discovers the

truth about his creation. Devastated by this discovery, he leaps into the CG waters that lap at the base of the building. The leap itself is a CG shot and then, once underwater, David is carried along in the current by a CG school of fish. Just as he is rescued from the depths, David sees the Blue Fairy and spurns rescue, returning to the water, his amphibian helicopter getting trapped.

Two thousand years pass; the earth freezes over. Reusing and digitally enhancing footage from *Firefox* (1982, Eastwood)[29] to create a CG environment 2000 years in the future, CG is then used to depict the alien spaceships and the aliens.[30] These scenes are among the most spectacular in the film. Yet, although the narrative pauses, in a sense it is an essential beat in the pacing of the film that allows the audience to absorb the passing of aeons. It is necessary to condense narrative for filmmaking, sometimes to its detriment. For example, one of the most common problems with fast-paced storytelling is that it denies the audience the time needed to engage with emotionally impacting moments. Indeed, characters often have little time to respond emotionally to the experiences that are supposed to be having sufficient impact to change them. One of the most impressive moments in *The Fellowship of the Ring* is the screen time allowed for the fellowship to mourn the passing of Gandalf. These pauses, necessary for the characters' emotional connection, also are crucial to such emotional connections from audiences. Thus, in *A.I.* the spectacularity of the aliens and their arrival is necessary to give audiences enough time to follow the travel forward in time, to accept the passing of humanity and the evolution of mecha.

In *A.I.*'s closing scenes, the Blue Fairy makes two CG appearances: once when she disintegrates at David's touch when he is released from his frozen cocoon in the helicopter and is finally able to touch her[31] and again when she appears in the aliens' representation of the Swinton home so that she can grant David his wish. This final appearance, a fully CG image, was deliberately fashioned to be "neither real nor completely artificial."[32] This describes the nature of CG images in this and many other films. A mix of the human and the "other" is presented on screen. Animations driven by motion capture reveal their humanity, as André Bustanoby notes in Chapter 3. Human performances, when scrutinized, might reveal their artifice. Undoubtedly such images ask what it means to be human.

Aside from those instances where DVFx are used to bring to the screen scripts that are bad examples of storycraft, DVFx also can achieve prominence over storycraft when the story seeks to express such an epic scale in visuals, emotional impacts, and intellectual themes that it must reach for astonishment—

because astonishment is the very subject that the narrative seeks to explore. *A.I.* may be regarded in this way. As this chapter shows, the movie strives to achieve more than drawing upon mythology to inspire hope in a "Saturday Matinee" style. It asks—in a direct fashion and in a subtextual manner—what it means to be human and what it means to create sentient, emotionally responsive life. The film does not answer all aspects of these questions, but it does offer the idea that love is in some way a necessary response.

Spielberg's take would suggest that the capacity to love is what makes us human, for this is the quality that David's creator has sought to instill in his mecha, and it is this quality that is tested throughout David's journey. Further, although David is offered all manner of scientific proofs of the nature of his creation—a revelation so shocking he seeks to end his existence—the sight of the Blue Fairy renews his faith and resurrects his dream to become a real boy. The reward for David's commitment to his love and his dream is a reunion with his mother. In a film that addresses the long-standing issue of men—that is, males—as creators of life, David asserts both directly and in action that woman is his creator. His desire is to love and be loved by his mother, and he knows that only the Blue Fairy—whom he emphatically identifies as "woman"—can grant him the wish to be a real boy.

In one of the earliest scenes David's creator, Professor Hobby, states that he wants to create "a child that will love its parents with a love that will never end." He is challenged by his audience, who asks, "Can you get a human to love them back?" and wants to know what responsibility a human has toward the kind of mecha Hobby is proposing to create. Hobby's response is that of the Bible: "Didn't God create Adam to love him?" In some way this film is asking not only what it means to be human but also whether by creating sentient life we become god(s).

In many ways this is no longer an idle question but one that scientific and technological progress will demand that we confront. Indeed, artificial intelligence programs have been used to "grow" DVFx—most famously and aptly the brain structure for the opening shot of *Fight Club*. It would appear, then, that a film such as *A.I.* uses not only its narrative but also the means of its creation to raise crucial questions and attempt to answer them, as creative works usually do. It is a role that science-fiction films traditionally have fulfilled, yet the range of effects used in *A.I.*, although upholding many of the basic principles common to the genre of science fiction, does much more and is representative of how DVFx are evolving as a narrative tool when used insightfully by storytellers.

In some ways the three filmmakers considered in this chapter are responsible for making accessible the technology that so many filmmakers now use to tell an extremely broad range of films. Lucas's use of the effects conforms to the genre and standards of innovation most would associate with blockbuster filmmaking, but his facility has served every kind of filmmaking. Cameron's use of effects consistently has pushed the technology, and his use of effects to realize an epic period romance is in some respects a signal that the full range of effects practice has moved beyond the limits of science-fiction and action/adventure genres.

Yet, as this discussion shows, it is Spielberg who has used effects in a way that demonstrates the full range of their narrative capacity. He achieves this because his films span a wide range of genres and because he makes films that appeal to very broad demographic. Audiences who would not go to a "big effects film" readily attended *Schindler's List* and *Saving Private Ryan*. To what extent those audiences made note of the effects *as effects* is a matter of conjecture. What *is* known is that the effects used in these films serve the narrative.

Spielberg's work is not primarily effects-driven—if that is a term that is fair to use at all. Lucas and Cameron, though, both use DVFx as an integral part of their filmmaking practice. In comparison, Spielberg's use of effects is driven more by story than by technical approach. Even in a film such as *A.I.*, with the traditional relationships of effects, science fiction, and technology, the narrative itself is the source of motivation for the effects and how they are used. As the film's physical effects supervisor Michael Lantieri says:

[H]istorically, whenever technology bumps forward, we find a way to tell a story around that new technology—be it animation composites in *Roger Rabbit* or computer graphics in *Jurassic Park*. But the thing about *A.I.* that will always be special to me is that the story came first, and the technology that allowed us to tell it came second. The tools were really in the service of the story.[33]

Robert Allen and Douglas Gomery define two key approaches in the evolution of technology. First, "The great man theory is grounded upon an assumption of the autonomous agency of human subjects, regarding technological development as dependent upon the activities of a handful of individual inventors and pioneers."[34] The work of Spielberg, Lucas, and, to a lesser extent, Cameron, seem to be exemplars of the "great man theory." Certainly Lucas, who was awarded a National Medal of Science and Technology in 2006, is an innovator of this caliber given that his record of invention, if not based on his own personal expertise, does seem to reflect his ability to find, nurture, and support

those with the talent to create the inventions. Spielberg and Cameron, on the other hand, have not been inventors of technology so much as a pioneers of its usage. In this sense their work has laid the foundation for what Allen and Gomery identify as the second approach. "[The] second evolutionary approach shifts the focus from the creative individual to the technology and its relationship to aesthetic consequences."[35]

Duncan Petrie comments, "Technology sets the parameters and determines the space within which innovative techniques can occur."[36] Yet, with DVFx there is, as yet, no set parameter. In a sense, the space it creates is still unbounded. Many innovations arise from the demands of scripts, others from discoveries that arise from the creative problem-solving process. It is an area of technological development that, while it has come a long way in the last twenty years, shows promise of continued development and realization. This development is in regard to technology's use as storytelling devices, not the very complex area of technological development in the wider socioeconomic sphere—even though those influences have implications for the development of CG technology.

From a storyteller's perspective, as the examples in this chapter show, while DVFx have emerged from a special-effects tradition as old as the history of film, the innovation they can offer to storytellers is only beginning to be explored and applied across the range of narratives in film. The full extent of the aesthetic consequences of technology usage in the case of DVFx is yet to achieved. Those effects offer incredibly powerful visual and narrative tools, and it is only now, with them being applied across the broad range of film narratives and with increasing mastery, that the aesthetic of DVFx is becoming definable.

In the hands of a filmmaker such as Spielberg, the technology has been used to conform to the identified aesthetic of the spectacular, but also to the aesthetics of verisimilitude. What appears to drive his usage is his ability to make DVFx work both technically and narratively in a unified way. In some ways his body of work has been building as if preparing for the challenge of marrying his aesthetic with Kubrick's—the legacy he inherited in accepting to undertake *A.I.* This has a kind of poetry, as *2001* elevated science-fiction filmmaking from the B movies with its narrative looseness and aesthetic. Spielberg's science-fiction work, long considered to have been responsible for elevating the B movie to the production standards of the A-list, meets Kubrick's standards for technical realization but enjoys an appeal that reaches a wider audience because of its fidelity to classical narrative. In drawing upon his own and Kubrick's oeuvre, Spielberg has achieved with *A.I.* representation of the wider vision and potential of DVFx. That said,

its commercial reception was not impressive as it took less than its production budget in domestic box-office returns and earned only \$235,926,552 worldwide in gross returns.[37] It was not well received by critics either, seeming to disappoint fans of both Kubrick and Spielberg. *The New Yorker*'s review described it as "an extraordinarily accomplished movie, but a failure."[38]

Perhaps the answer to the story's problem lies in the idea that a story, like a man, cannot serve two masters. If the marriage of Spielberg and Kubrick's storytelling proved at times to be a bit of an odd match, it is perhaps because it strove to place Spielberg's identifiably ordinary people in extraordinary circumstances alongside the struggle for an extraordinary character to achieve ordinariness. The epic nature of the themes inherent in the story are always at the core of the action, such as in the heart-rending moments when the child pleads for its mother's love or begs the Blue Fairy to make him a real boy so that his mother will love him.

In some respects David's experience of finding out the truth of his creation is not unlike the experience of our species as its scientific realizations document and reveal the nature of our own creation and the scope of our universe. Yet, it would seem that Spielberg argues that for some storytellers, even in a universe where we are learning that the simple struggles of a puny bunch of humans in the vastness of space does not amount to the metaphorical hill of beans, some of us still look for that "new hope." Some still seek to view the universe as a place where we are loved, and we create representations of a benevolent universe in which our creator(s) or more superior beings will look upon us with love because we can love. These stories attempt to create a paradigm that allows reconciliation between our knowledge of science and technology and our emotional need to be loved and valued.

Yet behind this desire is the understanding, and the fear, that—as the father in *A.I.* points out—the ability to love might be inextricably linked to the ability to hate. Thus, the storytellers always will have scope to ride the pendulum swings of our perceptions about what the universe might have in store for us. For Spielberg, the view is generally of benevolence. For Lucas, the valour of individuals will preserve the world as we know it, no matter where in the universe its battles are fought. For Cameron, regardless of the events that overtake the individuals, love will endure and find its way. It would seem that in the hands of a capable filmmaker, DVFx can provide the tools to create an as yet unlimited range of representations but, in terms of storytelling, it would seem that one will generally find what one believes—or at least hopes—one will find.

Somewhere over the Rainbow: Imagined Worlds and Visions of the Future Realized through Digital Visual Effects

Once I got into *Star Wars,* it struck me that . . . a whole generation was growing up without fairy tales. You just don't get them any more, and that's the best stuff in the world—adventures in far-off lands. It's fun. . . . I wanted to do a modern fairy-tale, a myth. One of the criteria of the mythical fairy-tale situation is an exotic, faraway land, but we've lost all the fairy-tale lands on this planet. Every one has disappeared. . . . But there is a bigger, mysterious world in space that is more interesting than anything around here. We've just begun to take the first step and can say, "Look! It goes on for a zillion miles out there!" You can go anywhere and land on any planet.

—GEORGE LUCAS[1]

This chapter turns to one last aspect of DVFx in filmmaking that speaks to film's earliest ambitions: the ability to show the wonders of the world. When film first revealed the far-flung corners of the planet to audiences, it did so well within the tradition of Tom Gunning's cinema of attractions. However, as George Lucas has noted this planet is now an explored and populated place, so the imaginary worlds of a "galaxy far, far away" are offered up as the new frontier where new wonders and adventures might yet lie. DVFx offer an extremely powerful way to represent these imaginary places because they are also the way the real frontier of space is being visualized and its exploration achieved.

In her discussion of the relationship between what science fiction represents and what technology is being used to achieve in the real world, Annette Kuhn remarks, "In the instance of special effects, the cinematic apparatus and the technological future represented in the fictional worlds of science fiction films

begin to coincide."[2] She cites *The Dream Is Alive,* a documentary about NASA's *Challenger* program, and observes, "many of the film's images, however, look exactly like science-fiction film images."[3]

As noted previously, the astonishing images of planets in space that were crafted in a studio by Stanley Kubrick now are joined by images beamed back to real Earth by satellite, robotic, and extraterrestrial telescopes. At a time when serious plans for crewed missions to Mars are the substance of newspaper articles and classroom science projects, the documentary use of DVFx to describe space travel takes on a somewhat less theoretical aura, as do the fictionalized versions in feature films. These once wholly imaginary images now are grounded in real data, based on photographic evidence, and there is little difference between the images used by those making the plans to launch a spacecraft and those telling stories about spacecraft in those galaxies far, far away.

Similarly, images of future cities crafted with DVFx have an allure that could not be offered by traditional matte-painting techniques. In the first instance, the future of the cities we live in is being shaped by the same technology used by the film industry to build imaginary cities or modify those we inhabit now. Current architectural practice relies heavily on CG visualizations of buildings and urban spaces, both for design and for construction. This melding of the existing built environment with the proposed or the imagined offers us a worldview of the space which we occupy as a mutable zone, one subject to constant modification and alternate views.

That these alternate views and imaginary places can be explored with the aid of virtual camera moves and, blended with performance imagery, contributes to the blurring of the boundaries between solid experience and projected experience. No longer are visions of the future sketched out in flat 2-D representations; they are explorable and manipulable and when crafted by the right hands they are indistinguishable from photographic images of the built environment as it currently stands. Scott Bukatman, in his paper "The Ultimate Trip: Special Effects and Kaleidoscopic Perception," discusses the enduring fascination with supernatural phenomena and its realization in film. He summarizes this discussion by observing:

Cinema always combines the material and the immaterial, the solid and the phantasmatic, the permanent and the ephemeral, the rational and the uncanny. Gunning and [Terry] Castle agree that despite its scientist underpinnings this is a "fundamentally uncanny" medium. Geoffrey O'Brien puts it eloquently, "Upon the motion picture—

the most alluring mechanism of the age of mechanical reproduction—would devolve the task of reconstructing the imaginary worlds it had helped to dismantle."[4]

Where film once revealed the far away places of the world to audiences able to travel no further than their local cinema, CG now reveals—reconstructs— reinvents—distant places where adventure might yet occur. These cinematic images of the imagined future mirror, in many respects, the images we are offered of the proposed future. CG documentary images of archaeological site reconstructions, the growth and spread of cities, the construction of buildings— existing and proposed—graphically demonstrate how the world has changed and propose what changes might yet occur.

The perception that the world we live in is a mutable space, and the space we reach for is a livable mutation, informs our storycraft and DVFx work to make this convincing within our lived experience and our imagined future. As Bukatman comments, "Artificial infinities abound in SF: generation ships, outer space, cyberspace, boundless cities, cosmic time, galactic empires, *2001's* mysterious monolith, the endless underground cities of the Krel in *Forbidden Planet.*"[5] Yet these images abound outside of science fiction when they are projected into the visualizations of a future that is beginning to return to us from the depths of space.

The imaginary and the real indeed are coinciding and cinema has been the medium that has foreseen and, in some ways, inspired many of the aspirations that are now being fulfilled. Bukatman observes, "It might even be argued that cinema is the very paradigm of an artificial, technological environment that has incorporated utopian fantasies of nature, kinetic power, spiritual truth, and human connection."[6] Cinema also has influenced the development of the technology of computer graphics, taking the means of scientific realization and demanding more of it, pushing its capabilities and making available to science improved tools for advances into space, the built environment, and manipulation of the natural world—including our own physiology. A good example of this interaction is the adoption by oceanographers of the wave data sets from the film *The Perfect Storm.*

The imaginary worlds of film often are presented to us in establishing shots, and increasingly as fully CG settings. David Bordwell and Kristin Thompson note that "Specific settings fulfill distinct narrative functions,"[7] and as the previous example of an aerial establishing shot of a town demonstrates, CG techniques can be used to establish virtually any kind of setting. Of establishing

shots, Seymour Chatman in his essay "What Novels Can Do That Films Can't (And Vice Versa)" remarks, "we can see why precisely the absence of characters endows establishing shots with a descriptive quality. It is not that story-time has been arrested. It is just that it has not yet begun."[8]

The imaginary cities of the future or of distant galaxies are revealed not only in films' opening frames but throughout as new locations are presented. Chatman's observation about story time having not yet commenced is a clue to the measure of the narrative function of the shot. Establishing shots can be revealed in many ways. They can be used to ease the spectator into the diegetic world—as the earlier example suggests—or they can be used to astonish the spectator, twisting their expectations and revealing the diegetic world in a surprising or unexpected way.

In this latter case they straddle the fine line between narrative tool and spectacular display. Where CG environments extend beyond setting up the world to become the substance of the setting, the tension between the narrative drive of the scene and the spectacularity of the images may be at its greatest. In general the balance will tip based on the quality of the acting performance and the film's dramatic elements. Where these are weak or lacking, the spectacularity of the images (if these images are noticeably impressive) may be favored by audiences and critics. For a skilled filmmaker, directing the audience's attention to drama or setting, as M. Night Shyamalan indicates in chapter 2, is an option the director exercises with an understanding of the consequences it has for the overall pacing and emotive impact of the film.

While in many instances the use of CG environments is understated and used Seamlessly to preserve the diegetic world, in the case of future cities and imaginary worlds spectacularity often is a desired outcome. As Lucas's remarks indicate, the intention is to establish a sense of wonder and excitement so that the adventure of the narrative can be believed. The oral tradition has established fairy tales and epic adventures as events that happen far away in time or place and somewhere unlike home. And while the events that spark the journey—as Joseph Campbell describes (see chapter 5)—indeed may be sparked by incidents in the ordinary world, the journey itself often will require a step into the unknown.

For filmmakers, establishing an unknown place in a well-documented, populous, and highly observed planet is an increasingly difficult task, the advent of DVFx and the reusable data sets of deserts, forests, oceans, and star fields is an obvious boon. It would seem that no matter how canonical the tale, the

ability to position the story in a special setting can be a critical factor in engaging the audience.

Vivian Sobchack, commenting on these representations of alien places, observes, "There are 100 billion stars in our galaxy and 100 billion galaxies in the visible universe, and one of the stock themes of science fiction is that of alien civilizations. But it is difficult to imagine these different worlds without falling back on human standards and thus making them ridiculous."[9] While this comment is made in the context of establishing alien civilizations and the much more complex task that science fiction undertakes in creating the social structures of "other worlds," her comments also reflect the challenge that creating the visual representations of such civilizations and "other" sentient beings holds for artists. E. H. Gombrich also has remarked on the difficulty of rendering the imaginative or unknown, saying, "The familiar will always remain the likely starting point for the rendering of the unfamiliar; an existing representation will always exert its spell over the artist even while he strives to record the truth."[10]

Yet stories continue to seek exotic circumstances against which to pit their heroes. This challenge is being met through the rediscovery and reinvention of our past—*Troy* (2004, Petersen) and *Alexander* (2004, Stone)—through fantasies (*Lord of the Rings*), or blended future-pasts (*Sky Captain and the World of Tommorrow*). Executing these large-scope projects without DVFx has become, from a film production perspective, unimaginable.

There are, of course, many stories told in mundane settings, and in these the "specialness" of the story often focuses on the qualities of the human drama at play. But many genres draw upon strong traditions of setting and mise-en-scène that, as indicated in the case of period drama (see chapter 3), have become impractical without the use of DVFx. Thus, for the continued development of these genres, reliance upon DVFx may be crucial to how these genres operate as a means of critical examination of the cultural, ideological, political, and psychological factors that underpin their narratives.

Obviously, the tradition of visualizing the future or imagined world predates the use of DVFx. Indeed, in "Visions of the Future in Science Fiction Films from 1970 to 1982," H. Bruce Franklin states, "The first great archetypal image of the future projected in the early SF film is The Wonder City of the Future."[11] However, since the advent of DVFx, the use of graphics technology to realize the settings for much of the drama has become the common practice, not only for feature films but also for television dramas. Therefore, the practices and approaches used in CG are now the most common production technique used for

crafting these crucial images and are fundamental to the implications that critical analyses draw from such imagery.

Kuhn comments that "science fiction films are singular in that at the levels of image and spectacle they 'real-ize' the genre's topic of the imaginary and the speculative, proposing a necessary connection between the visible worlds created in films and the stories for which these worlds constitute the settings."[12] This also holds true for films outside the science-fiction genre. Fantasy films have offered us images ranging from the photographically realistic images of Middle Earth (*The Lord of the Rings*) to the more theatrically influenced Hogwarts (*Harry Potter*). Period films have presented us with reconstructed images of Rome (*Gladiator*) and the ruins of Warsaw (*The Pianist*). Disaster films also draw upon such images to persuade, shock, and dramatize events such as meteor strikes (*Deep Impact,* 1998, Leder) or climate change (*The Day after Tomorrow*).

In these different genres, different narrative functions may be in operation and different implications may be drawn. Janet Staiger's essay "Future Noir: Contemporary Representations of Visionary Cities" comments on science fiction's "rewriting"[13] of cityscapes and argues that "the mise-en-scène of cities in science-fiction films might be understood as utopian commentaries about the hopes and failures of today or, inversely, dystopian propositions, implicit criticisms of modern urban life and the economic system that produces it."[14]

The narrative intentions of the fantasy world of Hogwarts may owe more to Bruno Bettelheim's fairytale purposes than they do to Campbell's myths, which are more closely realized by the deeds of Middle Earth. The narrative intentions of period films, it is commonly thought, work best when they resonate with the events and crises of the times in which they are told. But of science-fiction and disaster films—this latter considered by some to be a subgenre of science fiction—there has been substantial discourse.

Sobchack, in her paper "Cities on the Edge of Time: The Urban Science-Fiction Film," examines the images of the city science-fiction films, present both future cities and the ruins of current cities depicted in disaster films. She comments that "the fantasy of the imaginary city constitutes it in a positive image of highness and fullness, envisions it as the site of human aspiration—its vertical projection pointing towards spiritual transcendence and, perhaps, a better and fuller (that is, a materially expanded and more "civilized") future."[15] These future cities tap into the idea that the future is a place where humanity has improved on itself. If people today look back on the past and consider they come a long way from a more "primitive" life then it follows that the future will

be a place where we are wiser, happier, and perhaps approaching immortally good health. Translating this concept into an image of human aspiration achieved often involves showing technological and architectural advances such as new forms of transportation and skylines filled with magnificent buildings.

However, this is not the only vision we have of the future. Sobchack also discusses another future view: "the razing of the city and, most particularly, the bringing low of those monuments that stand as symbols of modern civilization's aspirations and pride."[16] These images can be of our experience of destruction in cities as we know them now in the near future, or they can be distant visions of our great cities with today's landmarks mixed in with the rubble of the imaginary buildings of the future. Sobchack says in relation to these destructions, "Its poetic reverberations have nothing to do with aspiration and ascendancy and everything to do with, as [Susan] Sontag puts it, 'the fantasy of living through one's own death and more, the death of cities, the destruction of humanity itself.'"[17] Sobchack offers another view of dystopian future cities: "The second image of the failure of the aspiring city is equally powerful, yet quite different—retaining the city's highness, but temporizing its value as 'past' . . . [where] 'highness' becomes dominated by the negative and nihilistic value of '*emptiness*.'"[18]

She follows these astute observations with a cinema history account of future cities and goes on to remark upon the destructive sequences in recent films, citing *Deep Impact, Armageddon* (1998, Bay), *Godzilla* (1998, Emmerich), *Independence Day,* and *Mars Attacks!* (1996, Burton). Of these she observes the lack of "human affect and real consequence attached"[19] to scenes of destruction and comments that these cities seem "to exist only for destruction."[20]

From these arguments, support for Staiger's evaluation of science-fiction rewriting cityscapes as a comment on modern and perhaps future life can be found. CG representations of Sobchack's "higher, fuller" future world are especially persuasive when their realism closely matches the architectural representations of proposed building sites in the physical world. The link between the sell of the developer's marketing plan and the aspirational images of the future is made easily. The kind of CG images that offer photorealistic visions of real building developments and the fictional brave new world of the future can portray the destruction of our existing and imagined world with graphic clarity. The link between cinematic images of destroyed cities and their relationship to the desire to survive death has been horrifically tested by the experience of the events in New York City on September 11, 2001. Many commenting on the events of that day described it as being like something out of a movie, not only

for the magnitude of the event itself but because CG has rendered these kinds of images so realistically in film after film.

Sobchack's insight that so many film images of cities in disaster films seem to exist only to be destroyed is true in terms of their technical creation for filmic purposes. Models often are fabricated from materials selected for their destroyability, with CG elements offering the finessing touches to these scenes of destruction. Yet, in light of 9/11, these images now have a different resonance for many. Even those films, such as *A.I.,* which depict the Twin Towers being ruined in a future they in reality did not survive to meet, give pause because the images anticipate visually a future not unlike what did befall them. Further, while the experience of the towers' destruction was intended to "bring low" the aspirations and pride of America, the people of New York, in keeping with Sontag's arguments, have sought to find triumph in their survival and in their will to rise above experience. The events of 9/11 have influenced the subject matter of projects green-lighted for film production and offer spectators a greater sense of "real consequence" attached to images of urban destruction. They also have highlighted, because of the massive nature of the real-life disaster, the "realism" of many of the fictional representations that preceded the attack. This coincidence of the cinematic image and the lived experience reinforces the increasing sense of verisimilitude and value for the thematic material on offer.

In regard to ruined, dystopian, "empty" future cities, the films *Mission to Mars* and *Final Fantasy* offer two views different from that proposed by Sobchack. In *Mission to Mars,* the "ruins" on Mars are not empty so much as dormant, the face in the sand prepared for us in the faith that we would fulfill our evolutionary destiny. In *Final Fantasy,* the ruined cities of Earth are ghosts that harbor the "natural" wavelengths that can be used to heal the forces of destruction. The films Sobchack cites—*Deep Impact, Armageddon,* et al.—while showing massive destruction, also end with human triumph. As in *Final Fantasy,* the narrative tendency of disaster stories is for hope to blossom amidst the ruins, as Viktor Frankl's experience as a Holocaust survivor persuaded him to believe it must.

Thus, it would seem that whatever wonders of the world cinematic images present, be they of an imagined world of future utopia or dystopia, another significant theme is the life that survives and clings to hope amidst the ruins. As stories establish settings that are limited only by our imaginative powers (given that our representational powers in the area of DVFx are currently unbounded), and we anticipate a future that can be "real-ized" by our continued advances in technology, the human element is the representational factor most in question.

Depictions of cyborgs, robots indistinguishable from humans, and enhanced human physical performance (either through mutation, or supernatural or technologically assisted means) are also elements of the future world and wonders being explored with the assistance of DVFx. The growing use of CG characters is discussed in chapters 3 and 4, yet there remains an aspect of this form of representation that bears further consideration here: the question of our own place and constitution in these imaginary and future worlds. In *Making Meaning,* David Bordwell discusses the issue of "characters as persons" and observes, "Humans are predisposed, biologically and culturally, to attend to humanlike agents in representations."[21] Clearly, as much of the previous discussion suggests, this observation carries inherent implications for CG characters.

At the time of this writing, the greatest achievements in CG characters are those of Gollum in the *Lord of the Rings* series and King Kong in Peter Jackson's 2005 remake. To build credibility for the CG representation, the character of Gollum is established in the narrative well before his transformation from hobbit/human to unnatural being. The series of morphs that depict the impact of the ring's corrupting influence serves to warn audiences of the threat posed to the film's hero, Frodo. The transformation also works to establish a sense of pity for the creature and show that, once, he was not unlike the other characters in whose fate we are invested.

The creation of this CG representation has, at its base, a human performance. Andy Serkis, the actor engaged to play the part, performed alongside the other actors and was either removed digitally or was kept out of frame. His performances also were recorded through motion capture and then animated for compositing into scenes where Gollum interacts with the others. Serkis has said:

The work that the animators had been doing on Gollum was beautiful. . . . what they'd been doing with the raw material of my performance on set and in motion capture was so inspiring. They were managing to capture the essence of what I was doing and then augment it, taking it to another level, amplifying the underlying psychology of the acting with their phenomenal talent.[22]

As previously noted in chapter 3, the work of animators is not simply that of operating a computer and manipulating menus that digitally control performance criteria. To a great extent, they also must "act out" and visualize the performance they are crafting for the screen. The achievement of such a coherent performance by a team of animators is an impressive result—a kind of orchestration of performance. The result is a convincing representation of "the

other"—a depiction of mutation and its impact upon character. The underlying humanity of the representation is telling and effective, and it is also thematically symbolic of the changes humanity itself might undergo as it embraces the instruments of power it forges to master its world.

Once again a relationship exists between the technology used to produce the representation and what the representation means thematically. Motion capture was developed for and still is used for medical and scientific research into human physiological performance, and it provides data of value to those creating technologies necessary to assist in prosthetic and robotic developments. The images of technology grafted onto humans in *Star Trek's* representations of the Borg—the cyborgian, anti-individualist alien hive species—are extreme examples of what science strives to achieve for humans whose bodies have needs beyond self-repair and traditional medical assistance. The robotic creations of *A.I.* are equally extreme representations of the kinds of technology currently being developed in laboratories around the world, assisted by data captured from humans.

While our steps into space are, at best, tentative when set against the vastness of the universe, our developments in robotics and cyborgian technologies are equally small in the face of the ways these futures are represented in films. Our hopes and fears concerning these developments, however, are light-years ahead of our actual achievements and are well-expressed in our storycraft. Our ability to create representations of monsters—such as the Balrog in the *Lord of the Rings* films—belongs to a long tradition of making "real" our fears so that we might examine and confront them. Our representations of our own mutations and evolutions might serve this aim also. That we do this now with such powerful tools of representation is perhaps a measure of how fearful we are about who we will be in this future world we envision.

Of the technology used to capture the essence of the corrupted creature, Gollum, Serkis has said:

Performance capture will be used more and more, but the technology will become less and less invasive, allowing acting to retain its purity. As I have discovered, it does require pure, truthful acting—no costume, no set, no makeup—but it offers the potential of an infinite range of characters that can be literally mapped onto an actor's interpretation of a role.[23]

It would seem that his experience has convinced him that the ability to "look good naked" (as *American Beauty* character Lester Burnham put it) is at the heart

of such transformations. For Serkis the technology was still in the service of performance and, in his view, would become more so. It is an expression of hope that would fit well into a future world narrative.

These future world narratives and imaginary places need not focus on the "shiny, bright, brave new world of tomorrow" any more than they are doomed to be dystopian places of despair and destruction. The choice of setting and the thematic substance of the narratives will be shaped, as they always have been, by the times and the philosophies of the writers and filmmakers who craft them.

After nearly fifty years of space travel, argument now focuses on whether it is better for robots or humans to take our next steps beyond the gravitational pull of our own planet. Perhaps we are like the travelers in the first coracles who ventured beyond the sight of their own shore, and ahead of us lies a future of travel and exploration on the sea of stars. If it is to be so, it will be helped by the fact that we are able to contextualize those first coracle builders. Perhaps, because of our ability to represent these steps in our development through CG realizations of both times past and future, we are increasingly aware not only of where we want to go, but how we have arrived at where we are now.

Of our first views of Earth from space, Campbell says, "we have all now seen for ourselves how very small is our heaven-born earth, and how perilous our position on the surface of its whirling, luminously beautiful orb."[24] He describes the first walk on the Moon and the return to Earth, adding the observation that "we all became eyewitness to the fact that, although the moon is over two hundred thousand miles away from us, a knowledge of the laws of the space through which it moves was already in our minds . . . centuries before we got there."[25] Our ability to harness this knowledge depends upon working out and expressing the detail so we can translate our fundamental understanding of how things are into the actions of what we can do. It is a task that CG was designed to assist and does so on a diversity of levels. As Campbell says, "Space and time, as Kant already recognized, are the 'a priori forms of sensibility,' the antecedent preconditions of all experience and action whatsoever, implicitly known to our body and senses even before birth, as the field in which we are to function."[26]

The increasing popularity of science fiction and the emergence of computer graphics technology at this point in our history is a valuable partnership for exploration of our ideas about the future and our place within it. As Bordwell and Thompson observe, "the animated film constitutes the extreme limit of the director's control of mise-en-scène—the most controlled sort of film there is."[27] The increasing use of animated sequences and elements—including

performances—in films may reflect a desire to control our future and our role within it, a desire sublimated in the means we are using to craft our stories.

As Bettelheim's work suggests, fairy tales offer children a means to confront the tasks of growing up. He says, "For a story truly to hold the child's attention, it must entertain him and arouse his curiosity. But to enrich his life, it must stimulate his imagination; help him to develop his intellect and to clarify his emotions; be attuned to his anxieties and aspirations; give full recognition to his difficulties, while at the same time suggesting solutions to the problems which perturb him."[28] Many films seek to fulfill the role of fairy tales, and DVFx, by realizing imaginary worlds and representing poetic concepts, assist in representing the images required to fulfill the deep needs we have for story. If the filmmakers are sufficiently aware of how they work—both technically and narratively—DVFx offer a means to be better storytellers.

Kuhn suggests that one of the appeals of the science-fiction genre is, as mentioned earlier, the display of other worlds. Many films offer a view into other worlds of some kind. They can be times past, other cultures and places, other socioeconomic classes, other races. The impact of CG in creating these other worlds to experience is partly served by a remembrance of worlds past. The archaeological reconstructions that are photographically persuasive allow past civilizations to rise phoenix-like from the dust and ashes of time. This imagery serves to remind us not only that what we have now will pass but also that the passage of our times can be survived, that new, differently magnificent futures are possible—regardless of the dystopian warnings that may visit any particular moment in history. While the glory that was Rome was unlikely to have forecast the splendidness of New York, having been able to revive the image of Rome's great monuments we can imagine a New York brought to ruin while new cities of "highness and fullness" prevail. The question is whether will we recognize ourselves in these new cities and frontier towns of space.

Thus the wonders of the world are not only of this earth or of our current constitution. They are also of the worlds upon which we might yet walk and the beings we might yet become—willingly or unwillingly—as we commit ourselves to technology as the means of our continued evolution and expansion. In 1970 Campbell stated, "Our astronauts on the moon have pulled the moon to earth and sent the earth soaring to heaven."[29] DVFx in filmmaking and in scientific fields are set to take us beyond the works of our conscious imaginations and into worlds we have yet to dream into being.

Byting off More Than You Can Chewbacca: Summary and Conclusions

The in-your-face special effects of these films are red herrings. Media coverage plays them up, and many viewers love to experience them, but they are not the most important manifestation of the digital turn in contemporary cinema.
—STEPHEN PRINCE.[1]

When the term "digital" can indicate anything from how we access information to whether the car will start or the fridge operate, the scope of discussion about "the digital" can range from anxious rant to optimistic hype. Some of the criticisms about DVFx are a reflection of these impulses to condemn or exalt. So it is encouraging to note that in the quotation that opens this chapter Stephen Prince puts his finger on a very important pulse point in relation to the "digital revolution" and its many implications. Digital technologies *are* having a profound impact on the industry and much of the blame being laid at the door of DVFx would be applied more appropriately to other digital transformations.

The primary importance of using DVFx is its relationship to storytelling. Yet, as the review of *Van Helsing* in chapter 1 demonstrates, much of the commentary on DVFx is quite beside the point, especially in relation to storycraft. Perhaps the fear that technology will swamp storytelling is not so much fear about the future of storytelling as it is fear about how technology might overrun our future. And while such a discussion of technology and its impacts could logically follow many divergent paths, the essential concern of DVFx is how they are coming to bear on this most fundamental part of film artistry.

For some theorists, privileging narrative seems to be an easy and superficial approach. Yet, as many examples throughout this book show, storytelling is anything but a simple craft. On some level the criticisms aimed at "Hollywood computer-generated-effects movies" emanate from an assumption that the qualities and standards of a "good story" are agreed upon and well known. Yet a whole body of theory is devoted to the contested topic of narration, and bookstores hawk a seemingly endless supply of "how-to" books for scriptwriters. Even working from the common ground of classical/commercial/three-act storytelling leaves a considerable range of stories to take into account in assessing the impacts of DVFx.

This examination of whether DVFx affect narrative in a different way than traditional special and optical effects do takes into account whether or not critical considerations of special effects also might have positioned critical consideration of the rise of DVFx. Then, having established a view about the role of special effects in general, it asks if DVFx simply were viewed by critics as an extension of special-effects practice. Relating to this issue is the question of excess—the extent to which the spectacularity of effects dominates or overrides narrative, a measure of which is the extent to which the effects used are able to transmit story information. One of the intentions of this discussion is to examine whether nonnarrative usage of DVFx is on the rise and to assess whether this is affecting classical narrative structures in films. In essence, the question is the validity of the claim that the spectacularity of DVFx is at odds with the classical narrative.

Critical commentary on the use of effects usually focuses on its spectacularity and asserts that DVFx stop the narrative in order to draw attention to the technology that created them in order to comment on technology itself. While there is a long tradition of using effects as spectacle in narratives that have inherent thematic ties to technology (such as in science fiction), this is not always the case. In some instances, DVFx work both spectacularly *and* narratively, such as in *A.I.,* and displays of technology do not always have spectacular value or thematic resonance when, for example, they simply work as the props of everyday life.

For the most part, traditional storycraft practices are what drive the use of effects. Indeed, in many instances a film's spectacularity, even though it may rely upon effects to be achieved, more often results from the kinetic value of violent action sequences. The growing use of action sequences, which is correlated with formula writing and with what Robert McKee calls "the blurring of values," proves to be a significant factor affecting storycraft. Such action

sequences often do arrest the narrative. As with DVFx, though, when action sequences are used well, they contribute to, rather than distract from, good storytelling. It is this relevance to story that is the crux of understanding the specific purpose of spectacular moments, no matter how they are contrived.

Action scenes and visually impressive moments in film do not exist in a vacuum. One of the main issues in good storycraft is values—either expressed in the form of "wisdom" or demonstrated through moral choices. The political and religious appropriation of the term "values" in recent years gives it a loadedness that makes using the term in other contexts somewhat awkward. However, the expression of values—in whatever way they are defined within and by the text—appears to be critical to the quality of a story. In scriptwriting terms, this refers to the clarity of the themes and a congruence between the film's thematic intents and its dramatic construction and mise-en-scène, to which neither DVFx nor action sequences are antithetical.

These values and moral choices also fit within a larger aspect, their relationship to the kind of story being told. In spite of the extensive discussion about the mythic nature of storytelling in film, fairytale elements—putting the ordinary person in extraordinary circumstances—seems to be a more common structure for Hollywood films than those of the mythic proportions of superhuman achievements that form Joseph Campbell's hero's journey in its broadest understanding. Furthermore, while many films discussed in this book can be related to the hero's journey, and while it is a useful and appropriate framework for analysis of many other Hollywood films, its adoption by scriptwriters as a formula creates the same problems that arise from most formula-driven approaches.

For many the lack of address of social issues and ideological concerns that Hollywood stories convey (or at least their very limited address with regard to their thematic concerns) is a big issue for film, and it is one that many film theorists seek to confront. However, from a storyteller's point of view, addressing these wider issues is a matter of conscience and a matter of truth that every artist confronts. Of course, industry practices and wider ideologies will infuence the stories chosen and the resources made available to filmmakers. Yet only writers have the power to determine what they will commit to paper. As the originator of stories, the screenwriter is in a unique position of freedom of expression, one that few others will have more than moments of throughout the production process in such a collaborative artform. Nonetheless, this role in Hollywood is not considered very powerful even though scriptwriters are charged with the task of crafting what many consider to be modern mythology.

With the magnitude of that task in mind, it is perhaps prudent to give thought to Campbell's four functions served by "a properly operating mythology."[2] The first he identifies is:

the mystical function: to waken and maintain in the individual a sense of awe and gratitude in relation to the mystery dimension of the universe . . . so that he recognizes that he participates in it. . . . The second function . . . is to offer an image of the universe that will be in accord with the knowledge of the time, the sciences and the fields of action of the folk to whom the mythology is addressed. . . . The third function . . . is to validate, support, and imprint the norms of a given, specific moral order, that, namely, of the society in which the individual is to live. And the fourth is to guide him, stage by stage, in health, strength, and harmony of spirit, through the whole foreseeable course of a useful life.[3]

Although the idea that "movies are our era's mythology" is a popular one, the veracity of the idea is tangential to this discussion. Nonetheless, there are commonalities between the functions Campbell proposes and the role movies can play in modern cultures.

As tools for the "mythmakers" of Hollywood, DVFx can assist those crafting a film's narrative in realizing the first two functions Campbell identifies: "awakening a sense of awe and gratitude in relation to the mystery dimension of the universe" and the "offering of images of the universe in accord with the knowledge of the time." Indeed, given the discussion in regard to the spectacularity of DVFx imagery and its narrative placement, the first function probably is the most recognized role effects would be expected to play in a "movies as mythology" argument. Further, that DVFx are one of the means by which scientists develop the knowledge of our times in relation to understanding the universe, the second function also is one that can be associated with DVFx

The last two functions however, fall within the boundaries of storycraft itself and, while DVFx may be used to convey story information needed for "advising on norms" and providing "spiritual guidance," they do not of themselves undertake this function without considerable supporting context from story elements. It is through the thematic framing and development of a narrative that these elements are addressed, and while images like those in the rose petal shot in *American Beauty* can support the "spiritual guidance" themes that operate in the film, such a sequence must be used as part of a much bigger storycraft structure.

Discussion of effects usage and their narrative placement invariably confronts the fact that good stories well told are rare and hard to achieve. In "The

Work of Art in the Age of Mechanical Reproduction," Walter Benjamin recounts Aldous Huxley's oft-quoted observation on the distribution of talent versus the production of product.[4] Huxley's argument relates that the rise of the printing press has increased the amount of material being made available in the absence of a commensurate rise in the naturally occurring talent to create material of a high standard. Such an observation, of course, raises many issues in relation to romantic ideas of "gifted" talent versus developed talent. However, regardless of these views, the production of films always has conformed to the bell curve. A smaller proportion is exceptionally good or exceptionally bad material, but the largest proportion is merely competent and ordinary. Material across this quality continuum however, uses DVFx and, consequently, these effects may be used most often in the service of poorly told stories. Nonetheless, this does not define their usage. To do that, a few core questions begin to define the scope of the impacts of DVFx.

Does using digital visual effects undermine classical storytelling structure? No, it does not. Bad storytelling undermines classical storytelling structure, and when DVFx are used in these kinds of scripts, even when they are of a very high technical standard, they usually seem a very expensive way to fill the screen in what are otherwise badly conceived projects.

Are digital visual effects being used as a substitute for story? The examples in this book show that some narrative premise is attached to almost any movie. Admittedly, many of these premises have been weak and poorly sustained by their story structures. Some films do feel like an endless series of car chases, fight scenes, or effects sequences. Yet, as overworked as these elements may be, they are presented within a "story" that attempts to justify the fights, chases, and effects.

The insight that these might be *kinds* of films, as Steve Neale observes—such as the Hong Kong swordplay film—is one way to look at how these films fit into the overall generic structuring of stories. On the other hand, they simply might be films such as Jan de Bont's *The Haunting,* with poor storycraft instead of good storycraft.

In broad terms, computer graphics themselves—for example the adoption of moving-text imagery, and in particular the use of the "magic computer" with its expositionary role—offered a powerful means of providing not only straightforward exposition but symbolic and thematic materials. As mentioned in chapter 4, the "IKEA catalog" sequence in *Fight Club* uses on-screen text and image manipulation to convey thematic story information. Digital visual effects also demonstrate a capacity to serve traditional expositionary purposes—to give

means for extensive conceptual and backstory elaboration and, as such, are an invaluable story information tool. In many instances these uses of DVFx clearly support traditional classical narrative purposes.

Do DVFx always draw attention to themselves? As the framework of narrative functions demonstrates, DVFx provide a range of usages, many of which are never noticed by audiences. Therefore, when effects are being analyzed, their functional usage in the context of the narrative environment is more important than how obvious they are to the audience. In some instances DVFx are extremely attention-seeking, but spectacle can fit easily into narrative filmmaking, as it always has done with traditional effects. As so many commentators have noted, from its origins filmmaking has sought to exploit spectacle and to take advantage of the "addiction to narrative" that authors such as Brian Winston and Michele Pierson have noted. Furthermore, many narratives rely upon spectacular moments as part of the storytelling process.

Once again, the issue of values presents itself. While DVFx can be used spectacularly, there are contexts that must be taken into account. For example, when DVFx are used to heighten physical danger—often in very spectacular scenes— the effects only convey inner perils and moral strengths when they also are scripted and used representationally within that narrative context. The overwhelming usage of DVFx in application to the hero's role, for example, is an exploitation of its value as a means of increasing the perceived proximity and extent of danger posed to the hero or to exaggerate the hero's physical prowess. However, great acts of character are what make heroes, not great displays of DVFx; therefore storycraft is essential to the full realization of the hero. Where this happens, a film drawing upon DVFx is capable of attaining exceptional power thematically.

This argues against the often-made assertion that special effects are inherently and inevitably self-reflexive and spectacular, but it does not deny that instances of self-reflexivity and spectacularity exist in the use of special effects, especially in action sequences. These kinds of uses are not mutually exclusive. As the examples in chapters 4 and 5 demonstrate, spectacularity is in some instances specifically part of the narrative that works to establish the diegetic world, exaggerate violence, provide spectacle as part of the story itself, or stop the narrative to let themes resonate or provide a beat in the overall structure of the narrative. Spectacularity, while a valuable concept, does not capture the full practice and potential of DVFx, and it is not one of its enduring qualities.

It would be unusual to argue in this age that the spectacularity of color in film is narratively arresting and impossible to argue that it is *always* self-reflexive and distracts from narrative cohesion. Accordingly, in relation to much of current DVFx practice it should be noted that the demographic audience of the typical Hollywood blockbuster film—males who are age 16 to 24—has never known films without CG images. The oldest of this group would have been in preschool when the Genesis Effect first screened at the cinema.

While the use of DVFx can offer moments of spectacularity and nonnarrative awe, as in the manner proposed by the oft-cited *2001,* to attribute this quality to the use of *all* DVFx is inaccurate and, in some respects, takes away from those moments where such instances of spectacularity do quite properly occur. Using words like *always* and *never* when claiming that effects are self-reflexive and never can be invisible overstates the case and underestimates the skill of effects artists.

Furthermore, whether the kinetic thrill derives from the violence portrayed or the effects used to portray them bears closer consideration. The spectacularity of violence is an important distinction because DVFx bring a deceptive power to images of violence, one that must have implications for spectators. What is more, while these images are perceptually realistic, they also may convey an especially false cognitive realism. In other words, no matter how "realistic" the violence appears because of the skill in creating its representation, a real-life experience of a violent event is unlikely to bear any resemblance to the film portrayal, and the repetition of digitally enhanced scenes of violence can give a very false sense of what true violence is like. Real violence—the stuff of mob beatings and drive-by-shootings—does not provide the sound-enriched, graphically detailed, multi-angled, temporally manipulated images that are depicted in film so perfectly. To judge from films, people being engulfed by flames and thrown a great distance by an explosion only to emerge unscathed is quite routine. Drawing the conclusion that these images are realistic—even if they are photorealistically portrayed—would be to accept a state of false cognitive realism; what we see and believe to be true is simply not so, even if we have seen many persuasive visual representations of such instances.

The issue of violence in film and its impacts on society are far beyond the scope of this book but, in the interests of researchers who seek to pursue those matters, further consideration of how DVFx not only present graphic detail but exaggerations of graphic detail in convincingly real representations, is of relevance.

If the purpose of spectacularity is to inspire experience of the sublime, it is unlikely that violence is the poet's answer, no matter how perfectly depicted.

Are digital visual effects limited to certain genres? This question almost seems redundant and, of course, the answer is "not at all." While these effects continue to have special meaning for science-fiction films, the breadth of their narrative function and their adoption by filmmakers across the range of genres is likely to weaken this perception over time, even if it does not take away science fiction's unique relationship with effects. Furthermore, their use within genres highlights the importance of using them in keeping with those genre traditions in order for them to be most powerful in those thematic contexts. As filmmakers develop greater facility in using DVFx to realize story information and elements, effects are being used outside of the traditional genres to great success and acclaim. When it comes to using DVFx to display technology within films, such instances are not necessarily meaningful unless the narrative also provides a context that draws out these themes. While many critical commentaries have considerable enthusiasm for the use of DVFx as a celebration of technology and as an emerging nonnarrative form, landmark DVFx films such as the *Lord of the Rings* trilogy show that reliance upon a classical narrative premise is the foundation for integrated DVFx work. Even when these classical narratives prove to be flawed examples of storycraft, little evidence indicates that they are attempts to establish a new narrative form.

Have digital visual effects fundamentally changed the filmmaking process? And if so, how? DVFx offer greater technical range, control, and precision than can be achieved with traditional optical and special effects, in addition to offering new techniques altogether. These new techniques include: virtual camera moves, digital lighting, synthetic realities, fully photoreal CG imagery, motion capture of performance for animation of photoreal images, and fully CG characters. Filmmakers have used these techniques to extend the story information tools available, and this practice has implications for theoretical discussion related to the critical discussion that has favored camera movement, mise-en-scène, and performance. There is no doubt that digitally crafted images affect composition, framing, scale, and shot duration; therefore they have aesthetic and ideological implications for such academic considerations.

There is still a great reliance upon and expectation that Hollywood films will conform to the structure of having a beginning, a middle, and an end. However, DVFx have changed the means of representation available to filmmakers. They offer filmmakers the power of the recording medium as well as the power and

symbolism available to representative arts. To exert painterly control over all aspects of the mise-en-scène is an enormous boon to a storyteller. That this kind of control is being extended to performance, as well as to setting, is likely to provide even greater imaginative scope for the realization of film narratives. Ultimately, when used well, narrative context informs the use of DVFx both stylistically and as a means of communicating story information.

As Thomas Schatz observes regarding the developments of new sound technologies, ". . . the new audio effects . . . encouraged filmmakers to focus upon action and urban violence, and also to develop a fast-paced narrative and editing style."[5] Digital visual effects have had a similar impact and in some respects, continuing the established trend of a technological innovation leading to experimentation and the development of fresh filmmaking techniques. However, in terms of visual representation and the meaningfulness of what can be expressed in symbolic and thematic terms, DVFx have had a much broader impact than simply adding to the kinetic thrills of action sequences.

What does the future of digital visual effects practice hold for storycraft? Visual effects supervisor Kim Libreri (*Catwoman,* 2004, Pitof; *Matrix Reloaded; Matrix Revolutions*) in an article for *VFX World* predicts that the future will hold better virtual humans and synthetic massive environments, and that DVFx will move from emulation to simulation.[6] Of this latter point he says that instead of "recreating the *appearance* of things digitally, we will more and more be able to recreate the *physics* of movement, light, etc."[7] Digital performers and the digital environments that are being crafted for both human and digital performers, he says, will achieve even greater standards of realism and technical mastery.

As chapter 10 discusses, DVFx are not only our means for imagining new worlds and frontiers for fantastical purposes, they also allow us to imagine the future in order to construct it now—as a built environment or as new technological developments—including medical/technological alterations to our physical beings. Thus, the relationship between the technology used to create the representation and what the representation means thematically for our future is not solely a matter of storycraft but also of our lived existence. That we now have animated and digitally created representations that can provide a visual context for how we have arrived at this time and place provides us with a convincing realization of where we might yet go, and it may indeed be what is behind some of the anxiety in the criticisms of DVFx.

We not only can look upon images of a reconstructed past and demonstrate how time has taken its toll on land and the built environment, but we now can

do so more powerfully with images as realistic as those of the world around us. This sense of continuity and mutation, of the force and flux of time, is particular to our era because of the power of the moving image and the verisimilitude of the digitally crafted images portrayed within the film frame. As a result, the meaning of future representations has changed. No matter how fantastical these images are, with a heightened awareness of the magnitude of change that has already occurred, these proposed futures attain a new level of potential, one that often is being constructed around us.

As CG characters such as Gollum in the *Lord of the Rings* films show, we now are capable of going beyond morphing to achieve a new way of being transformed; not just a new/hybrid way of performing, but a way to shapeshift. This new kind of shapeshifting involves a sacrifice of identity, a loss of self where through motion capture we are the data and the data is us.

In terms of the potential these innovations and the current standards in DVFx offer, there is a growing sublime usage of DVFx, such as that found in the films *Amélie* and *American Beauty,* that show us how moments of spectacularity may be less about the technology and instead about the concept and the emotional response being sought or conveyed. This portrayal of fantasy elements, state-of-mind sequences, and emotional-response cues (such as the key in Amélie's pocket), uplift us from the narrative without breaking it or removing audiences from the context it offers. It is these kinds of sequences that demonstrate the potential of DVFx for storytelling.

Nonetheless, as noted many times, good stories are rare delights, whether this is as a result of poor storycraft or simply a proportional reality. The issue is that DVFx relate to the quality of storycraft. Simply put, when used by a skilled storyteller, DVFx provide extensive new means of bringing images to the screen—images that thematically and symbolically communicate the fundamental materials of story. And while these instances are not new kinds of stories or story structures, they are new tools for and approaches to storytelling. These effects provide the means by which to tell the kind of stories that can be described as the impossible—or as yet unachieved—made real. Filmmaker George Miller waited ten years for the necessary technology to make *Babe,* and he achieved a major technical breakthrough with the DVFx needed to portray talking animals. The Genesis Effect was sold to George Lucas on its offer of an impossible camera move. In many ways this is the most significant impact of DVFx for filmmakers: access to the impossible—the making real of images previously limited to the representational arts, the mind's eye, or the writer's pen.

The road for DVFx has not been an easy journey, as it has required long, slow technical innovation to build the bridge from the imagined to the realized. However, the result is the increasingly skilled use of digitally created images to innovate visually and to use DVFx as a storytelling tool. As *Amelie* and *American Beauty* have shown, the avant garde of the surreal now is used for quirky love stories and dark comedies.

Through DVFx, male and female heroes have extraordinary power to cheat death. The effects have taken them to impossible places, pitted them against characters that only could be achieved through computer graphics, and heightened the verisimilitude of images for all kinds of film genres. The camera's position no longer is restricted by its physicality, and where in traditional filmmaking some images had to be implied, now they can be shown. Whether re-creating the past, inventing space travel with believably active humans, or drawing upon invisible effects to ensure maximum control over the image and environment, DVFx have changed film production and image creation. By mastering the ability to control storms and other elements of nature, provide convincing representations of the future, and manipulate time and space, DVFx have taken the recording arts into a new realm where issues of representation must be reconsidered alongside photographic theory. Where once filmmakers had to rely on a big guy in a fur-covered suit, now human performance can be the essence of CG animation.

However, while DVFx have completely reequipped the storyteller's toolbox, they have not rewritten the storyteller's rulebook entirely. They have not created a new narrative form; what might be perceived as a techno-narrative instead may be a consequence of formulaic writing dominated by whammos and the kinetic drive of violence and action scenes. Those instances where an opportunity is made to rework the narrative to accommodate the latest effects in order to provide an excuse for the use of DVFx simply may be a developmental phase by some filmmakers and rarely is successful unless the narrative reworking establishes thematic relationships that make the DVFx work for the story as a whole.

The nonnarrative effects film in the tradition of the Whitneys described in chapter 3 remains a fine-arts form of expression. Hollywood films remain committed to narrative structure as a vehicle for CG usage. If there is any hint that this might change, it could be in the idea expressed in the *Wired* article "Life after Darth," which states that George Lucas' next direction is a return to the avant garde.[8] Given that he built ILM to sustain himself as an independent

filmmaker and that now he is considered to be the establishment that some of the latest independent filmmakers hold to blame for the death of independent filmmaking, it will be fascinating to see if Lucas achieves anything approaching similar success with the mainstreaming of avant-garde filmmaking.

In the meantime, while much is made of the spectacularity of DVFx, most spectacular scenes and images still have a narrative purpose. In part, spectacularity serves to verify and convince audiences of the immensity and significance of the hero's experience. If the hero's experience is mundane, we do not have as much a sense of the magnitude or exceptionality of her experience, and thus, faith in the transformation that follows. Even Lester Burnham's vision of roses (*American Beauty*), in a "show us your tits" kind of world, is exceptional.

Bruno Bettelheim argues that children who grow up too quickly turn to stories of magic and fantasy. Campbell asserts that mythology (and storytelling) are driven by the impulse to transcend mortality. And Viktor Frankl discovered that hope is the reason we keep living and what gives us meaning. This necessity to give ourselves hope—magical hope for childish hearts overwhelmed by the magnitude of our real problems, ones too great for any individual to solve—might be at the heart of the impulse to support the "industry of escapism."

The technology that brings images and narratives into our homes also brings awareness—like the apple of knowledge—and we no longer need to stand at the foot of the melting glaciers to understand what it might mean for our own doorsteps. We may tell stories to convince ourselves that we might yet transcend our destiny and the end that awaits, or at least to live so greatly that we will transcend it by being remembered.

If stories serve to address these very deep needs, there must be some understanding that not all attempts will be excellent. As for the escalation of violence and a confusion of values, the relationship between these two elements is not so distant. Justifying acts of extreme violence is difficult, although the magnitude of the fear that drives the impulse to respond with violence may be understandable. Finding an opponent who justifiably can be blamed for all that is wrong so that the hero's triumph over that opponent creates a sensation of victory no longer is an easy desire to satisfy. *The Matrix* presents a rationale where the enemy is simply a program—an artificial intelligence—that had to be destroyed to save the human race. In comparison, *A.I.* confronts the concept that violence is a demonstration of our fear of the "other" and offers the solution of overcoming this fear through acts of humanity and compassion. The appeal, then, of creating aliens or supernatural creatures who are irrefutably evil—

deserving of violent retaliation—makes sense when attacks and violence against humans present a morally difficult premise. This still does not address our real fears and the impulse to violence, but it remains one of our most favored coping mechanisms and a considerable facet of our stories.

Our arguments about whether we agree with the values espoused in films and the images used to convey them perhaps is no different from the wider disputes of philosophers, and that may be one of the purposes of our storytelling: to give us common ground on which to argue fundamental values. Campbell says,

The first condition, therefore, that any mythology must fulfill if it is to render life to modern lives is that of cleansing the doors of perception to the wonder, at once terrible and fascinating, of ourselves and of the universe of which we are the ears and eyes and the mind.[9]

If digital visual effects are a growing means by which we craft images of wonder—both terrible and fascinating—then they should be considered as more than escapist spectacle, and when contexted by strong narrative they can offer meaningfulness comparable to that of the great representational images. For some, as Lester Burnham observes in *American Beauty,* "beauty is found in places you least expect it," and in the case of DVFx often where it cannot be seen but somehow can be felt. While we may never truly define "meaning" or "wisdom" nor how they continue to manifest and disguise themselves in our endeavors, we also are unlikely to give up the search. In this perseverance we show ourselves to be heroes.

Appendix A: Genres of Films Featured in *Cinefex* Magazine

1980

Issue 1
Star Trek: The Motion Picture, science fiction
Alien, science fiction/horror

Issue 2
The Empire Strikes Back, science fiction
Star Trek: The Motion Picture, science fiction

Issue 3
Star Wars: Episode V—The Empire Strikes Back, science fiction
Phase IV, science fiction

1981

Issue 4
Altered States, science fiction
Outland, science fiction

Issue 5
Clash of the Titans, fantasy/adventure
Ray Harryhausen, special feature

Issue 6
Raiders of the Lost Ark, fantasy/adventure
Dragonslayer, fantasy/adventure
CGI, special feature

1982

Issue 7
Willis O'Brien, special feature

Issue 8
Tron, science fiction
Silent Running, science fiction

Issue 9
Blade Runner, science fiction

Issue 10
Poltergeist, horror
Firefox, action/thriller

1983

Issue 11
E.T.: The Extraterrestrial, science fiction
Robert Swarthe, special feature

Issue 12
Something Wicked This Way Comes, dark fantasy
Stop-motion update, special feature

Issue 13
Star Wars: Episode VI—Return of the Jedi, science fiction

Issue 14
The Right Stuff, period/action
Brainstorm, science fiction
Twilight Zone: The Movie, science fiction/horror

1984

Issue 15
Never Say Never Again, action
The Day After, science fiction/TV movie
Ralph Hmmeras—special feature

Issue 16
Rick Baker, special feature

Issue 17
Ghostbusters, comedy/horror
The Last Starfighter, science fiction/children's

Issue 18
Indiana Jones and the Temple of Doom, fantasy/action
Star Trek III: The Search for Spock, science fiction

Issue 19
Gremlins, comedy/horror
Buckaroo Banzai, children/fantasy
Dreamscape, science fiction/fantasy

1985

Issue 20
2010, science fiction

Issue 21
Terminator, science fiction
Dune, science fiction

Issue 22
Return to Oz, fantasy/children's
Baby, fantasy/children's

Issue 23
Explorers, science fiction/children's
Lifeforce, science fiction
My Science Project, science fiction/children's

Issue 24
Cocoon, science fiction
Back to the Future, science fiction/comedy
The Goonies, fantasy/children's

1986

Issue 25
Enemy Mine, science fiction
German special effects, special feature
Fright Night, horror

Issue 26

Poltergeist II, horror

Young Sherlock Holmes, fantasy/adventure

Issue 27

Aliens, science fiction/war

Issue 28

The Fly, science fiction/horror

Big Trouble in Little China, action/adventure

Short Circuit, fantasy/children's

1987

Issue 29

Star Trek IV: The Voyage Home, science fiction

King Kong Lives, fantasy/action

Issue 30

Little Shop of Horrors, comedy/horror

The Gate, horror

The Golden Child, comedy/fantasy

Issue 31

Spaceballs, science fiction/comedy

The Witches of Eastwick, comedy/fantasy

Masters of the Universe, science fiction

Issue 32

RoboCop, science fiction/action

Innerspace, science fiction/comedy

1988

Issue 33

Dick Smith, special feature

James Bond, special feature

Predator, science fiction

Issue 34

Beetlejuice, science fiction/comedy

Batteries Not Included, science fiction/children's

Issue 35
Who Framed Roger Rabbit?, animation/fantasy
Willow, fantasy/action

Issue 36
Dead Ringers, horror
Alien Nation, science fiction
The Blob, science fiction /horror
Die Hard, action

1989

Issue 37
Star Trek—The Next Generation, science fiction
The Fly II, science fiction

Issue 38
Terry Gilliam, special feature

Issue 39
The Abyss, science fiction

Issue 40
Indiana Jones and the Last Crusade, fantasy/action
Ghostbusters II, comedy/horror

1990

Issue 41
Batman, comic book/action
Honey, I Shrunk The Kids, comedy/children's

Issue 42
The Hunt for Red October, action/adventure
Tremors, comedy/horror
Star Trek V: The Final Frontier, science fiction

Issue 43
Total Recall, science fiction/action
Back to the Future II & III, science fiction/comedy

Issue 44
Dick Tracy, comic book/action

Ghost, supernatural thriller

Always, drama/fantasy

1991

Issue 45

RoboCop 2, science fiction/action

Die Hard 2, action

Flight of the Intruder, action/war

Issue 46

Rick Baker update, special feature

Simulator rides, special feature

Godfather trilogy, drama

Issue 47

Terminator 2: Judgment Day, science fiction

Issue 48

The Rocketeer, period/fantasy

Backdraft, action

Cast a Deadly Spell, comedy/fantasy

1992

Issue 49

Hook, fantasy/children's

Naked Lunch, drama/fantasy

Star Trek VI: The Undiscovered Country, science fiction

Issue 50

Alien³, science fiction

The Lawnmower Man, science fiction

Issue 51

Batman Returns, comic book/action

Issue 52

Honey, I Blew Up the Kid, comedy/children's

Death Becomes Her, comedy/fantasy

1993

Issue 53
Bram Stoker's Dracula, horror
Close Encounters of the Third Kind, science fiction

Issue 54
Cliffhanger, action
Toys, comedy/fantasy

Issue 55
Jurassic Park, science fiction/horror
The Abyss, science fiction
Alive, drama/action

Issue 56
The Nightmare before Christmas, comedy/fantasy
Last Action Hero, action/fantasy
RoboCop 3, science fiction/action

1994

Issue 57
Attack of the 50 Foot Woman, science fiction
Demolition Man, science fiction/action

Issue 58
The Flintstones, cartoon/comedy
The Hudsucker Proxy, comedy/fantasy

Issue 59
True Lies, action/adventure

Issue 60
The Mask, comedy/fantasy
Forrest Gump, drama/comedy
Mary Shelley's Frankenstein, horror
Ed Wood, comedy/drama

1995

Issue 61
Interview with the Vampire, horror

Star Trek Generations, science fiction
Stargate, science fiction

Issue 62
Congo, action/adventure
Judge Dredd, science fiction/action
Dick Smith, special feature

Issue 63
Apollo 13, period/drama
Batman Forever, comic book/action

Issue 64
Jumanji, fantasy/children's
Toy Story, animation/children's
Waterworld, drama/action
Broken Arrow, action/thriller
Cutthroat Island, action/adventure
Money Train, action/comedy
Babe, fantasy/children's
Casino, crime/drama
Three Wishes, drama
Operation Dumbo Drop, action/adventure

1996

Issue 65
ILM, special feature
George Lucas, special feature
Star Wars, science fiction
Dennis Muren, special feature

Issue 66:
Dragonheart, fantasy/adventure
Twister, action/thriller
James and the Giant Peach, fantasy/children's

Issue 67
Independence Day, science fiction/action
Multiplicity, science fiction/fantasy
Mission: Impossible, action
The Nutty Professor, comedy/children's

Escape from L.A., action/adventure
The Arrival, science fiction
The Frighteners, comedy/horror

Issue 68
Mars Attacks!, science fiction/comedy
T2-3D: Battle across Time, special feature

1997

Issue 69
Dante's Peak, action/drama
Star Trek: First Contact, science fiction
The Relic, horror
Star Wars, science fiction
101 Dalmations, comedy/children's
The 6th Man, comedy/drama
Turbulence, action/thriller

Issue 70
The Lost World, science fiction
The Fifth Element, science fiction/action
Men in Black, science fiction/comedy
Con Air, action/thriller
Anaconda, thriller/horror

Issue 71
Spawn, thriller/action
Contact, science fiction
Batman & Robin, comic book/action
Volcano, action/thriller
Speed 2, action/thriller

Issue 72
Titanic, period/romance

1998

Issue 73
Starship Troopers, science fiction/comedy
Alien Resurrection, science fiction/horror
Flubber, comedy/children's

American Warewolf in Paris, horror/comedy
Event Horizon, science fiction/horror

Issue 74
The X-Files, science fiction/thriller
Lost in Space, science fiction/comedy
Independence Day, science fiction/action
Deep Impact, science fiction/drama
Sphere, science fiction/thriller
Deep Rising, action/horror
Dark City, science fiction/thriller

Issue 75
Armageddon, science fiction/action
Small Soldiers, science fiction/action
From Earth to the Moon, action/drama
Blade, action/horror
Dr. Doolittle, comedy/children's
Truman Show, comedy/drama

1999

Issue 76
Mighty Joe Young, fantasy/children's
What Dreams May Come, drama/fantasy
Pleasantville, fantasy/comedy
Antz, animation/children's
A Bug's Life, animation/children's
Virus, action/horror

Issue 77
My Favorite Martian, science fiction/comedy
Star Trek: Insurrection, science fiction
The Mummy, action/horror

Issue 78
Star Wars Episode I: The Phantom Menace, science fiction

Issue 79
The Matrix, science fiction/action/thriller
Deep Blue Sea, action/horror

Wild Wild West, action/western
The Haunting, horror

2000

Issue 80
Sleepy Hollow, horror
Stuart Little, fantasy/children's
Fight Club, drama/thriller

Issue 81
Mission to Mars, science fiction
End of Days, horror/action
Galaxy Quest, action/comedy
Bicentennial Man, science fiction/drama
Toy Story 2, animation/children's
Pitch Black, science fiction/horror

Issue 82
Dinosaur, animation/children's
The Perfect Storm, adventure/drama
Chicken Run, animation/children's
Gladiator, period/action
U-571, action/war
Battlefield Earth, science fiction/action

Issue 83
X-Men, science fiction/action
Hollow Man, science fiction/horror
The Cell, science fiction/horror
The Patriot, period/war
What Lies Beneath, horror

2001

Issue 84
How the Grinch Stole Christmas, fantasy/children's
Red Planet, science fiction/action
Vertical Limit, action/adventure
Bedazzled, fantasy/comedy
102 Dalmations, comedy/children's

Genres of Films Featured in *Cinefex* Magazine

Issue 85

2001: A Space Odyssey, science fiction

The Mummy Returns, action/horror

The 6th Day, science fiction/action

Monkeybone, animation/fantasy

Issue 86

Pearl Harbor, period/drama

Evolution, science fiction/comedy

Moulin Rouge, musical/drama

Final Fantasy: The Spirits Within, science fiction/animation

Driven, action/thriller

Issue 87

A.I.:Artificial Intelligence, science fiction

Planet of the Apes, science fiction

Jurassic Park III, science fiction/horror

Tomb Raider, action/fantasy

2002

Issue 88

Harry Potter and the Sorcerer's Stone, fantasy/children's

Shrek, animation/children's

Monsters Inc., animation/children's

The Fast and the Furious, thriller/action

Issue 89

Lord of the Rings: The Fellowship of the Ring, fantasy/adventure

The Time Machine, science fiction

Black Hawk Down, war/action

Issue 90

Star Wars: Episode II—Attack of the Clones, science fiction

Spider-Man, comic book/action

Issue 91

Men in Black 2, science fiction/comedy

Minority Report, science fiction/thriller

Reign of Fire, science fiction/action

2003

Issue 92

Lord of the Rings: The Two Towers, fantasy/adventure

xXx, action/adventure

Spy Kids, children/action

Issue 93

Harry Potter and the Chamber of Secrets, fantasy/children's

Star Trek: Nemesis, science fiction

Adaptation, comedy/drama

Daredevil, comic book/action

Issue 94

The Hulk, comic book/action

X-Men United, science fiction/action

The Core, science fiction

Issue 95

Matrix Reloaded, science fiction/action

Terminator 3: Rise of the Machines, science fiction

Seabiscuit, period/drama

Spy Kids 3D, children/action

2004

Issue 96

Lord of the Rings: The Return of the King, fantasy/adventure

Master and Commander, period/war

Peter Pan, fantasy/children's

Issue 97

Hellboy, comic book/horror

Matrix Revolutions, science fiction/action

Passion of the Christ, period/drama

Issue 98

Van Helsing, comic book/horror

Troy, period/drama

Day after Tomorrow, science fiction/disaster

Sky Captain and the World of Tomorrow, science fiction/animation

Issue 99

Spider-Man 2, comic book/action

Alien vs. Predator, science fiction

Harry Potter and the Prisoner of Azkaban, fantasy/children's

I, Robot, science fiction

2005

Issue 100

Polar Express, animation/children's

Lemony Snicket's A Series of Unfortunate Events, fantasy/children's

Issue 101

The Aviator, period drama

Son of the Mask, comedy/fantasy

Issue 102

Sin City, comic book/crime

Constantine, comic book/action

Q&A: George Lucas

Star Wars Episode III: Revenge of the Sith, science fiction

The Hitchhiker's Guide to the Galaxy, science fiction/comedy

Issue 103

Overviews:

 Fantastic Four, comic book/action

 The Island, science fiction/action

 Charlie and the Chocolate Factory, fantasy/children's

 Herbie: Fully Loaded, children's

Stealth, science fiction/action

War of the Worlds, science fiction

Batman Begins, comic book/action

Appendix B: Films, Release Years, and Directors

1941, 1979, Steven Spielberg
2001: A Space Odyssey, 1968, Stanley Kubrick

A.I., 2001, Steven Spielberg
A Night to Remember, 1958, Roy Ward Baker
Abyss, The, 1989, James Cameron
Adaptation, 2002, Spike Jonze
African Queen, The, 1961, John Huston
Alien, 1979, Ridley Scott
Aliens, 1986, James Cameron
Alien³, 1992, David Fincher
Alien Resurrection, 1997, Jean-Pierre Jeunet
Always, 1989, Steven Spielberg
Amélie, 2001, Jean-Pierre Jeunet
Amistad, 1997, Steven Spielberg
American Beauty, 1999, Sam Mendes
American Graffiti, 1973, George Lucas
Animatrix, The, 2003, Peter Chung, Andy Jones, Yoshiaki Kawajiri, Takeshi Koike, Mahiro Maeda, Koji Morimoto, and Shinichiro Watanabe
Apollo 13, 1995, Ron Howard
Armageddon, 1998, Michael Bay

Babe, 1995, Chris Noonan
Babe: Pig in the City, 1998, George Miller

Bank, The, 2000, Robert Connolly
Being John Malkovitch, 1999, Spike Jonze
Ben Hur, 1959, William Wyler
Big Fish, 2003, Tim Burton
Birthday Boy, 2004, Sejong Park
Blade II, 2002, Guillermo del Toro
Blade Runner, 1982, Ridley Scott
Bourne Identity, The, 2002, Doug Liman
Braveheart, 1995, Mel Gibson

Cell, The, 2000, Tarsem Singh
Charlie Chan, (30 titles between 1931 and 1949)
Chopper, 2000, Andrew Dominik
Chronicles of Narnia: The Lion, The Witch and The Wardrobe, 2005, Andrew
 Adamson
Citizen Kane, 1941, Orson Welles
Close Encounters of the Third Kind, 1977, Steven Spielberg
Color Purple, 1985, Steven Spielberg
Crooked Mick, 2005, Phil Smith
Crouching Tiger, Hidden Dragon, 2000, Ang Lee

Dante's Peak, 1997, Roger Donaldson
Dark Angel (TV series), 2000–2002
Day after Tomorrow, The, 2004, Roland Emmerich
Deep Impact, 1998, Mimi Leder
Devil's Backbone, The, 2001, Guillermo del Toro
Dish, The, 2000, Rob Sitch
Dog Day Afternoon, 1975, Sidney Lumet
Duel, 1971, Steven Spielberg
Donnie Darko, 2001, Richard Kelly
Dr. Doolittle, 1967, Richard Fleischer
Dr. Doolittle, 1998, Betty Thomas

Empire of the Sun, 1987, Steven Spielberg
Eraser, 1996, Chuck Russell
E.T.: The Extraterrestrial, 1982, Steven Spielberg

Eternal Sunshine of the Spotless Mind, The, 2004, Michel Gondry
Exorcist, The, 1972, William Friedkin

Fairy Tale: A True Story, 1997, Charles Sturridge
Fight Club, 1999, David Fincher
Filatelista, 2004, Jacob Zaremba
Final Fantasy: The Spirits Within, 2001, Hironobu Sakaguchi and Motonori
 Sakakibara
Finding Neverland, 2004, Marc Forster
Firefox, 1982, Clint Eastwood
Fly Away Home, 1996, Carroll Ballard
Forrest Gump, 1994, Robert Zemeckis

Game, The, 1997, David Fincher
Ghosts of the Abyss, 2003, James Cameron
Gladiator, 2000, Ridley Scott
Godfather, The, 1972, Francis Ford Coppola
Godzilla, 1998, Roland Emmerich
Gone With the Wind, 1939, Victor Fleming

Halloween, 1978, John Carpenter
Halloween II, 1981, Rick Rosenthal
Halloween III: Season of the Witch, 1982, Tommy Lee Wallace
Halloween 4: The Return of Michael Myers, 1988, Dwight H. Little
Halloween 5, 1989, Dominique Othenin-Girard
Halloween: The Curse of Michael Myers, 1995, Joe Chappelle
Halloween H20: 20 Years Later, 1998, Steve Miner
Halloween: Resurrection, 2002, Rick Rosenthal
Harry Potter and the Sorcerer's/Philosopher's Stone, 2001, Chris Columbus
Harry Potter and the Chamber of Secrets, 2002, Chris Columbus
Harry Potter and the Prisoner of Azkaban, 2004, Alfonso Cuarón
Harry Potter and the Goblet of Fire, 2005, Mike Newell
Haunting, The, 1963, Robert Wise
Haunting, The, 1999, Jan de Bont
Hero, 2002, Zhang Yimou
Hook, 1991, Steven Spielberg
Hunger, 1974, Peter Foldes

Independence Day, 1996, Roland Emmerich
Indiana Jones and the Last Crusade, 1989, Steven Spielberg
Indiana Jones and the Temple of Doom, 1984, Steven Spielberg
Interview with the Vampire, 1994, Neil Jordan

Jason and the Argonauts, 1963, Don Chaffey
Jaws, 1975, Steven Spielberg
Jurassic Park, 1993, Steven Spielberg

King Kong, 1933, Merian C. Cooper and Ernest B. Schoedsack
King Kong, 2005, Peter Jackson
Kung Fu Hustle, 2004, Steven Chow

Lady in the Lake, 1947, Robert Montgomery
Lemony Snicket's A Series of Unfortunate Events, 2004, Brad Silberling
Lethal Weapon, 1987, Richard Donner
Lethal Weapon 2, 1989, Richard Donner
Lethal Weapon 3, 1992, Richard Donner
Lethal Weapon 4, 1998, Richard Donner
Lord of the Rings: The Fellowship of the Ring 2001, Peter Jackson
Lord of the Rings: The Two Towers, 2002, Peter Jackson
Lord of the Rings: The Return of the King, 2003, Peter Jackson
Lost World: Jurassic Park, 1997, Steven Spielberg

Mars Attacks! 1996, Tim Burton
Master and Commander, 2003, Peter Weir
Matrix, The, 1999, Andy and Larry Wachowski
Matrix Reloaded, 2003, Andy and Larry Wachowskip
Metropolis, 1927, Fritz Lang
Mission to Mars, 2000, Brian De Palma
Monsters Inc., 2001, Peter Dockter, David Silverman, and Lee Unkrich
Moulin Rouge, 2001, Baz Luhrmann

Nancy Drew series, 1938; 1939; 1939; 1939, William Clemens

0 Brother Where Art Thou? 2000, Joel and Ethan Coen

Panic Room, 2002, David Fincher

Parent Trap, The, 1961, David Swift

Parent Trap, The, 1998, Nancy Meyer

Pearl Harbor, 2001, Michael Bay

Perfect Storm, The, 2000, Wolfgang Petersen

Pianist, The, 2002, Roman Polanski

Pleasantville, 1998, Gary Ross

Polar Express, The, 2004, Robert Zemeckis

Professional, The, 1994, Luc Besson

Rabbit Proof Fence, 2002, Phil Noyce

Raiders of the Lost Ark, 1981, Steven Spielberg

Romeo+Juliet, 1996, Baz Luhrmann

Saving Private Ryan, 1998, Steven Spielberg

Schindler's List, 1993, Steven Spielberg

Shaolin Soccer, 2001, Steven Chow

Showtime, 2002, Tom Dey

Shrek, 2001, Andrew Adamson, Vicky Jenson

Sixth Sense, The, 1999, M. Night Shyamalan

Sky Captain and the World of Tomorrow, 2004, Kerry Conran

Solarmax, 2000, John Weiley

Spirited Away, 2001, Hayao Miyazaki

Star Trek: The Motion Picture, 1979, Robert Wise

Star Trek: The Wrath of Khan, 1982, Nicholas Meyer

Star Trek III: The Search for Spock, 1984, Leonard Nimoy

Star Trek IV: The Voyage Home, 1986, Leonard Nimoy

Star Trek V: The Final Frontier, 1989, William Shatner

Star Trek VI: The Undiscovered Country, 1991, Nicholas Meyer

Star Trek: Generations, 1994, David Carson

Star Trek: First Contact, 1996, Jonathan Frakes

Star Trek: Insurrection, 1998, Jonathan Frakes

Star Trek: Nemesis, 2002, Stuart Baird

Star Trek: Enterprise (TV series), 1966–1969

Star Wars: Episode I—The Phantom Menace, 1999, George Lucas

Star Wars: Episode II—Attack of the Clones, 2002, George Lucas

Star Wars: Episode III—Revenge of the Sith, 2005, George Lucas

Star Wars: Episode IV—A New Hope, 1977, George Lucas

Star Wars: Episode V—The Empire Strikes Back, 1980, Irvin Kershner

Star Wars: Episode VI—Return of the Jedi, 1983, Richard Marquand

Story of Computer Graphics, 1999, Frank Foster

Strange Days, 1995, Kathryn Bigelow

Stuart Little, 1999, Rob Minkoff

Sugarland Express, 1973, Steven Spielberg

Swordfish, 2001, Dominic Sena

Terminator, 1984, James Cameron

Terminator 2: Judgment Day, 1991, James Cameron

Terminator 3: Rise of the Machines, 2003, Jonathan Mostow

Thin Man, 1934, Van Dyke; 1936; 1939; 1941; 1945, Thorpe; 1947, Buzzell;
(TV series), 1957–1959

THX1138, 1971, George Lucas

T2-3D (theme park feature), 1996

Titanic, 1997, James Cameron

To Kill A Mockingbird, 1962, Robert Mulligan

Toy Story, 1995, John Lasseter

Tron, 1982, Steven Lisberger

Twilight Zone: The Movie, 1983, Joe Dante, John Landis, George Miller, and
Steven Spielberg

Van Helsing, 2004, Stephen Sommers

Walking with Dinosaurs, 1999, Tim Haines and Jasper James

What Lies Beneath, 2000, Robert Zemeckis

Who Framed Roger Rabbit, 1988, Robert Zemeckis

Willow, 1988, Ron Howard

Zelig, 1983, Woody Allen

Notes

Chapter One

1. Paul Byrnes in his review "Van Helsing," in the *Sydney Morning Herald,* May 7–13, 2004, p. 9, Metro Section, col. 1.

2. Chris Norris, "Charlie Kaufman and Michel Gondry's Head Trip," *Film Comment* 40, no. 2, March/April 2004, p. 20 (2).

3. Ibid.

4. *The Eternal Sunshine of the Spotless Mind* by Buzz Image Groupe. http://www.softimage .com/Products/xsi/%/2ov4/industry/media

5. Catherine Feeny, "Buzz Image Group and *The Eternal Sunshine of the Spotless Mind,*" *VFX Pro* Feature, April 30, 2004, no. 12, p. 58. http://www.vemedia.net/CPC/vfxpro/ printer_8091.shtml

6. Shilo T. McClean, *So What's This All about Then: A Non-User's Guide to Digital Effect in Filmmaking* (Sydney: Australian Film Television & Radio School, 1998).

7. Andrea Gronemeyer, *Film: A Concise History* (London: Laurence King Publishing, 1998), p. 57.

8. Ibid, p. 58.

9. Vivian Sobchack, "The Fantastic," in Geoffrey Nowell-Smith, ed., *The Oxford History of World Cinema* (Oxford: Oxford University Press, 1997), p. 312.

10. Ibid.

11. Albert J. La Valley, "Traditions of Trickery: The Role of Special Effects in the Science Fiction Film," in George Slusser and Eric S. Rabkin, *Shadows of the Magic Lamp* (Carbondale: Southern Illinois University Press, 1985), p. 144.

12. Martin Barker (with Thomas Austin), *From Antz to Titanic: Reinventing Film Analysis* (London: Pluto Press, 2000), p. 83.

13. Ibid., p. 81.

14. Ibid., p. 83.

15. Ibid., pp. 171–172.

16. Joel Black, *The Reality Effect: Film Culture and the Graphic Imperative* (London: Routledge, 2002), p. 11.

17. Ibid., p. 10.

18. Ibid., p. 8.

19. Ibid., p. 10–11.

20. Ibid., p. 17.

21. Barker, *From Antz to Titanic,* p. 191.

22. Ibid., p. 201.

23. Laura Kipnis, "Film and Changing Technologies," in John Hill and Pamela Church Gibson, eds., *The Oxford Guide to Film Studies* (Oxford: Oxford University Press, 1998), p. 603.

24. Kristin Thompson, *Storytelling in the New Hollywood: Understanding Classical Narrative Technique* (Cambridge, MA: Harvard University Press, 1999), p. 1.

25. Ibid., p. 8.

26. David Bordwell, *Narration in the Fiction Film* (London: Methuen & Co., 1985), p. 53.

27. David Bordwell, Janet Staiger, and Kristin Thompson, *The Classical Hollywood Cinema: Film Style and Mode of Production to 1960* (London: Routledge, 1985), p. 21.

28. Ibid., p. 21.

29. Thompson, *Storytelling in the New Hollywood: Understanding Classical Narrative Technique* (Cambridge, MA: Harvard University Press, 1999), p. 19.

30. Bordwell, *Narration in the Fiction Film* (London: Routledge, 1985), p. 163.

31. Bordwell, Staiger, and Thompson, *The Classical Hollywood Cinema,* p. 72.

32. Steve Neale, *Cinema and Technology: Image, Sound, Colour* (London: MacMillan Education Ltd, 1985), p. 88.

33. David Bordwell, *On The History of Film Style* (Cambridge, MA: Harvard University Press, 1997), pp. 35–38.

34. Neale, *Cinema and Technology,* p. 139.

35. Edward Buscombe in Neale, *Cinema and Technology,* p. 146.

36. Neale, *Cinema and Technology,* p. 150.

37. Ibid.

38. Bordwell, Staiger, and Thompson, *The Classical Hollywood Cinema,* p. 340.

39. Thompson, *Storytelling in the New Hollywood,* p. 284.

40. Bordwell, Staiger, and Thompson, *The Classical Hollywood Cinema,* p. 287.

Chapter Two

1. Stephen R. L. Clark, "Ancient Philosophy," in *The Oxford History of Western Philosophy* (Oxford: Oxford University Press, 2000), p. 2.

2. Richard Kearney, *On Stories* (London: Routledge, 2002), p. 14.

3. E. H. Gombrich, *Art and Illusion: A Study in the Psychology of Pictorial Representation,* 6th ed. (London: Phaidon Press Inc., 2002), p. 152.

4. Ibid., p. 110.

5. James Monaco, *How to Read a Film: Movies, Media, Multimedia,* 3rd ed. (Oxford: Oxford University Press, 2000), p. 27.

6. Richard Kearney, *On Stories,* p. 5.

7. William Goldman, *Which Lie Did I Tell? More Adventures in the Screen Trade* (London: Bloomsbury Publishing, Plc., 2000), p. 462.

8. Aristotle, *Poetics,* translated, with an introduction by Gerald F. Else (Ann Arbor: Ann Arbor Paperbacks/University of Michigan Press, 1990), p. 30.

9. Ibid., p. 20.

10. Ibid., p. 26.

11. Ibid., p. 27.

12. Ibid., p. 28.

13. Ibid., p. 31.

14. Ibid., p. 35.

15. Ibid., p. 41.

16. Ibid., p. 44.

17. Ibid., p. 66.

18. Walter Benjamin, "The Storyteller," in *Illuminations,* trans. Harry Zohn (London: Fontana Press, 1992), p. 83.

19. Ibid., p. 86.

20. Ibid.

21. Robert McKee as quoted by Brett Thomas in "Memo Hollywood: You've Lost the Plot," in the *Sun-Herald,* February 23, 2003, p. 1, Sunday Metro, col. 3.

22. Robert McKee as quoted by David Caesar in "Me and Bobby McKee," in the *Sydney Morning Herald,* Weekend Edition, June 16–17, 2001, p. 7, Metropolitan section, col. 5.

23. Benjamin, "The Storyteller," pp. 87–89.

24. Ibid.

25. Ibid., p. 90.

26. Lev Manovich, *The Language of New Media* (Cambridge, MA: MIT Press, 2001), p. 217.

27. Benjamin, *Illuminations,* p. 101.

28. Bruno Bettelheim, *The Uses of Enchantment: The Meaning and Importance of Fairy Tales* (London: Penguin Books, 1991), p. 3.

29. Ibid., p. 4.

30. Ibid., p. 57.

31. Ibid., p. 143.

32. Ibid., p. 144.

33. Ibid.

34. Ibid., p. 8.

35. Ibid., p. 9.

36. Benjamin, "The Storyteller," p. 93.

37. Bettelheim, *The Uses of Enchantment,* p. 10.

38. Ibid., p. 111.

39. Ibid., p. 37.

40. Ibid.

41. Ibid., p. 39.

42. Ibid., p. 24.

43. Ibid., p. 26.

44. Ibid., p. 40.

45. Ibid., pp. 127–128.

46. Christopher Vogler, *The Writer's Journey: Mythic Structure for Storytellers and Scriptwriters* (Studio City, CA: Michael Wiese Producitons, 1992).

47. Joseph Campbell, *The Hero with a Thousand Faces* (Princeton, New Jersey: Princeton University Press, 1973), p. 28.

48. Ibid., p. 382.

49. Ibid., p. 30.

50. Ibid., p. 257.

51. Ibid., p. 391.

52. Bettelheim, *The Uses of Enchantment,* p. 110.

53. Walter Benjamin, "The Storyteller," p. 86.

54. Steve Neale, *Genre* (England: British Film Institute, 1980), p. 20.

55. Edward Branigan, *Point of View in the Cinema: A Theory of Narration and Subjectivity in Classical Film* (Berlin, New York, Amsterdam: Mouton Publishers, 1984), p. 174.

56. Edward Branigan, *Narrative Comprehension and Film* (London and New York: Routledge, 1992), pp. 118–122.

57. Ibid., p. 124.

58. Nancy L. Stein and David Bordwell, cited by Edward Branigan, *Narrative Comprehension and Film,* p. 14.

59. Branigan, *Narrative Comprehension and Film,* p. 65.

60. Vivan Sobchack, *Screening Space: The American Science Fiction Film* (New Brunswick, NJ: Rutgers University Press, 1987), p. 25.

61. Neale, *Genre,* p. 22.

62. Branigan, *Narrative Comprehension and Film.*, p.6.

63. Bordwell, *Narration in the Fiction Film* (London: Routledge, 1985), p. xi.

64. Ibid.

65. Ibid., p. 3.

66. Ibid.

67. Ibid.

68. Tom Gunning, "Narrative Discourse and the Narrator System," in Leo Braudy and Marshall Cohen, eds., *Film Theory and Criticism,* 5th ed. (New York: Oxford University Press, 1999), p. 461.

69. Bordwell, *Narration in the Fiction Film,* p. 49.

70. Ibid., p. 50.

71. Gunning, "Narrative Discourse and the Narrator System," p. 461.

72. Ibid.

73. Ibid., p. 462.

74. Ibid.

75. Bordwell, *Narration in the Fiction Film,* p. 35.

76. Ibid.

77. Ibid., p. 149.

78. Tom Gunning, "'Now You See It, Now You Don't': The Temporality of the Cinema of Attractions," *Velvet Light Trap,* Fall 1993, p. 3 (10) Infotrac.

79. Ibid.

80. Roberta Pearson, "Transitional Cinema," in Nowell-Smith, *The Oxford History of World Cinema* (Oxford: Oxford University Press, 1997), p. 29.

81. Michele Pierson, *Special Effects: Still in Search of Wonder* (New York: Columbia University Press, 2002), pp. 16–31.

82. Brian Winston, *Technologies of Seeing: Photography, Cinematography and Television* (London: British Film Institute, 1996), p. 25.

83. Tom Stempel, *FrameWork: A History of Screenwriting* (Syracuse: Syracuse University Press, 2000), p. 3.

84. Ibid., p. 13.

85. Ibid.

86. Ibid., p. 25.

87. Ibid., p. 48.

88. Thomas Schatz, *The Genius of the System: Hollywood Filmmaking in the Studio Era* (London: Faber and Faber, 1998), pp. 8–9.

89. Ibid., p. 168.

90. Stempel, *Framework,* p. 263.

91. Denny Martin Flinn, *How Not to Write a Screenplay: 101 Common Mistakes Most Screenwriters Make* (Los Angeles, CA.: Lone Eagle Publishing Company, LLC., 1999), p. 153.

92. Ibid., p. 154.

93. Robert McKee, *Story* (USA: ReganBooks/HarperCollins Publishers, 1998), p. 45.

94. Ken Dancyger and Jeff Rush, *Alternative Scriptwriting: Writing beyond the Rules,* 2nd ed. (Boston: Focal Press, 1995).

95. Linda Aronson, *Scriptwriting Updated* (St. Leonards, Australia: Allen & Unwin, 2000), p. xiii.

96. Ibid.

97. Manovich, *The Language of New Media,* p. 238.

98. Ibid., p. 310.

99. Ibid., pp. 310–311.

100. Linda Seger, *Making a Good Script Great* (Hollywood: Samuel French Trade, 1987), p. 78.

101. Syd Field, *Screenplay: The Foundations of Screenwriting* (New York: Bantam Doubleday Dell Publishing Group, Inc., 1994), back cover.

102. Christopher Williams, "After the Cassic, the Classical and Ideology: The Differences of Realism," in Christine Gledhill and Linda Williams, eds. *Reinventing Film Studies* (London: Arnold/Hodder Headline Group, 2000), p. 214.

103. Peter Wollen, from "Signs and Meaning in the Cinema: The Auteur Theory," in Leo Braudy and Marshall Cohen, *Film Theory and Criticism,* 5th ed. (New York: Oxford University Press, 1999), p. 534.

104. Ibid.

105. Ibid.

106. Schatz, *The Genius of the System,* p. 198. For examples of early reworking of successful projects and the development of franchises, see pp. 169–170. For discussion of the formulaic nature of screwball comedy motifs, see p. 190.

107. Ibid., p. 198.

108. Kristin Thompson, *Storytelling in the New Hollywood: Understanding Classical Narrative Technique* (Cambridge, MA: Harvard University Press, 1999), p. x.

109. Ibid., p. 4.

110. Ibid.

111. Ibid., p. 11.

112. Ibid., p. 27.

113. Ibid., p. 19.

114. Ibid., p. 35.

115. Ibid., p. 36.

116. Ibid., p. 245.

117. Ibid., p. 247.

118. Ibid., p. 306.

119. Syd Field, *Going to the Movies: A Personal Journey through Four Decades of Modern Film* (New York: Dell Publishing, 2001), p. 152.

120. Ibid.

121. Thompson, *Storytelling in the New Hollywood,* p. 344.

122. Ibid.

123. Ibid, p. 350.

124. Schatz, *The Genius of the System,* p. 270.

125. Annette Kuhn, ed., *Alien Zone II: The Spaces of Science Fiction Cinema* (London: Verso, 1999), p. 5.

126. Roger Warren Beebe, "After Arnold: Narratives of the Posthuman Cinema," in Vivian Sobchack, ed. *Meta-Morphing: Visual Transformation and the Culture of Quick Change* (Minneapolis: University of Minnesota Press, 2000), p. 171.

127. Steve Neale, *Cinema and Technology: Image, Sound, Colour* (London: MacMillan Education Ltd., 1985), p. 23.

128. Thomas Elsaesser cited in Sean Cubitt, *The Cinema Effect* (Cambridge, MA: The MIT Press, 2004), p. 220.

129. Ibid., pp. 221–222.

130. Norman M. Klein, *The Vatican to Vegas: A History of Special Effects* (New York: The New Press, 2004), p. 277.

131. Ibid., p. 279.

132. Ibid., pp. 279–280.

133. Ibid., p. 282.

134. Linda Elizabeth Overesch in Angela Ndalianis, *Neo-Baroque Aesthetics and Contemporary Entertainment* (Cambridge, MA: MIT Press, 2004), p. 15.

135. Ndalianis, *Neo-Baroque Aesthetics and Contemporary Entertainment,* pp. 205 and 256.

136. Michele Pierson, *Special Effects: Still in Search of Wonder* (New York: Columbia University Press, 2002), p. 46.

137. Christopher Williams, "After the Classic, the Classical and Ideology: The Differences of Realism," in Gledhill and Williams, *Reinventing Film Studies,* p. 214.

138. M. Night Shyamalan in Annie Nocenti, "Writing and Directing *The Sixth Sense:* A Talk with M. Night Shyamalan," *Scenario* 5, no. 4, 52.

139. Richard Kearney, *On Stories,* p. 5.

140. Ibid., p. 155.

141. Ibid., p. 125.

142. Ibid., p. 126.

143. Ibid., p. 127.

144. Ibid., p. 160.

145. Anthony Kenny, ed., *The Oxford History of Western Philosophy* (Oxford: Oxford University Press, 2000), p. v.

146. Stephen R. L. Clark, "Ancient Philosophy," in *The Oxford History of Western Philosophy,* p. 28.

Chapter Three

1. Piers Bizony, *Digital Domain: The Leading Edge of Visual Effects* (London: Aurum Press Ltd., 2001), p. 9.

2. It would take another volume to define and explain the technical details of special effects and DVFx and this chapter relies somewhat on the understanding that most of the basic principles of film production and DVFx techniques are familiar to the reader. For more in-depth reading on special and digital visual effects and film production I recommend the following: Bizony, *Digital Domain;* Shilo T. McClean, *So What's This All about Then? A Non-User's Guide to Digital Effects in Filmmaking* (Sydney: Australian Film Television & Radio School, 1998); M. Vaz and P. Duignan, *Industrial Light & Magic: Into the Digital Realm* (London: Virgin, 1996); Steve Weiss, ed., *CG 101: A Computer Graphics Industry Reference* (Indianapolis, Indiana: New Riders, 1999); J. Brosnan, *Movie Magic: The Story of Special Effects in the Cinema* (New York: Plume, 1976); Karen Goulekas, *Visual Effects in a Digital World: A Comprehensive Glossary of over 7, 000 Visual Effects Terms* (St. Louis, MO: Morgan Kaufmann, 2001).

3. Frank Foster, *The Story of Computer Graphics* (ACMSiggraph, Video Review #137, documentary film, 2000).

4. Ibid.

5. Ibid.

6. Ibid.

7. Weiss, *CG101,* p. 416.

8. Foster, *Story of Computer Graphics.*

9. Ibid.

10. Ibid.

11. It is worth noting that *Who Framed Roger Rabbit?* (1988, Zemeckis), won an Academy Award for its achievements in Visual Effects and all of the compositing was undertaken using optical cameras. According to Ed Jones, director of postproduction at Industrial Light & Magic, "There were 162 original elements. When you add in all of the mattes and intermediate stocks, we were probably working with 400 to 500 pieces of film. There were around 300 passes through the optical printer." Mark J. P. Wolf, "In the Frame of Roger Rabbit: Visual Compositing in Film." *Velvet Light Trap,* Fall 1995, p. 45 (15) Infotrac.

12. Foster, *Story of Computer Graphics.*

13. René Clair quoted in Leo Braudy and Marshall Cohen, eds., *Film Theory and Criticism,* 5th ed. (New York: Oxford University Press, 1999), p. 177.

14. Edward Branigan, *Point of View in the Cinema: A Theory of Narration and Subjectivity in Classical Film* (Berlin: Mouton Publishers, 1984), p. 104.

15. Scott Bukatman, "There's Always . . . Tomorrowland: Disney and the Hypercinematic Experience," in *Matters of Gravity: Special Effects and Supermen in the 20th Century* (Durham, NC: Duke University Press, 2003), p. 27.

16. Ibid., p. 29.

17. James Monaco, *How to Read a Film: Movies, Media, Multimedia,* 3rd ed. (Oxford: Oxford University Press, 2000), p. 96.

18. Ibid., p. 163.

19. Ibid., p. 183.

20. Ibid., p. 83.

21. Ibid., p. 186.

22. David Bordwell and Kristin Thompson, *Film Art: An Introduction* (New York: McGraw-Hill Publishing, 1990), p. 334.

23. Ibid., p. 44.

24. Ibid., p. 156.

25. Ibid., p. 177.

26. Ibid., p. 183.

27. Branigan, *Point of View in the Cinema,* p. 53.

28. Ibid., p. 62.

29. Ibid.

30. Lev Manovich, *The Language of New Media* (Cambridge, MA: MIT Press, 2001), p. 85.

31. Branigan, *Point of View in the Cinema,* p. 57.

32. Ibid.

33. David Bordwell, Janet Staiger, and Kristin Thompson, *The Classical Hollywood Cinema: Film Style and Mode of Production to 1960* (London: Routledge, 1985), p. 30.

34. Ibid., p. 263.

35. Ibid., p. 307.

36. David Bordwell, *Making Meaning: Inference and Rhetoric in the Interpretation of Cinema* (Cambridge, MA: Harvard University Press, 1989), p. 163.

37. Ibid., p. 164.

38. Monaco, *How to Read a Film,* p. 94.

39. Maya Deren, "Cinematography: The Creative Use of Reality," in Braudy and Cohen, *Film Theory and Criticism,* p. 222.

40. Ibid., p. 223.

41. Rudolf Arnheim, *Art and Visual Perception: A Psychology of the Creative Eye,* The New Version (Berkeley: University of California Press, 1974), p. 385.

42. Branigan, *Point of View in the Cinema,* p. 64.

43. Scott Ross in Bizony, *Digital Domain,* p. 131.

44. James Cameron in Don Shay, "Back to Titanic," *Cinefex* 72, December 1997, p. 76.

45. Shay, "Back to Titanic," p. 92.

46. André Bustanoby in Bizony, *Digital Domain,* p. 128.

47. Ibid.

48. Remington Scott in Andy Serkis, *The Lord of the Rings GOLLUM: How We Made Movie Magic* (New York: Houghton Mifflin Co., 2003), p. 86.

49. Michael Stern, "Making Culture into Nature," in Annette Kuhn, ed., *Alien Zone: Cultural Theory and Contemporary Science Fiction Cinema* (London: Verso, 1990), p. 66.

50. John Ellis, from "Visible Fictions," in Braudy and Cohen, *Film Theory and Criticism,* p. 544.

51. Kent Jones, "Lord of the Rings: The Two Towers," in *Film Comment* 39, no. 1 (January/Febuary 2003): p. 73 (2) Proquest.

52. Sean Dodson, "Creating Kaya," in *The Age,* November 18, 2003. http://www.theage.com.au/articles/2003/11/17/1069027046664.html

53. Ibid.

54. Scott Bukatman, "X-Bodies: The Torment of the Mutant Superhero," in *Matters of Gravity,* p. 66.

55. Scott Bukatman, "Taking Shape: Morphing and the Performance of Self," in *Matters of Gravity,* p. 134.

56. Ibid., p. 135.

57. Mark Wolf, "A Brief History of Morphing," in Vivian Sobchack, ed., *Meta-Morphing: Visual Transformation and the Culture of Quick Change* (Minneapolis: University of Minnesota Press, 2000), p. 100.

58. Lev Manovich, *The Language of New Media,* p. 295.

59. H. R. Giger in *Alien Legacy: 20th Anniversary Special Edition* box set DVD collection (Twentieth Century Fox Film Corporation, 2000).

60. Walter Benjamin, "The Work of Art in the Age of Mechanical Reproduction," in *Illuminations,* pp. 218–219.

61. Joseph Campbell, "The Inspiration of Oriental Art," in *Myths to Live By* (New York: Penguin Books, 1972), p. 117.

62. André Bazin, "What Is Cinema?" in Braudy and Cohen, eds., *Film Theory and Criticism,* p. 196.

63. Rudolf Arnheim from "Film As Art," in Braudy and Cohen, *Film Theory and Criticism,* pp. 213–214.

64. Stanley Cavell, from "The World Viewed," in Braudy and Cohen, *Film Theory and Criticism,* p. 334.

65. Brian Henderson, "Toward a Non-Bourgeois Camera Style," in Braudy and Cohen, *Film Theory and Criticism,* p. 62.

66. Ibid., p. 61.

67. Walter Benjamin, "The Work of Art in the Age of Mechanical Reproduction," in *Illuminations,* trans. Harry Zohn (London: Fontana Press, 1992), p. 230.

68. Monaco, *How to Read a Film,* p. 575.

69. Mark Pesce, "The New Reality for Producers," keynote address, Screen Producers Association of Australia Conference, 18 November 2003.

70. Tim de Lisle, "Home box office," *The Guardian,* Friday, January 14, 2005. Guardian Unlimited. http://guardian.co.uk

71. Ibid.

Chapter Four

1. Stephen Prince, "True Lies: Perceptual Realism, Digital Images, and Film Theory," *Film Quarterly* 49, no. 3 (Spring 1996), pp. 27–38. http://communication.ucsd.edu/tig/123/prince.html

2. Ibid.

3. Brooks Landon, in "Diegetic or Digital? The Convergence of Science-Fiction Literature and Science-Fiction Film in Hypermedia," in Kuhn, *Alien Zone II: The Spaces of Science Fiction Cinema* (London: Verso, 1999), pp. 31–49.

4. Ibid., p. 35.

5. Ibid., pp. 38–39.

6. Ibid., p. 41.

7. Ibid.

8. Norman M. Klein, *The Vatican to Vegas: A History of Special Effects* (New York: The New Press, 2004), p. 223.

9. David Koepp quoted in Don Shay and Jody Duncan, *The Making of Jurassic Park: An Adventure 65 Million Years in the Making* (New York: Ballantine Books/Random House, 1993), p. 56.

10. Ibid.

11. *Seconds from Disaster: The Wreck of the Sunset Limited* (Barlow-Smithson Productions/National Georgraphic). Screened 10:30 p.m., 23 March 2005, Channel 7, Sydney, Australia.

12. Kevin Haug quoted in Jody Duncan, Don Shay, and Joe Fordham, "State of the Art: A Cinefex 25th Anniversary Forum," in *Cinefex* 100, January 2005, p. 98.

13. Eric Brevig quoted in Duncan, Shay, and Fordham, "State of the Art."

14. This issue of spectatorship is given excellent analysis by Michele Pierson in her book, *Special Effects: Still in Search of Wonder* (New York: Columbia University Press, 2002). In relation to the connoisseurship that has developed about special effects, she says, "Like amateurism, connoisseurship partakes in a discourse of possessive individualism that not only enables individuals to feel they possess special skills or knowledge but also provides them with a mode of social engagement with their chosen object of study," p. 42.

15. Rob Coleman quoted in Duncan, Shay, and Fordham, "State of the Art," p. 55.

16. Tim McHugh quoted in Jody Duncan, Don Shay, and Joe Fordham, "State of the Art," pp. 54–55.

17. Kristin Thompson, *Storytelling in the New Hollywood: Understanding Classical Narrative Technique* (Cambridge, MA: Harvard University Press, 1999), p. 246.

18. Rob Coleman, in Duncan, Shay, and Fordham, "State of the Art," p. 55.

19. Mark Stetson in Jody Duncan, Don Shay, and Joe Fordham, "State of the Art," p. 104.

20. Albert J. La Valley, "Traditions of Trickery: The Role of Special Effects in the Science Fiction Film," in George Slusser and Eric S. Rabkin, *Shadows of the Magic Lamp* (Carbondale: Southern Illinois University Press, 1985), p. 144.

21. Annette Kuhn, "Cultural Theory and Science Fiction Cinema," in Kuhn, *Alien Zone: Cultural Theory and Contemporary Science Fiction Cinema* (London: Verso, 1990), p. 7.

22. Stephen Prince, "True Lies."

23. Vivian Sobchack, "At the Still Point of the Turning World," in *Meta-Morphing: Visual Transformation and the Culture of Quick Change* (Minneapolis: University of Minnesota Press, 2000), p. 137.

24. Nick Brooks quoted by Joe Fordham, in "The VFX of "Fight Club" (Part One)," November 16. 1999. http://www.aviduniverse.com/article/mainv/0,7220,11756314,00.html

25. Stephen Prince, "The Emergence of Filmic Artifacts: Cinema and Cinematography in the Digital Era," in *Film Quarterly* 57, no. 3, p. 28.

26. Ibid.

27. Edward Branigan, *Point of View in the Cinema: A Theory of Narration and Subjectivity in Classical Film* (Berlin, New York, Amsterdam: Mouton Publishers, 1984), pp. 73–94.

28. E. H. Gombrich, *Art and Illusion: A Study in the Psychology of Pictorial Representation,* 6th ed. (London: Phaidon Press Inc., 2002), p. 329.

29. Ben Snow in Duncan, Shay, and Fordham, "State of the Art," p. 77.

30. Andy Jones, in Duncan, Shay, and Fordham, "State of the Art."

31. Annette Kuhn, "Sensuous Spaces—Introduction," in *Alien Zone II*, pp. 221–222.

Chapter Five

1. Robert McKee, *Story* (USA: ReganBooks/HarperCollins Publishers, 1998), p. 17.

2. Ibid.

3. Ibid., pp. 126–127.

4. Ibid., p. 248.

5. Ibid., p. 249.

6. James Monaco, *How to Read a Film: Movies, Media, Multimedia,* 3rd ed. (Oxford: Oxford University Press, 2000), p. 263.

7. Ibid.

8. Ibid., p. 265.

9. Ibid.

10. Robert Warshow, "Movie Chronicle: The Westerner," in Leo Braudy and Marshall Cohen, eds., *Film Theory and Criticism,* 5th ed. (New York: Oxford University Press, 1999), p. 667.

11. Peter Wollen, from "Signs and Meaning in the Cinema: The Auteur Theory," in Braudy and Cohen, *Film Theory and Criticism,* p. 521.

12. Ibid., p. 522.

13. Joseph Campbell, "The Emergence of Mankind," in *Myths to Live By* (New York: Penguin Books, 1972), p. 24.

14. Joseph Campbell, *Transformations of Myth through Time* (New York: Harper & Row, 1999), p. 210.

15. Campbell, *The Hero with a Thousand Faces* (Princeton, New Jersey: Princeton University Press, 1973), p. 16.

16. Schatz, *The Genius of the System: Hollywood Filmmaking in the Studio Era* (London: Faber and Faber, 1998), p. 146.

17. Kevin H. Martin, "War Stories," in *Cinefex* 65, March 1996, 72.

18. Kevin H. Martin, "Mission Accomplished," in *Cinefex* 81, April 2000.

19. Colin Kennedy, "Final Fantasy," in *Empire,* September 2001, p. 90.

20. Motonori Sakakibara, Roy Sato, and Junichi Yanagihara in an interview with the author, 7 January 2004, Honolulu, HI.

21. Kevin H. Martin, "A Cut Above," in *Cinefex* 82, July 2000, p. 14.

22. Ibid., p. 31.

23. Ibid., p. 14.

24. Ibid., p. 27.

25. Neale, *Genre* (England: British Film Institute, 1980), p. 35.

26. Ibid.

27. The Production Code quoted in Schatz, *The Genius of the System,* p. 167.

28. Viktor E. Frankl, *Man's Search for Meaning* (New York: Pocket Books/Washington Square Press, 1959), p. 57.

29. Ibid., p. 86.

30. Ibid., p. 87.

31. Ibid.

32. Ibid., p. 88.

33. Ibid., p. 98.

34. Ibid.

35. Ibid., p. 127.

36. Ibid., p. 133.

37. American Film Institute, June 2003. News broadcast, CNN, 13 June 2003.

38. Harper Lee, *To Kill a Mockingbird* (London: Arrow Books, 1997), p. 124.

39. Ibid., p. 237.

40. Barbara Paul-Emile, "Warriors of the Spirit: Women's Mythic Inner Journey," paper presented at the Hawaii International Conference on Arts and Humanities, January 8–11, 2004.

Chapter Six

1. David Bordwell, *Making Meaning: Inference and Rhetoric in the Interpretation of Cinema* (Cambridge, MA: Harvard University Press, 1989), p. 210.

2. Shirley Jackson, *The Haunting of Hill House* (New York: Penguin Books, 1984).

3. Robert Wise, *The Haunting,* an MGM film, 1963.

4. Jan de Bont, *The Haunting,* a DreamWorks film, 1999.

5. Janet Staiger, "The Central Producer System: Centralized Management after 1914," in David Bordwell, Janet Staiger, and Kristin Thompson, *The Classical Hollywood Cinema: Film Style and Mode of Production to 1960* (London: Routledge, 1985), p. 131.

6. Thomas Schatz, *The Genius of the System: Hollywood Filmmaking in the Studio Era* (London: Faber and Faber, 1998), p. 279.

7. Bryan Senn, "The Haunting," in Gary J. and Susan Svehla, eds., *Cinematic Hauntings* (Baltimore: Midnight Marquee Press, 1996), p. 73.

8. Ibid., p. 80.

9. Ibid., p. 92.

10. Ibid.

11. Ibid., p. 94.

12. Christine Sandoval, "The House That Roared," in *Cinefex* 79, October 1999, p. 46.

13. Joel Black, *The Reality Effect: Film Culture and the Graphic Imperative* (London: Routledge, 2002), p. 211.

14. Kristin Thompson, *Storytelling in the New Hollywood: Understanding Classical Narrative Technique* (Cambridge, MA: Harvard University Press, 1999), p. 245.

15. Ibid., p. 247.

16. Ibid., p. 14.

17. Ian Brown, in an interview with the author, 20 May 2002, Sydney, Australia.

18. Rob Legato quoted in Jody Duncan, Don Shay, and Joe Fordham, "State of the Art: A Cinefex 25th Anniversary Forum," in *Cinefex* 100, January 2005, p. 26.

19. Stan Winston quoted in Duncan, Shay and Fordham, "State of the Art," p. 103.

Chapter Seven

1. Neale, *Genre and Hollywood* (London: Routledge, 2000).

2. Ibid., p. 27.

3. Ibid., p. 207.

4. Ibid., p. 9.

5. Rick Altman, "Cinema and Genre," in Geoffrey Nowell-Smith, ed., *The Oxford History of World Cinema* (Oxford: Oxford University Press, 1997), p. 277.

6. Tom Ryall, "Genre and Hollywood," in John Hill and Pamela Church Gibson, eds., *The Oxford Guide to Film Studies* (Oxford: Oxford University Press, 1998), p. 329.

7. Ibid.

8. Christine Gledhill, "Rethinking Genre," in Christine Gledhill and Linda Williams, eds. *Reinventing Film Studies* (London: Arnold/Hodder Headline Group, 2000), p. 224.

9. Robert McKee, *Story* (USA: ReganBooks/HarperCollins Publishers, 1998), p. 80.

10. Thomas Schatz, *Hollywood Genres* (New York: Random House, 1993), p. 16.

11. Ibid., p. 21.

12. Ronald B. Tobias, *Twenty Master Plots (and How to Build Them)* (Cincinnati, Ohio: Writer's Digest Books, 1993).

13. Schatz, *Hollywood Genres,* pp. 21–22.

14. David Bordwell and Kristin Thompson, *Film Art: An Introduction* (New York: McGraw-Hill Publishing, 1990), p. 69.

15. Ibid.

16. Vivan Sobchack, *Screening Space: The American Science Fiction Film* (New Brunswick, NJ: Rutgers University Press, 1987), pp. 17–20.

17. Kuhn, *Alien Zone: Cultural Theory and Contemporary Science Fiction Cinema* (London: Verso, 1990), p. 148.

18. Ibid.

19. Ibid.

20. Ibid.

21. Steve Neale, "You've Got to Be Fucking Kidding: Knowledge, Belief and Judgments in Science Fiction," in Kuhn, *Alien Zone,* p. 161.

22. Ibid., pp. 163–164.

23. Ibid., p. 166.

24. Tom Gunning, "An Aesthetic of Astonishment: Early Film and the (In)credulous Spectator," in Leo Braudy and Marshall Cohen, eds., *Film Theory and Criticism,* 5th ed. (New York: Oxford University Press, 1999), p. 825.

25. Albert J. La Valley, "Traditions of Trickery: The Role of Special Effects in the Science Fiction Film," in George Slusser and Eric S. Rabkin, *Shadows of the Magic Lamp* (Carbondale: Southern Illinois University Press, 1985), p. 143.

26. Ibid., p. 144.

27. Angela Ndalianis, "Special Effects, Morphing Magic and the 1990s Cinema of Attractions," in Sobchack, *Meta-Morphing: Visual Transformation and the Culture of Quick Change* (Minneapolis: University of Minnesota Press, 2000), p. 256.

28. Angela Ndalianis, *Neo-Baroque Aesthetics and Contemporary Entertainment* (Cambridge, MA: MIT Press, 2004), p. 29.

29. Sobchack, *Screening Space,* pp. 287–288.

30. Martin Barker (with Thomas Austin), *From Antz to Titanic: Reinventing Film Analysis* (London: Pluto Press, 2000), p. 85.

31. Ibid., p. 81.

32. Roger Warren Beebe, "After Arnold: Narratives of the Posthuman Cinema," in Sobchack, *Meta-Morphing,* p. 171.

33. Neale, *Genre* (England: British Film Institute, 1980), p. 31.

34. James Monaco, *How to Read a Film: Movies, Media, Multimedia,* 3rd ed. (Oxford: Oxford University Press, 2000), p. 361.

35. Annette Kuhn, ed., *Alien Zone II: The Spaces of Science Fiction Cinema* (London: Verso, 1999), p. 11.

36. Schatz, *Hollywood Genres,* p. 6.

37. Vivian Sobchack quoted in Kuhn, *Alien Zone II,* p. 3.

38. Barry Keith Grant, "'Sensuous Elaboration': Reason and the Visible in the Science-Fiction Film," in Kuhn, *Alien Zone II,* p. 22.

39. Vivian Sobchack, "The Virginity of Astronauts: Sex and the Science Fiction Film," in Kuhn, *Alien Zone,* pp. 103–115.

40. Brooks Landon quoted in Kuhn, *Alien Zone II,* p. 12.

41. Ibid., p. 13.

42. Hugh Ruppersberg, "The Alien Messiah," in Kuhn, *Alien Zone,* p. 32.

43. Ibid., p. 37.

44. Kuhn, *Alien Zone II,* p. 5.

45. Scott Bukatman, *Matters of Gravity: Special Effects and Supermen in the 20th Century* (Durham, NC: Duke University Press, 2003), p. 5.

46. Ibid., p. 6.

47. Scott Bukatman, "The Artificial Infinite: On Special Effects and the Sublime," in *Matters of Gravity,* p. 93.

48. Bordwell and Thompson, *Film Art,* p. 202.

49. Ibid.

50. Bukatman, "The Artificial Infinite," p. 109.

51. Scott Bukatman, "The Ultimate Trip: Special Effects and Kaleidoscopic Perception," in *Matters of Gravity,* pp. 115–116.

52. Bukatman, "The Artificial Infinite," p. 82.

53. Scott Bukatman, "There's Always . . . Tomorrowland: Disney and the Hyper-cinematic Experience," in *Matters of Gravity: Special Effects and Supermen in the 20th Century* (Durham, NC: Duke University Press, 2003), p. 14.

54. Bruno Bettelheim, *The Uses of Enchantment: The Meaning and Importance of Fairy Tales* (London: Penguin Books, 1991), p. 51.

55. La Valley, "Traditions of Trickery," p. 157.

56. Schatz, *Hollywood Genres,* p. 16.

57. Kuhn, *Alien Zone II,* p. 12.

58. Scott McQuire, *Crossing the Digital Threshold* (Brisbane, Queensland: Australian Key Centre for Cultural and Media Policy, 1997), p. 59.

59. Roy Vallis, "The Future of Popular Film Tradition: More Real, More Fantastic, More Ancient" presented at the Hawaii International Conference on Arts and Humanities, January 8–11, 2004.

60. Ibid.

61. Otto Durholz quoted in David Bordwell, Janet Staiger, and Kristin Thompson, *The Classical Hollywood Cinema: Film Style and Mode of Production to 1960* (London: Routledge, 1985), p. 243.

62. Schatz, *Hollywood Genres,* p. 31.

63. Ibid., p. 30.

64. Ibid., p. 261.

65. Ibid., p. 264.

66. Ibid., pp. 265–266.

67. My thanks to Sean Cubitt for his observation that this may also concern what we have lost.

Chapter Eight

1. Angela Ndalianis, *Neo-Baroque Aesthetics and Contemporary Entertainment* (Cambridge, MA: MIT Press, 2004), p. 36.

2. Ibid., p. 41.

3. Paul M. Sammon in Dan O'Bannon, *Alien: The Illustrated Screenplay* (London: Orion Books, 2000), p. 8.

4. Ibid., p. 9.

5. Ibid., pp. 9–14.

6. Will Brooker, "Internet Fandom: The Continuing Narratives of Star Wars, Blade Runner and Alien," in Annette Kuhn, ed., *Alien Zone II: The Spaces of Science Fiction Cinema* (London: Verso, 1999), p. 53.

7. Ibid., p. 62.

8. Ibid., pp. 62–63.

9. Stephen Mulhall, *On Film* (London: Routledge, 2002), pp. 3–4.

10. Kristin Thompson, *Storytelling in the New Hollywood: Understanding Classical Narrative Technique* (Cambridge, MA: Harvard University Press, 1999), p. 13.

11. Ibid., p. 283.

12. Ibid., p. 284.

13. Ibid., p. 286.

14. Ibid.

15. Ibid., p. 298.

16. Ibid., p. 304.

17. Ibid., p. 306.

18. Ibid.

19. James Cameron in *Alien Legacy: 2oth Anniversary Special Edition* box set DVD collection (Twentieth Century Fox Film Corporation, 2000).

20. Ridley Scott in *Alien Legacy*.

21. James Cameron in *Alien Legacy*.

22. Bill Norton, "Cloning Aliens," in *Cinefex* 73, March 1998.

23. Bruce Kawin, "The Mummy's Pool," in Leo Braudy and Marshall Cohen, eds., *Film Theory and Criticism,* 5th ed. (New York: Oxford University Press, 1999), p. 683.

24. Mulhall, *On Film,* p. 8.

25. Barbara Creed, *The Monstrous-Feminine: Film, Feminism, Psychoanalysis* (London: Routledge, 1993), p. 1.

26. Ibid., p. 7.

27. Ibid., p. 25.

28. Joseph Campbell in Campbell and Fraser Boa, *The Way of Myth: Talking with Joseph Campbell* (Boston: Shambhala Publications, 1994), pp. 88–89. Campbell has said, "In rituals and myths, most of the problems involved in finding male adulthood come about because the male has to intend to become an adult. It is different for the female. For the young woman, it happens to her. With her first menstruation she's a woman. Next thing she knows she's a mother. She doesn't have to work this thing out. It's working itself out on her and the problem of the woman is to realize who and what she has already become. The problem of the male, on the other hand, is to become what he can be. All the myths know this and all the myths build it up."

29. Creed, *The Monstrous-Feminine,* p. 51.

30. Ibid., p. 53.

31. Mulhall, *On Film,* p. 23.

32. Ibid., p. 19.

33. Ibid., p. 25.

34. Ibid., p. 72.

35. Ibid., p. 73.

36. Ibid., p. 101.

37. Ibid.

38. Ibid.

39. Ibid., p. 106.

40. Ibid., p. 93.

41. Ibid., p. 106.

42. Ibid., p. 134.

43. Ibid.

44. Ibid., p. 121.

45. Christine Geraghty, "Re-examining stardom: questions of texts, bodies and performance," in Christine Gledhill and Linda Williams, eds. *Reinventing Film Studies* (London: Arnold/Hodder Headline Group, 2000), p. 191.

46. James Monaco, *How to Read a Film: Movies, Media, Multimedia,* 3rd ed. (Oxford: Oxford University Press, 2000), p. 358.

47. Mulhall, *On Film,* p. 5.

48. Henri Focillon, "The Life Forms in Art" quoted in Thomas Schatz, *Hollywood Genres* (New York: Random House, 1993), pp. 37–38.

49. Mulhall, *On Film,* p. 9.

50. Leo Braudy quoted in Schatz, *Hollywood Genres,* p. 38.

Chapter Nine

1. John Baxter, *George Lucas: A Biography* (London: HarperCollins Publishers, 1999), p. 164.

2. Ibid., pp. 170–171.

3. George Lucas quoted in an interview with Stephen Zito that appeared in *American Film,* edited by Hollis Alpert, in April 1977 and is reprinted as an introduction to George Lucas's *Star Wars: A New Hope* (London: Faber and Faber, 1997), p. xii.

4. George Lucas quoted in Baxter, *George Lucas,* p. 403.

5. John Williams quoted in Baxter, *George Lucas,* p. 245.

6. Ibid., p. 164.

7. Baxter, *George Lucas,* p. 170.

8. Ibid., p. 180.

9. Ian Freer, *The Complete Spielberg* (London: Virgin Publishing, 2001), p. 152.

10. Ibid., p. 163.

11. Ibid., p. 210.

12. Lisa Kennedy, "Spielberg in the Twilight Zone," in *Wired* 10, no. 6, June 2002, p. 108.

13. Don Shay and Jody Duncan, *The Making of Jurassic Park: An Adventure 65 Million Years in the Making* (New York: Ballantine Books/Random House, 1993), p. 135.

14. Ibid., p. 138.

15. Ibid., p. 139.

16. Edward Branigan, *Point of View in the Cinema: A Theory of Narration and Subjectivity in Classical Film* (Berlin, New York, Amsterdam: Mouton Publishers, 1984), p. 95.

17. Stephen Mulhall, *On Film* (London: Routledge, 2002), p. 36.

18. Joe Fordham, "Mecha Odyssey," in *Cinefex* 87, October 2001, p. 66.

19. Dennis Muren quoted in Fordham, "Mecha Odyssey," p. 70.

20. Fordham, "Mecha Odyssey," p. 71.

21. Ibid., p. 77.

22. Ibid., p. 69.

23. Ibid., p. 71.

24. Ibid., p. 66.

25. Ibid., p. 78.

26. Ibid., p. 81.

27. Ibid., pp. 81–82.

28. Ibid., p. 83.

29. Ibid., p. 89.

30. Ibid., p. 92.

31. Ibid., p. 90.

32. Ibid., p. 93.

33. Michael Lantieri quoted in Fordham, "Mecha Odyssey," p. 93.

34. Robert Allen and Douglas Gomery quoted in Duncan Petrie, "History and Cinema Technology," in John Hill and Pamela Church Gibson, eds., *The Oxford Guide to Film Studies* (Oxford: Oxford University Press, 1998), p. 239.

35. Ibid.

36. Petrie, "History and Cinema Technology," p. 239.

37. Box Office Mojo. http://www.boxofficemojo.com

38. David Denby, "A.I.: Artificial Intelligence," *New Yorker*, online archives. http://www.newyorker.com/online/filmfile

Chapter Ten

1. George Lucas quoted in an interview with Stephen Zito that appeared in *American Film*, edited by Hollis Alpert, in April 1977 and is reprinted as an introduction to George Lucas's *Star Wars: A New Hope* (London: Faber and Faber, 1997), p. xv.

2. Annette Kuhn, ed., *Alien Zone: Cultural Theory and Contemporary Science Fiction Cinema* (London: Verso, 1990), p. 150.

3. Ibid.

4. Bukatman, Scott Bukatman, "The Ultimate Trip: Special Effects and Kaleidoscopic Perception," in *Matters of Gravity: Special Effects and Supermen in the 20th Century* (Durham, NC: Duke University Press, 2003), p. 121.

5. Scott Bukatman, "The Artificial Infinite: On Special Effects and the Sublime," in *Matters of Gravity,* p. 104.

6. Ibid., p. 105.

7. David Bordwell and Kristin Thompson, *Film Art: An Introduction* (New York: McGraw-Hill Publishing, 1990), p. 148.

8. Seymour Chatman, "What Novels Can Do That Films Can't (and Vice Versa)," in Leo Braudy and Marshall Cohen, eds., *Film Theory and Criticism,* 5th ed. (New York: Oxford University Press, 1999), p. 441.

9. Vivan Sobchack, *Screening Space: The American Science Fiction Film* (New Brunswick, NJ: Rutgers University Press, 1987), p. 93.

10. E. H. Gombrich, *Art and Illusion: A Study in the Psychology of Pictorial Representation,* 6th ed. (London: Phaidon Press Inc., 2002), p. 72.

11. H. Bruce Franklin, "Visions of the Future in Science Fiction Films from 1970 to 1982," in Kuhn, *Alien Zone,* p. 20.

12. Annette Kuhn, "City Spaces—Introduction," in *Alien Zone II: The Spaces of Science Fiction Cinema* (London: Verso, 1999), p. 78.

13. Janet Staiger, "Future Noir: Contemporary Representations of Visionary Cities," in Kuhn, *Alien Zone II,* p. 97.

14. Ibid., p. 99.

15. Vivian Sobchack, "Cities on the Edge of Time: The Urban Science-Fiction Film," in Kuhn, *Alien Zone II,* p. 129.

16. Ibid., p. 130.

17. Ibid., p. 131.

18. Ibid.

19. Ibid., p. 139.

20. Ibid.

21. Bordwell, *Making Meaning: Inference and Rhetoric in the Interpretation of Cinema* (Cambridge, MA: Harvard University Press, 1989), p. 153.

22. Andy Serkis, *The Lord of the Rings GOLLUM: How We Made Movie Magic* (New York: Houghton Mifflin Co., 2003), p. 100.

23. Ibid., pp. 116–117.

24. Joseph Campbell, "The Moon Walk—The Outward Journey," in *Myths to Live By* (New York: Penguin Books, 1972), p. 237.

25. Ibid.

26. Ibid., p. 238.

27. Bordwell and Thompson, *Film Art,* p. 153.

28. Bruno Bettelheim, *The Uses of Enchantment: The Meaning and Importance of Fairy Tales* (London: Penguin Books, 1991), p. 5.

29. Joseph Campbell, "The Moon Walk," in *Myths to Live By,* p. 244.

Chapter 11

1. Stephen Prince, "The Emergence of Filmic Artifacts," in *Film Quarterly* 57, no. 3, p. 24.

2. Joseph Campbell, "Schizophrenia—The Inward Journey," in *Myths to Live By* (New York: Penguin Books, 1972), p. 214.

3. Ibid., pp. 214–215.

4. Aldous Huxley quoted in Walter Benjamin, "The Work of Art in the Age of Mechanical Reproduction," in *Illuminations,* trans. Harry Zohn (London: Fontana Press, 1992), pp. 240–241.

5. Thomas Schatz, *Hollywood Genres* (New York: Random House, 1993), p. 85.

6. Kim Libreri, "12 Predictions on the Future of VFX," in *VFX World,* December 7, 2004, pp. 1–3. http://vfxworld.com

7. Ibid., p. 3.

8. Steve Silberman, "Life after Darth," *Wired* 13, no. 5, May 2005. http://www.wired.com

9. Joseph Campbell, "Envoy: No More Horizons," in *Myths to Live By,* p. 257.

Bibliography

Altman, Rick. "Cinema and Genre." In Geoffrey Nowell Smith, ed., *The Oxford History of World Cinema.* Oxford: Oxford University Press, 1997.

Aristotle. *Poetics.* Translated with an introduction and notes by Gerald F. Else. Michigan: Ann Arbor Paperbacks/University of Michigan Press, 1990.

Arnheim, Rudolf. *Art and Visual Perception: A Psychology of the Creative Eye,* The New Version. Berkeley: University of California Press, 1974.

————. "Film As Art." In Leo Braudy and Marshall Cohen, *Film Theory and Criticism,* 5th ed. New York: Oxford University Press, 1999, pp. 212–215.

Aronson, Linda. *Scriptwriting Updated.* St. Leonards, Australia: Allen & Unwin, 2000.

Barker, Martin, (with Thomas Austin). *From Antz to Titanic: Reinventing Film Analysis.* London: Pluto Press, 2000.

Baxter, John, *George Lucas: A Biography.* London: HarperCollins Publishers, 1999.

Bazin, André. "The Ontology of the Photographic Image" from *What Is Cinema?* Translated by Hugh Gray. In Leo Braudy and Marshall Cohen, *Film Theory and Criticism,* 5th ed. New York: Oxford University Press, 1999, pp. 195–199.

Beebe, Roger Warren Beebe. "After Arnold: Narratives of the Posthuman Cinema." In Vivian Sobchack, ed., *Meta-Morphing: Visual Transformation and the Culture of Quick Change.* Minneapolis: University of Minnesota Press, 2000, pp. 159–179.

Benjamin, Walter. *Illuminations.* Translated by Harry Zohn. Hannah Arendt, ed. London: Fontana Press, 1992.

————. "The Storyteller," In *Illuminations.* Translated by Harry Zohn. Hannah Arendt, ed. London: Fontana Press, 1992, pp. 33–107.

———. "The Work of Art in the Age of Mechanical Reproduction," In *Illuminations*. Translated by Harry Zohn. Hannah Arendt, ed. London: Fontana Press, 1992, pp. 211–244.

Bettelheim, Bruno. *The Uses of Enchantment: The Meaning and Importance of Fairy Tales.* London: Penguin Books, 1991.

Bizony, Piers. *Digital Domain: The Leading Edge of Visual Effects.* London: Aurum Press, Ltd., 2001.

Black, Joel. *The Reality Effect: Film Culture and the Graphic Imperative.* London: Routledge, 2002.

Bordwell, David. *Narration in the Fiction Film.* London: Routledge, 1985.

———. *Making Meaning: Inference and Rhetoric in the Interpretation of Cinema.* Cambridge, MA: Harvard University Press, 1989.

———. *On the History of Film Style.* Cambridge, MA: Harvard University Press, 1997.

Bordwell, David, Janet Staiger, and Kristen Thompson. *The Classical Hollywood Cinema: Film Style and Mode of Production to 1960.* London: Routledge, 1985.

Bordwell, David and Kristin Thompson. *Film Art: An Introduction.* New York: McGraw-Hill Publishing, 1990.

Branigan, Edward. *Narrative Comprehension and Film.* London: Routledge, 1992.

———. *Point of View in the Cinema: A Theory of Narration and Subjectivity in Classical Film.* Berlin: Mouton Publishers, 1984.

Braudy, Leo, and Marshall Cohen. *Film Theory and Criticism,* 5th ed. New York: Oxford University Press, 1999.

Brooker, Will. "Internet Fandom and the Continuing Narratives of *Star Wars, Blade Runner,* and *Alien.*" In Annette Kuhn, ed., *Alien Zone II: The Spaces of Science Fiction Cinema.* London: Verso, 1999, pp. 50–72.

Brosnan, J. *Movie Magic: The Story of Special Effects in the Cinema.* New York: Plume, 1976.

Bukatman, Scott. *Matters of Gravity: Special Effects and Supermen in the 20th Century.* Durham: Duke University Press, 2003.

———. "There's Always . . . Tomorrowland: Disney and the Hypercinematic Experience." In *Matters of Gravity: Special Effects and Supermen in the 20th Century.* Durham: Duke University Press, 2003, pp. 13–31.

———. "X-Bodies: The Torment of the Mutant Superhero." In *Matters of Gravity: Special Effects and Supermen in the 20th Century.* Durham: Duke University Press, 2003, pp. 48–78.

———. "Taking Shape: Morphing and the Performance of Self." In *Matters of Gravity: Special Effects and Supermen in the 20th Century.* Durham: Duke University Press, 2003, pp. 133–156.

———. "The Ultimate Trip: Special Effects and Kaleidoscopic Perception." In *Matters of Gravity: Special Effects and Supermen in the 20th Century.* Durham: Duke University Press, 2003, pp. 111–130.

———. "The Artificial Infinite: On Special Effects and the Sublime." In *Matters of Gravity: Special Effects and Supermen in the 20th Century.* Durham: Duke University Press, 2003, pp. 81–110.

Byrnes, Paul. "Van Helsing." *Sydney Morning Herald,* May 7–13, 2004, p. 9, Metro Section, col. 1.

Campbell, Joseph. *The Hero with a Thousand Faces.* Princeton, NJ: Princeton University Press, 1973.

Campbell, Joseph. *Myths to Live By.* New York: Penguin Books, 1972.

———. "The Inspiration of Oriental Art." In *Myths to Live By.* New York: Penguin Books, 1972, pp. 105–125.

———. "The Emergence of Mankind." In *Myths to Live By.* New York: Penguin Books, 1972, pp. 21–3.

———. "The Confrontation of East and West in Religion." In *Myths to Live By.* New York: Penguin Books, 1972, pp. 82–104.

———. "Schizophrenia—The Inward Journey." In *Myths to Live By.* New York: Penguin Books, 1972, pp. 201–232.

———. "The Moon Walk—The Outward Journey." In *Myths to Live By.* New York: Penguin Books, 1972, pp. 233–249.

———. "Envoy: No More Horizons." In *Myths to Live By.* New York: Penguin Books, 1972, pp. 81–110.

Campbell, Joseph, and Fraser Boa. *The Way of Myth: Talking with Joseph Campbell.* Boston, MA: Shambhala Publications Inc., 1994.

Campbell, Joseph. *Transformations of Myth through Time.* New York: Harper & Row Publishers, Inc., 1999.

Cavell, Stanley. "Photograph and Screen" from *The World Viewed.* In Leo Braudy and Marshall Cohen, *Film Theory and Criticism,* 5th ed. New York: Oxford University Press, 1999, pp. 334–335.

Caesar, David. "Me and Bobby McKee." *Sydney Morning Herald,* Weekend Edition, June 16–17, 2001, p. 7, Metropolitan section, col. 5.

Chatman, Seymour. "What Novels Can Do That Films Can't (and Vice Versa)." In Leo Braudy and Marshall Cohen, *Film Theory and Criticism,* 5th ed. New York: Oxford University Press, 1999, pp. 435–451.

Clark, Stephen R. L. "Ancient Philosophy" in *The Oxford History of Western Philosophy.* Oxford: Oxford University Press, 2000, pp. 1–56.

Creed, Barbara. *The Monstrous-Feminine: Film, Feminism, Psychoanalysis.* London: Routledge, 1993.

Cubitt, Sean. *The Cinema Effect.* Cambridge, MA: The MIT Press, 2004.

Dancyger, Ken, and Jeff Rush. *Alternative Scriptwriting: Writing beyond the Rules,* 2nd ed. Boston: Focal Press, 1995.

De Lisle, Tim. "Home Box Office." *The Guardian,* Friday, January 14, 2005. Guardian Unlimited. http://guardian.co.uk

Denby, David. "A.I.: Artificial Intelligence." *New Yorker,* online archives.http://www.newyorker.com/online/filmfile

Deren, Maya. "Cinematography: The Creative Use of Reality." In Leo Braudy and Marshall Cohen, *Film Theory and Criticism,* 5th ed. New York: Oxford University Press, 1999, pp. 216–227.

Dervin, Daniel. "Primal Conditions and Conventions: The Genre of Science Fiction." In Annette Kuhn, ed., *Alien Zone: Cultural Theory and Contemporary Science Fiction Cinema.* London: Verso, 1990, pp. 96–102.

Dodson, Sean. "Creating Kaya." *The Age,* November 18, 2003. http://www.theage.com.au/articles/2003/11/17/1069027046664.html

Easthope, Anthony. "Classic Film Theory and Semiotics." In John Hill and Pamela Church Gibson, eds., *The Oxford Guide to Film Studies.* Oxford: Oxford University Press, 1998, pp. 51–57.

Ellis, John. "Broadcast TV as Sound and Image" from *Visible Fictions.* In Leo Braudy and Marshall Cohen, *Film Theory and Criticism,* 5th ed. New York: Oxford University Press, 1999, pp. 385–394.

Feeny, Catherine. "Buzz Image Group and 'The Eternal Sunshine of the Spotless Mind,'" *VFX Pro* Feature, April 30, 2004. http://www.vemedia.net/CPC/vfxpro/printer_8091.shtml

Field, Syd. *Going to the Movies: A Personal Journey through Four Decades of Modern Film.* New York, New York: Dell Publishing, 2001.

———. *Screenplay: The Foundations of Screenwriting.* New York, New York: Bantam Doubleday Dell Publishing Group, Inc., 1994.

Flinn, Denny Martin. *How Not to Write a Screenplay: 101 Common Mistakes Most Screenwriters Make.* Los Angeles, CA: Lone Eagle Publishing Company, LLC, 1999.

Fordham, Joe. "Mecha Odyssey." *Cinefex* 87, October 2001.

————. "The VFX of 'Fight Club' (Part One)." November 16, 1999. http://www.aviduniverse.com/article/mainv/0,7220,11756314,00.html

Frankl, Viktor E. *Man's Search for Meaning.* New York, NY: Pocket Books/Washington Square Press, 1959.

Franklin, H. Bruce. "Visions of the Future in Science Fiction Films from 1970 to 1982." In Annette Kuhn, ed., *Alien Zone: Cultural Theory and Contemporary Science Fiction Cinema.* London: Verso, 1990, pp. 19–31.

Freer, Ian. *The Complete Spielberg.* London: Virgin Publishing, Ltd., 2001.

Geraghty, Christine. "Re-examining Stardom: Questions of Texts, Bodies, and Performance." In Christine Gledhill and Linda Williams, eds., *Reinventing Film Studies.* London: Arnold Publishing/Hodder Headline Group, 2000.

Gledhill, Christine, and Linda Williams, eds. *Reinventing Film Studies.* London: Arnold Publishing/Hodder Headline Group, 2000.

Gledhill, Christine. "Rethinking Genre." In Christine Gledhill and Linda Williams, eds., *Reinventing Film Studies.* London: Arnold Publishing/HodderHeadline Group, 2000, pp. 221–243.

Goldman, William. *Which Lie Did I Tell? More Adventures in the Screen Trade.* London: Bloomsbury Publishing, PLC. 2000.

Gombrich, E. H. *Art and Illusion: A Study in the Psychology of Pictorial Representation,* 6th ed. London/New York, NY: Phaidon Press Inc., 2002.

Goulekas, Karen. *Visual Effects in A Digital World: A Comprehensive Glossary of Over 7,000 Visual Effects Terms.* St. Louis, MO: Morgan Kaufmann, 2001.

Grant, Barry Keith, "'Sensuous Elaboration': Reason and the Visible in the Science Fiction Film." In Annette Kuhn, ed., *Alien Zone II: The Spaces of Science Fiction Cinema.* London: Verso, 1999, pp. 16–30.

Gronemeyer, Andrea. *Film: A Concise History.* London: Laurence King Publishing, 1998.

Gunning, Tom. "An Aesthetic of Astonishment: Early Film and the (In)credulous Spectator." In Leo Braudy and Marshall Cohen, *Film Theory and Criticism,* 5th ed. New York: Oxford University Press, 1999.

————. "Narrative Discourse and the Narrator System." In Leo Braudy and Marshall Cohen, *Film Theory and Criticism,* 5th ed. New York: Oxford University Press, 1999.

————. "Now You See It, Now You Don't: The Temporality of the Cinema of Attractions." *Velvet Light Trap,* Fall 1993, p. 3 (10) Infotrac.

Henderson, Brian. "Toward A Non-Bourgeois Camera Style." In Leo Braudy and Marshall Cohen, *Film Theory and Criticism,* 5th ed. New York: Oxford University Press, 1999.

Hill, John, and Pamela Church Gibson, eds. *Oxford Guide to Film Studies.* Oxford: Oxford University Press, 1998.

Jackson, Shirley. *The Haunting of Hill House.* New York: Penguin Books, 1984.

Jones, Kent. "Lord of the Rings: The Two Towers." *Film Comment* 39, no. 1, Jan/Feb 2003, p. 73 (2) Proquest.

Kawin, Bruce. "The Mummy's Pool." In Leo Braudy and Marshall Cohen, *Film Theory and Criticism,* 5th ed. New York: Oxford University Press, 1999, pp. 679–690.

Kearney, Richard. *On Stories.* London: Routledge, 2002.

Kennedy, Colin. "Final Fantasy." *Empire,* September 2001, pp. 86–90.

Kennedy, Lisa. "Spielberg in the Twilight Zone." *Wired,* 10.06, June 2002, pp. 104–113, 146.

Kenny, Anthony, ed. *The Oxford History of Western Philosophy.* Oxford: Oxford University Press, 2000.

Kipnis, Laura. "Film and Changing Technologies." In John Hill and Pamela Church Gibson, eds., *Oxford Guide to Film Studies.* Oxford: Oxford University Press, 1998, pp. 595–604.

Klein, Norman. M. *The Vatican to Vegas: A History of Special Effects.* New York: The New Press, 2004.

Kuhn, Annette, ed. *Alien Zone: Cultural Theory and Contemporary Science Fiction Cinema.* London: Verso, 1990.

Kuhn, Annette, ed. *Alien Zone II: The Spaces of Science Fiction Cinema.* London: Verso, 1999.

Kuhn, Annette. "Cultural Theory and Science Fiction Cinema." In *Alien Zone: Cultural Theory and Contemporary Science Fiction Cinema.* London: Verso, 1990, pp. 1–12.

Landon, Brooks, "Diegetic or Digital? The Convergence of Science-Fiction Literature and Science Fiction Film in Hypermedia." In Annette Kuhn, ed., *Alien Zone: Cultural Theory and Contemporary Science Fiction Cinema.* London: Verso, 1990, pp. 31–49.

La Valley, Albert J. "Traditions of Trickery: The Role of Special Effects in the Science Fiction Film." In George Slusser and Eric S. Rabkin, *Shadows of the Magic Lamp.* Carbondale: Southern Illinois University Press, 1985, pp. 141–157.

Lee, Harper. *To Kill a Mockingbird.* London: Arrow Books, 1997.

Libreri, Kim. "12 Predictions on the Future of VFX." *VFX World,* December 7, 2004, pp. 1–3. http://vfxworld.com

Lucas, George. *Star Wars: A New Hope.* London: Faber and Faber, 1997.

Manovich, Lev. *The Language of New Media.* Cambridge, MA: The MIT Press, 2001.

McClean, Shilo T. *So What's This All about Then: A Non-User's Guide to Digital Effect in Filmmaking.* Sydney: Australian Film Television & Radio School, 1998.

McKee, Robert, *Story.* USA: ReganBooks/HarperCollins Publishers, Inc., 1998.

McQuire, Scott. *Crossing the Digital Threshold.* Brisbane, Queensland: Australian Key Centre for Cultural and Media Policy, 1997.

Martin, Kevin H. "War Stories." *Cinefex* 65, March 1996, pp. 70–93.

———. "Mission Accomplished." *Cinefex* 81, April 2000, pp. 62–80.

———. "A Cut Above." *Cinefex* 82, July 2000, p. 13–31.

Monaco, James. *How to Read a Film: Movies, Media, Multimedia,* 3rd ed. Oxford: Oxford University Press, 2000.

Mulhall, Stephen. *On Film.* London: Routledge, 2002.

Ndalianis, Angela. "Special Effects, Morphing Magic and the 1990s Cinema of Attractions." In Vivian Sobchack, ed., *Meta-Morphing: Visual Transformation and the Culture of Quick-Change.* Minneapolis: University of Minnesota Press, 2000.

———. *Neo-Baroque Aesthetics and Contemporary Entertainment.* Cambridge, MA: The MIT Press, 2004.

Neale, Steve. "You've Got To Be Fucking Kidding: Knowledge, Belief, and Judgments in Science Fiction." In Annette Kuhn, ed., *Alien Zone: Cultural Theory and Contemporary Science Fiction Cinema.* London: Verso, 1990, pp. 160–168.

———. *Cinema and Technology: Image, Sound, Colour.* London: MacMillan Education Ltd, 1985.

———. *Genre.* England: British Film Institute, 1980.

———. *Genre and Hollywood.* London: Routledge, 2000.

Nocenti, Annie. "Writing and Directing The Sixth Sense: A Talk with M. Night Shyamalan." *Scenario* 5, no. 4, pp. 51–57, 184–187.

Norris, Chris. "Charlie Kaufman and Michel Gondry's Head Trip." *Film Comment* 40, no. 2, Mar/Apr 2004, p. 20 (2).

Norton, Bill. "Cloning Aliens." *Cinefex* 73, March 1998, pp. 98–117.

Nowell-Smith, Geoffrey, ed. *The Oxford History of World Cinema.* Oxford: Oxford University Press, 1997.

O'Bannon, Dan. *Alien: The Illustrated Screenplay.* London: Orion Books, Ltd., 2000

Pearson, Roberta. "Transitional Cinema." In Geoffrey Nowell-Smith, ed., *The Oxford History of World Cinema.* Oxford: Oxford University Press, 1997, pp. 23–42.

Petrie, Duncan. "History and Cinema Technology." In John Hill and Pamela Church Gibson, eds., *Oxford Guide to Film Studies.* Oxford: Oxford University Press, 1998, pp. 238–244.

Pierson, Michele. *Special Effects: Still in Search of Wonder.* New York: Columbia University Press, 2002.

Prince, Stephen. "True Lies: Perceptual Realism, Digital Images, and Film Theory." *Film Quarterly* 49, no. 3, Spring 1996, pp. 27–38. http://communication.ucsd.edu/tig/123/prince.html

———. "The Emergence of Filmic Artifacts: Cinema and Cinematography in the Digital Era." *Film Quarterly* 57, no. 3, p. 24–33.

Ruppersberg, Hugh. "The Alien Messiah." In Annette Kuhn, ed., *Alien Zone: Cultural Theory and Contemporary Science Fiction Cinema.* London: Verso, 1990, pp. 32–38.

Ryall, Tom. "Genre and Hollywood." In John Hill and Pamela Church Gibson, eds., *Oxford Guide to Film Studies.* Oxford: Oxford University Press, 1998, pp. 327–338.

Sandoval, Christine. "The House That Roared." *Cinefex* 79, October 1999, pp. 45–60, 121–128.

Schatz, Thomas. *Hollywood Genres.* New York: Random House, 1993.

———. *The Genius of the System: Hollywood Filmmaking in the Studio Era.* London: Faber and Faber, 1998.

Seger, Linda. *Making a Good Script Great.* Hollywood: Samuel French Trade, 1987.

Senn, Bryan. "The Haunting." In Gary J. and Susan Svehla, eds., *Cinematic Hauntings.* Baltimore: Midnight Marquee Press, Inc., 1996.

Serkis, Andy. *The Lord of the Rings GOLLUM: How We Made Movie Magic.* New York: Houghton Mifflin Company, 2003.

Shay, Don. "Back To Titanic." *Cinefex* 72, December 1997, pp. 15–76.

Shay, Don, Jody Duncan, and Joe Fordham. "State of the Art: A Cinefex 25th Anniversary Forum." *Cinefex* 100, January 2005, p. 17–107.

Silberman, Steve. "Life After Darth." *Wired* 13.05, May 2005. http://www.wired.com

Slusser, George, and Eric S. Rabkin. *Shadows of the Magic Lamp.* Carbondale: Southern Illinois University Press, 1985.

Sobchack, Vivian. *Meta-Morphing: Visual Transformation and the Culture of Quick Change.* Minneapolis: University of Minnesota Press, 2000.

————. "At the Still Point of the Turning World." In *Meta-Morphing: Visual Transformation and the Culture of Quick Change.* Minneapolis: University of Minnesota Press, 2000, pp. 131–158.

————. *Screening Space: The American Science Fiction Film.* New Brunswick, NJ: Rutgers University Press, 1987.

————. "Cities on the Edge of Time: The Urban Science Fiction Film." In Annette Kuhn, ed., *Alien Zone II: The Spaces of Science Fiction Cinema.* London: Verso, 1999, pp. 123–143.

————. "The Fantastic." In Geoffrey Nowell-Smith, ed., *The Oxford History of World Cinema.* Oxford: Oxford University Press, 1997, pp. 312–321.

————. "The Virginity of Astronauts: Sex and the Science Fiction Film." In Annette Kuhn, ed., *Alien Zone: Cultural Theory and Contemporary Science Fiction Cinema.* London: Verso, 1990, pp. 103–115.

Staiger, Janet. "Future Noir: Contemporary Representations of Visionary Cities." In Annette Kuhn, ed., *Alien Zone II: The Spaces of Science Fiction Cinema.* London: Verso, 1999, pp. 97–122.

————. "The Central Producer System: Centralized Management after 1914." In David Bordwell, Janet Staiger, and Kristin Thompson, *The Classical Hollywood Cinema: Film Style and Mode of Production to 1960.* London: Routledge, 1985, pp. 128–141.

Stempel, Tom. *Framework: A History of Screenwriting.* Syracuse: Syracuse University Press, 2000.

Stern, Michael. "Making Culture into Nature." In Annette Kuhn, ed., *Alien Zone: Cultural Theory and Contemporary Science Fiction Cinema.* London: Verso, 1990, pp. 66–72.

Thomas, Brett. "Memo Hollywood: You've Lost The Plot." *Sun-Herald,* February 23, 2003, p. 1, Sunday Metro, col. 3.

Thompson, Kristin. *Storytelling in the New Hollywood: Understanding Classical Narrative Technique.* Cambridge, MA: Harvard University Press, 1999.

Tobias, Ronald B. *Twenty Master Plots (and How to Build Them).* Cincinnati, Ohio: Writer's Digest Books, 1993.

Vallis, Roy. "The Future of Popular Film Tradition: More Real, More Fantastic, More Ancient." Presented at the Hawaii International Conference on Arts and Humanities, January 8–11, 2004.

Vogler, Christopher. *The Writer's Journey: Mythic Structure for Storytellers and Screenwriters.* Studio City, CA: Michael Wiese Productions, 1992.

Warshow, Robert. "Movie Chronicle: The Westerner." In Leo Braudy and Marshall Cohen, *Film Theory and Criticism,* 5th ed. New York: Oxford University Press, 1999, pp. 654–667.

Weiss, Steve, ed. *CG101: A Computer Graphics Industry Reference.* USA: New Riders Publishing, 1999.

Williams, Christopher. "After the Classic, the Classical and Ideology: The Differences of Realism." In Christine Gledhill and Linda Williams, eds., *Reinventing Film Studies.* London: Arnold Publishing/Hodder Headline Group, 2000, pp. 206–220.

Winston, Brian. *Technologies of Seeing: Photography, Cinematography, and Television.* London: British Film Institute, 1996.

Wolf, Mark. "A Brief History of Morphing." In Vivian Sobchack, ed., *Meta-Morphing: Visual Transformation and the Culture of Quick-Change.* Minneapolis: University of Minnesota Press, 2000, pp. 83–101.

———. "In the Frame of Roger Rabbit: Visual Compositing in Film." *Velvet Light Trap,* Fall 1995, p. 45 (15) Infotrac.

Wollen, Peter. "Signs and Meaning in the Cinema: The Auteur Theory." In Leo Braudy and Marshall Cohen, *Film Theory and Criticism,* 5th ed. New York: Oxford University Press, 1999, pp. 519–535.

Other References

American Film Institute, as reported on CNN Broadcast, Sydney, 14:53 p.m., 13 June 2003.

Box Office Mojo. http://www.boxofficemojo.com

Brown, Ian. Interview with the author, 20 May 2002, Sydney, Australia.

Cameron, James. *Alien Legacy: 2oth Anniversary Special Edition* box set DVD collection. Twentieth Century Fox Film Corporation, 2000.

de Bont, Jan. *The Haunting,* a DreamWorks film, 1999.

Foster, Frank. *The Story of Computer Graphics.* ACMSiggraph, Video Review #137, documentary film, 2000.

Giger, H. R. *Alien Legacy: 20th Anniversary Special Edition* box set DVD collection. Twentieth Century Fox Film Corporation, 2000.

Pesce, Mark. "The New Reality for Producers." Keynote address: Screen Producers Association of Australia Conference, 18 November 2003.

Paul-Emile, Barbara. *"Warriors of the Spirit: Women's Mythic Inner Journey."* Paper presented at the Hawaii International Conference on Arts and Humanities, January 8–11, 2004.

Sakakibara, Motonori, Roy Sato, and Junichi Yanagihara. Interview with the author, 7 January 2004, Honolulu, HI.

Scott, Ridley. *Alien Legacy: 20th Anniversary Special Edition* box set DVD collection. Twentieth Century Fox Film Corporation, 2000.

Seconds from Disaster: The Wreck of the Sunset Limited. Barlow-Smithson Productions/National Georgraphic. Screened 10:30 p.m., 23 March 2005, Channel 7, Sydney, Australia.

The Eternal Sunshine of the Spotless Mind by Buzz Image Group. http://www.softimage.com/Products/xsi/%/2ov4/industry/media

Wise, Robert. *The Haunting,* an MGM film, 1963.

Index

Index

Index

300